# Survivor

A portrait of
the survivors
of the Holocaust

Harry Borden

*foreword by* Howard Jacobson

CASSELL
ILLUSTRATED

# Contents

## *foreword by* Howard Jacobson

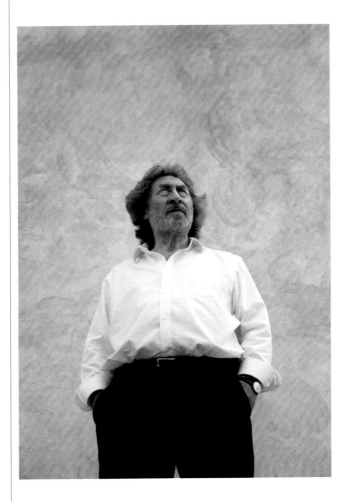

Among the horrors that Primo Levi quietly and even matter-of-factly documents in *If This is a Man* – that greatest of all accounts of incarceration in a Nazi death camp – is a dream of invisibility. Not invisibility in the here-and-now of camp life, which might have been welcomed, but invisibility in the longed-for future, back home "among friendly people". It is an *as-though* invisibility, not an actual one. Yes, they see him, but they cannot hear him. When he speaks of where he's been, his listeners don't follow. *Don't* or *won't*? This distinction is not made and perhaps cannot be made. Quite simply, his words don't reach them. "They are completely indifferent; they speak confusedly of other things among themselves, as if I was not there. My sister looks at me, gets up and goes away without a word."

On waking from this dream, Primo Levi experiences a "desolating grief". But he is not the only prisoner to have dreamed this; others anticipate the same anguish of the "unlistened-to story". Perhaps because they can barely trust the witness of their own eyes, they know how hard it will be for others to believe – to allow themselves to believe – the stories they have to tell. Better not to know.

Later in the book, Primo Levi describes the gleeful malice with which a German guard confirms what these dreams presage. Don't hope to be heeded when you return home, he warns. The words you speak will be as voices to the wind. The future will be deaf to you. History will expunge your experience as completely as it will expunge our guilt.

This terrible augury, uttered as though from hell, is in the end nothing more than the expression of a low opinion of human nature. Mankind cannot bear too much reality. The guard was proved right: the being "as if not there" would be the experience of many who wanted to talk about what they'd seen and undergone – that's when they were able to talk about it at all.

Many years have passed since the first publication of Primo Levi's great work, and we might speculate that things are simultaneously better and worse than he feared they would be. We are familiar with stories of survivor silence – the decades of speaking not

a syllable, of not wanting to put back into words what had now retreated, for safety's sake, into nightmare, decades of fearing being invisible and disbelieved, perhaps of wanting to be invisible and disbelieved as though that might make the memory of the experience vanish. We know, too, that such traumas don't stop with the generation that went through the camps but are passed on to children and even grandchildren in a terrible inheritance of guilt and shame. There are instances of too much memory, not too little, where the necessity to keep on telling, or least to keep on remembering, becomes an intolerable burden.

But however oppressive that burden, however cruel the cost of remembering – "If you could lick my heart, it would poison you," a survivor of the Warsaw ghetto famously admitted – the story has to go on being told. Not only as an individual imperative, where such an imperative still exists, but as a communal duty. Because, for all the apparent "visibility" of the Holocaust today – and the memorials and museums and countless films and books and articles on the subject certainly seem to have given the lie to the prison guard's hellish prognostications – there remain voices urging scepticism, forgetfulness, even a renegotiation of pity. "Negators of truth," Primo Levi called them.

Literal negators of the sort who once crawled over what was left of the camps with tape measures and set-squares to prove the gassings were exaggerated or even impossible – the foot-soldiers of denial – enjoy less credence than once they did, except in some Middle Eastern countries where anti-Semitism grows fat on conspiracy theory: Iran, for example, which sponsors an annual Holocaust cartoon contest, lampooning Jews and their fabrications. Elsewhere, Holocaust denial takes subtler and more insidious forms, now as Holocaust fatigue, in the course of which victims become confused with perpetrators, or dismissed as participants in mere "white-on-white crime" warranting neither pity nor recognition; now as Holocaust avidity – a species of competitiveness whose aim is to wrest the Holocaust from the Jews who, in this narrative, are presented as greedily insisting on an exclusivity of suffering.

Thus we have competing Holocaust Memorial Days, some held quite deliberately without the presence of Jews. Why privilege the Jews when the Holocaust was a crime against all humanity, and why privilege this Holocaust, when other groups have suffered at the hands of genocidal tyrants? What about *our* Holocaust? As often as not, such avidity is motivated by a familiar malevolence and spite. Jews are described as choosing to profit from the Holocaust, to deploy it to secure sympathy and assistance, or to justify the excesses of Zionism. One can detect in these accusations a retrospective half-justification of the Holocaust as a punishment not for what Jews had done but for what they *would* do, that's to say for refusing to learn its lessons. For how can a people be said to have been chastened or purified by the fires of extraordinary suffering if they don't thereafter behave with extraordinary forbearance? By this twisted reasoning it can be intimated that Jews brought upon themselves what was done to them by virtue of what they would go on to do to others. So do the fathers pay for the sins of their children.

Holocaust denial, Holocaust scepticism, Holocaust justification, Holocaust ridicule, Holocaust diminishment – in our time not listening is only one of the ways the stories go unheeded, and when those stories are unheeded or even mocked, it as though the dead are murdered a second time.

There are fewer and fewer survivors left to speak about what only they can know. It is all the more important, then, that they bear witness to a truth so many do not want to hear. Not sentimentally, or morbidly, not with self-pity or in expectation of praise or admiration, but with the strength of certainty. After a while there is nothing left you have to prove. There you stand, and your resolution is your truth, let the malicious and the jealous of heart deny you as they will. In this wonderful collection of photographs, Harry Borden offers to our gaze precisely that resolution. His subjects have experienced the worst and seem now not to be afraid of anything more the world can say or do to them. The nobility of these photographs resides in the something undefinable Harry Borden sees, and the unblinking steadiness with which he sees it – call it an indomitability of spirit, neither bitter nor disillusioned, neither ferocious nor reconciled. In the face of so much to be appalled by, his subjects give a degree of hope, if only by the quiet, unanswerable quality of their endurance. Not a hope that such events will never be repeated, or even that they will ever be fully understood, but that a still, small determination to look horror in the face and speak the truth survives beyond the "desolation of grief".

*— Howard Jacobson, May 2016*

*introduction by* | Harry Borden

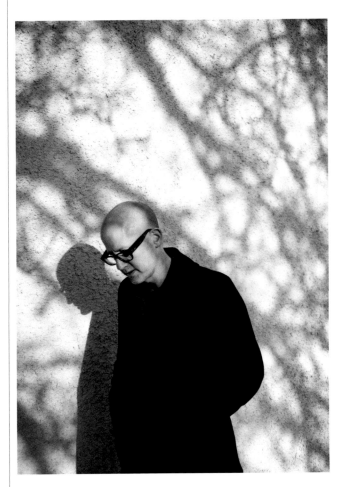

26 February 2008. I tentatively park my car in London's Regent's Park. The white stucco terraces are an intimidating façade, which only adds to my nervousness. I am here to photograph Peter Lantos, Fellow of the Academy of Medical Sciences, author, playwright and Holocaust survivor.

Peter's elegant Regency house gleams in the winter sunshine. He is softly spoken and erudite. As we discuss the project over coffee, I'm glad that I decided to leave most of my equipment in the car; it's less intrusive this way. We decide to take the picture in an upstairs room. I put my camera on a tripod and use nothing more for illumination than the daylight streaming through the sash windows.

This shoot, among the first of almost two hundred I would eventually complete for this project, established my approach. Afterward I gave Peter a blank sheet of paper and asked if he'd like to write a few words to accompany the portrait. With his old-fashioned fountain pen, he wrote, "Thinking of the horrors of Bergen-Belsen, I suddenly realized that I have arrived toward the end of my life, at a perfect moment of peace. I feel no pain, no anger and no hate."

The reason I was here, photographing Peter Lantos, was that, at the age of 40, having spent half my life photographing famous people, I wanted to do something with meaning.

I grew up on a farm in Devon, England. My dad, Charlie, was a resolutely atheist Jew who derived nothing from his background except a fear of anti-Semitism. When I was a boy he once told me that the Nazis would have killed us. I was shocked. I attended a Church of England primary school, sang in the choir and had always considered myself a Christian like my mum.

My dad's mother, Lillian, came and lived with us in Devon for a little while in the early 1970s. She had been born in Romania but had gone to America with her parents as a baby in 1907. Her husband, Harry, was a commercial artist who had arrived in the US from Ukraine. The pogroms of Eastern Europe behind them, they had built their own house and created a new life. Lillian would proudly tell me, my brother and my sister all about our Jewish heritage.

However, I think it was my dad's ambivalence toward this heritage – and his disturbing revelation that it had once been deemed punishable by death – that really motivated me to create this body of work.

On 15 May 2008 I gave a talk about my celebrity portraiture at the London Jewish Cultural Centre. In the audience were a few Holocaust survivors and, after the slideshow and anecdotes, I announced my intention to start this venture. I said that everyone who participated would get a print for their family, and the response was encouraging. I think that one or two of them just liked the idea of sitting for somebody who had once photographed Margaret Thatcher.

Later that year, having put a selection of the images online, I was interviewed by the *Australian Jewish News*. This provided an opportunity to see if there were any survivors from farther afield who might like to take part. The emails flooded in, so at Christmas I travelled to Melbourne, where I stayed with Joe Lewit. The son of Maria Lewitt, one of my subjects, Joe has helped me immensely.

Shortly after returning from my trip, I received a message from Miriam Hechtman, a writer and producer based in Sydney. The granddaughter of survivors, she had read the newspaper article about what I was doing and wanted to get involved. Miriam soon became an invaluable partner in this endeavour, accompanying me to Israel and North America. On 24 June 2010 we visited Kurt and Margaret Goldberger at their home in upstate New York. They were the last survivors I photographed to be included in these pages.

Many of the people in these portraits died before the book's publication. One day soon, all survivors will be gone. My hope is that this work honours not only all those who were gracious enough to take part but also every other survivor, along with the men, women and children who were killed during the Holocaust.

I set out to do something with meaning. Being fortunate enough to have met and photographed these remarkable people has certainly felt meaningful to me.

I'd like to thank: Miriam Hechtman, Guy Shalvi, Joe Lewit, Ruja Varon, Abbie Trayler Smith, Jane Anning, David Stromberg, Trevor Davies, Simon Crocker at the John Kobal Foundation, Ben Mitchell, Howard Jacobson, Cecile Mairat, Albert Bensusen, Dick and Susanne Clark, Paul Summerfield and Stephanie Rose at the London Jewish Cultural Centre.

*For Polly, Fred, Oscar and Florian*

# Survivor

The portraits

*Thinking of the horrors of Bergen-Belsen, I suddenly realized that I have arrived towards the end of my life, at a perfect moment of peace. I feel no pain, no anger and no hate.*

*Peter Lantos*

---

**Peter Lantos**

*Page 217*

Thinking of the horrors of Bergen-Belsen,
I suddenly realized that I have arrived
towards the end of my life, at a perfect
moment of peace. I feel no pain, no anger
and no hate.

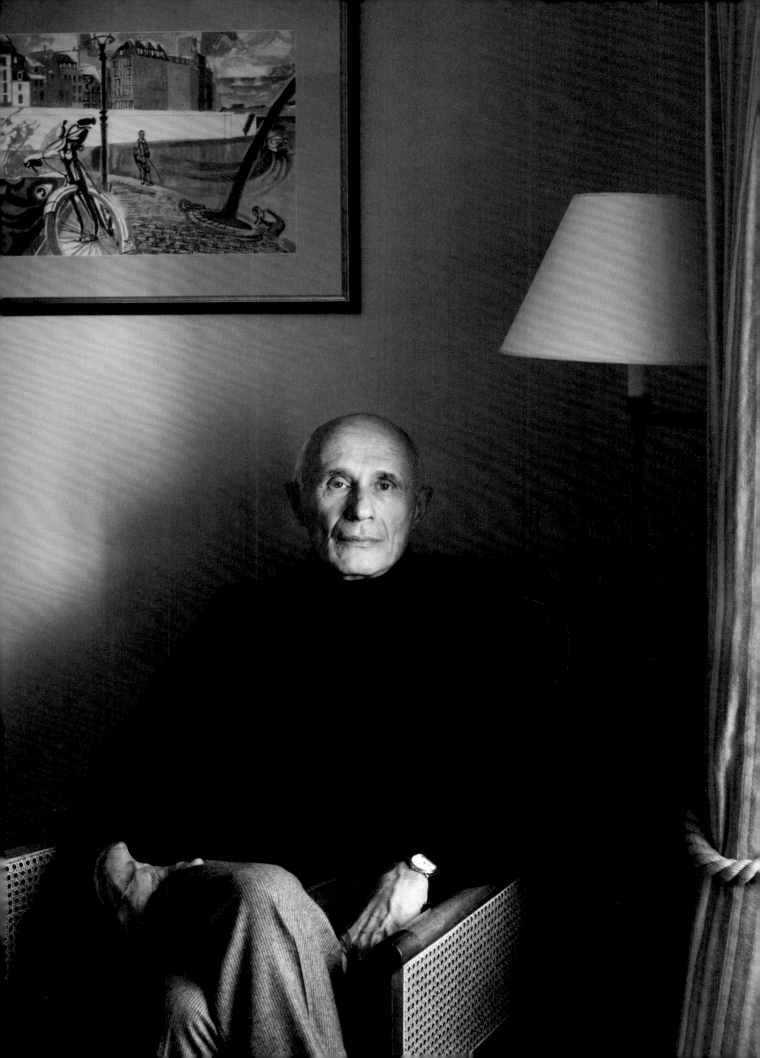

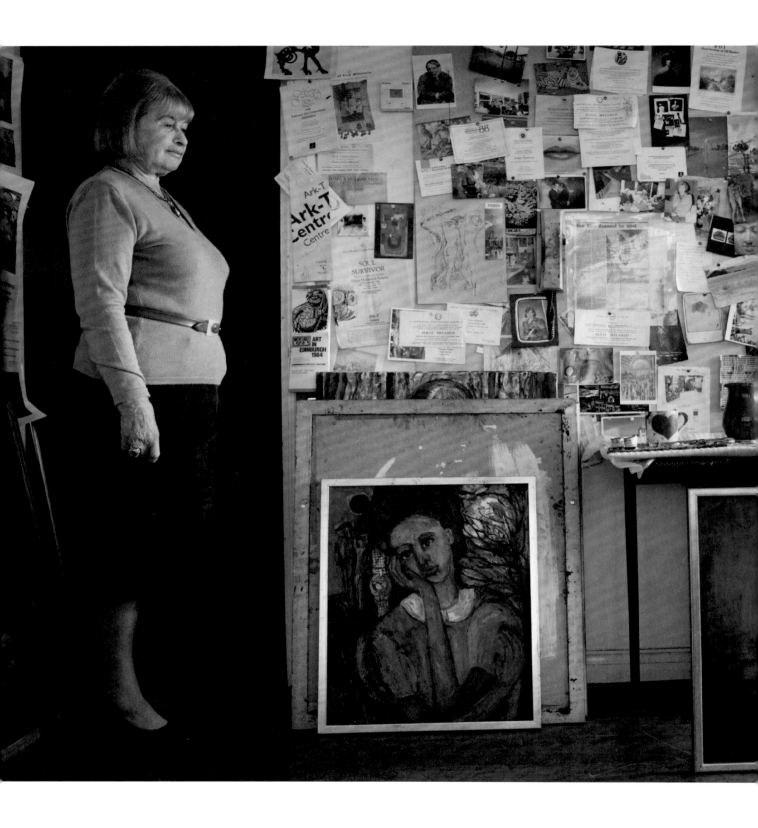

**Alicia Melamed Adams**          Love is forever.

Love is forever
Alice Melamed Adams

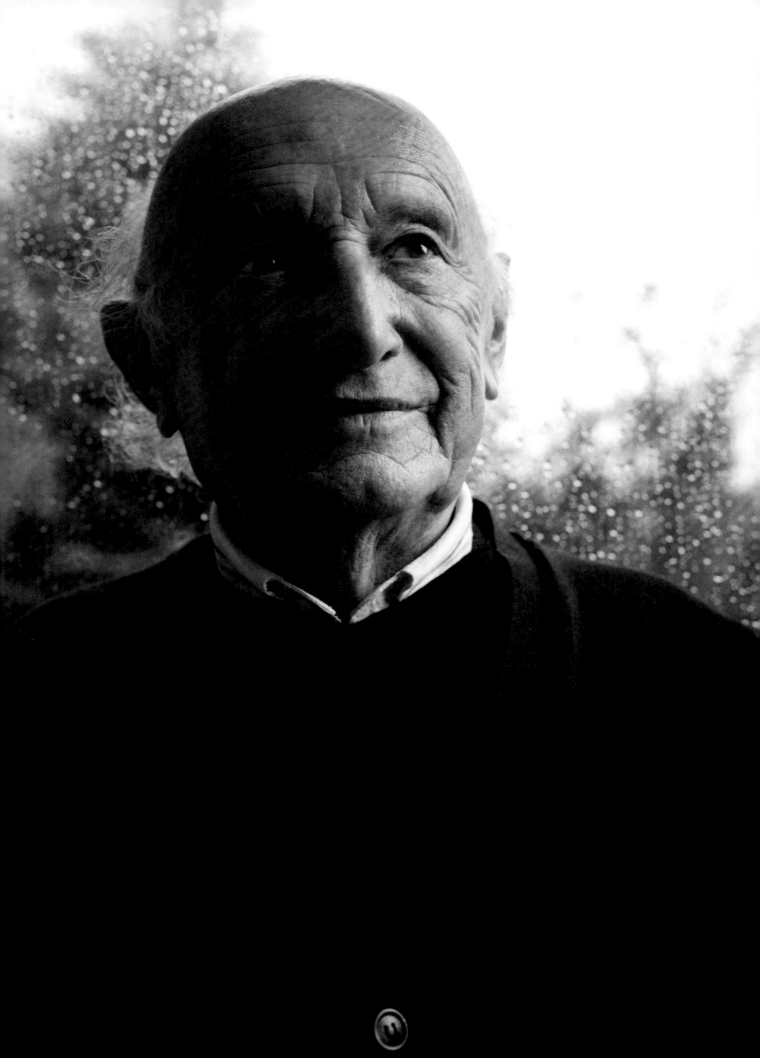

*My name is Izrael Nathan Melamed
not Adam Adams.*

My name is Izrael Nathan Melamed
not Adam Adams.

*We were rehearsing Brahms' lullaby in the singing lesson when the Headmistress came in and said "you've got to leave now, you're Jewish".*

*Aliza Shapiro*

We were rehearsing Brahms's lullaby in the singing lesson when the Headmistress came in and said "you've got to leave now, you're Jewish".

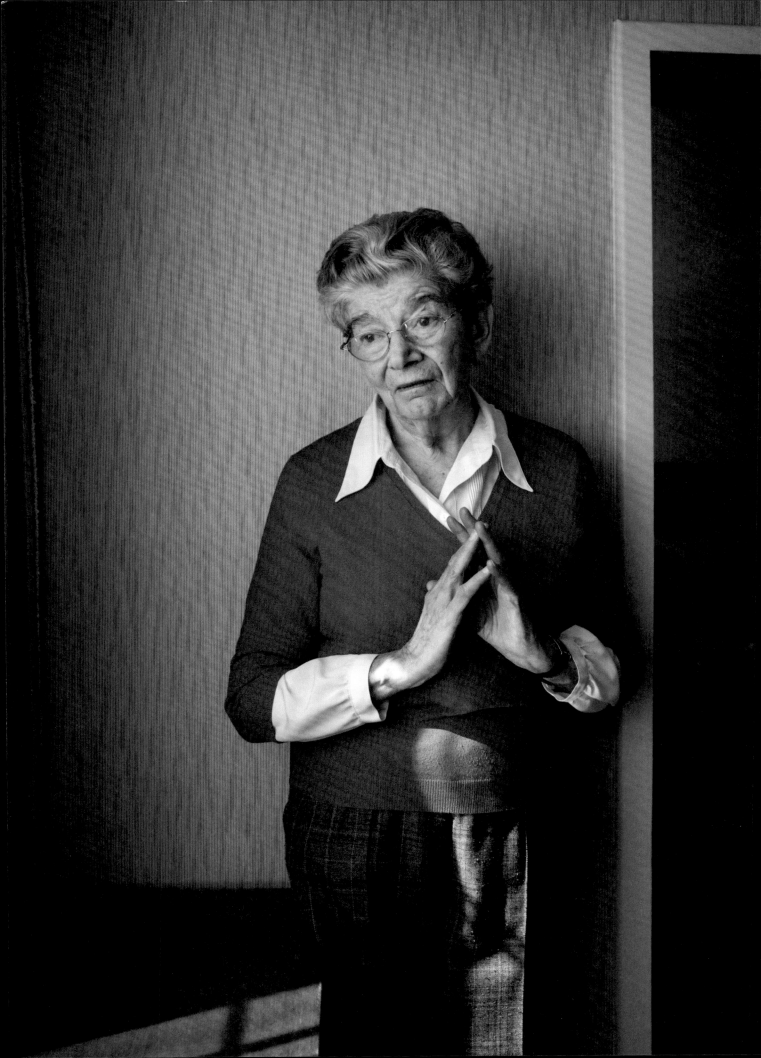

My Grandma used to say that she could
not believe what she went through. A
reminder of the past and an inspiration
for the future. A survivor in every
sense of the word. She lived to raise
two children and deeply cherished her
grandchildren and great grandchildren.
Grandma passed away 31 days ago.
Marcus & family.

**Barbara Stimler**

*Page 219*

My grandma used to say that she could
not believe what she went through. A
reminder of the past and an inspiration
for the future. A survivor in every sense of
the word. She lived to raise two children
and deeply cherished her grandchildren
and great grandchildren. Grandma passed
away 31 days ago.
*Marcus (grandson) and family*

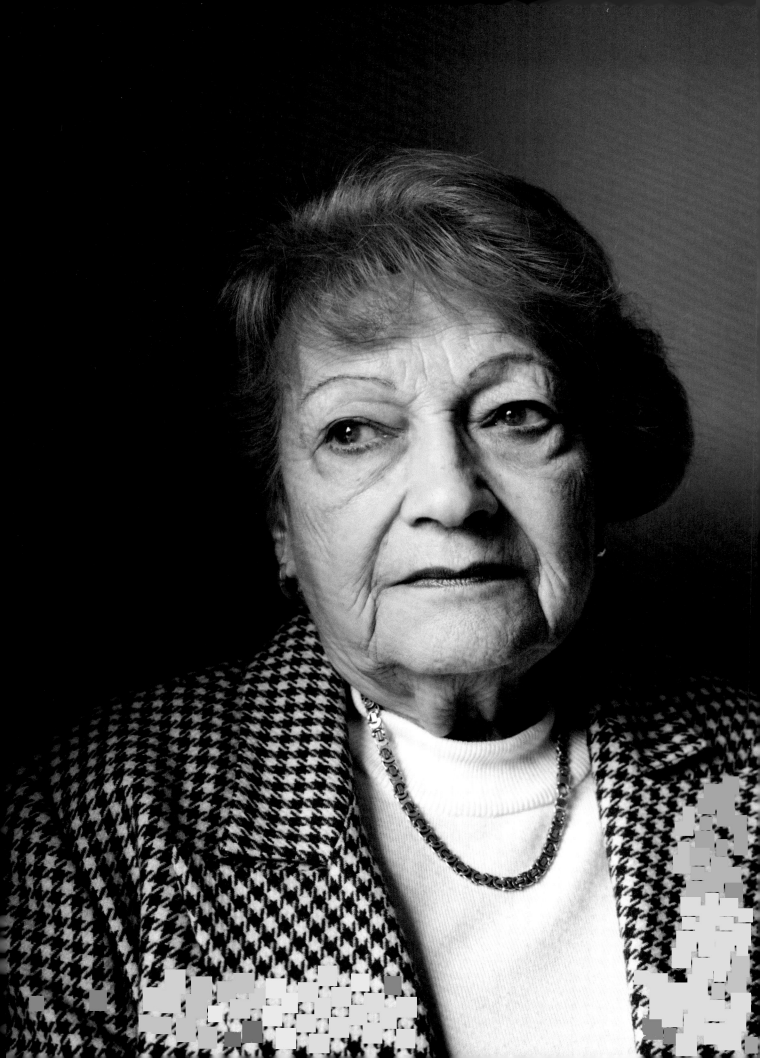

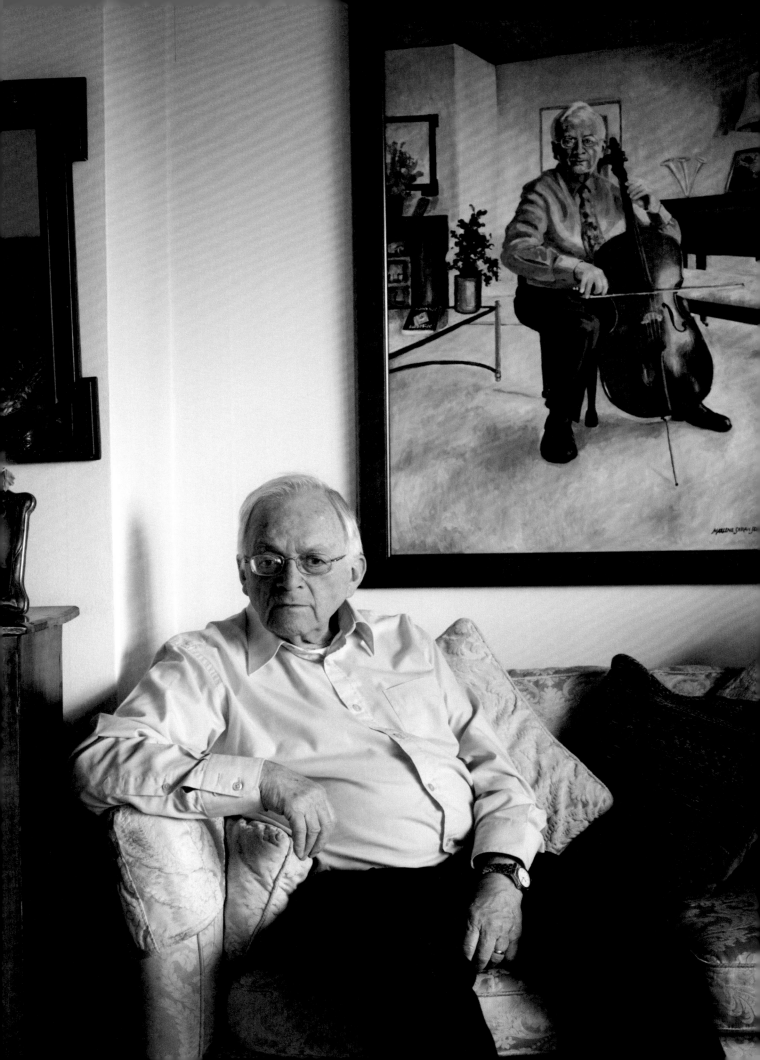

*I am glad to be an optimist, because that's what kept me alive*

*Fredu Knoller*

I am glad to be an optimist, because that's
what kept me alive.

Ein Junge in deiner Lage
kann sich sowas nicht leisten.

(A boy in your situation can't
afford to do something like this.)

Charles Wannan

formerly: Karl Hinselland

A boy in your situation can't afford to do
something like that.

As an Austrian Jewish refugee I
was threatened in Yugoslavia with being
sent back to the Austrian border. No
other country was prepared to offer me
a visa. Albania was the country that
saved my life. T. Scarlett Epstein

---

**Dr. T Scarlett Epstein**

*Page 220*

As an Austrian Jewish refugee I was
threatened in Yugoslavia with being sent
back to the Austrian border. No other
country was prepared to offer me a visa.
Albania was the country that saved my life.

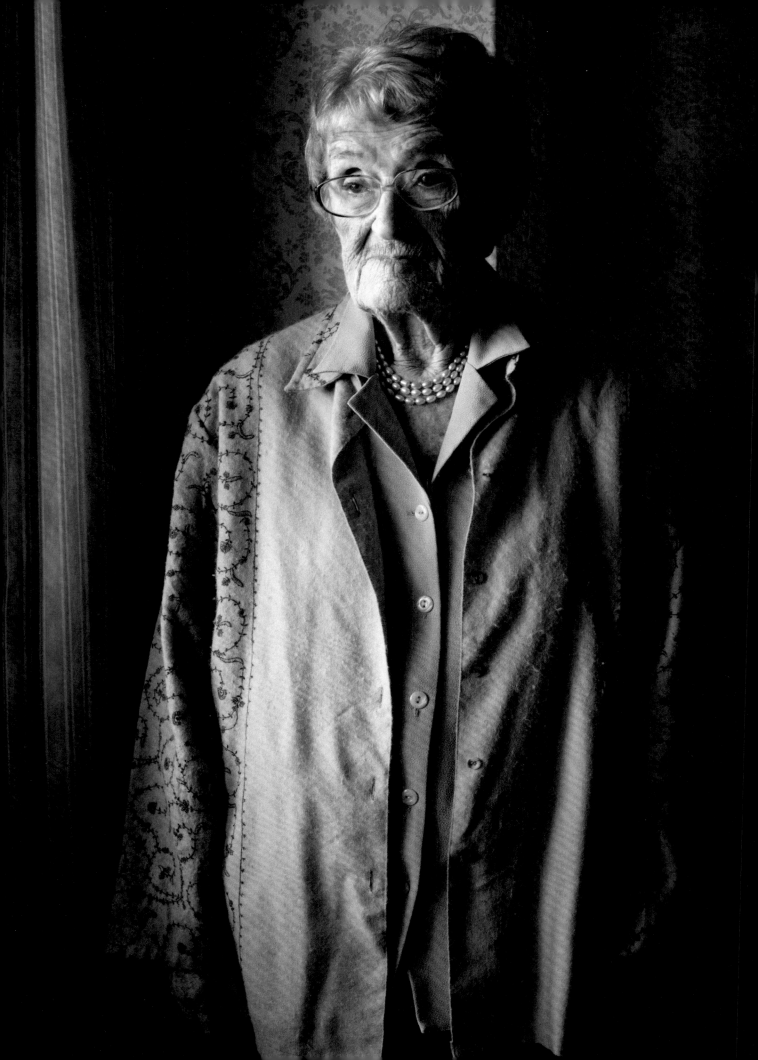

*When I was a teenager I went through hell. Eventually I came out of it, an optimist, a very happy person, who loves and appreciates life to the fullest.*

*Eva Schloss*

When I was a teenager I went through hell.
Eventually I came out of it, an optimist,
a very happy person, who loves and
appreciates life to the fullest.

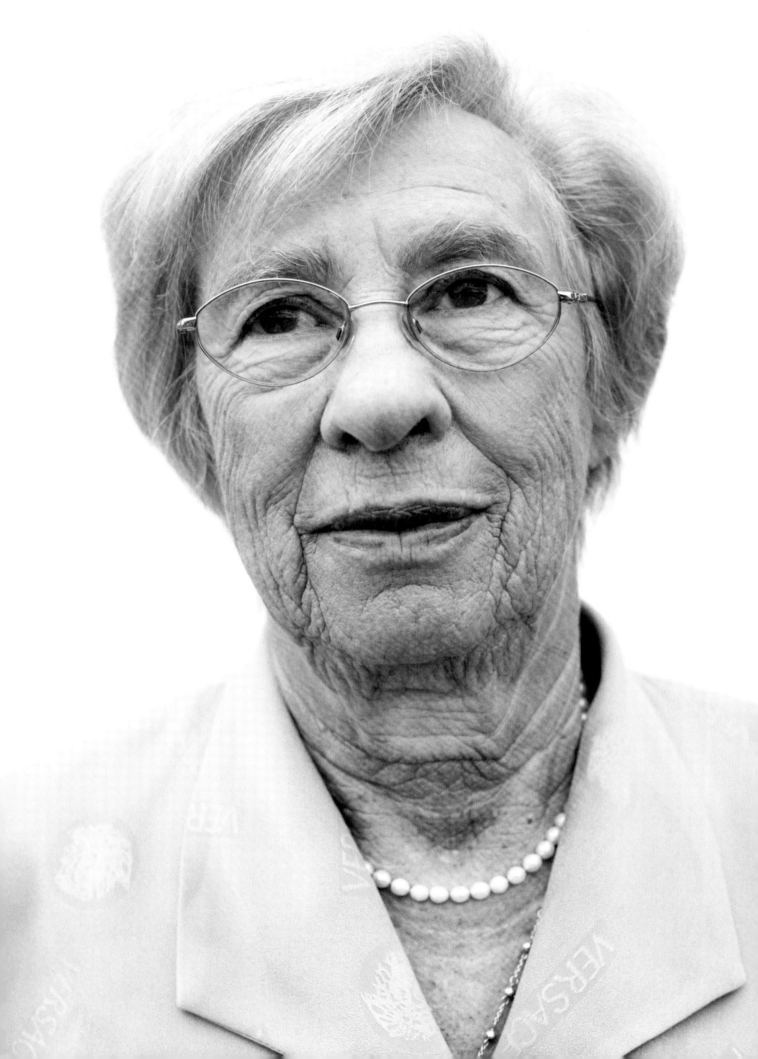

*I am happy to be able to live
in England for the last 70 years,
as this saved my life and
kept me happy and alive.*

Osias Findling

I am happy to be able to live in England for
the last 70 years, as this saved my life and
kept me happy and alive.

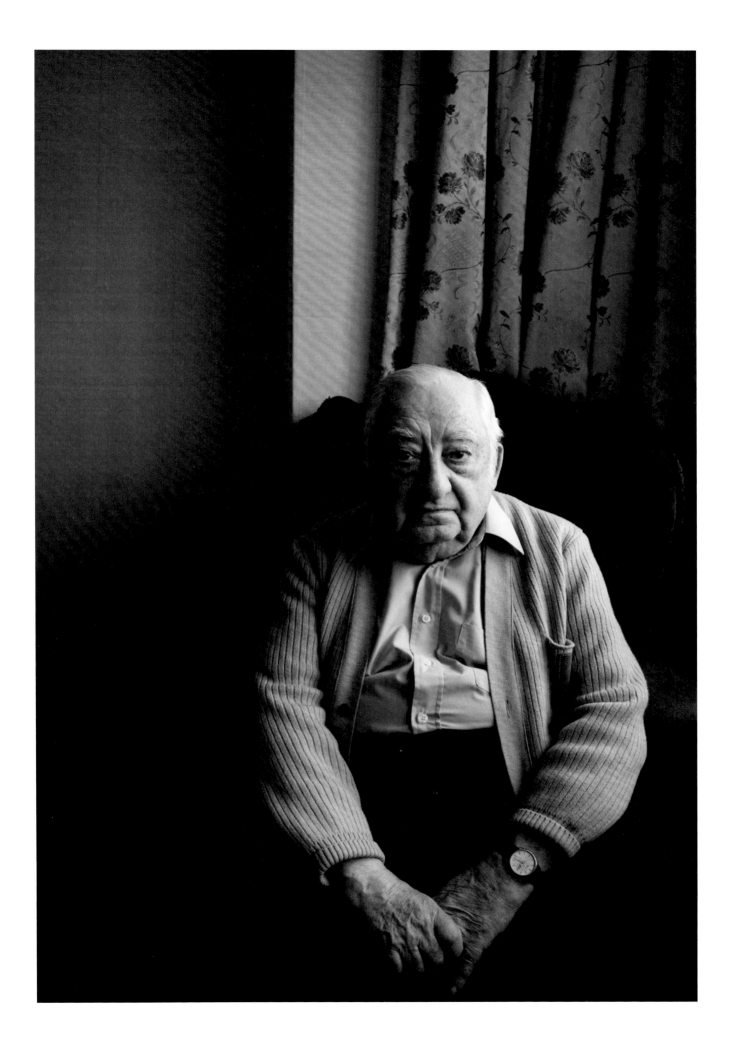

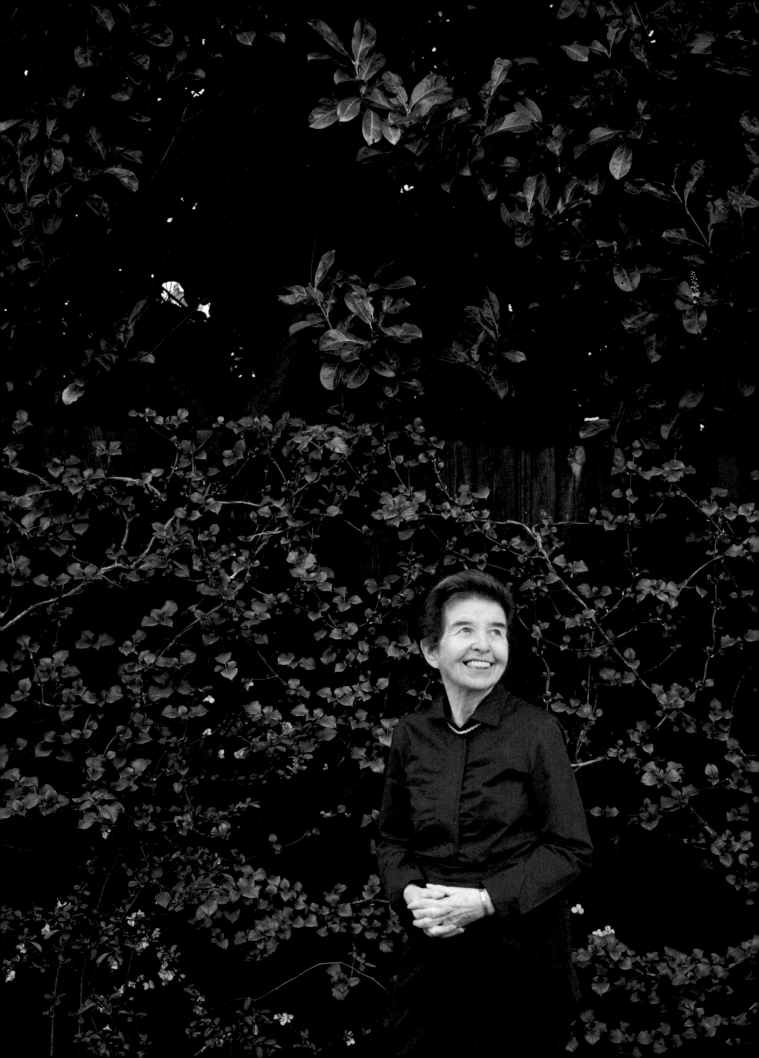

*I am a child survivor*

*Those of us who survived were not more worthy than those who perished. Nor were we braver, richer smarter or more resourceful. We were not. We were just luckier.*

*Eve R. Kugler*

**Eve Kugler**

*Page 221*

I am a child survivor. Those of us who survived were not more worthy than those who perished. Nor were we braver, richer, smarter or more resourceful. We were not. We were just luckier.

Despite the past, the present and
the future are important

*Koschland.*

---

Despite the past, the present and the
future are important.

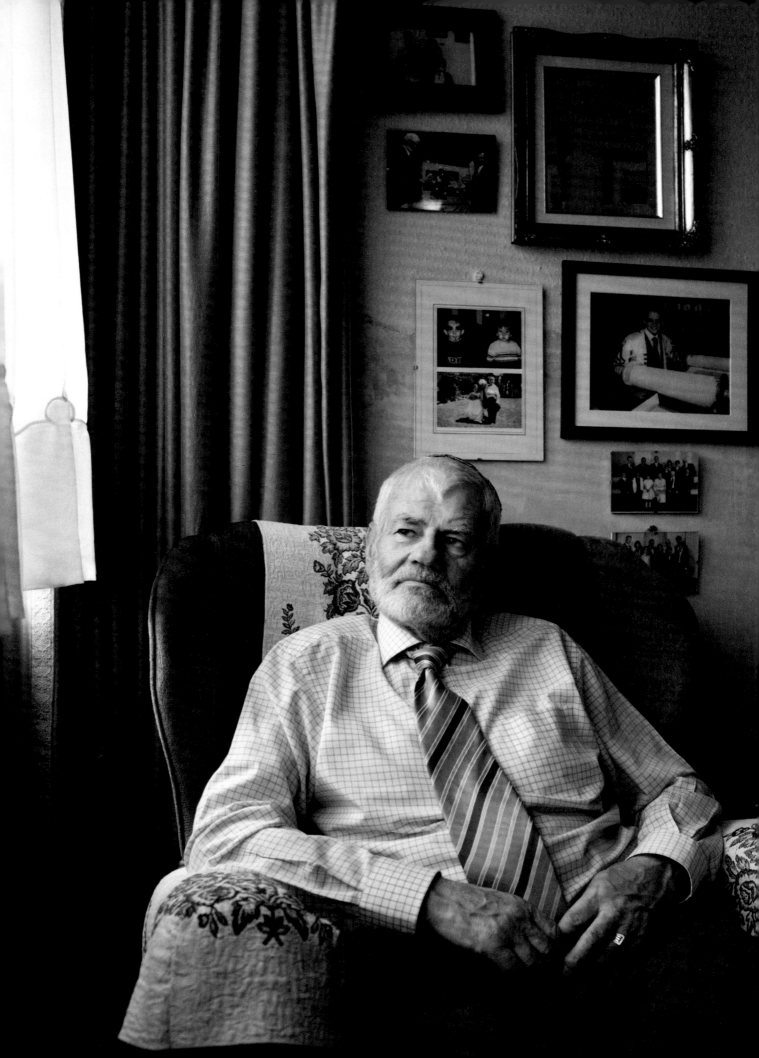

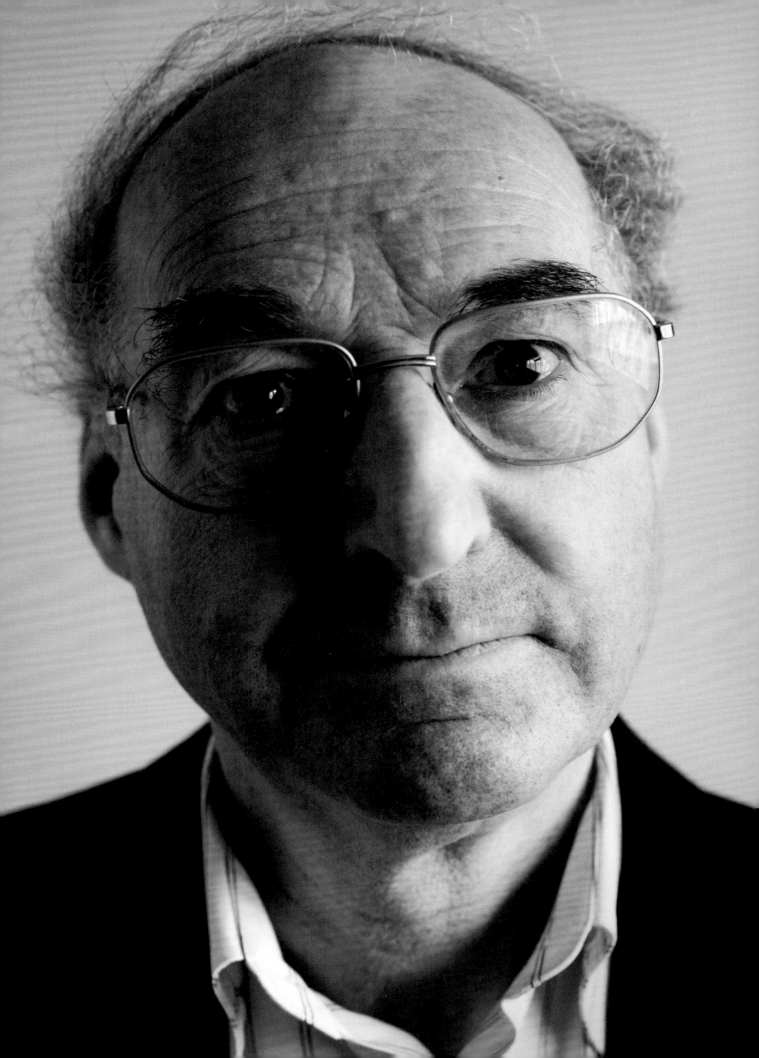

*.... and what has
the world learned
of all this?*

*Henri Obstfeld*

...and what has the world learned
of all this?

*Remember, small children and babies were murdered...*

*Marcel Ladenheim*

Remember, small children and babies
were murdered...

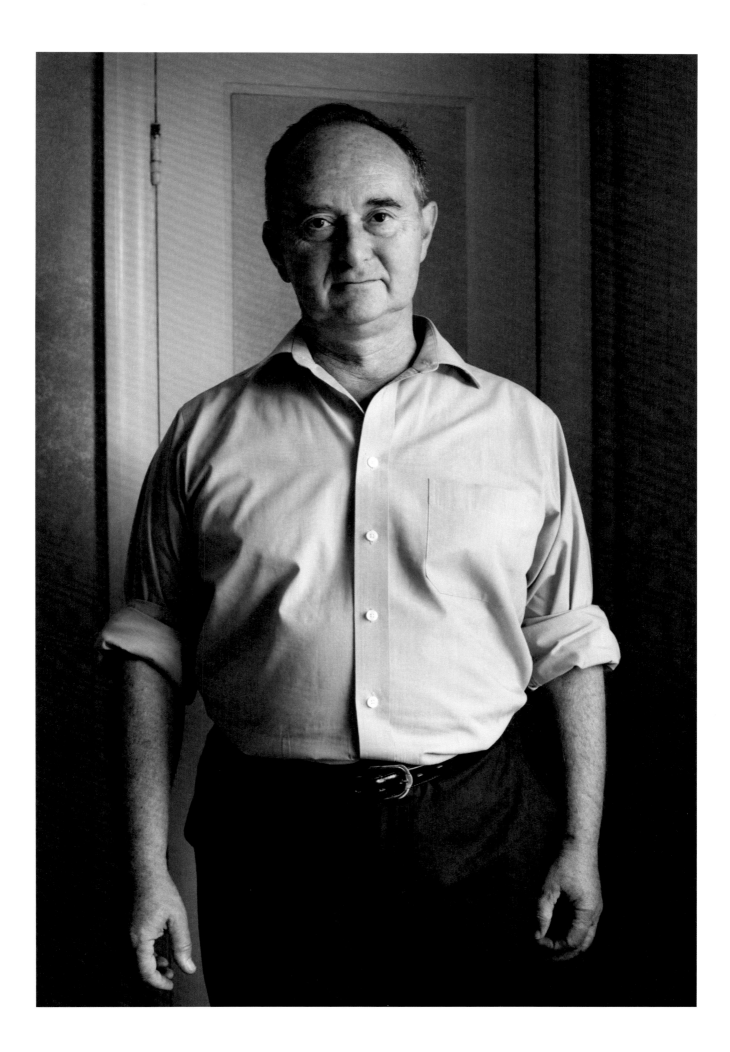

*I think of myself as a person, a wife and mother first and a survivor last*

*Mirjam Finkelstein*

I think of myself as a person, a wife and
mother first and a survivor last.

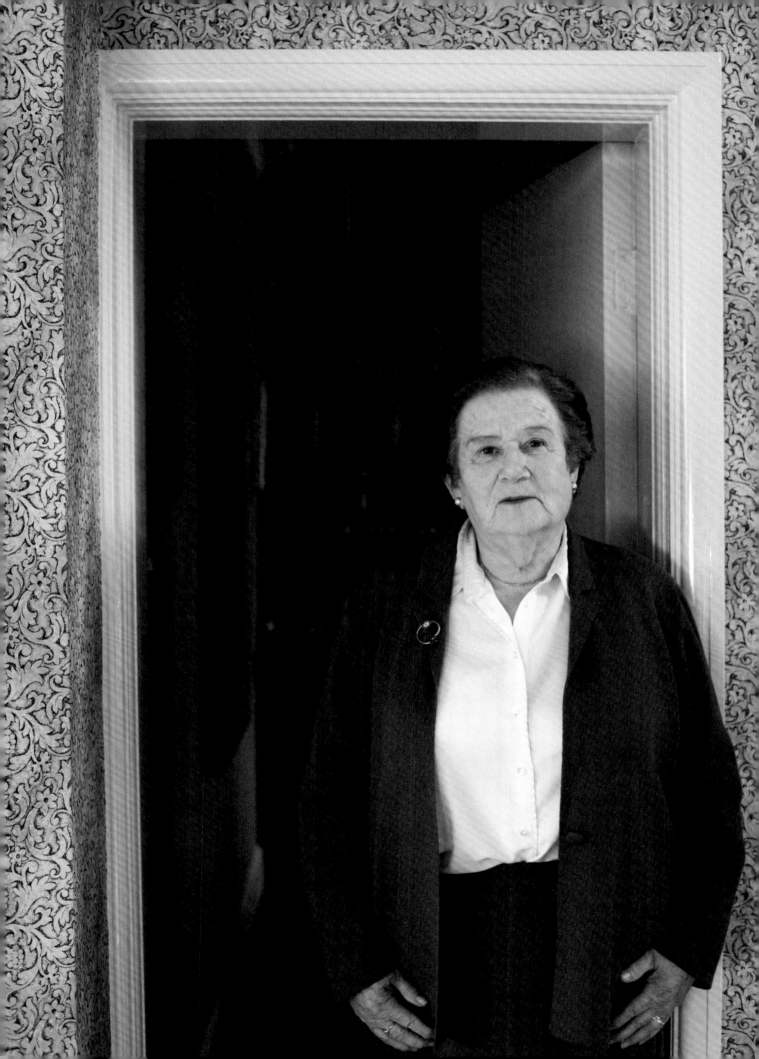

There is a mountain of literature,
film, music, painting, sculpture,
archive and history that refers
to the horror of the Holocaust.
Little is said of those survivors
who, despite their pains and loss,
made a success of their lives.
I wish to move the story on to
honour and celebrate those of
us whose rich and full lives
have embraced the future.

**Maurice Blik**

*Page 223*

There is a mountain of literature, film, music, painting, sculpture, archive and history that refers to the horror of the Holocaust. Little is said of those survivors who, despite their pains and loss, made a success of their lives. I wish to move the story on to honour and celebrate those of us whose rich and full lives have embraced the future.

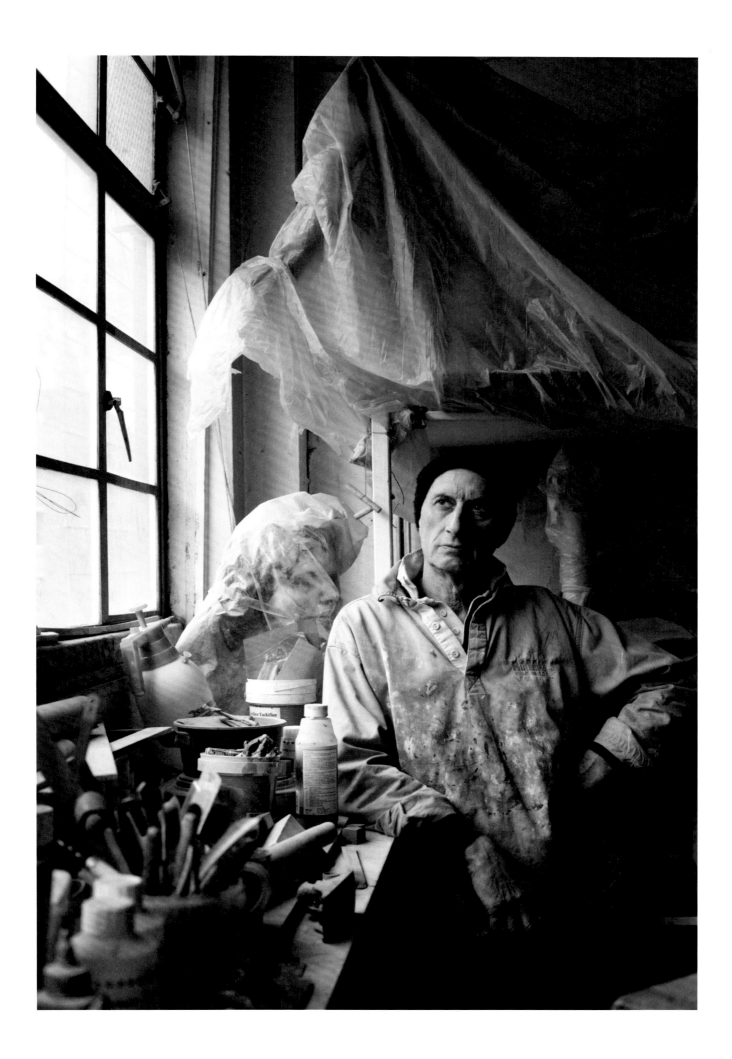

*Everyones experience*
*is very personal*
*Rita Knopf*

---

**Rita Knopf**

Everyone's experience is very personal.

**42** *Page 223*

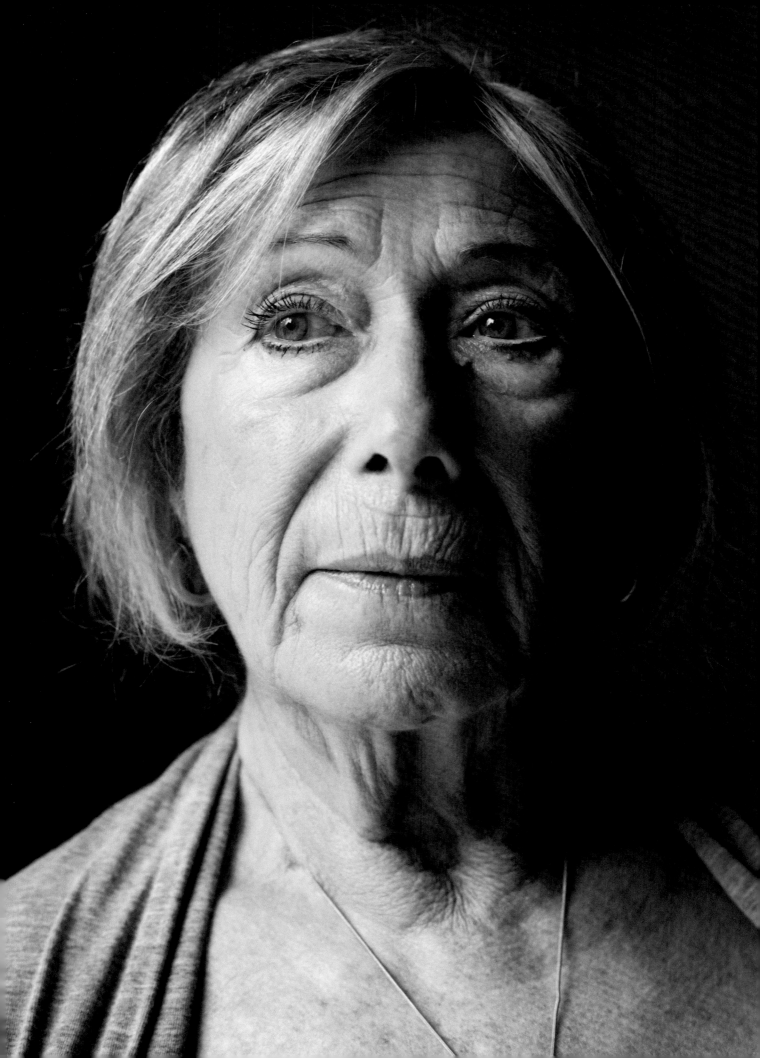

Our planet is as beautiful as
the Garden of Eden, so why
do we make weapons and
slaughter each other instead
of enjoying it?
Ruth Barnett

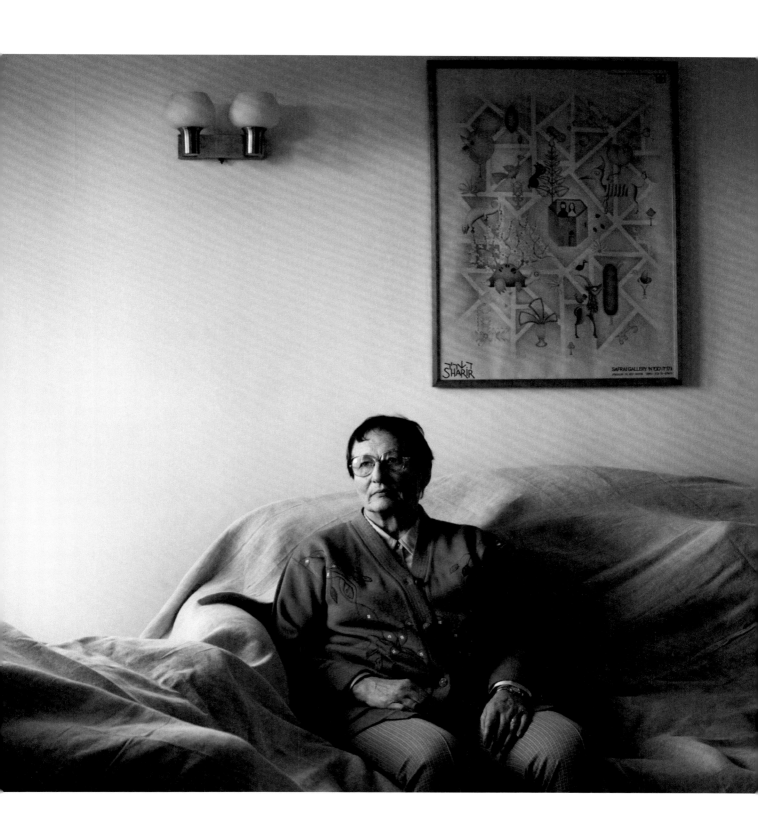

**Ruth Barnett**

*Page 223*

Our planet is as beautiful as the Garden
of Eden, so why do we make weapons and
slaughter each other instead of enjoying it?

My work as a teacher taught me to see each person as an individual.

*Vera Helga Schaufeld*

---

My work as a teacher taught me to see each person as an individual.

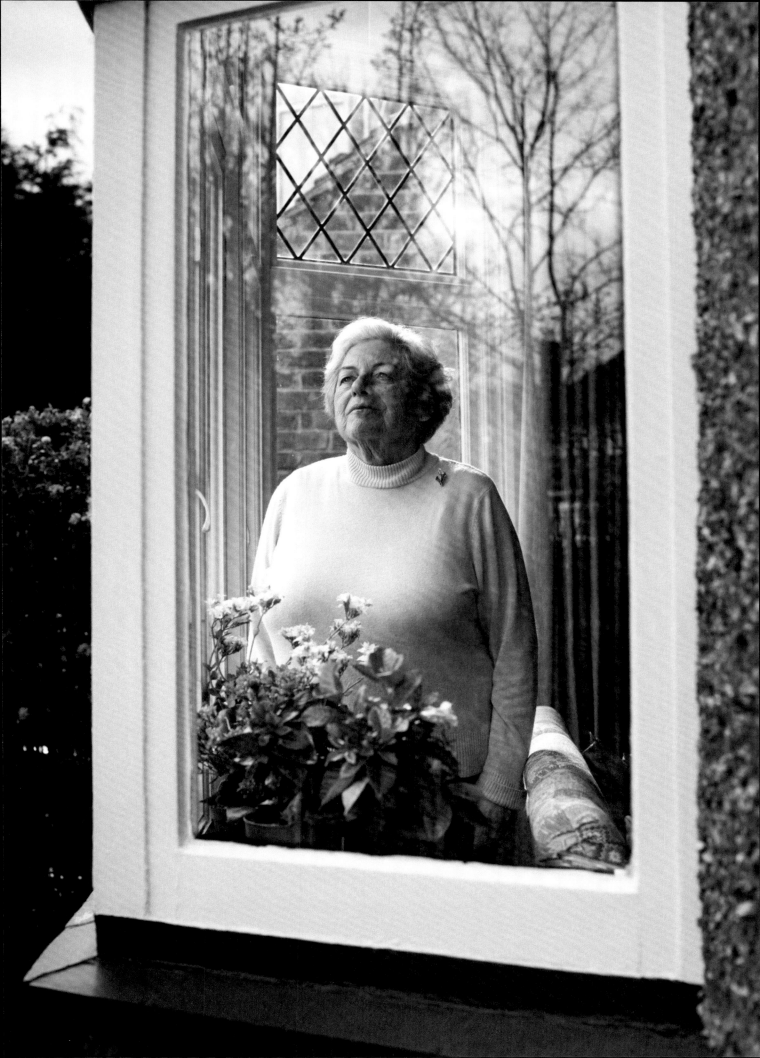

My Father said:

Lecheim, Lecheim, Lecheim

Life to all people

Krystyna
(daughter of
Benjamin Kinst)

My father said: Lecheim, Lecheim,
Lecheim. Life to all people.
*Krystyna (daughter)*

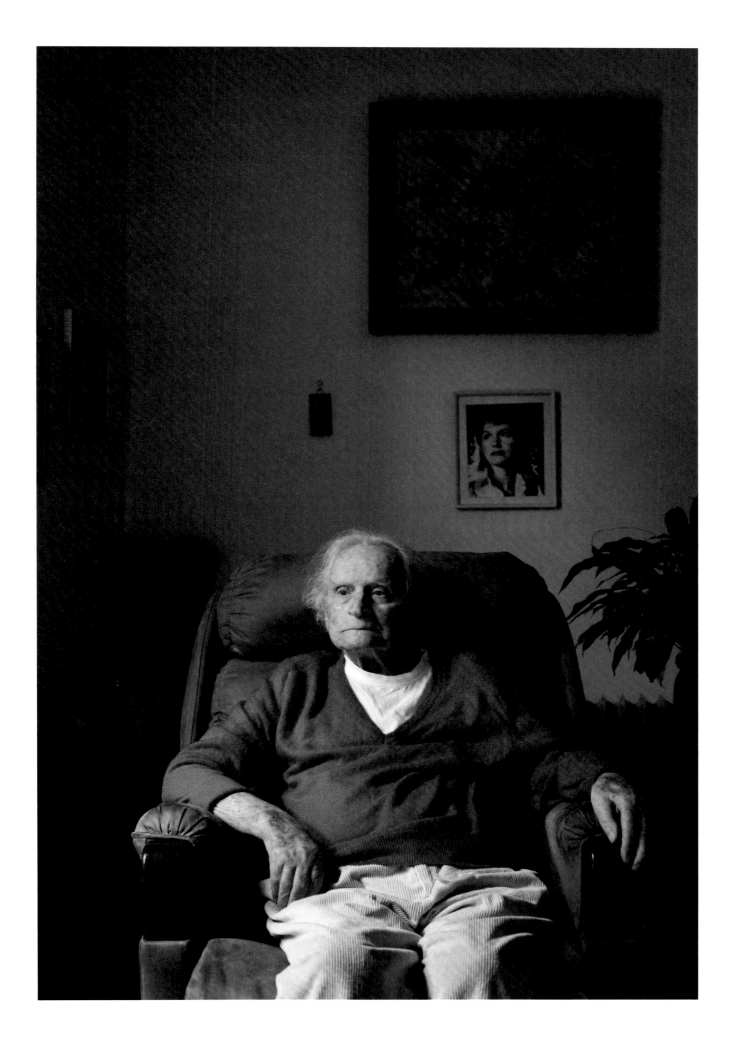

*ALONE,*

*There is no philosophy to describe*
*The sadness of a lone tree with dead roots*
*Even if nestled in faraway woods*
*all one can hear, is memories and tales*
*of Bygone years and prayers promised*
*for my soul, when I am gone.*

*Bronia Rosenbaum*

---

**Bronia Rosenbaum**

*Page 225*

**ALONE.**
There is no philosophy to describe
the sadness of a lone tree with dead roots
even if nestled in faraway woods

all one can hear, is memories and tales
of bygone years, and prayers promised
for my soul, when I am gone.

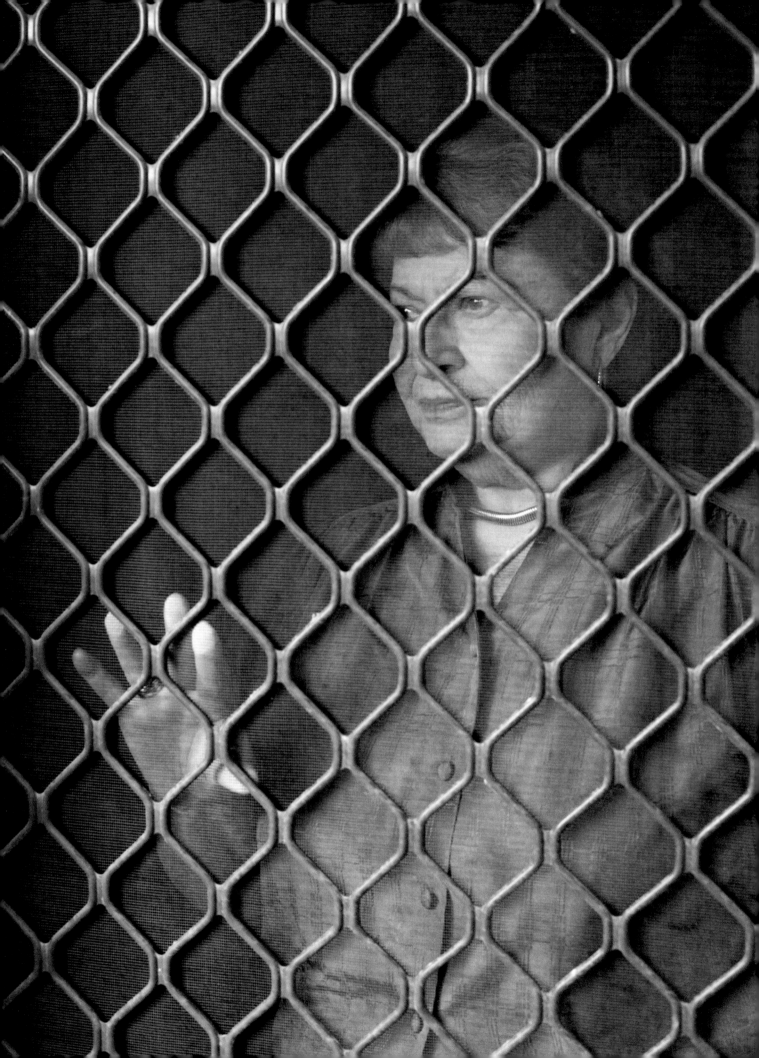

Then took my mother and pushed me back
with the butt of a gun — I knew I would never
see her again.
S. C. Altstock

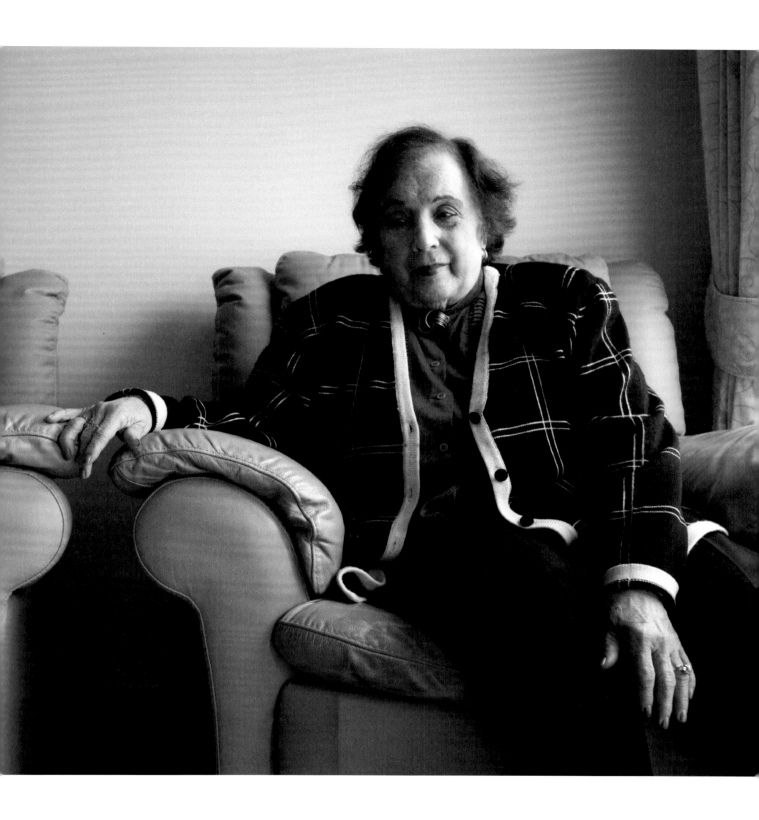

**Cesia Altstock**

*Page 227*

They took my mother and pushed me back
with the butt of a gun – I knew I would
never see her again.

*Even now I dream of the moment my "Father" told me to run.... I never saw him again.*

*M. Altstock.*

---

**Manek Altstock**

*Page 227*

Even now I dream of the moment
my father told me to run...I never saw
him again.

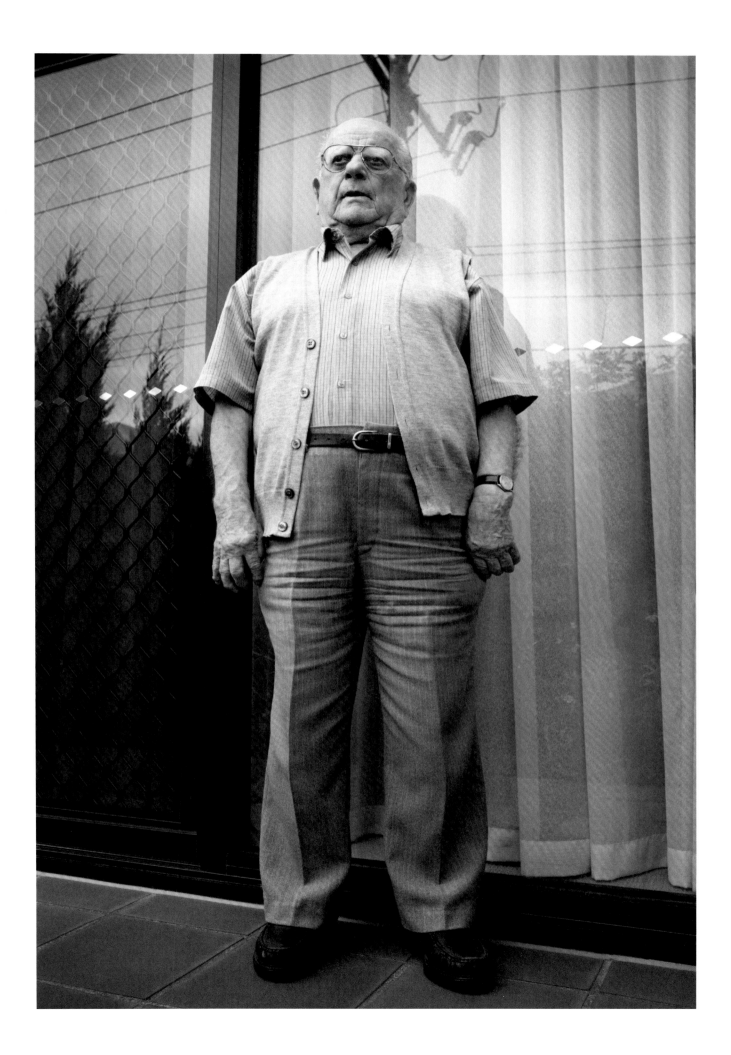

*Survived by a miracle......*
*Hard work, good luck, optimistic*
*attitude to life: keeps me going....*
*David Prince*

---

**David Prince**

*Page 227*

Survived by a miracle... Hard work,
good luck, optimistic attitude to life:
keeps me going...

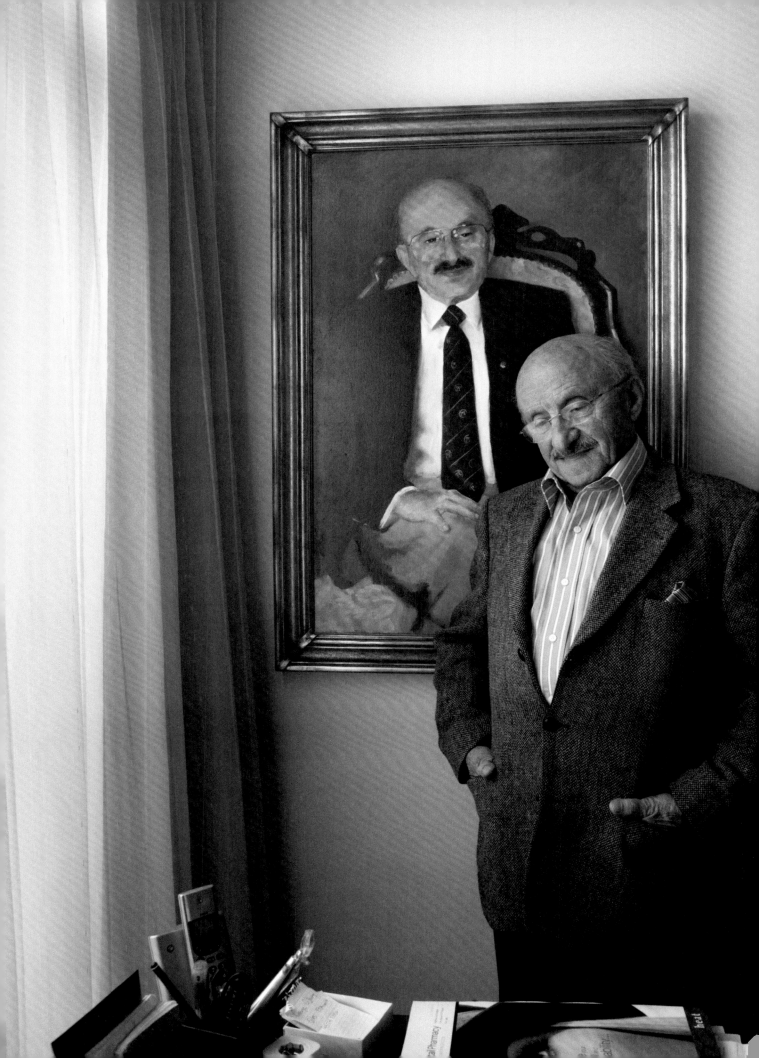

A long Road.....
From the gutters of life in my
early youth
to the beauty and freedom of
Australia, at my sunset....
Ella Prince

---

**Ella Prince**

*Page 228*

A long road...from the gutters of life in my early youth to the beauty and freedom of Australia, at my sunset...

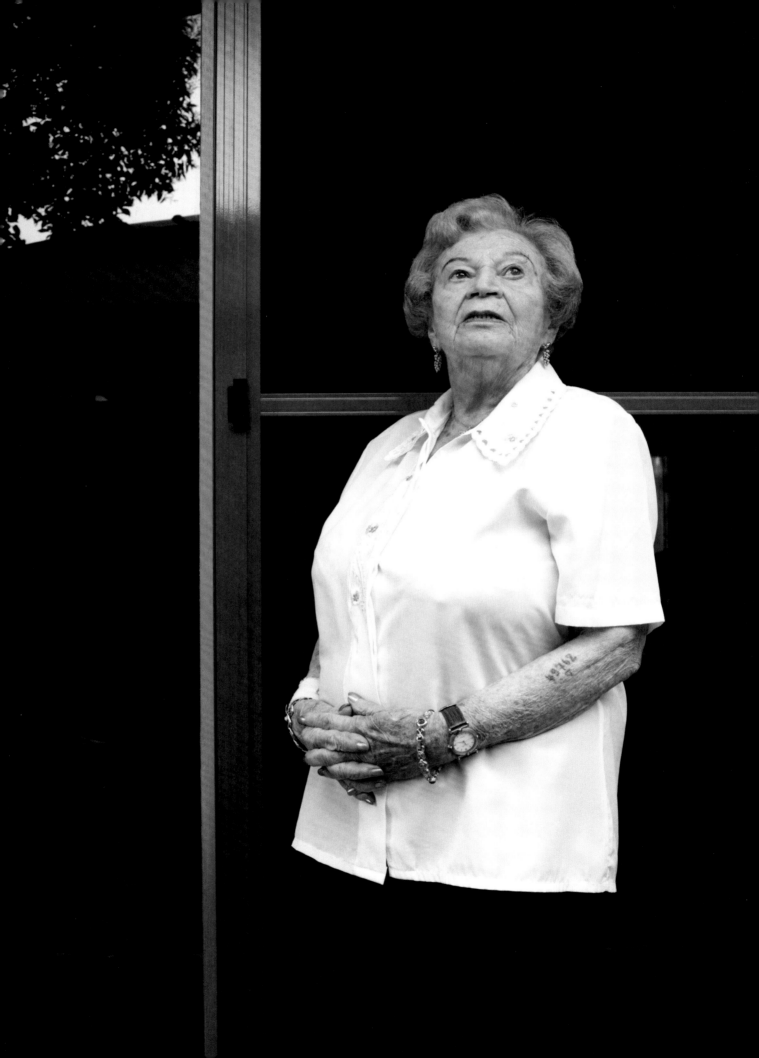

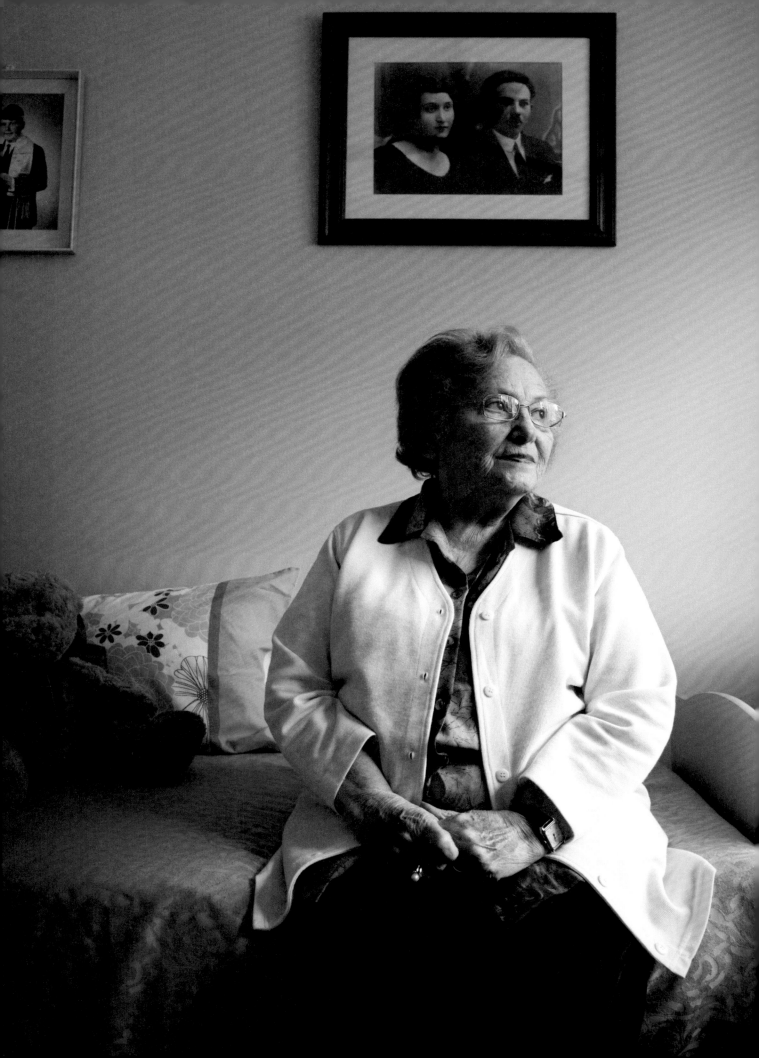

I COULD NEVER TELL MY CHILDREN
WHAT I WENT TROUGH BECAUSE
I WAS TOO EMOTIONAL TO SPEAK
I WAS ONLY 16 JEARS OF AGE
I SURVIDED BECAUSE I WAS
WERY LUCKY TO ECAPE FROM
SHARGOROD - TULCIN - DJURIN AND
MANY OTHER CONCENTRATION CAMPS

*Deborah Ana Tuckman*

**Deborah Ann Tuckman**

*Page 228*

I could never tell my children what I went
through because I was too emotional to
speak. I was only 16 years of age. I survived
because I was very lucky to escape from
Shargorod – Tulcin – Djurin and many
other concentration camps.

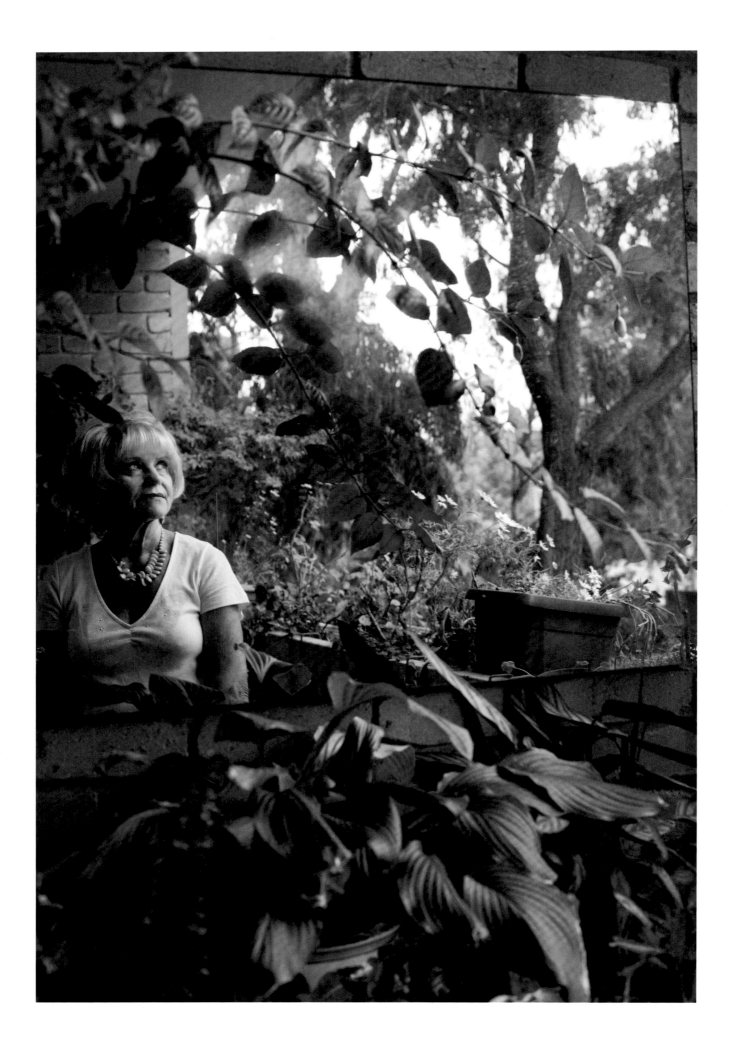

If as a good 10 year old girl,
I would have said, Jesus was a
Jew, I would have been killed instantly,
Dita Gould

---

**Dita Gould**

*Page 229*

If as a good 10 year old girl, I would have
said, Jesus was a Jew, I would have been
killed instantly.

*IF YOU LOVE, AND YOUR LOVE IS NOT RECIPROCATED, THEN IF YOU ARE OF SOUND MIND AND A PERSON OF INTEGRITY, YOU WILL KEEP YOUR LOVE TO YOURSELF.*

*G. STEIN*

**George Stein**

*Page 229*

If you love, and your love is not
reciprocated, then if you are of sound
mind and a person of integrity, you will
keep your love to yourself.

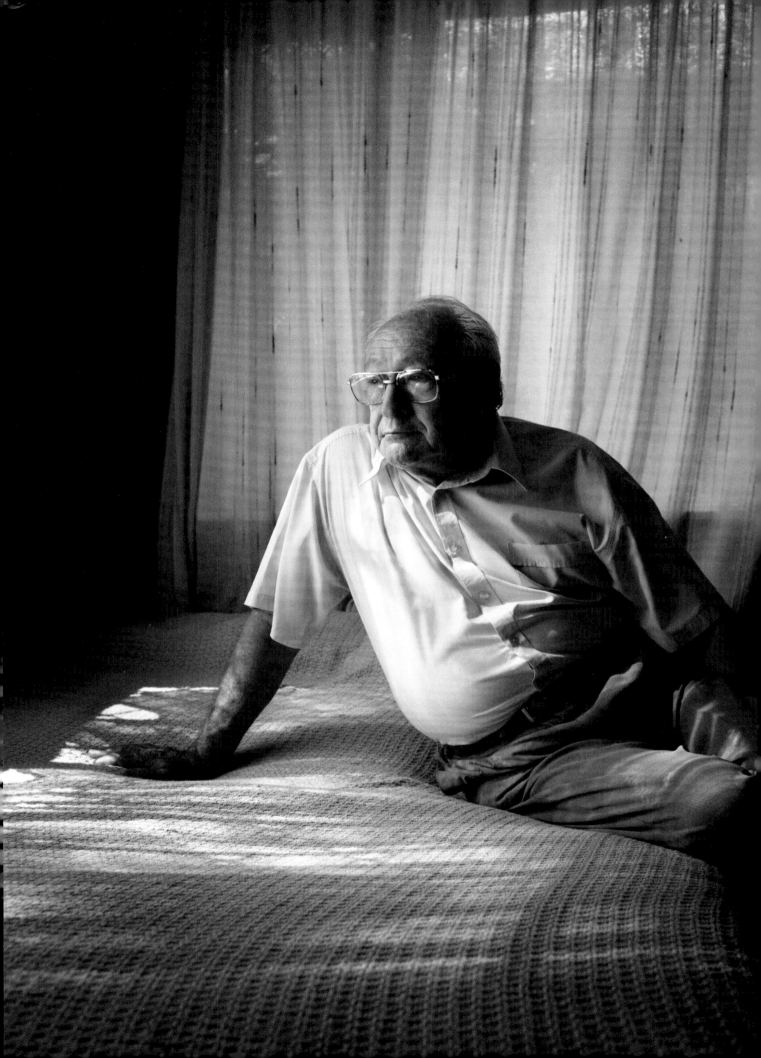

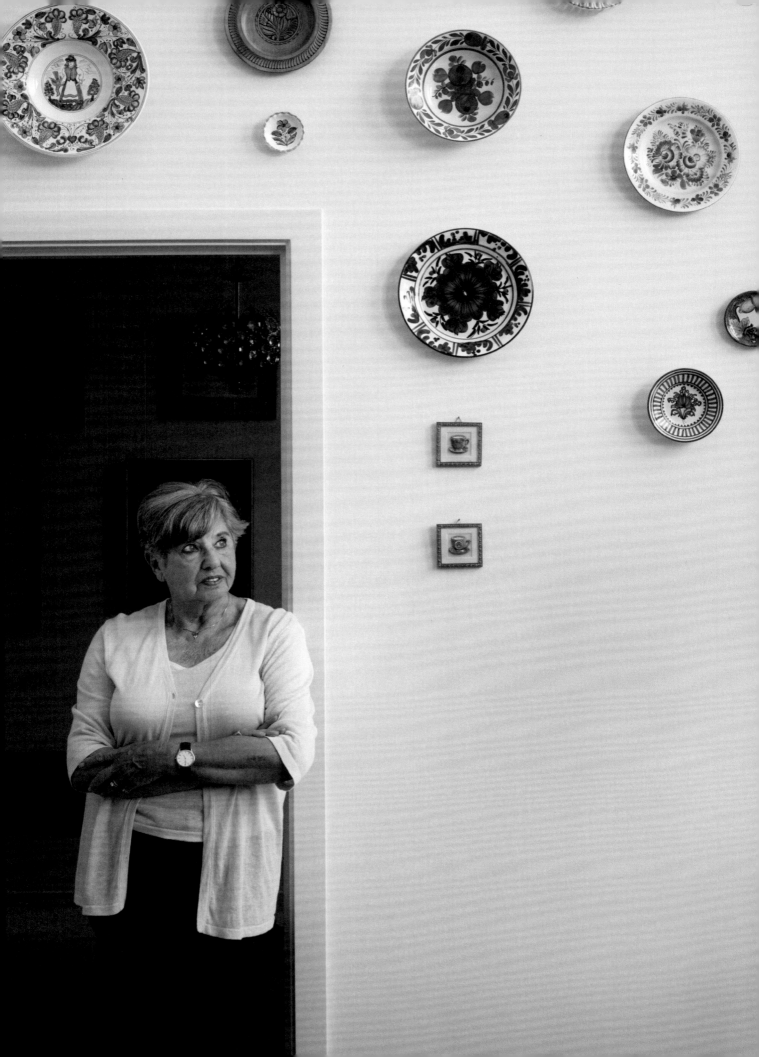

One can survive, even under the most horrible circumstances and never loose ones Optimismus. I am the living proof!!

Erika Hacker

**Erika Hacker**

*Page 230*

One can survive, even under the most
horrible circumstances and never lose
one's optimism. I am the living proof!!

67

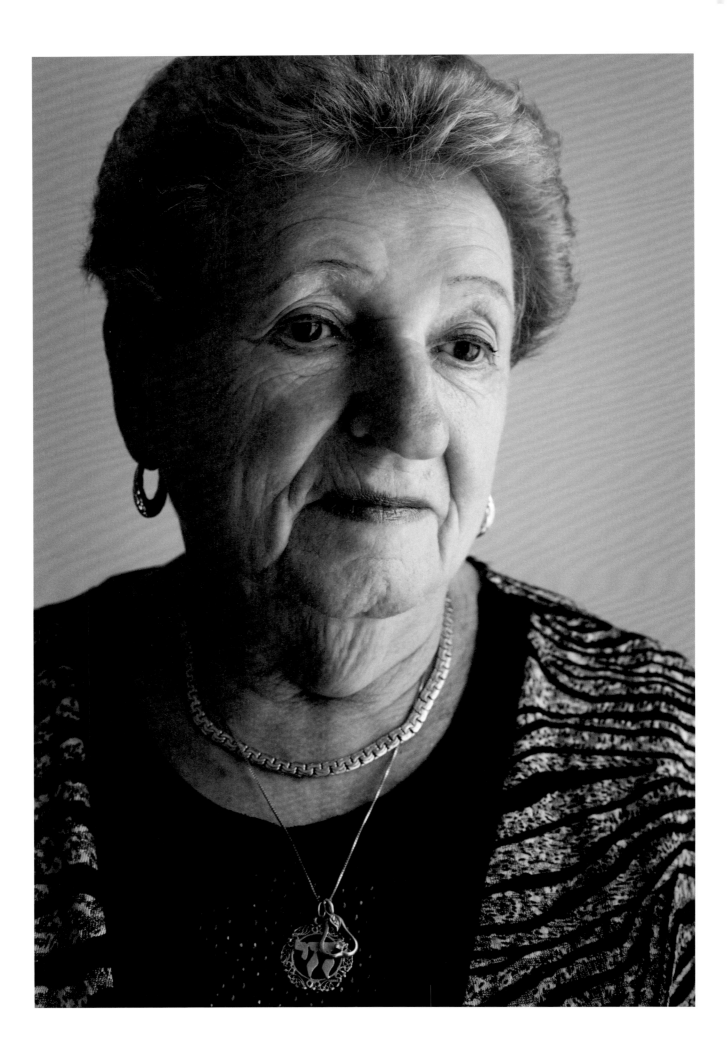

Mum and I went to Auszwic in 1944
I got separated From Mum. I Started
To cry. Mum Said Ester, Ester run
I never saw Mum again

Mum and I went to Auschwitz in 1944.
I got separated from Mum. I started to cry.
Mum said Ester, Ester run. I never saw
Mum again.

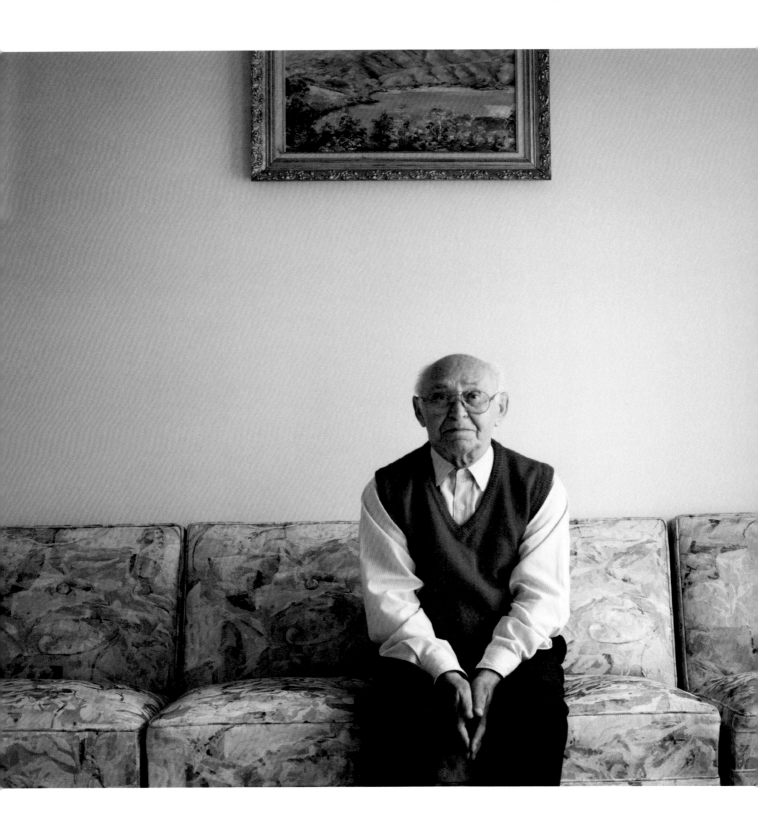

*I have nothing to say*

*M. Braitberg*

**Mayer Braitberg**         I have nothing to say.

My father always said to
me " why did G-d choose
me to live amongst all
the death ..... I know he
watches over me to this day "

by Rosie Davis
   daughter of Jacob Sperling

**Jack Sperling**

*Page 231*

My father always said to me "why did God
choose me to live amongst all the death...
I know he watches over me to this day."
*Rosie Davis (daughter)*

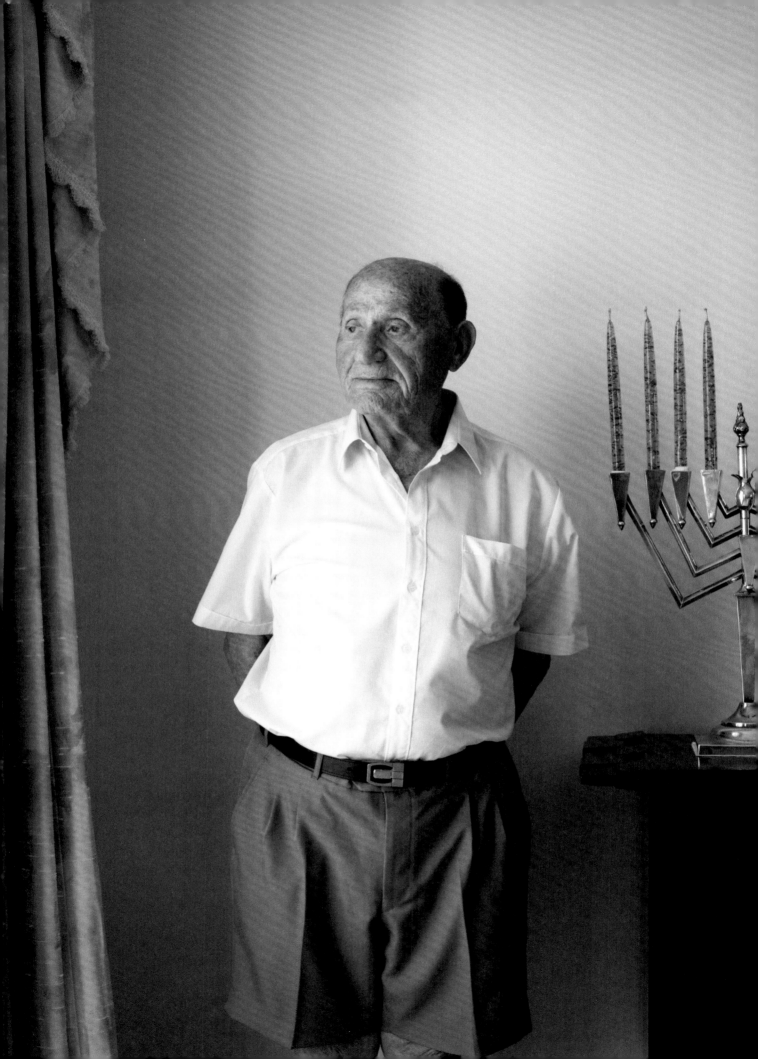

At the end of the day, Holocaust was
all about people!! Good people, bad
people, and the ones who were indifferent.
For me survival is an on-going process.

Kitia Altmann
Auschwitz tatoo A-25441

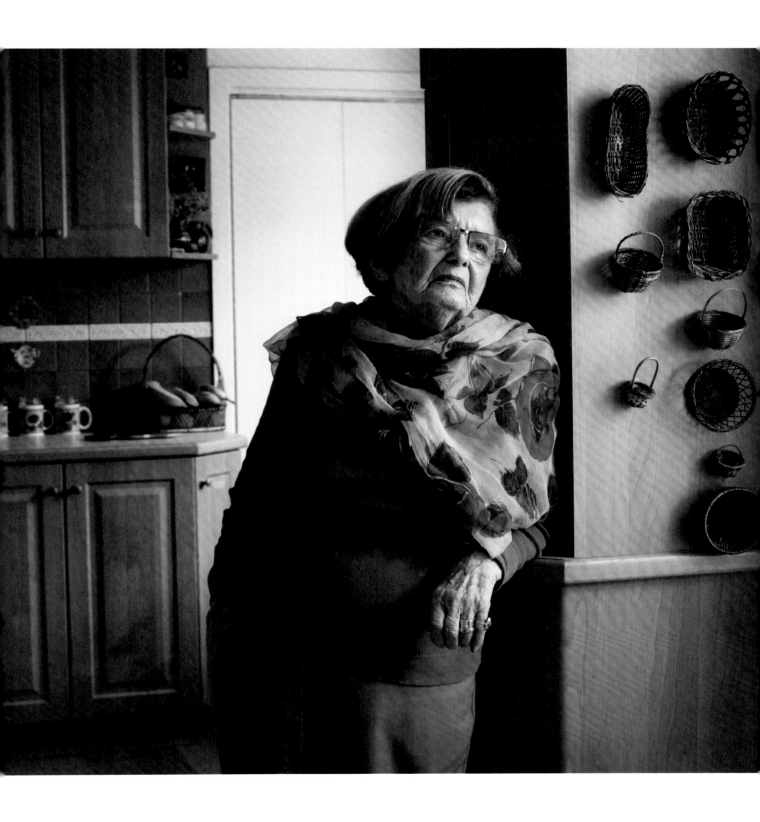

**Kitia Altmann**

*Page 231*

At the end of the day, Holocaust was all about people!! Good people, bad people, and the ones who were indifferent. For me survival is an on-going process.

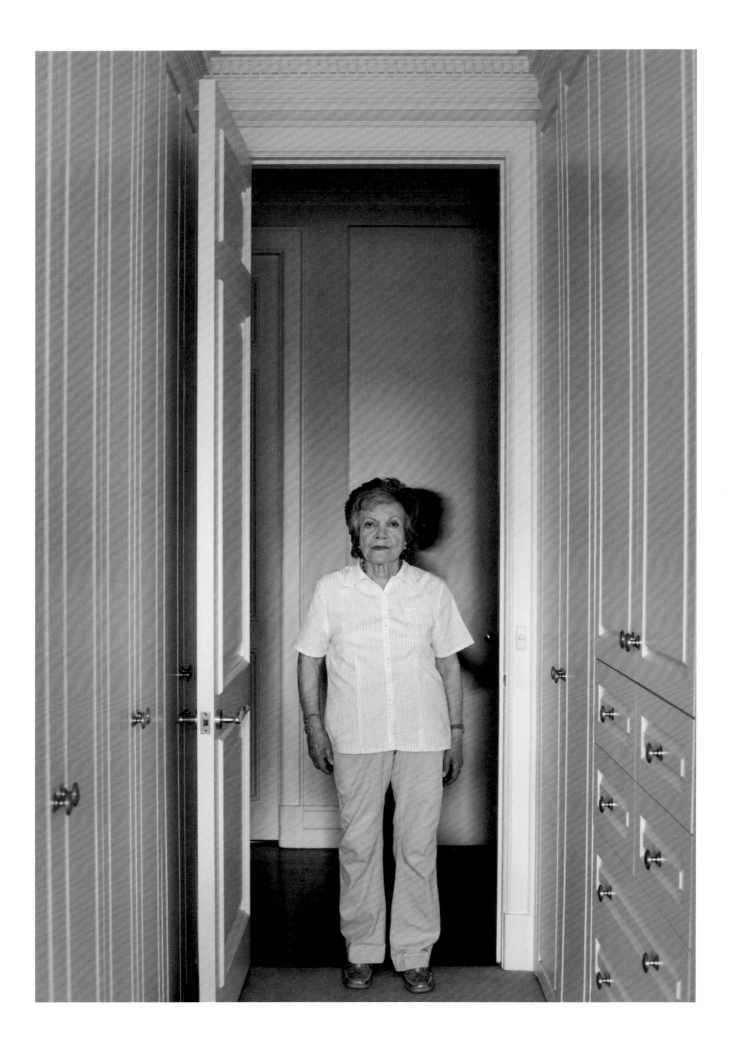

*I am happy to be still here.*

*Jadzia Opat*

---

**Jadzia Opat**           I am happy to be still here.

*I BELIEVE I'M THE LAST HOLOCAUST SURVIVOR OUT OF THE 70 OR SO JEWISH FAMILIES INCLUDING MY MOTHER, SISTER AND BROTHER WHO LIVED IN MY BIRTHPLACE OF ZAGÓRÓW IN POLAND I STILL LIVE WITH THE NIGHTMARES*

*Leon Jedwab*

**Leon Jedwab**

*Page 232*

I believe I'm the last Holocaust survivor
out of the 70 or so Jewish families
including my mother, sister and brother
who lived in my birthplace of Zagórów in
Poland. I still live with the nightmares.

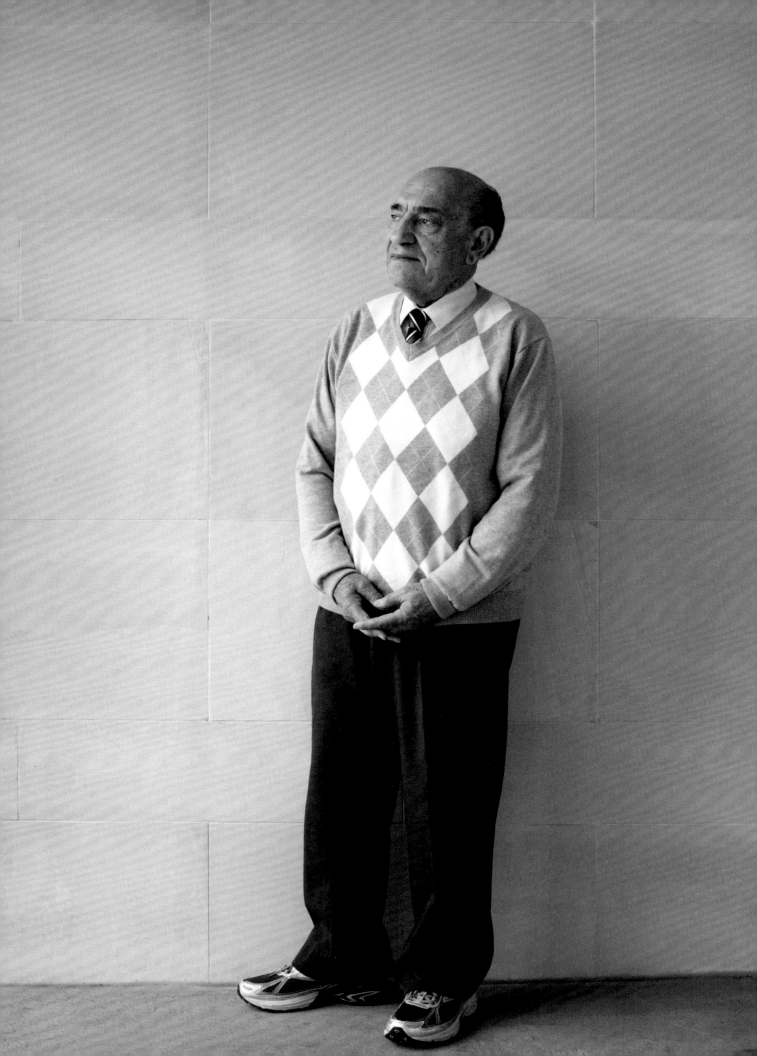

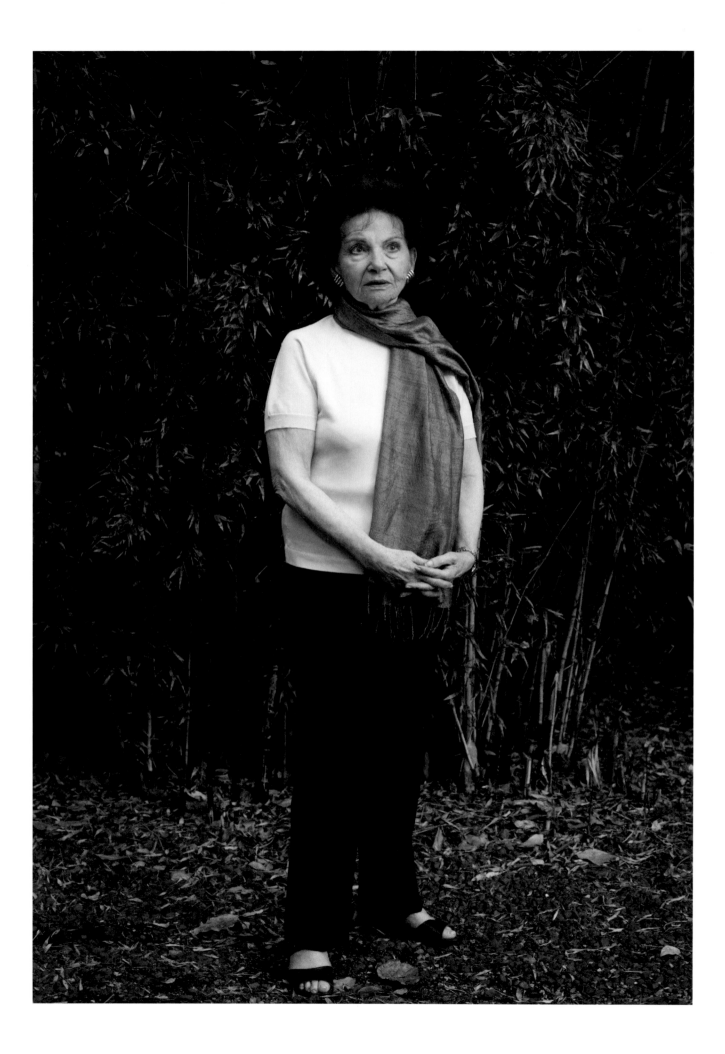

*A physically and emotionally crippling experience.*

*Tosha Jedwab*

A physically and emotionally
crippling experience.

*The best time of my life is when I AM with my family*

*Leon Rosenzweig*

The best time of my life is when I am
with my family.

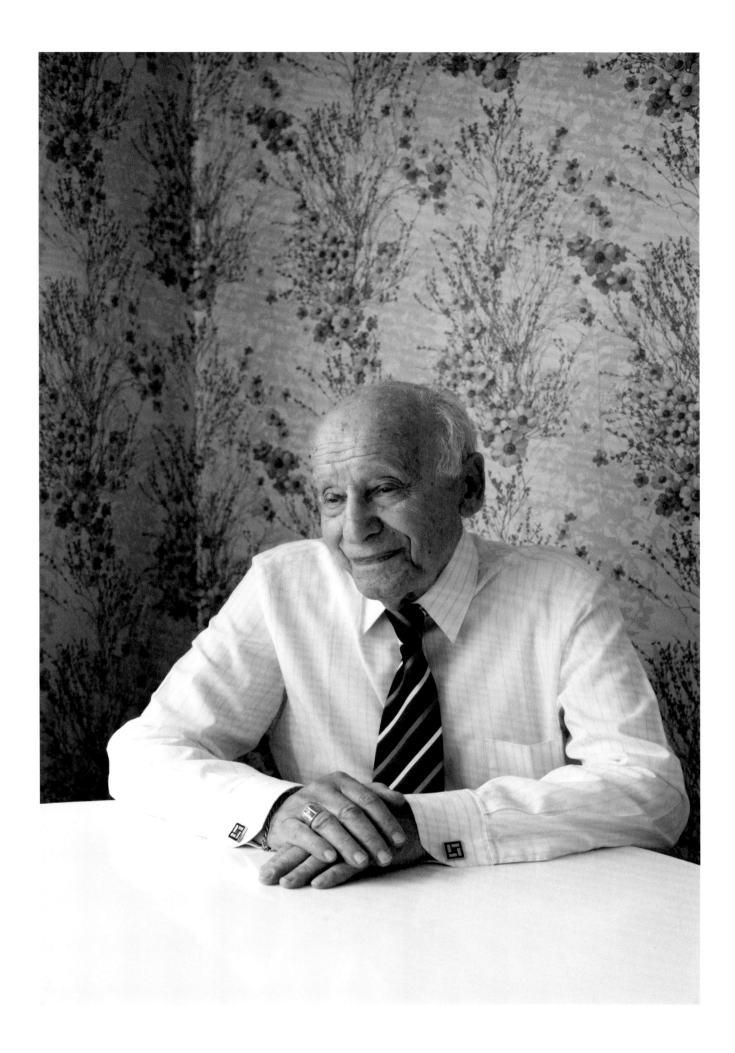

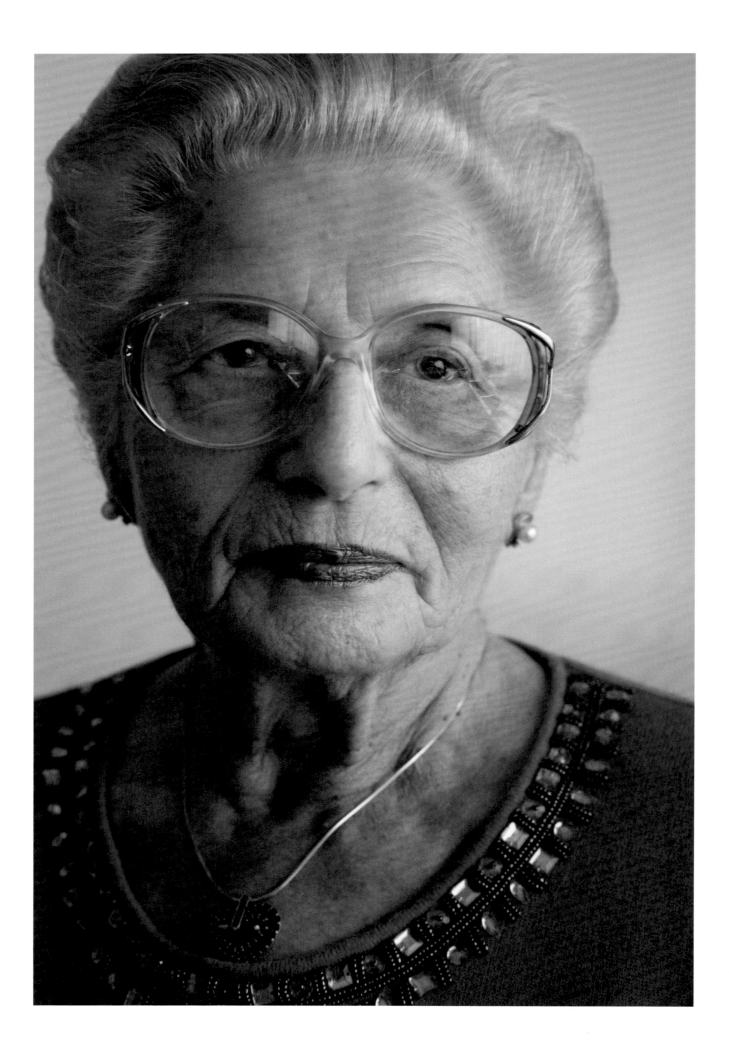

In memory of my
parents
Lucia Rosenzweig

---

*After surviving the war and the consequences of the war every day has been and is a bonus for me*

*Lina Varon*

After surviving the war and the
consequences of the war every day
has been and is a bonus for me.

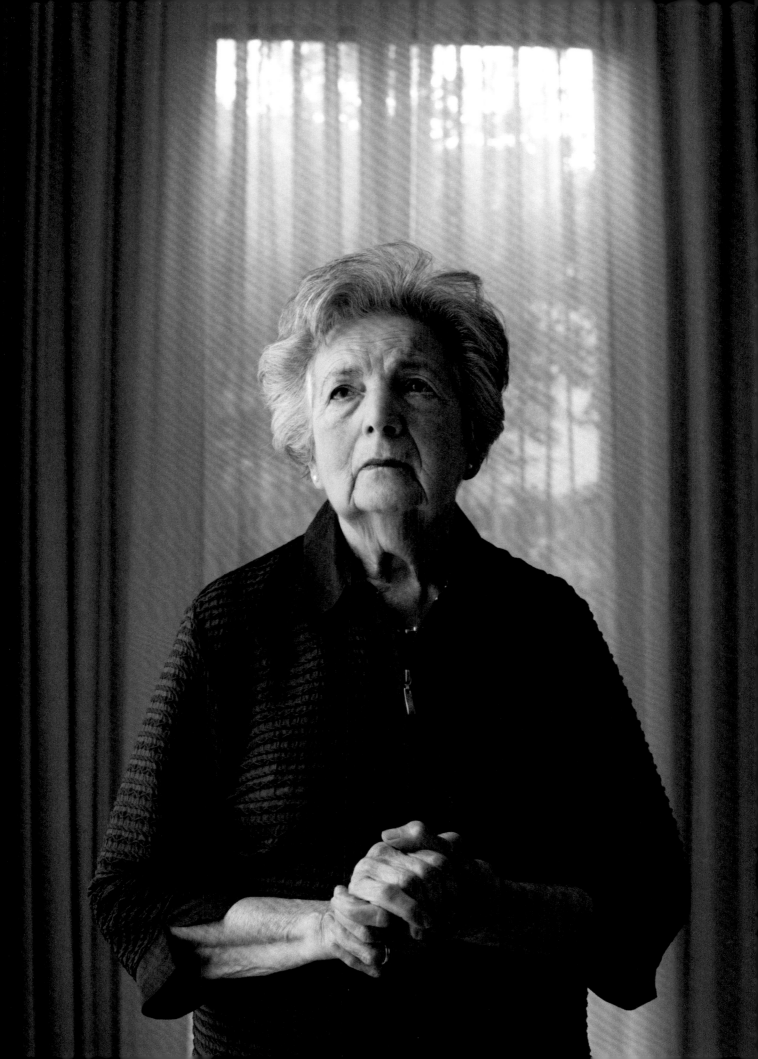

*The last time i saw my Parents was wen we arived at Auswitz My fater came back to get his prayer book. He kissed us and said " we will never see eachother agan "*

*Mary Elias*

**Mary Elias**

*Page 233*

The last time I saw my parents was when we arrived at Auschwitz. My father came back to get his prayer book. He kissed us and said "We will never see each other again."

88

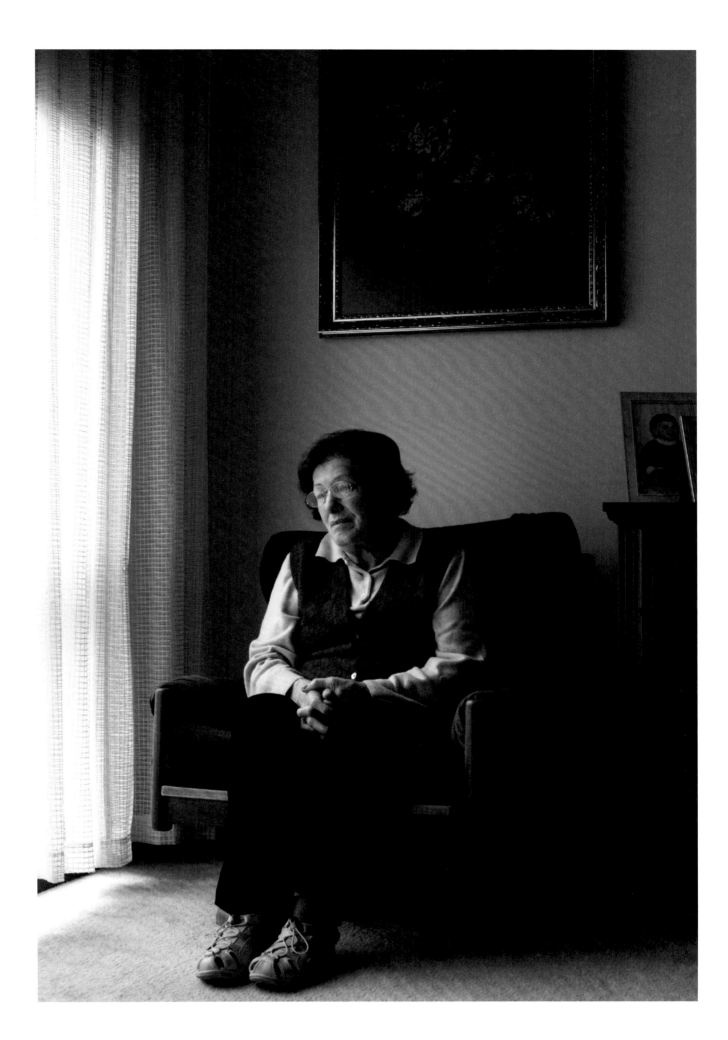

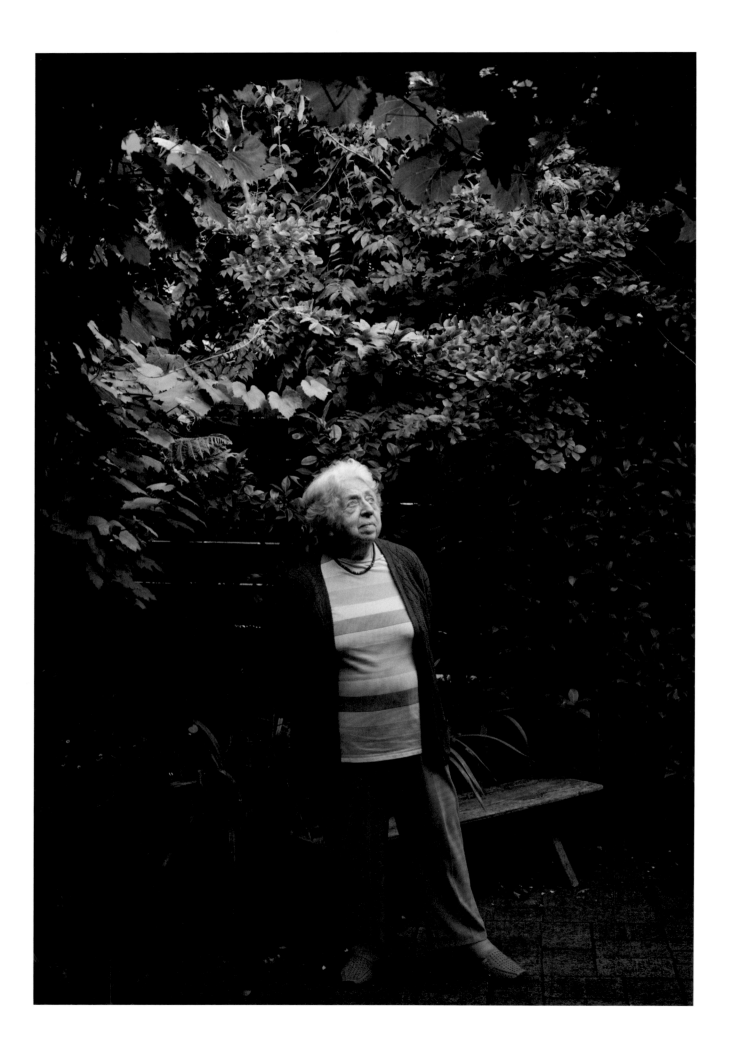

*I am grateful to Australia and its
unique people for letting us into this
country, giving us a chance to lick our
wounds, and then to carry on with
a normal life.*

Maria Lewitt

I am grateful to Australia and its unique
people for letting us into this country,
giving us a chance to lick our wounds,
and then to carry on with a normal life.

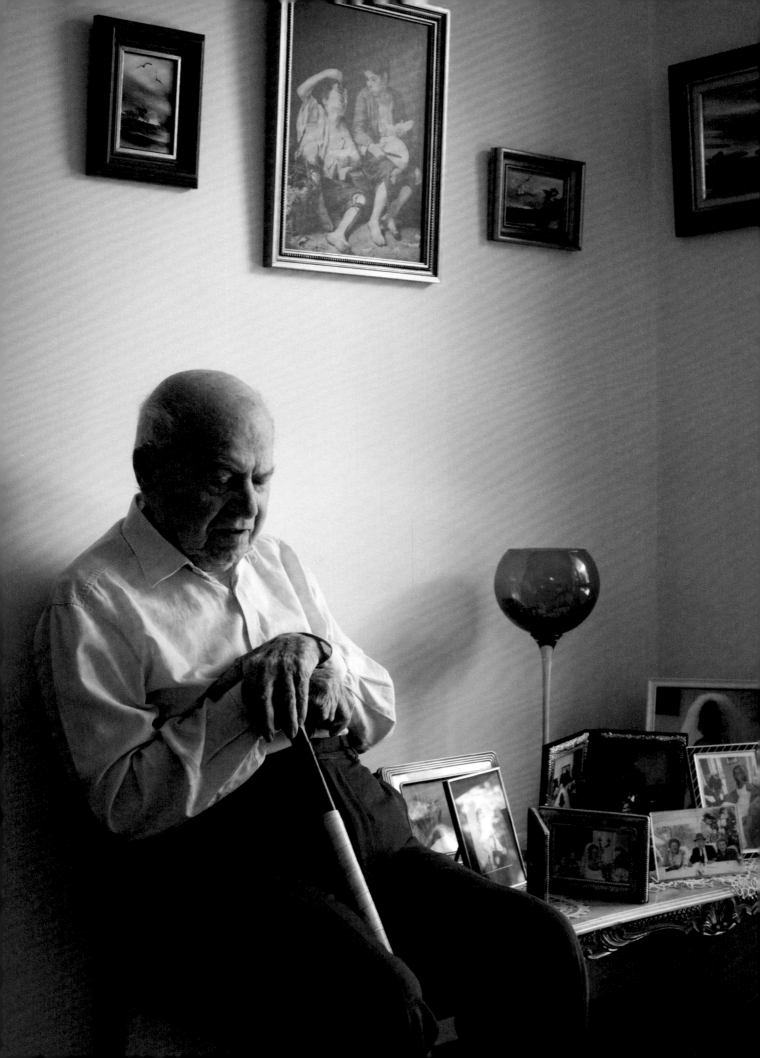

My father has often asked himself:
"How was it possible that a Lump
like Hitler could take over a country
of over sixty million people, nearly
conquer the world, and murder
so many millions?"

Alex, son of Mietek Skovron

---

**Mietek Skovron**

*Page 234*

My father has often asked himself:
"How was it possible that a Lump like
Hitler could take over a country of over
sixty million people, nearly conquer the
world, and murder so many millions?"
*Alex (son)*

After surviving the Second World War
I hoped that people learned from it,
but unfortunately nothing changed.
People still kill one another.
Sarah Gavrow

**Sarah Saaroni**

*Page 235*

After surviving the Second World War
I hoped that people learned from it, but
unfortunately nothing changed. People
still kill one another.

I SURVIVED HITLER.

THAT IS MY REVENGE

SAM. GOODCHILD.

**Sam Goodchild**          I survived Hitler. That is my revenge.

*Page 235*                                                                                               97

Everybody has a story to be told –
they are all important for everybody
to know what has happened.
mine is nearly at its end but at least
it is not the ending that the nazis had
planned for me.

Suzanne Goodchild

**Suzanne Goodchild**

*Page 235*

Everybody has a story to be told – they are all important for everybody to know what has happened. Mine is nearly at its end but at least it is not the ending that the Nazis had planned for me.

*We were in hell, lost everything, came back and I try to let everybody to know how it was to suffer because of hatred.*
*Life is beautifull, do not hate anybody be a good example to all around you*
*Stephanie Heller*

*In hope that our past will teach the new generation to live in peace and harmony together*
*Annetta Able*

**Stephanie Heller (in red) &**
**Annetta Able (in blue)**

*Page 236*

We were in hell, lost everything, came back and I try to let everybody know how it was to suffer because of hatred. Life is beautiful, do not hate anybody, be a good example to all around you.
*Stephanie Heller*

In hope that our past will teach the new generation to live in peace and harmony together.
*Annetta Able*

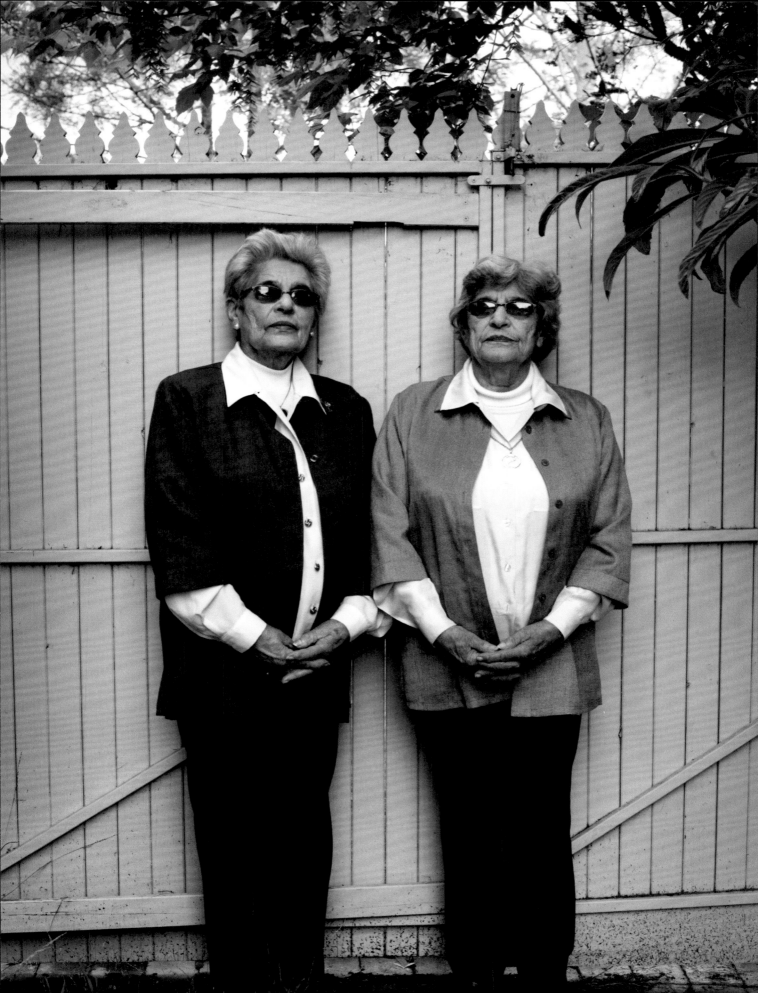

At the end of the war 1945
The world of the Ghetto The brutality
and death were over. I survived alone

Silvia Migdalek

**Silvia Migdalek**

*Page 237*

At the end of the war in 1945 the world of
the ghetto, the brutality and death were
over. I survived alone.

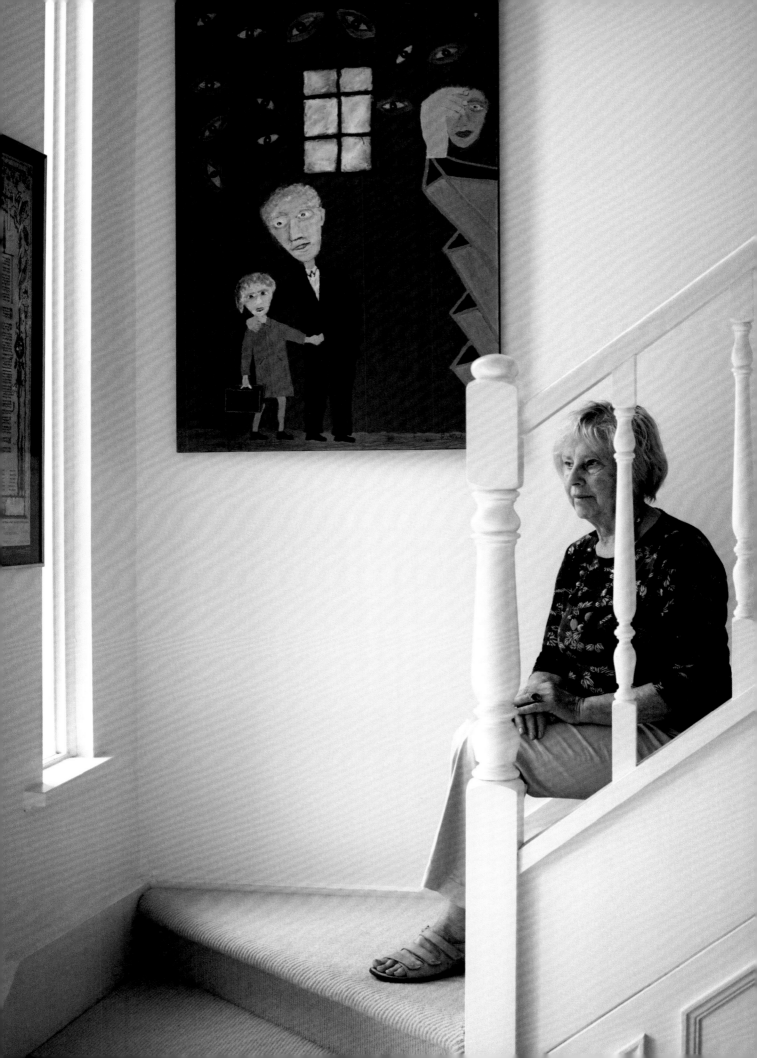

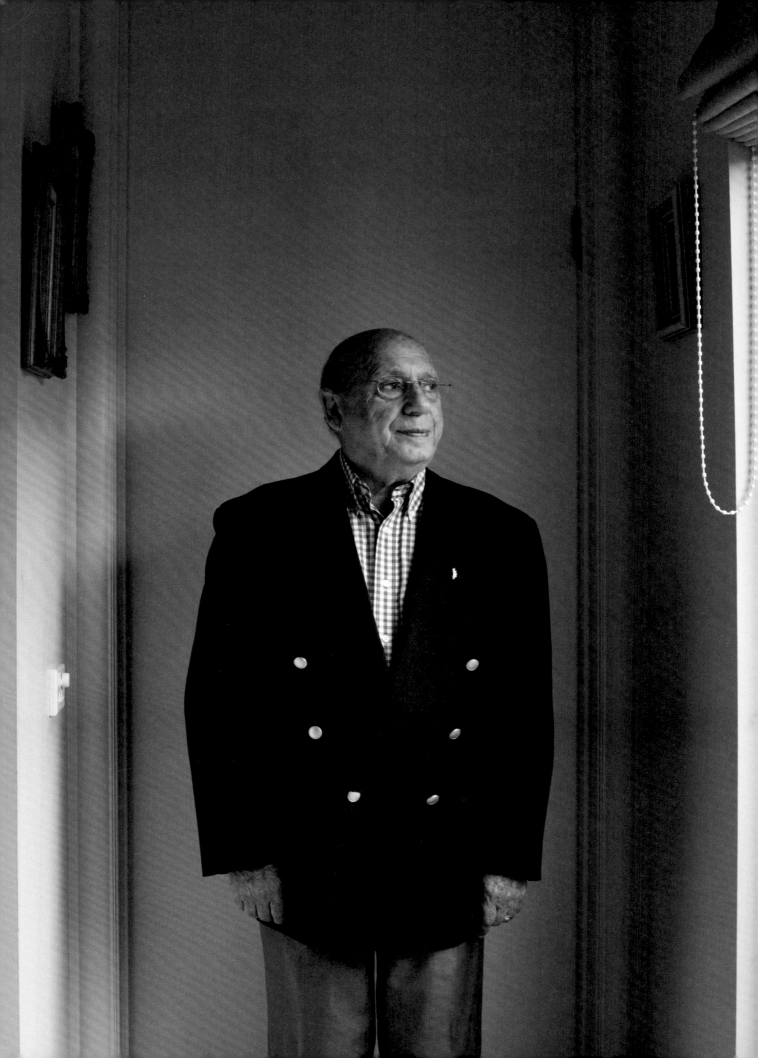

LITTLE DID I KNOW that I WOULD FIND THE
STRENGTH TO SURVIVE THOSE INSUFFERABLE
CIRCUMSTANCES that ARE STILL FAR BEYOND
HUMAN UNDERSTANDING. I AM PROUD TO SAY
THAT I AM HERE, BUT MANY OF THOSE
WHO ARE PART OF OUR LIFE ARE NOT.
AND SO MY HEART SILENTLY WEEPS.
TUVIA LIPSON

**Tuvia Lipson**

*Page 237*

Little did I know that I would find the strength to survive those insufferable circumstances that are still far beyond human understanding. I am proud to say that I am here, but many of those who are part of our life are not. And so my heart silently weeps.

My name is Hersel.
Szarfsztum Born.
3-3 1928 in Ryki
Poland,
Am proud to
Be A Jew
Zi Sharp

**Zvi Sharp**

*Page 238*

106

My name is Hersek Szarfsztum. Born
3-3 1928 in Ryki, Poland, I am proud
to be a Jew.

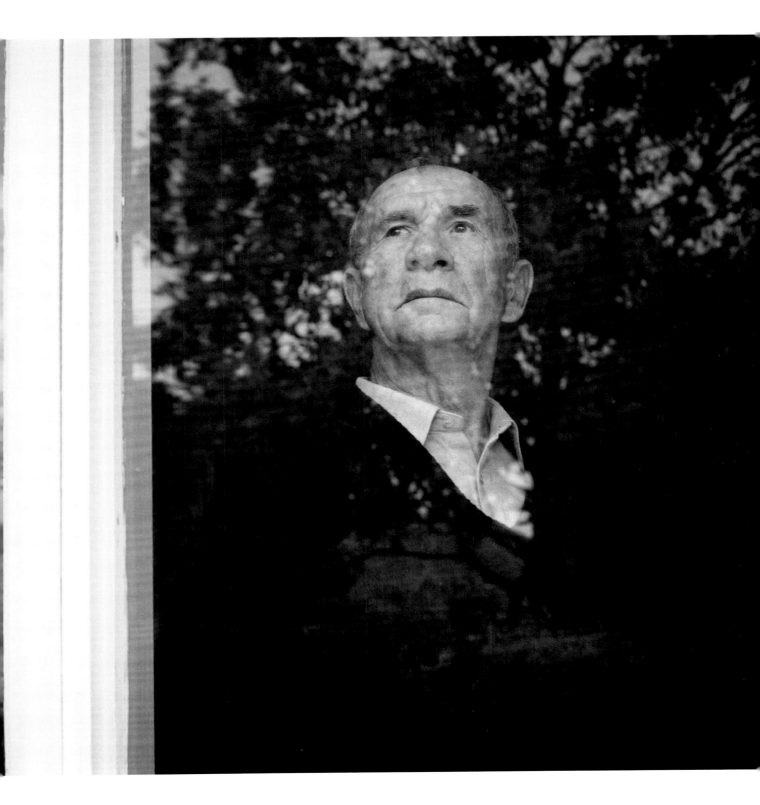

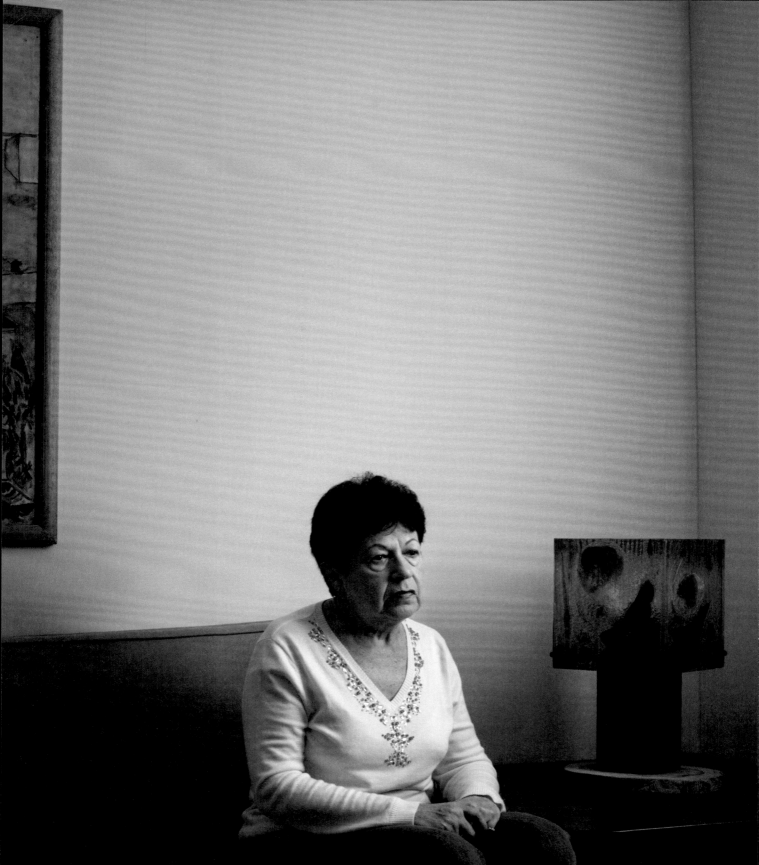

I was born in 1938 in Kaunas
Lithuania.
In 1944 during Holocast I lost my
parents and grew up in family
of my uncle.
In 1969 I come to ISRAEL and
living all years in Ramat-Gan
and Working like doctor of diag-
nostic Radiology. in hospital and
clinic.

KAPULSKI AVIGAIL
RAMAT-GAN ISRAEL

**Abigail Kapulsky**

*Page 238*

I was born in 1938 in Kaunas, Lithuania.
In 1944 during Holocaust I lost my parents
and grew up in family of my uncle. In
1969 I came to Israel and living all years
in Ramat-Gan and working like doctor of
diagnostic radiology in hospital and clinic.

I have remained
in getto Kaunas after
27 March 1944 after
the children action
when most of the
childrens were killed
I TAMAR WEINTRAUB

---

**Itamar Carmon**

*Page 238*

I have remained in Ghetto Kaunas after
27 March 1944 after the children action
when most of the children were killed.

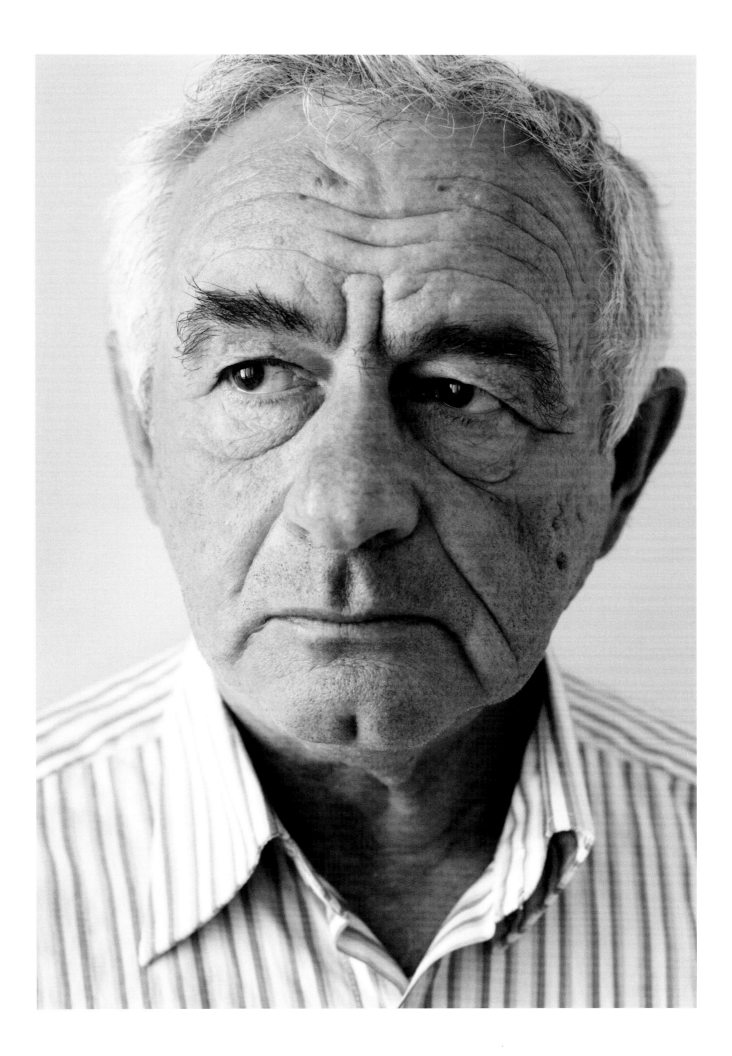

The day of my birth
tells all the story
10. 11. 1938

Dan Vaintraub

The day of my birth tells all the story.
10.11.1938.

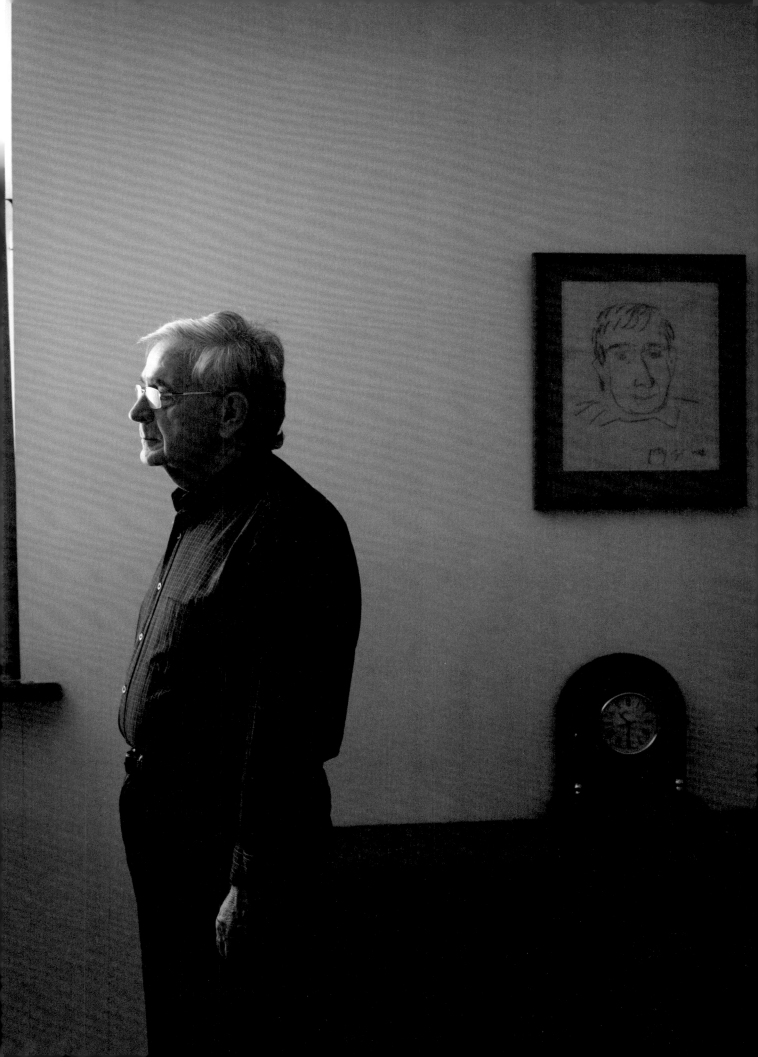

**Aryeh Luria**

*Page 239*

I am honoured to participate in this worldwide Holocaust remembrance project. I am grateful to my late mother Lea Luria née Gold who had the courage to smuggle out four children, two her own and two nephews from Ghetto Shaulay in the darkest hours of human history and gave us all new life. May she rest in peace.

I am honored to Participate in
this worldwide Holocaust remembrance
project. I am grateful to my late
Mother Lea Luria nee Gold who had
the courage to smuggle out Six children
2 her own and two nephews from
Ghetto Shavlui in the darkest hours
of Human history and gave us all new
Life. May she rest in Peace.

Aryeh Luria.

*I am just very happy to be able to tell the world about the years 1943–1945 and hope it will help to prevent it from ever-happening again.*

*Erna Stopper-Bindelglas*

**Erna Stopper-Bindelglas**

*Page 239*

I am just very happy to be able to tell the world about the years 1943–1945 and hope it will help to prevent it from ever happening again.

My father says:
"Can't believe what I
saw and experienced –
and it's even more incredible
that I survived and built
a new life".
Sonia Traeger
daughter of Azriel Huss
Huss Azriel

**Azriel Huss**

*Page 239*

My father says: "Can't believe what
I saw and experienced – and it's even
more incredible that I survived and built
a new life."
*Sonia Traeger (daughter)*

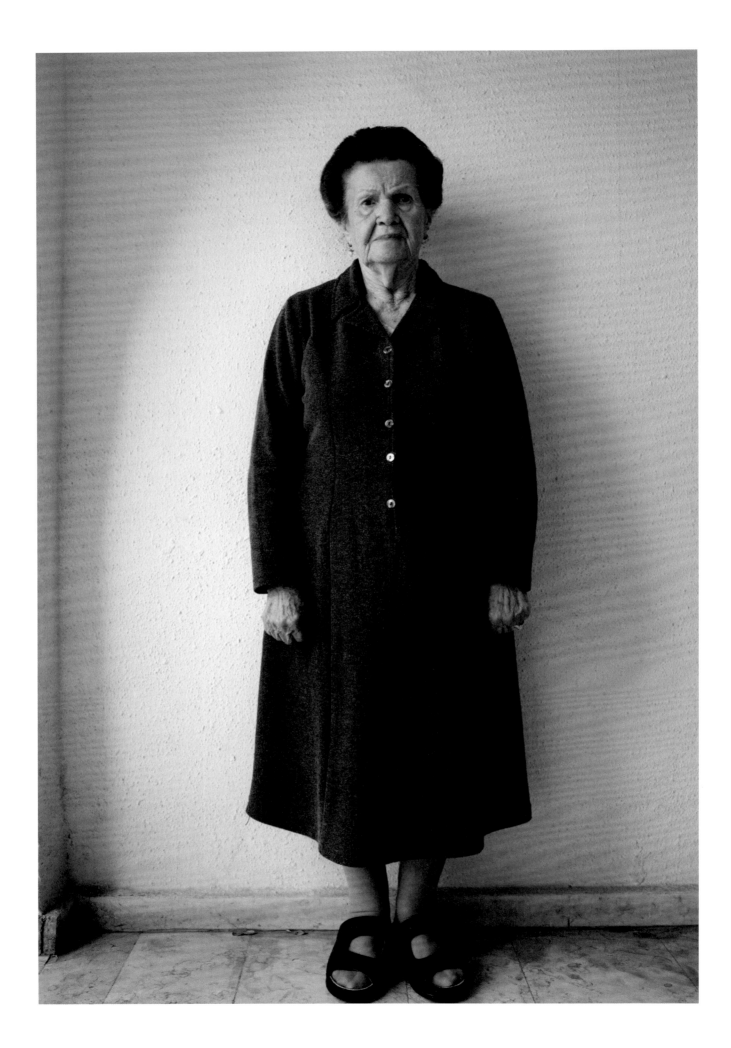

My mother says:
"Came from hell, arose from
the ashes —
Built a new life, raised
a family: 2 children, 9 grand
children and so far, 4 great-
grandchildren.
Sonia Traeger
daughter of Rivka Huss

Rifka Huss

---

**Rivka Huss**

*Page 239*

My mother says: "Came from hell, arose
from the ashes – built a new life, raised a
family: 2 children, 9 grandchildren and
so far, 4 great-grandchildren."
*Sonia Traeger (daughter)*

*Being born in 1940 in Holland and having survived with my parents, hidden by righteous gentiles, I felt it as my duty to work voluntary for my fellow Holocaust survivors*

*Barend ישכר Elburg*

**Barend (Yssachar) Elburg**

*Page 240*

Being born in 1940 in Holland and
having survived with my parents, hidden
by righteous Gentiles, I feel it is my
duty to work voluntary for my fellow
Holocaust survivors.

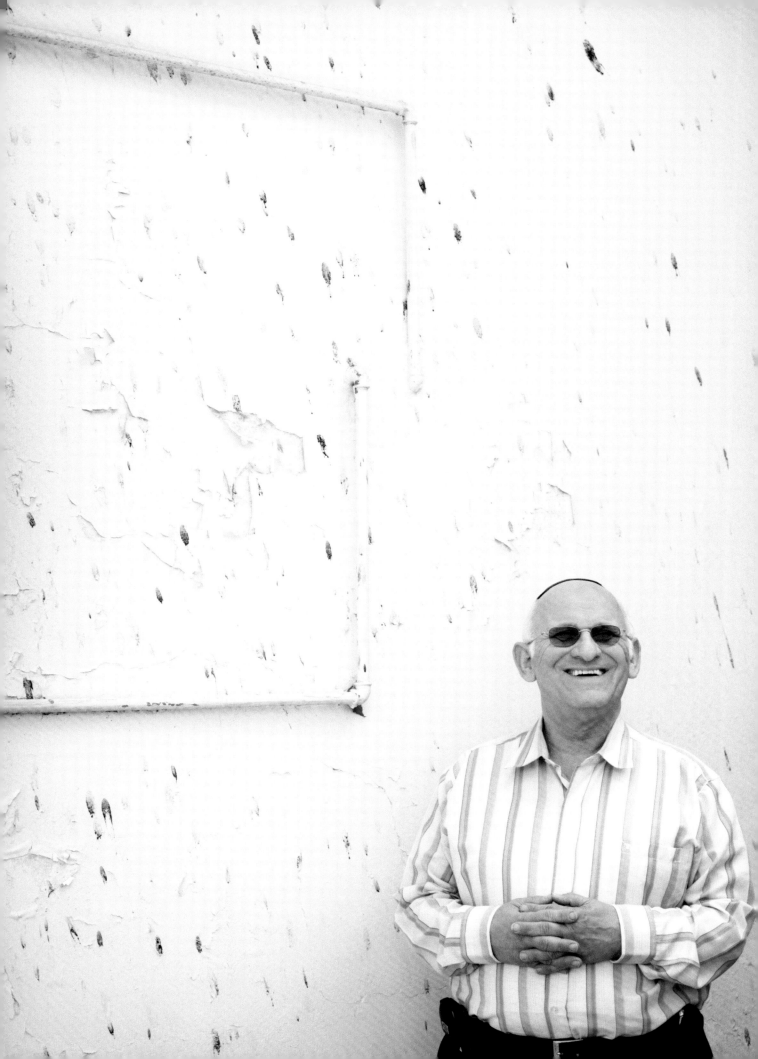

we will never let it happen again.

*Edith Sykora*

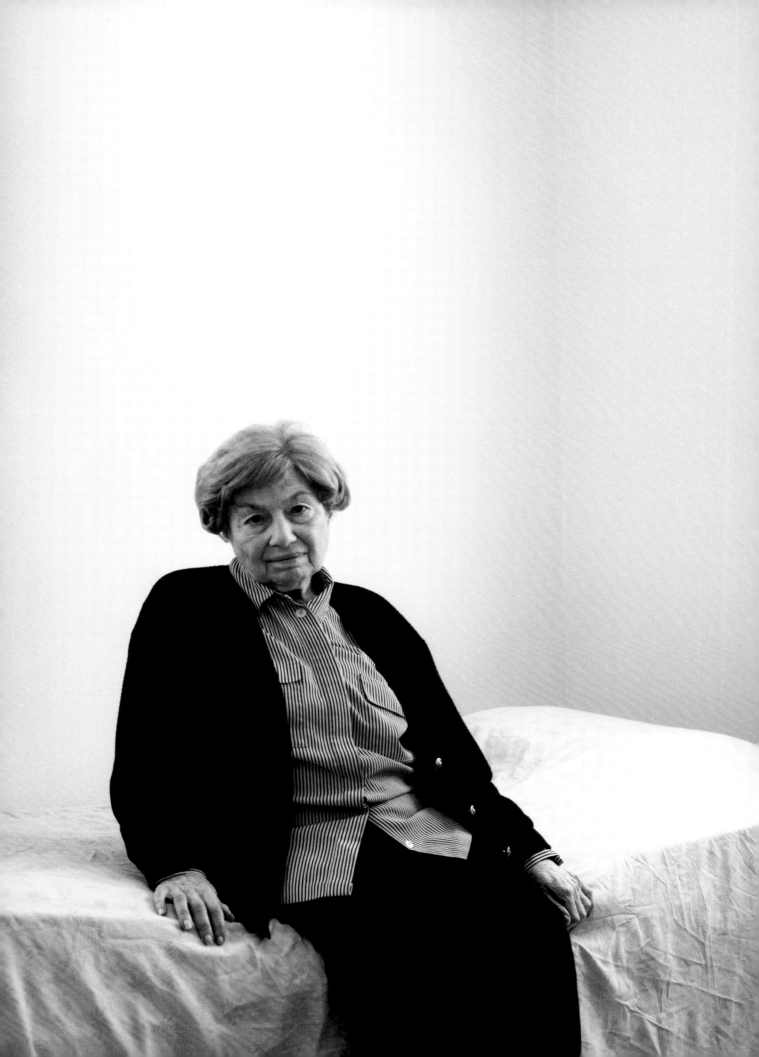

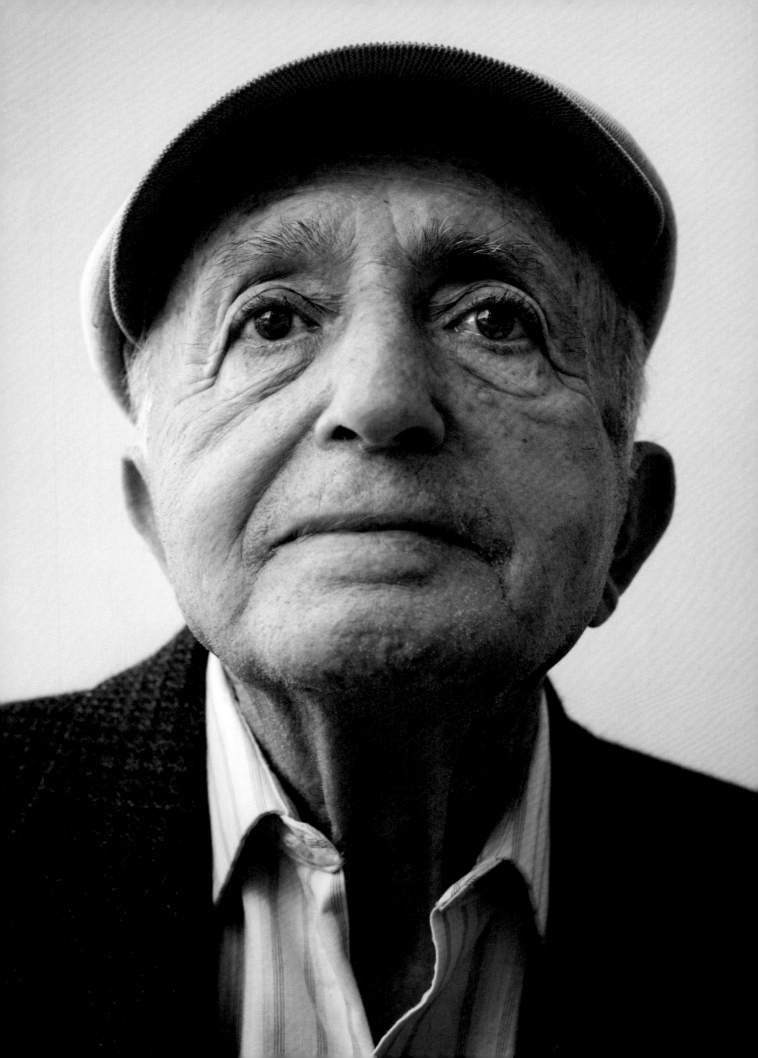

*[Handwritten text:]*

I am Joel Sykora here with my wife Edith in Israel we came from the US 2½ years ago. We live about 10 Min away from our Son Daniel and families 6 grand children, this was our main reason to come here. Unfortunately life is not easy health wise, but it is good to be here. We hope the small grand children will remember us for awhile.

Joel Sykora

**Joel Sykora**

*Page 240*

I am Joel Sykora. I live with my wife Edith in Israel. We came from the US 2½ years ago. We live about 10 minutes away from our son Daniel and family of 6 grandchildren, this was our main reason to come here. Unfortunately life is not easy health wise, but it is great to be here. We hope the small grandchildren will remember us for a while.

After two years of being a prisoner in several concentration Camps situated in Salizia like Birkenau and Auschwitz, and after same more time, about four monter in Mathausen, I believed 100%. that what Is the most important thing for the human being is in one word - Peace. With peace we can make what we want, and we can give life to new generations. this is the most important thing for human beings to live and give life

**Jacques Stroumsa**

*Page 240*

After two years of being a prisoner in several concentration camps situated in Silesia like Birkenau and Auschwitz, and after some more time, about four months in Mauthausen, I believed 100% that what is the most important thing for the human being is in one word – Peace. With peace we can make what we want, and we can give life to new generations. This is the most important thing for human beings – to live and give life.

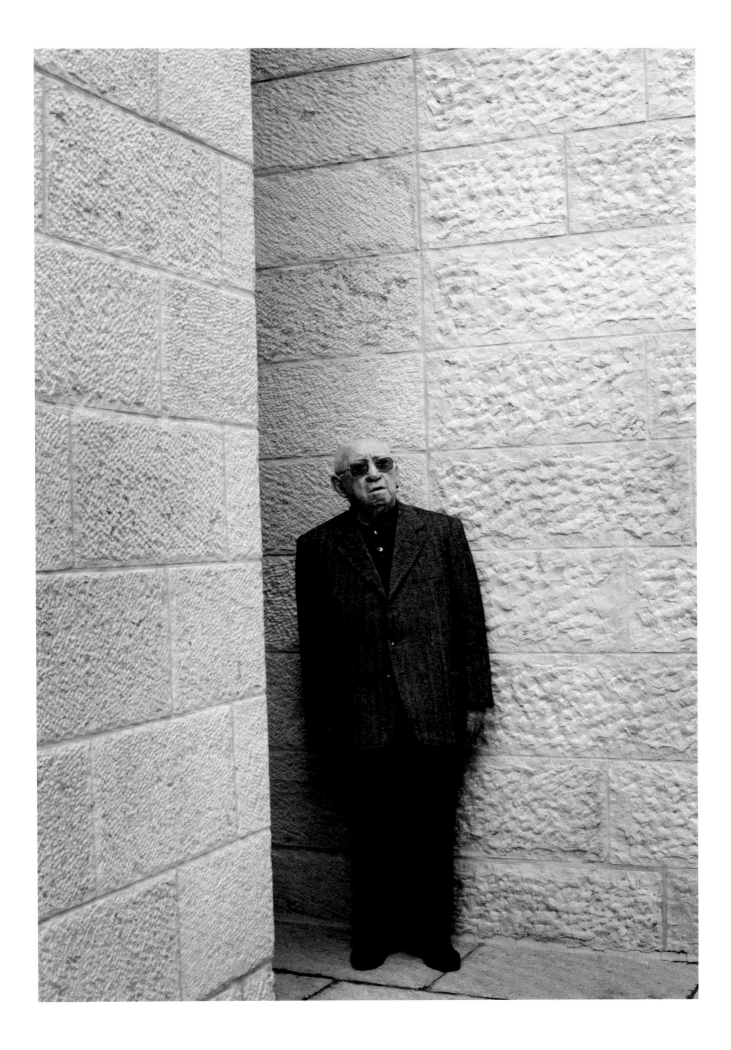

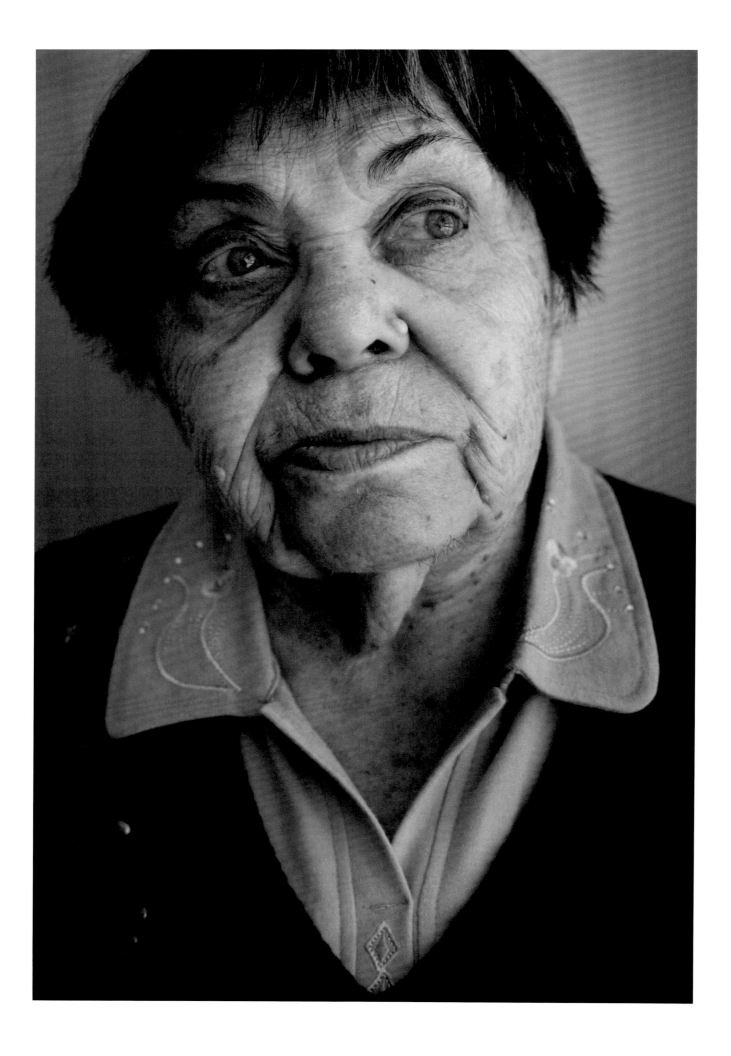

רחלה׳

הולד׳ פרצ׳ לחיי, כשהייתי ילדה בת 11, ב-1941.
הורי, אחי, סבתי, סבא, דודי, דודות – כל המשפחה
נספתה בשואה.
נשארתי לבד ודודי גם כל זמן המלחמה במוסד-יתומים,
נגמרה המלחמה, הגעתי לארץ-ישראל, הייתי בקיבוץ,
למדתי, התחתנתי ובניתי משפחה גדולה.
יש לי ארבע בנות, שמונה עשר נכדים ושישה נינים,
אני חושבת שההשקעה הכי טובה של ניצול שואה –
היא הקמת משפחה גדולה במקום כזו שניספתה.
יש לנו ארץ נהדרת, דמוקרטית, משגשגת עם הצבא
הכי מוסרי בעולם.
החלום של ניצולי השואה התגשם.
אני חושבת שכל אחד מאיתנו הוא ניצול שואה. ואלה
שלא היו בשואה צריכים לראות עצמם כאילו עברו
כל השואה, כדי שהרוע יימחק מן העולם, כדי שלא
תקרה עוד שואה, וכן שכל העמים יאמינו בשלום!

בברכה לכל
מי יתן
רחלה׳

76251

**Leah Ben-Dov**

*Page 241*

The Holocaust erupted into my life when I was an 11-year-old girl in 1941. My parents, brother, grandmother, grandfather, uncles, aunties all died in the Holocaust. I was left alone and spent all my time during the war in an orphanage. The war was over and I got to Israel. I was in a kibbutz, I studied, I got married and I built a big family. I have four girls, eighteen grandchildren and six great-grandchildren. I think the best investment of a Holocaust survivor is building a big family instead of that that was annihilated. We have a great country, democratic, prosperous with the most moral army in the world. The dream of the Holocaust survivors has come true. I think that everyone of us is a Holocaust survivor. And those that were not in the Holocaust need to see themselves as if they went through the Holocaust so evil is eradicated from the world and so that another genocide will never happen again and that all the peoples believe in peace.

*In Limbo:*

*In the Black Hole of our*
*Planet Earth*

*Auschwitz*
*They drove me out*
*When it ceased to be;*
*Yet who will drive*
*it out of me?*
*It still exists.*
*Only death will be*
*my exorcist.*

*Lidia Vago*

---

**Lidia Vago**

*Page 241*

**In Limbo**

In the black hole of our
Planet Earth
Auschwitz
They drove me out
When it ceased to be;

Yet who will drive
it out of me?
It still exists.
Only death will be
my exorcist.

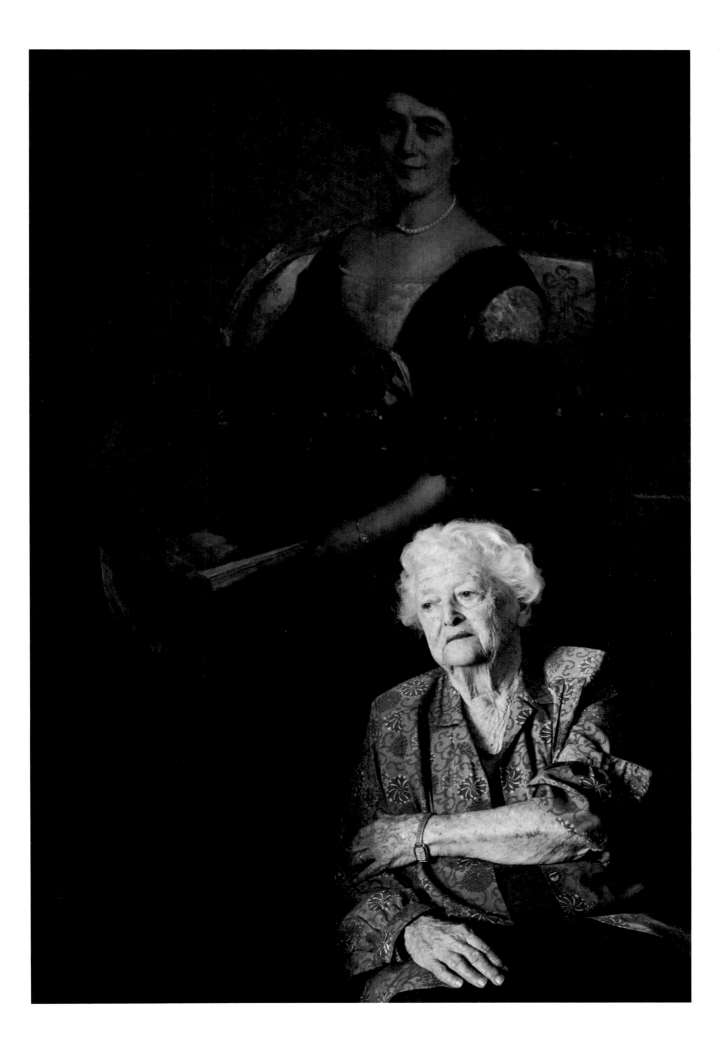

as a Holocast Surviver
Never To Forget!
Never again!
Mark Shamir

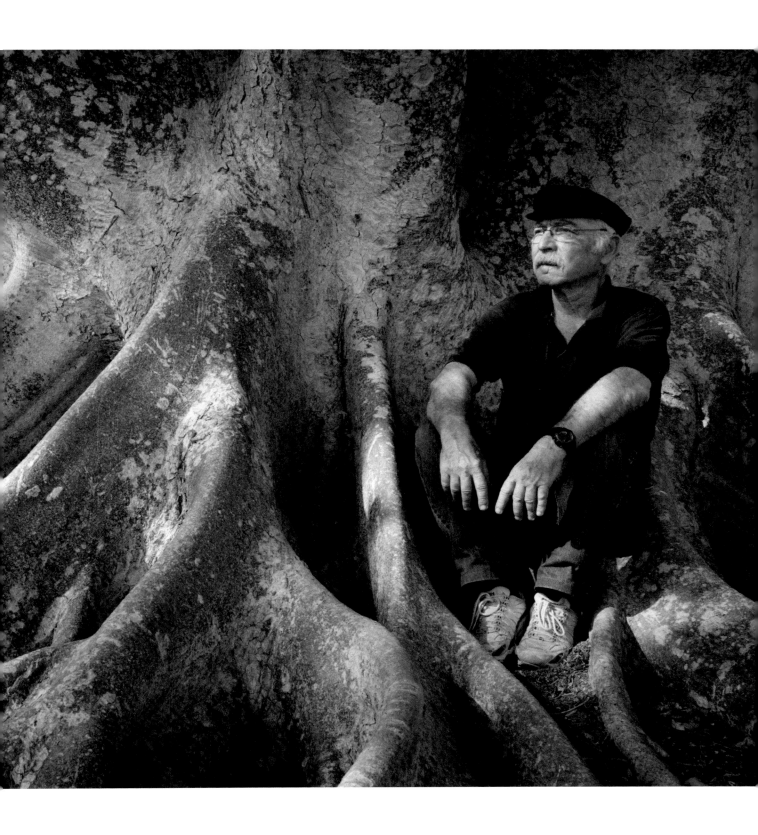

**Moshe Shamir**

*Page 242*

As a Holocaust survivor never to forget!
Never again!

*To remember and not only to commemorate,*

*Irene Eber*

To remember and not only
to commemorate.

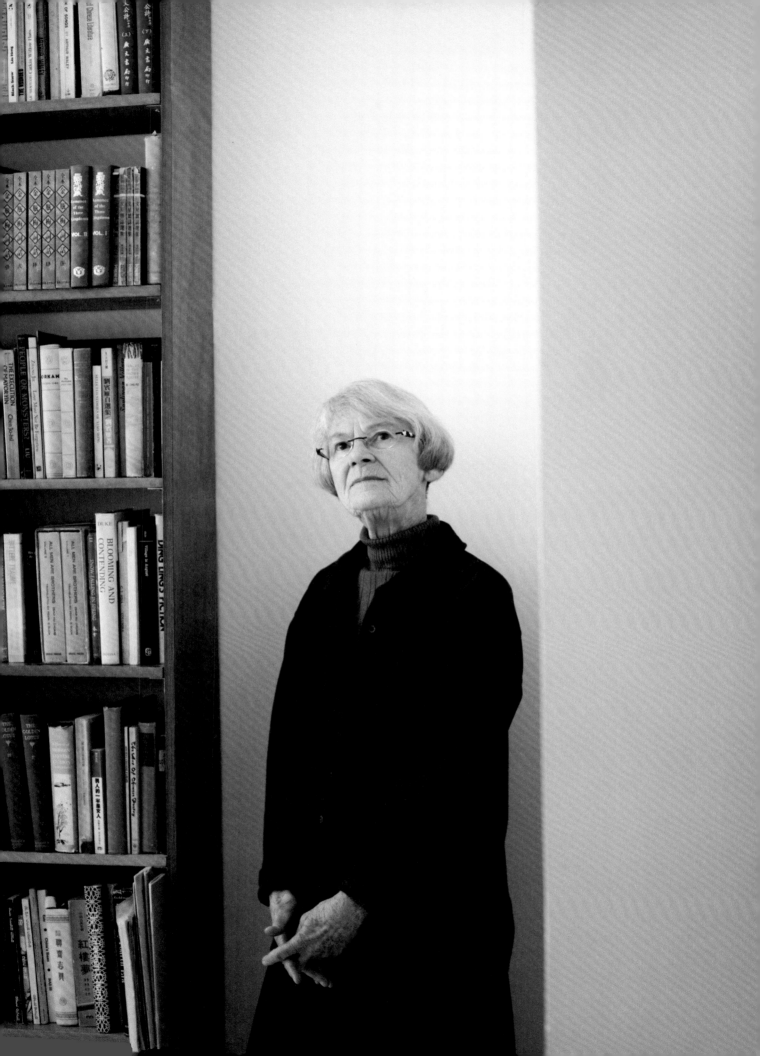

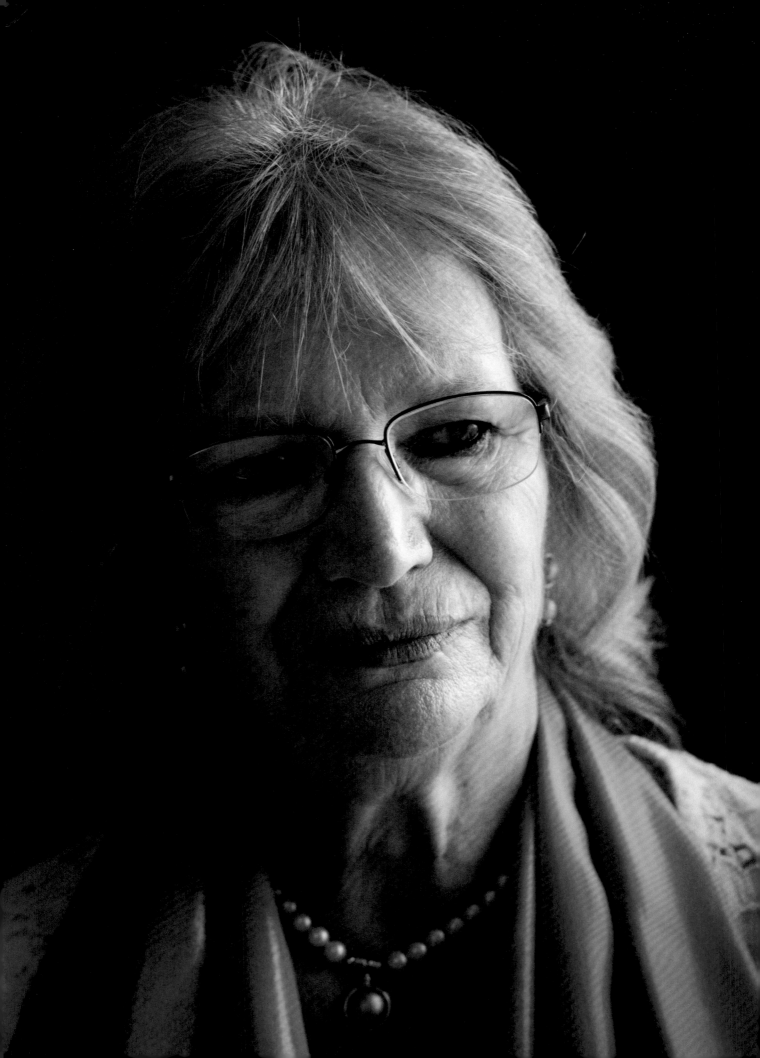

It is our moral and conscientious obligation of the survivors of The Holocaust, and of Jews all over the world, to carry the torch of remembrance of The Holocaust and The Heroism of this Human Earthquake in "Cultural Europe" (1939 – 1945), from generation to generation, to those generations – when none of us – survivors of the flames of hell will be alive anymore.

*Relli Robinson (Głowinski)*

**Relli Robinson**

*Page 243*

It is our moral and conscientious obligation of the survivors of The Holocaust, and of Jews all over the world, to carry the torch of remembrance of The Holocaust and The Heroism of this Human Earthquake in "Cultural Europe" (1939–1945), from generation to generation, to those generations – when none of us – survivors of the flames of hell will be alive anymore.

The horrors that my family
and I went through together
with countless other in the
Bergen Belsen concentrament camp
should _never_ be forg pen
Thank you for this book

**Roni Raanan**

*Page 243*

**140**

The horrors that my family and I went
through together with countless others in
the Bergen-Belsen concentration camp
should never be forgotten. Thank you for
this book.

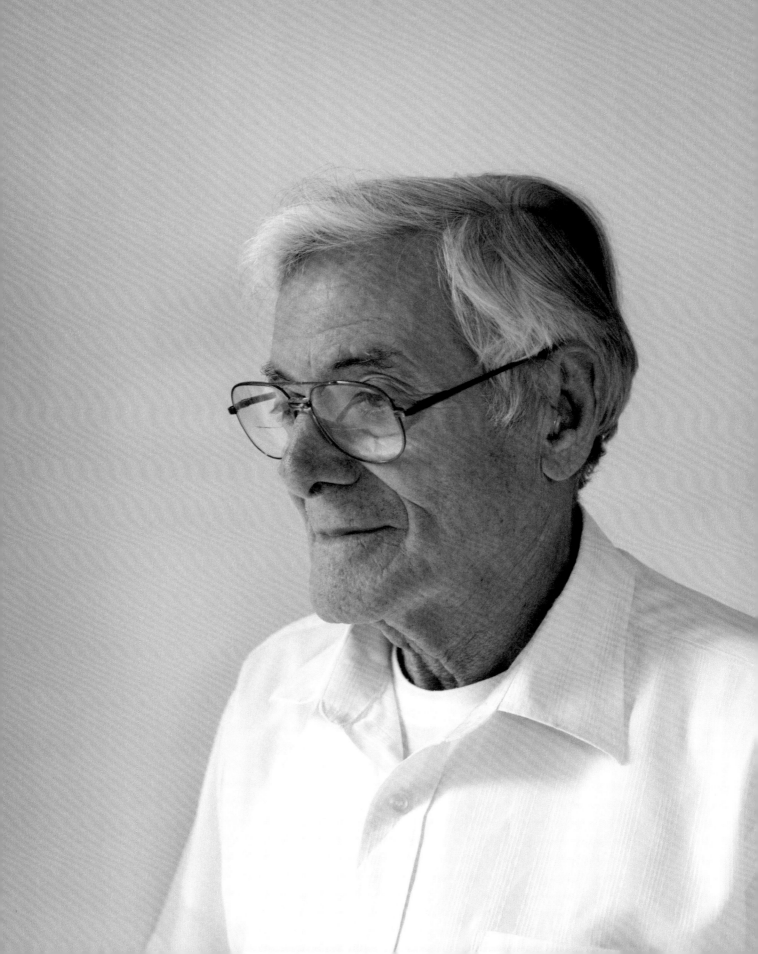

*Child-survivor*

*A smile of a grand daughter*
*a hug of an already grown up grandson*
*a concerning "how are you" from a daughter,*
*a son*

*A look from my beloved*
*In all these exists my happiness*
*Indeed, I don't need the breaking of glass*
*To remind me of my devastation*
*I am a child survivor*
*who doesn't forget, who longs*
*If I only could just once*
*Put my head in mother's warm lap*
*Wrapped in her soft look*
*If I could only once*
*Walk, my hand in fathers warm hand*
*My cheek rubbing his rough coat –*
*I am a child survivor*
*A child of the warm*
*I survive anew, every day.*

*Ruth Lavie Jourgrau*

---

**Ruth Lavie Jourgrau**

*Page 244*

**Child-survivor**

A smile of a granddaughter
a hug of an already grown up grandson
a concerning "how are you" from a
daughter,
a son
A look from my beloved
In all these exists my happiness
Indeed, I don't need the breaking of glass
to remind me of my devastation
I am a child survivor
who doesn't forget, who longs
If I only could just once
Put my head in Mother's warm lap
Wrapped in her soft look
If I could only once
Walk, my hand in Father's warm hand
My cheek rubbing his rough coat –
I am a child survivor
A child of the war
I survive anew, every day.

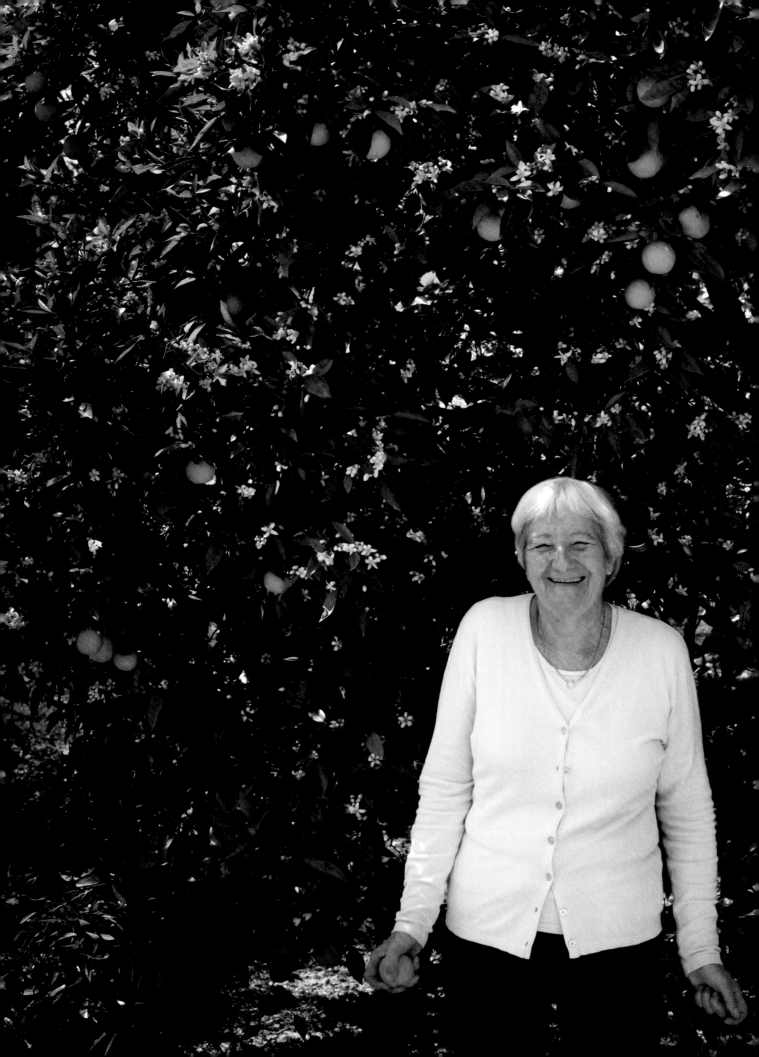

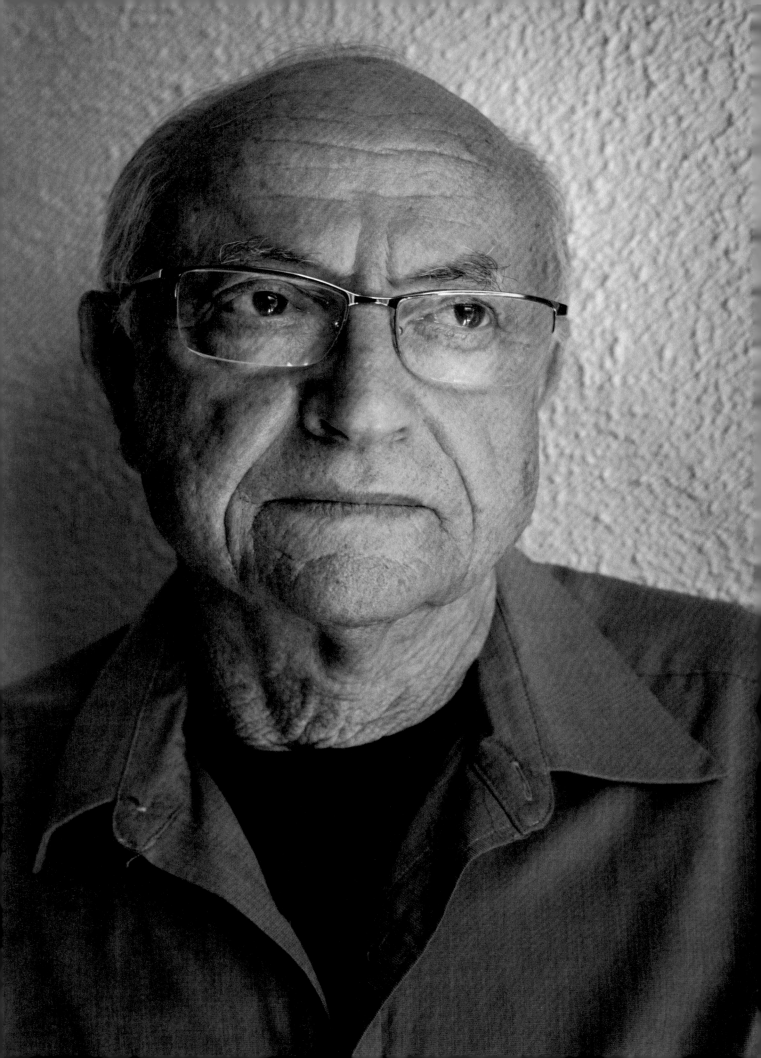

My name is Jack Jaget.
I am a Holocost survivor.
My family was hidden
for 22 months under a pigs sty.
there twice searches by the gestapo.
If we were discovered, my family
and the Polish family that hid us
would have been shot on the spot.

*Jack Jaget.*

**Jack Jaget**

*Page 246*

My name is Jack Jaget. I am a Holocaust survivor. My family was hidden for 22 months under a pigsty. There were twice searches by the Gestapo. If we were discovered, my family and the Polish family that hid us would have been shot on the spot.

We must not forget, we must always remember, share our memories. We must not hate, it is a distructive emotion, it does not help to survive and tell the story the way it should be told.

Sarah (Cookie) Capelovitch (nee Schilingovsky).

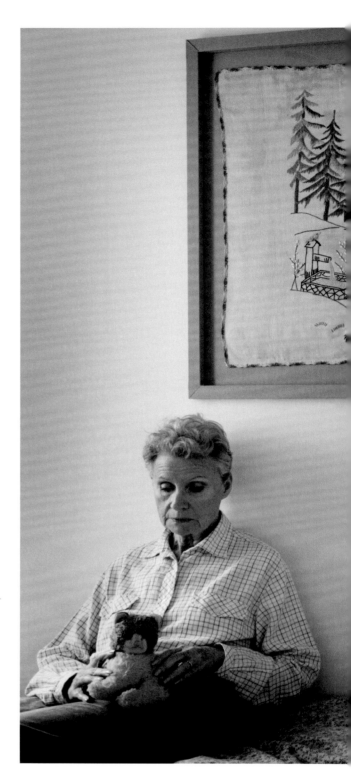

**Sarah Capelovitch**

*Page 246*

We must not forget, we must always remember, share our memories. We must not hate, it is a destructive emotion, it does not help to survive and tell the story the way it should be told.

*....while being photographed I was thinking*

*a. The date is the 29th of March — the third day of the "Kinder-Aktion" in 1944, in ghetto Kovno — an aktion that I am one of the few that miraculously have escaped.*

*b. Just yesterday I have spent several wonderful hours with 3 of my 5 grandchildren.*

*That's the greatest compensation I could wish to myself.*

*Shalom (Kaplan) Eilati*

---

**Shalom Eilati**

*Page 246*

...While being photographed I was thinking a. the date is the 29th of March – the third day of the "Kinder-Aktion" in 1944, in ghetto Kovno – an action that I am one of the few that miraculously have escaped. b. Just yesterday I have spent several wonderful hours with 3 of my 5 grandchildren. That's the greatest compensation I could wish to myself.

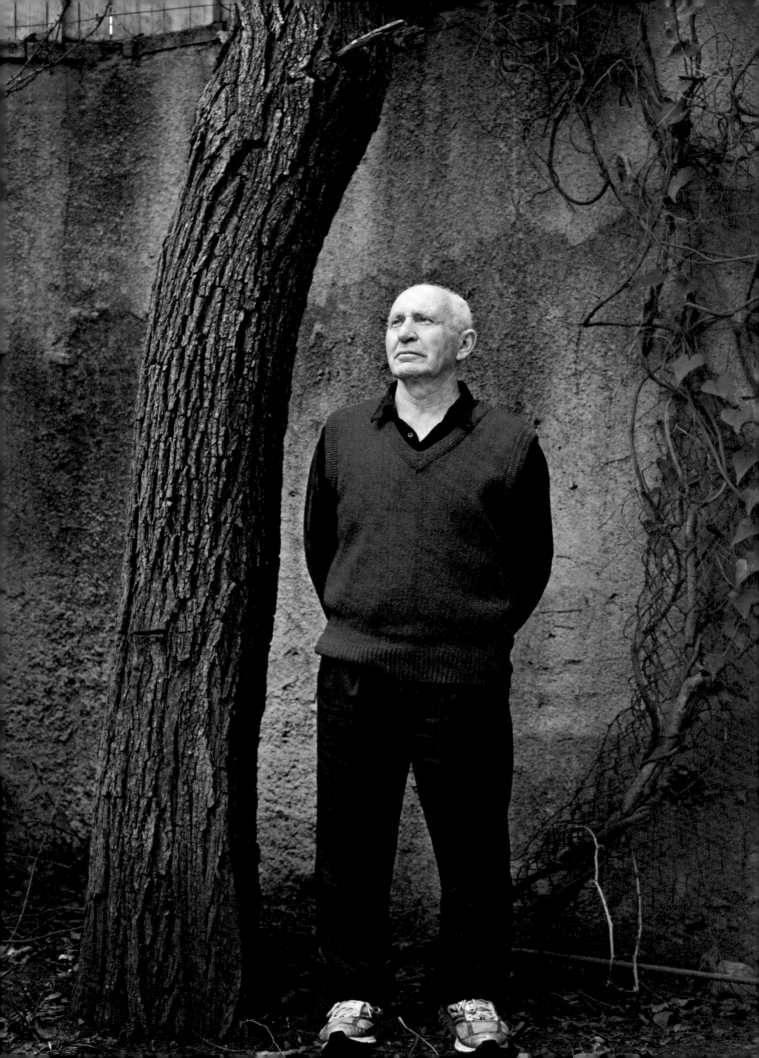

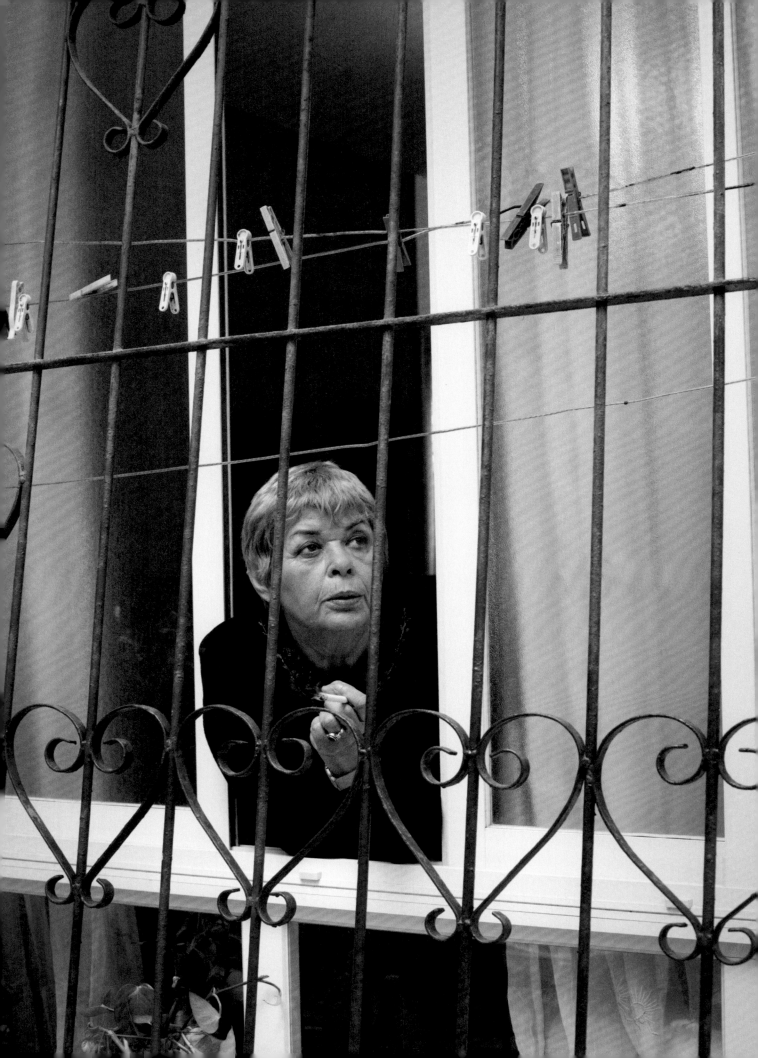

*Fathers Watch*

*My fingers stroke the screw*
*meant to stretch one more day*
*from his legacy.*
*Touch the worn strap*
*that embraced his wrist.*
*It's too big for me for me,*

*and as I am getting older every day is a*
*struggle with the guilt.*
*Why me – from the fifteen thousand children*
*who were in Theresienstadt.*

*Tel Aviv 28 March 2009*

---

**Vera Meisels**

*Page 247*

**Father's Watch**
My fingers stroke the screw
meant to stretch one more day
from his legacy.
Touch the worn strap
that embraced his wrist.
It's too big for me for me,

and as I am getting older every day is a
struggle with the guilt.
Why me – from the fifteen thousand
children who were in Theresienstadt.

Tel Aviv 28 March 2009

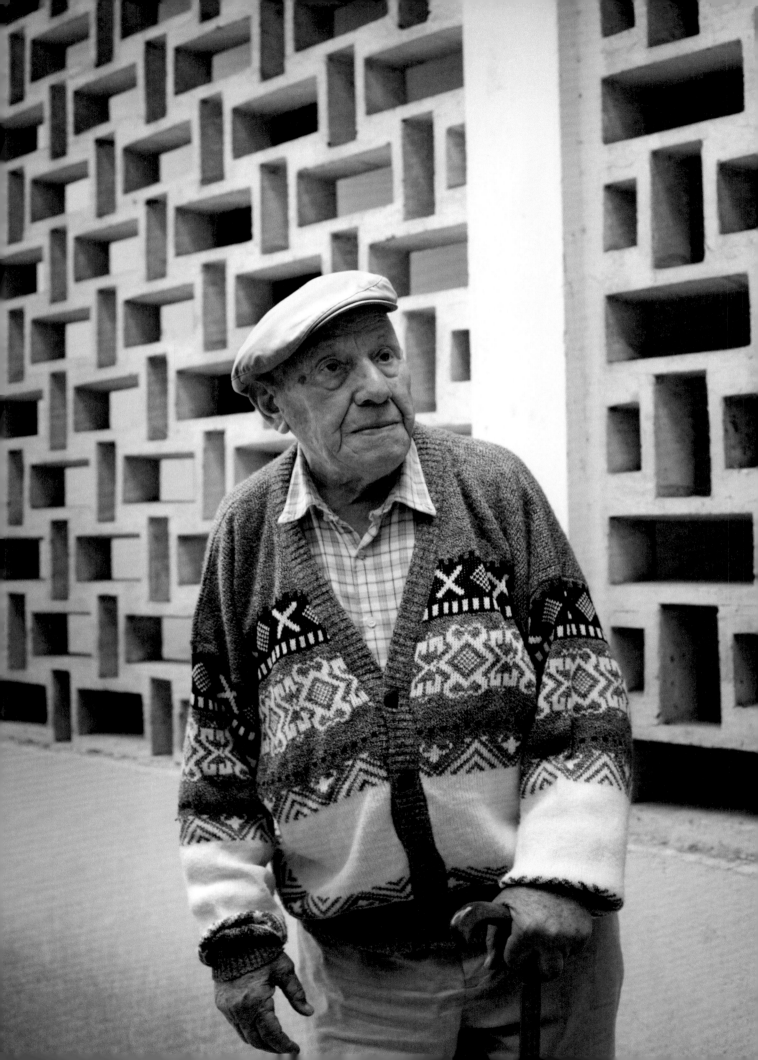

**Yaakov Kronenfeld**

*Page 247*

I am Yaakov Kronenfeld.
I was born in February 1919 in Romania.
We were eight kids: four girls and four boys.
I married and had two children, a boy and a girl, six grandchildren and nine great grandchildren.

I live in Rehovot and I have a 24-hour carer day and night.
I feel good and I have a lot of nachas from my children and all the family.

153

**Janek (Yona) Fuchs**

*Page 248*

Having today 3 children and 14
grandchildren, I think I won the
war against Hitler!

HAVING TODAY 3CHILDREN
AND 14 GRANDCHILDREN,
I THINK I WON THE WAR
AGAINST HITLER!

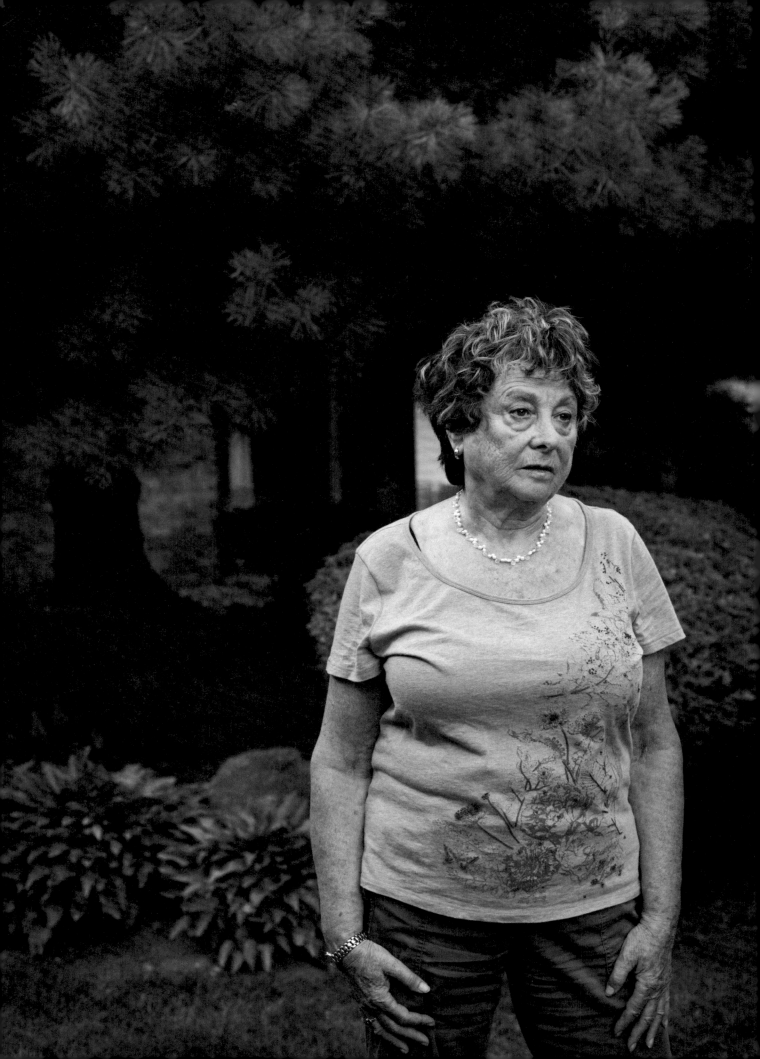

As a Hungarian Jew,
I ran from the Germans,
I ran from the Soviets,
I've stopped running.
Beauty and love
surround me!

Agi Muller

**Agi Muller**

*Page 248*

As a Hungarian Jew,
I ran from the Germans,
I ran from the Soviets,
I've stopped running.
Beauty and love surround me!

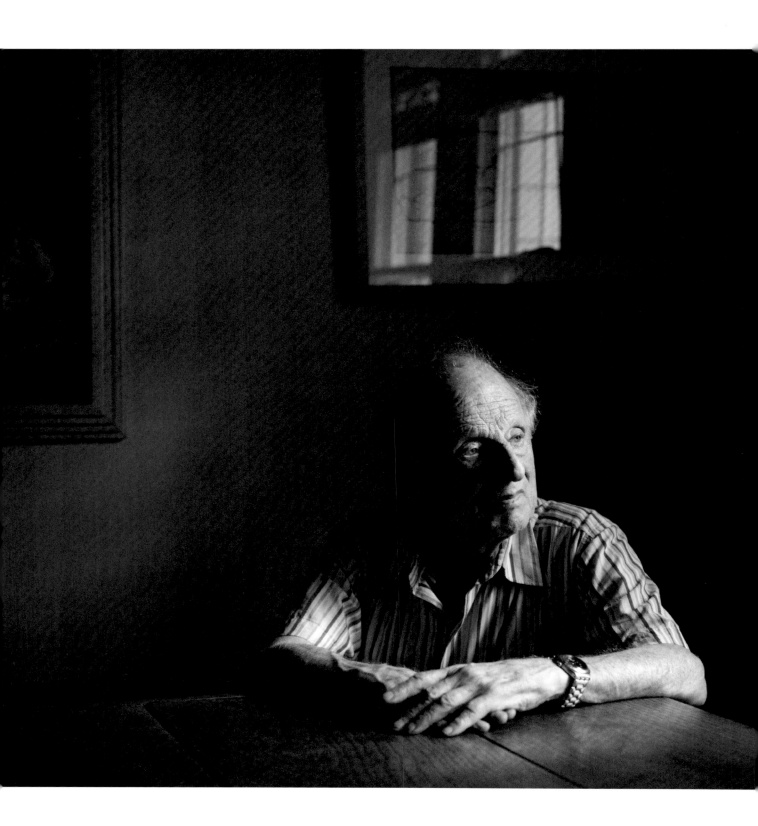

I left Berlin in 1939 with a "Kindertransport" to Holland where I survived in hiding and finally came to New York/New Jersey, but without my younger Brother Ulli who perished in Auschwitz. I wish to thank Miriam and Harry for their work to show some of the faces that those who outlived the nazi nightmare.

Arno Rosenfeld

---

I left Berlin in 1939 with a "Kindertransport" to Holland where I survived in hiding and finally came to New York/New Jersey, but without my younger brother Ulli who perished in Auschwitz. I wish to thank Miriam and Harry for their work to show some of the faces of those who outlived the Nazi nightmare.

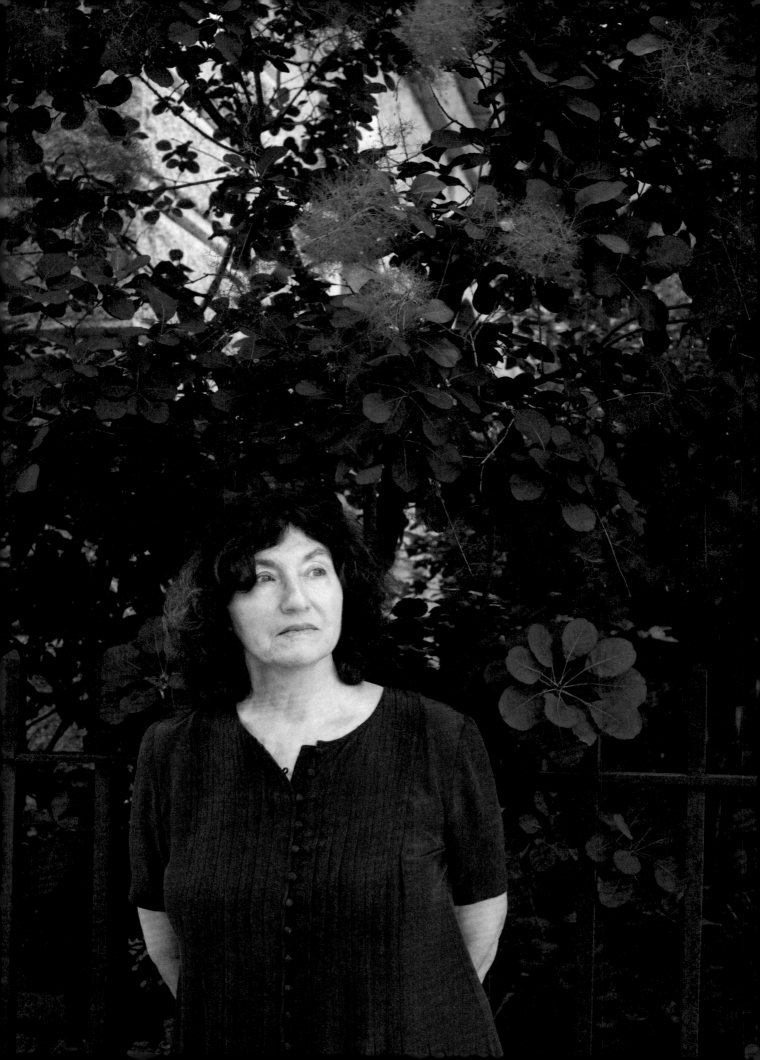

BORN
in ANTWERP
Belgium

I was 4 yo when the
Gestapo Took my father
away
never saw him again –
I was too young to remember
him
One day I needed a birth
certificate + my sister in
Belgium was able to get it for
me –
in the Certificate was my father
Signature it was extremely
emotional To see his hand writing
a proof of his life
I would like to dedicate this
To the memory of my father
DAVID SCHÖNBERG, so that his
name will not be lost.

AVA SCHONBERG–

**Ava Schonberg**

*Page 250*

Born in Antwerp, Belgium.
I was 4 years old when the Gestapo took
my father away. Never saw him again –
I was too young to remember him. One day
I needed a birth certificate and my sister
in Belgium was able to get it for me – on
the certificate was my father's signature,
it was extremely emotional to see his
handwriting, a proof of his life. I would like
to dedicate this to the memory of my father
DAVID SCHÖNBERG, so that his name
will not be lost.

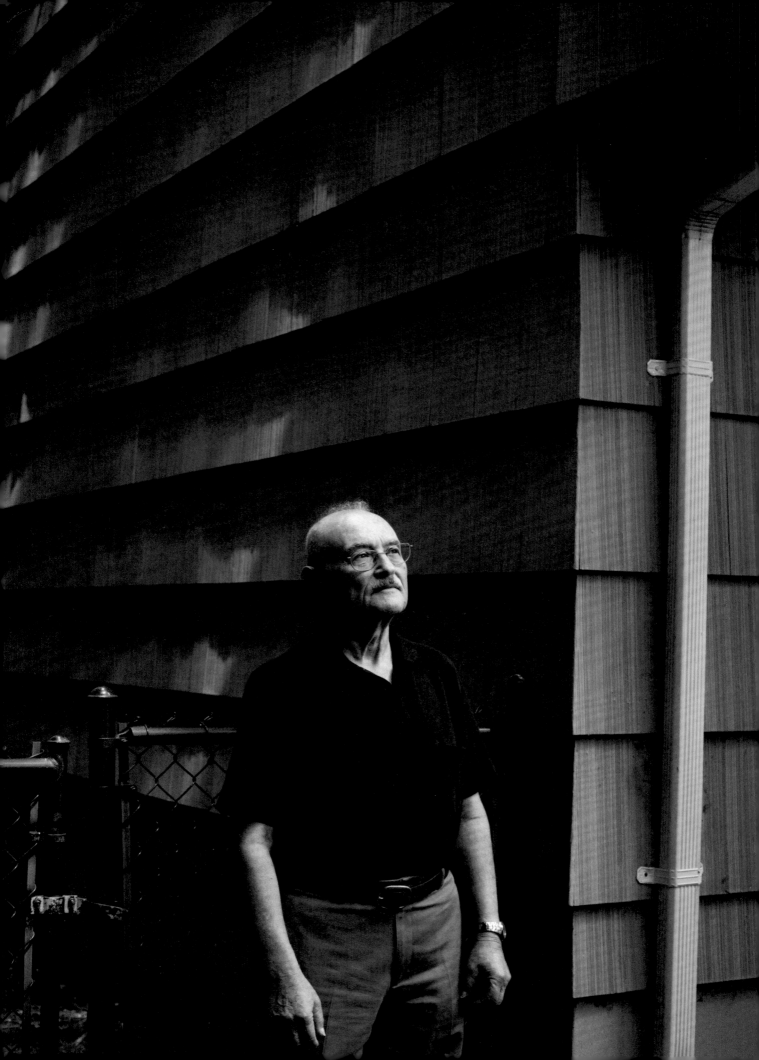

Yet know that God has wronged me
He has thrown up siege works around me
I cry, "Violence!" but am not answered;
I shout, but can get no justice
He has barred my way; I cannot pass;
He has laid darkness upon my path.

Job, verse 19.6 – 19.8

Yet know that God has wronged me
He has thrown up siege works around me
I cry, "Violence!" but am not answered;
I shout, but can get no justice

He has barred my way; I cannot pass;
He has laid darkness upon my path.
*Job, verse 19.6–19.8*

This is in honor of Angele, our governess. She was the one who saved us during the Holocaust by arranging for my Mother to be hidden in a farm, my two brothers to be put in an orphanage and myself in a convent.

*Lilly Glass*

**Lilly Glass**

*Page 250*

This is in honour of Angela, our governess. She was the one who saved us during the Holocaust by arranging for my mother to be hidden in a farm, my two brothers to be put in an orphanage and myself in a convent.

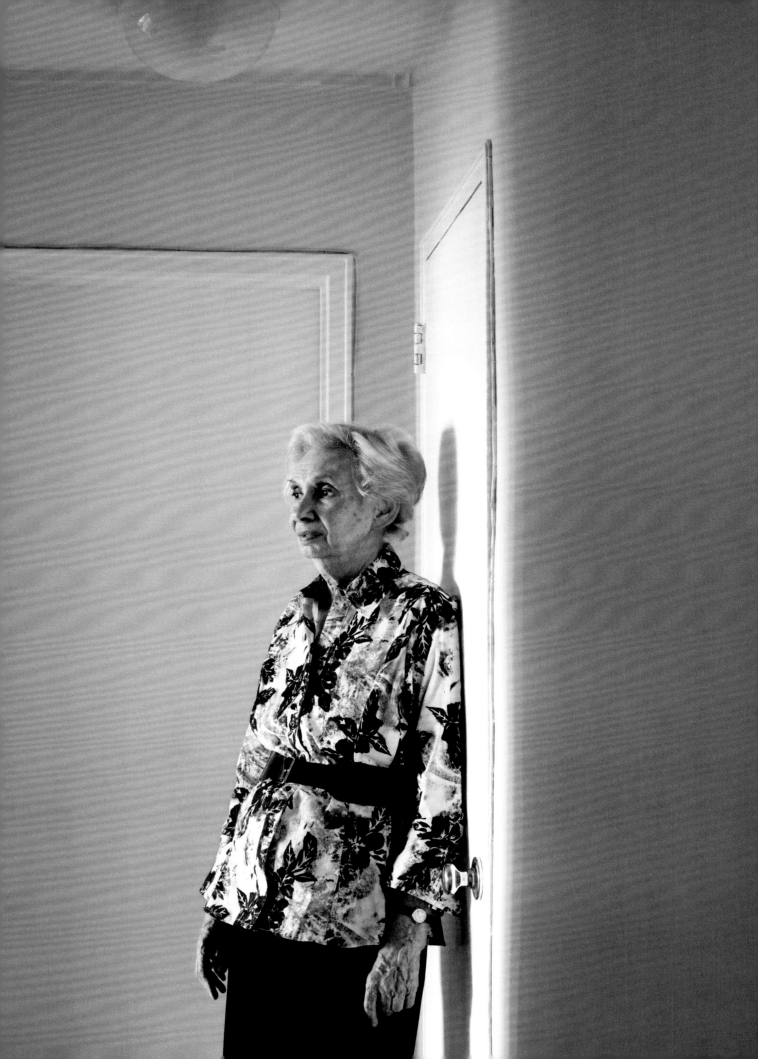

*I am very fortunate to have survived. I have led a good and productive life in the U.S. However Israel is very important to me. Had Israel existed then – there would not have been a holocaust*

*Bertha Strauss*

I am very fortunate to have survived.
I have led a good and productive life in
the US. However, Israel is very important
to me. Had Israel existed then – there
would not have been a holocaust.

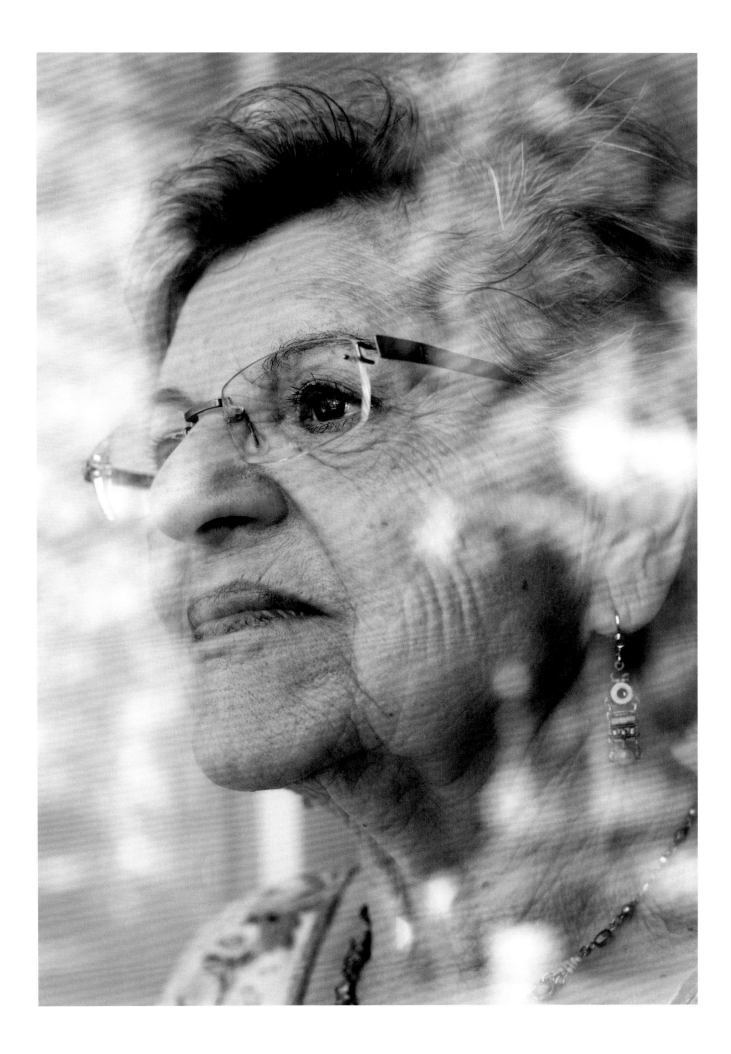

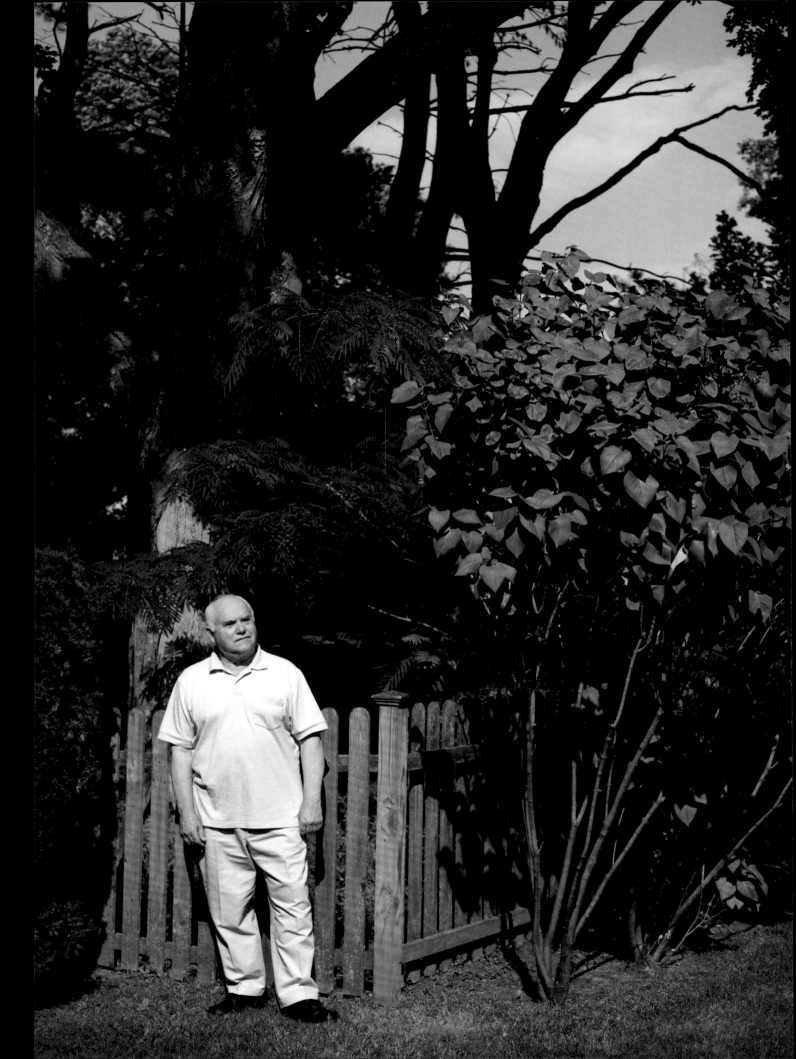

*One must be careful not to participate in hate. What happened before could happen again.*

Leo Dreyfuss

*Page 251*

One must be careful not to participate
in hate. What happened before could
happen again.

a clean desk is the sign of a sick mind,

Charles Schulz

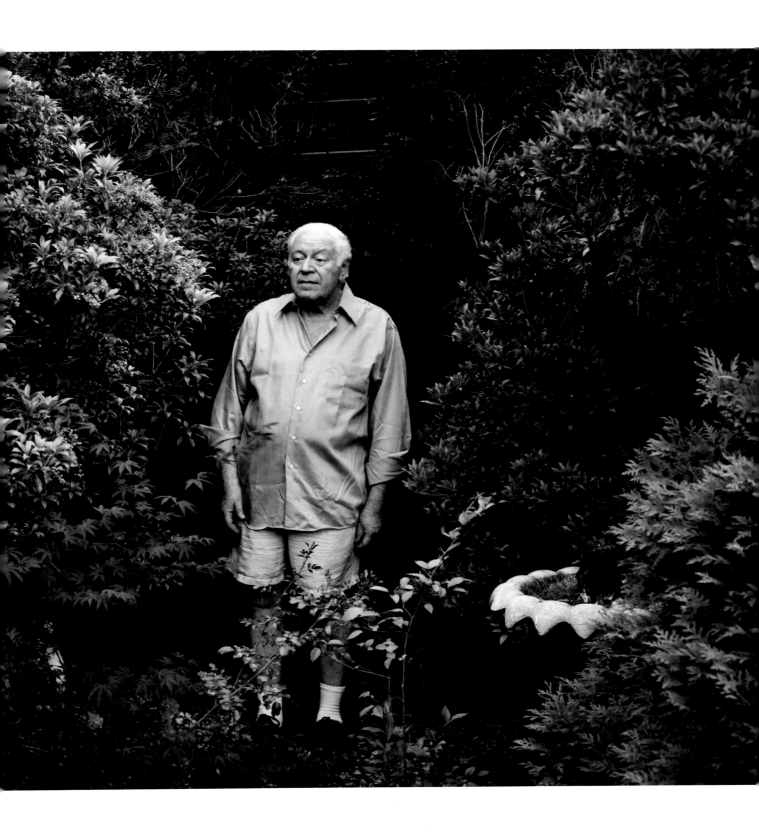

**Charles Srebnik**

A clean desk is the sign of a sick mind.

*Page 251*

The Gift

In my morn,
I was left waiting at the gate,
While inside,
The fires of hell roared:
Black smoke billowed in the air as the chimneys
        spewed with the stench of charred flesh.
And I caught but a glimpse of the horror.

In my afternoon,
The sun shone brightly on fertile earth,
And I partook in the peace and bore fruit,
Though from time to time I felt a twinge in my soul.

Now in my twilight,
I stand again,
This time at Heaven's Gate,
And wait again for God to roll the dice
And wonder again:
Why, why, of all the millions, why me?

Christine Month

---

**The Gift**
In my morn,
I was left waiting at the gate,
While inside,
The fires of hell roared:
Black smoke billowed in the air as the
chimneys spewed with the stench of
charred flesh.
And I caught but a glimpse of the horror.

In my afternoon,
The sun shone brightly on fertile earth,
And I partook in the peace and bore fruit,

Though from time to time I felt a twinge
in my soul.

Now in my twilight,
I stand again,
This time at Heaven's Gate,
And wait again for God to roll the dice,
And wonder again:
Why, why, of all the millions, why me?

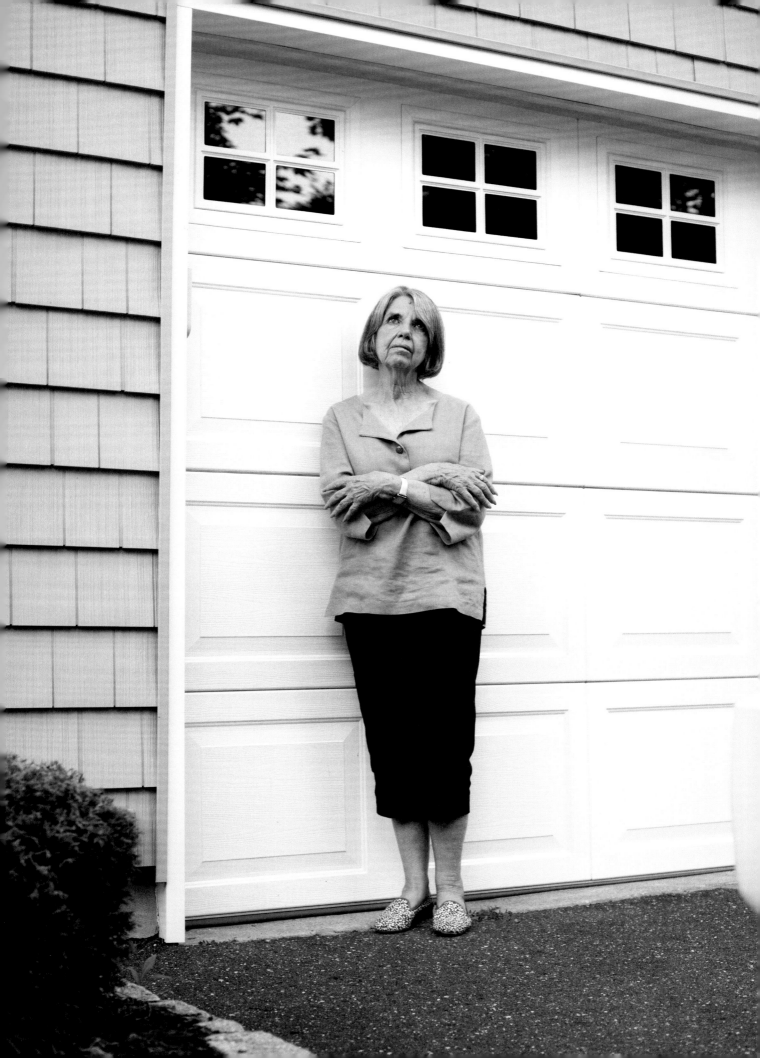

*In my heart I always felt my parents would survive — Debora Brenner*

In my heart I always felt my parents
would survive.

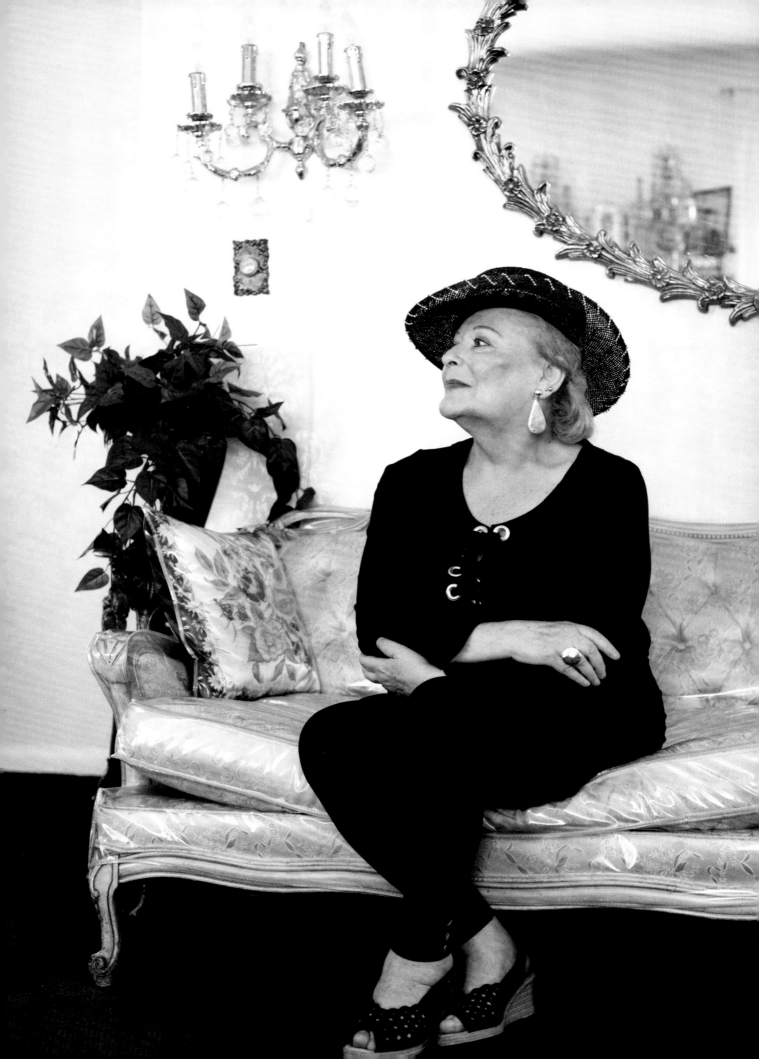

_Wiara, nadzieja i miłość_

_Dora Reym_

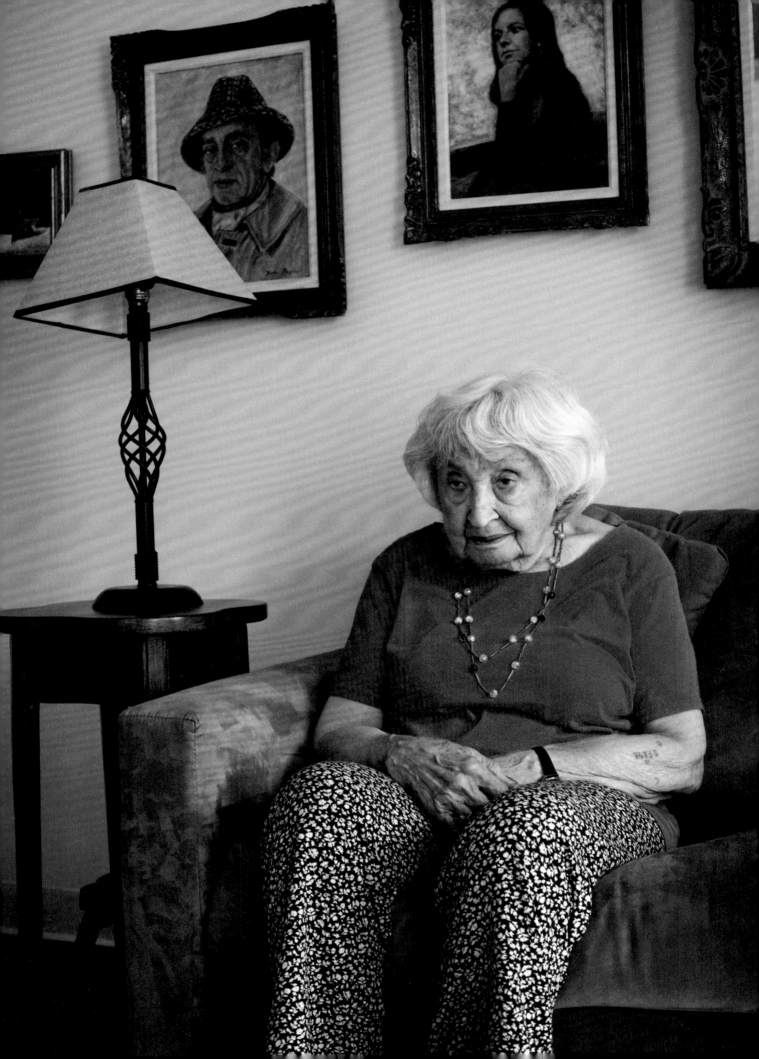

As a small child I was saved from certain death by the courageous actions of my parents as well as strangers. They were all ordinary people, both brave and flawed. What I learned from their actions is that you don't have to be good to do good. A hopeful lesson—any of us can make a difference! And I believe the "lesson" that's usually drawn from the Holocaust—"Never Again"—should apply not only to the Jewish people but to everyone.

It's what we all have yet to learn.

Maia Rayne Binford

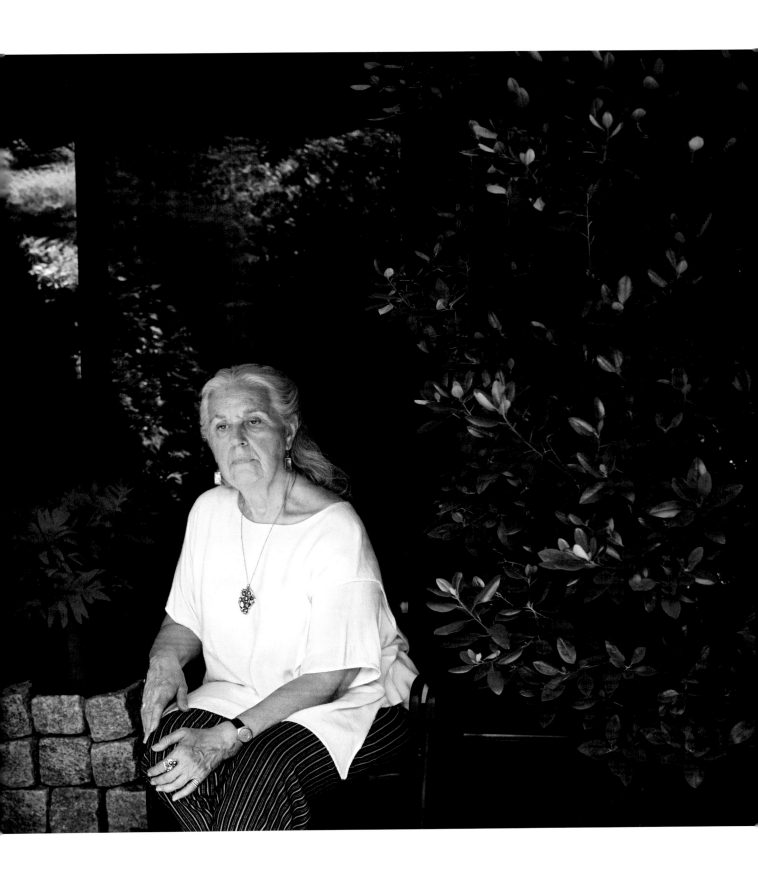

**Mira Reym Binford**

*Page 253*

As a small child I was saved from certain death by the courageous actions of my parents as well as strangers. They were all ordinary people, both brave and flawed. What I learned from their actions is that you don't have to be good to do good.

A hopeful lesson – any of us can make a difference! And I believe the "lesson" that's usually drawn from the Holocaust – "Never Again" – should apply not only to the Jewish people but to everyone. It's what we all have yet to learn.

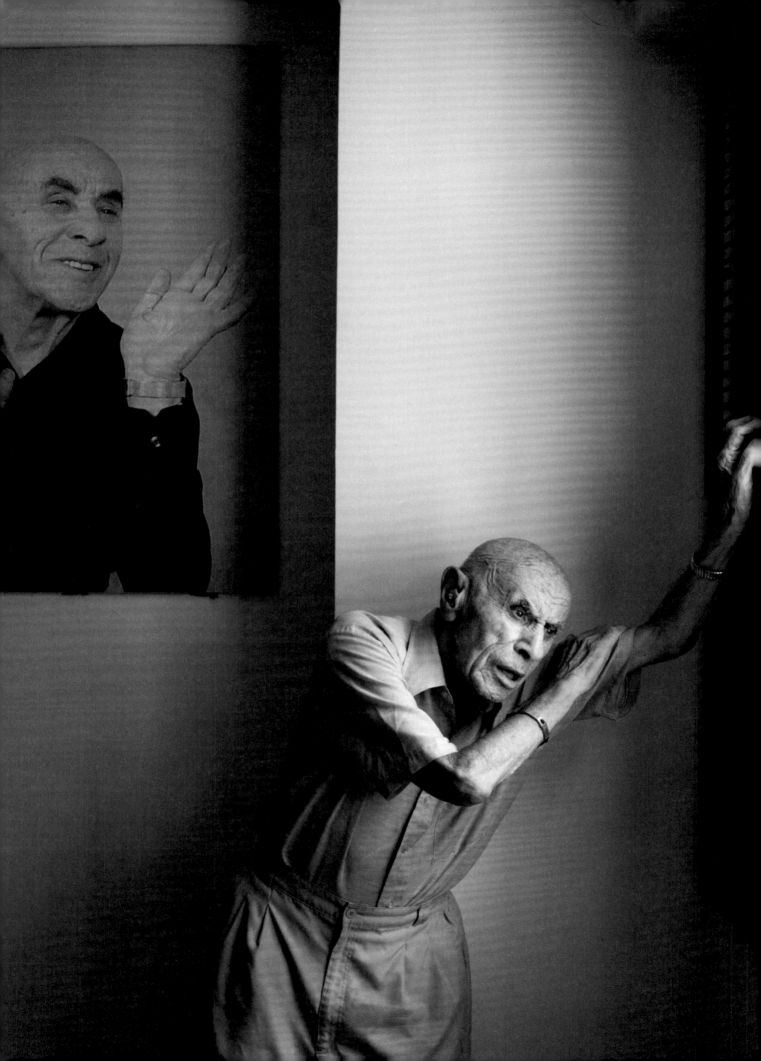

*In my dancing I was trying to express to express a full range of human emotions from the joy of life to deep sorrow of pain and suffering of tragic life.*

*Felix Fibich*

**Felix Fibich**

*Page 254*

In my dancing I was trying to express a
full range of human emotions from the joy
of life to deep sorrow of pain and suffering
of tragic life.

*... the aim is a full life in a fair and open community. We are all responsible for each other.*

*Frederick Terna*

...the aim is a full life in a fair and open community. We are all responsible for each other.

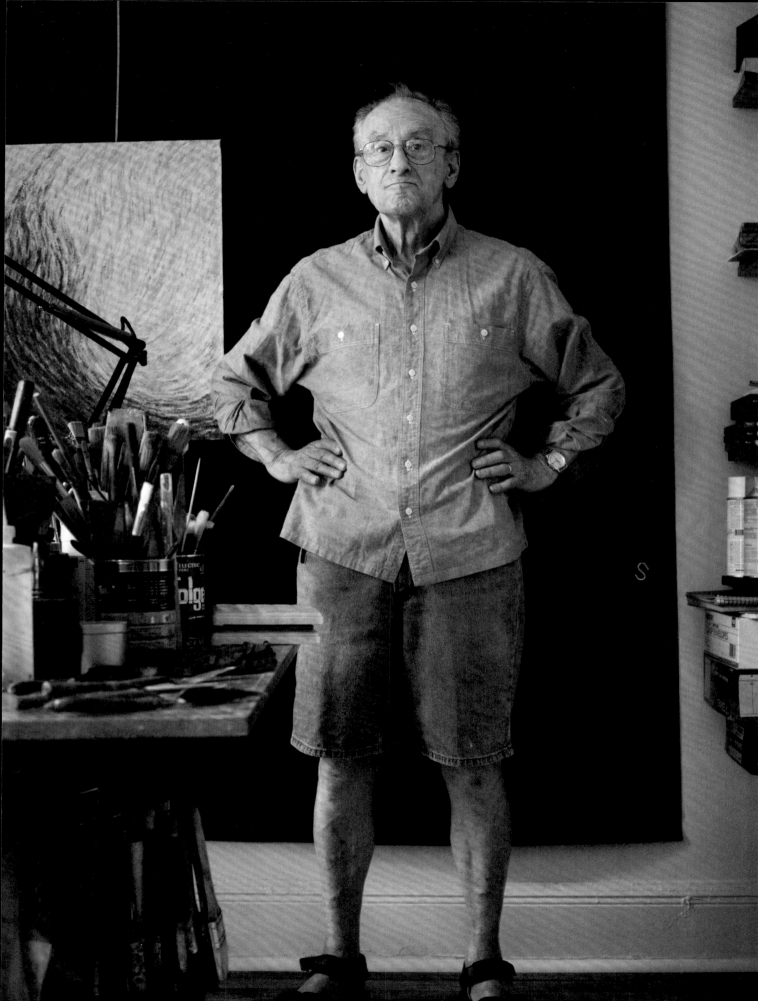

Life is like a dream
it passes us by Quickly
it is good to take chances in life!
never to loose your hope
Hitler did not succeed to Rob Us
survivours from Our Dreams
and Our Dreams came True.
in great ways, the most
Fortunete survivors
are the Ones who bringt
New Generations to this world

                  Hana Kantor

---

**Hana Kantor**

*Page 255*

Life is like a dream, it passes us by quickly. It is good to take chances in life! Never to lose your hope. Hitler did not succeed to rob us survivors from our dreams and our dreams came true in great ways. The most fortunate survivors are the ones who brought new generations to this world.

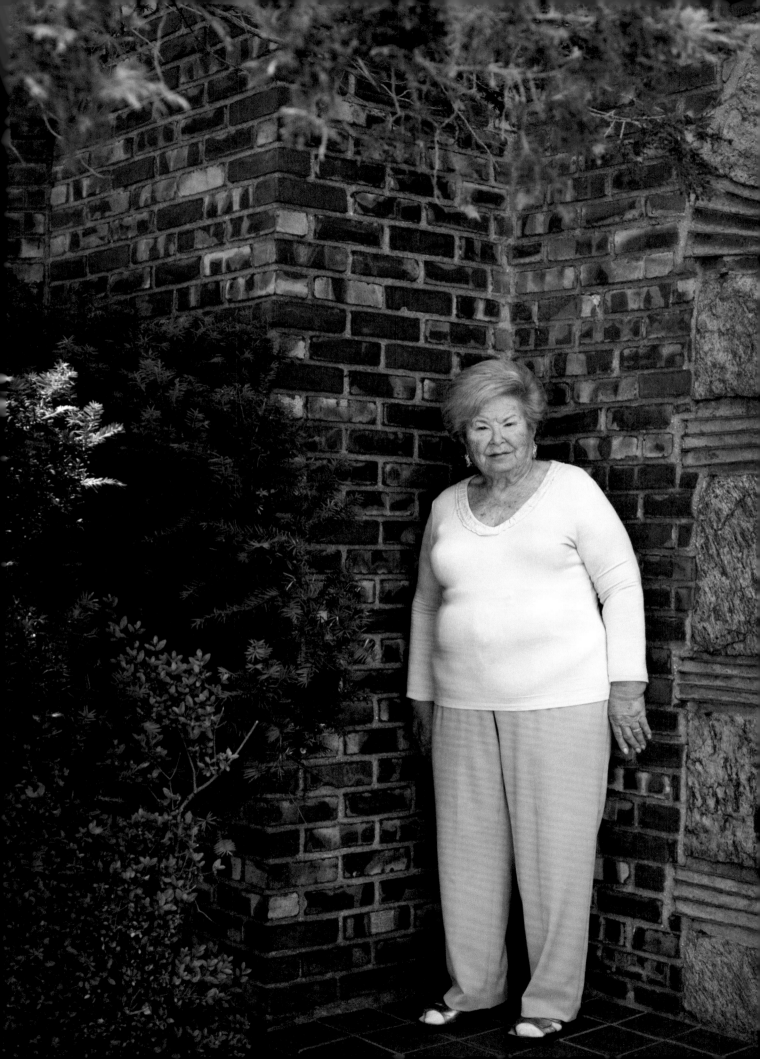

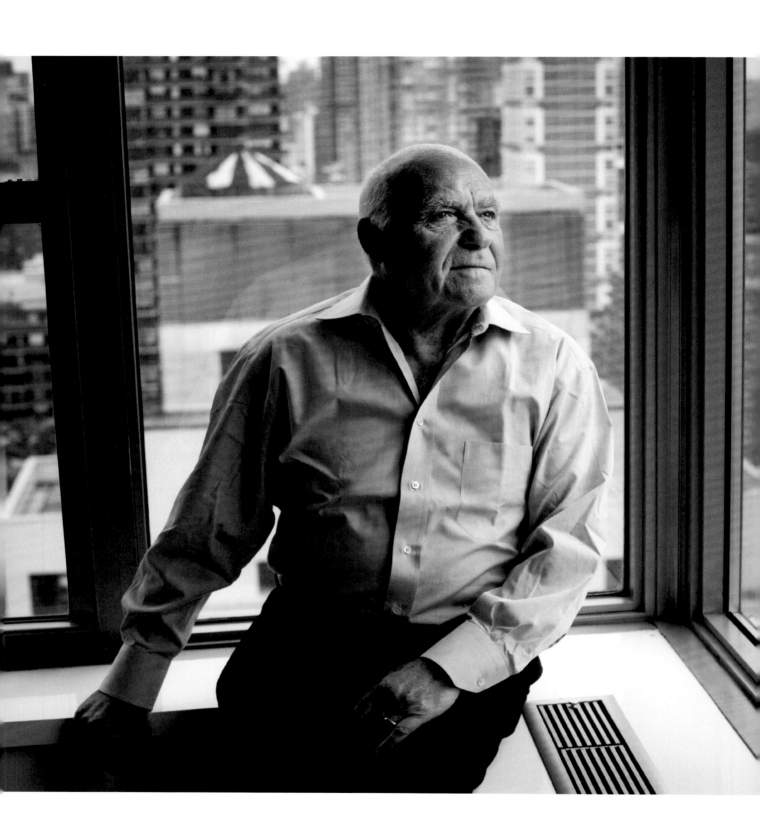

*I lived through hell and very frightening times, but I never lost hope for better life.*

H. Birman

**Henry Birman**

*Page 255*

I lived through hell and very frightening
times, but I never lost hope for better life.

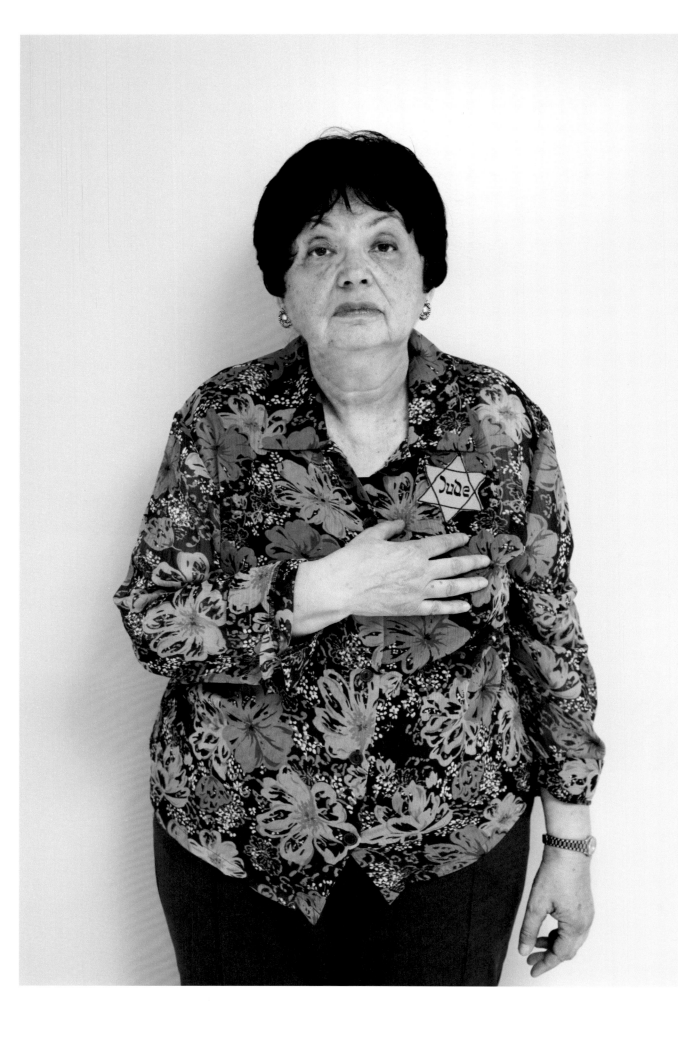

*"I stand tall and proud,*

*My voice shouts in silence loud;*

*I am a real person still,*

*No one can break my spirit or will!"*

*I am a star!*

*Inge Auerbacher*

*XIII - 1 - 408*

---

**Inge Auerbacher**

*Page 256*

"I stand tall and proud,
My voice shouts in silence loud;
I am a real person still,
No one can break my spirit or will!"
I am a star!

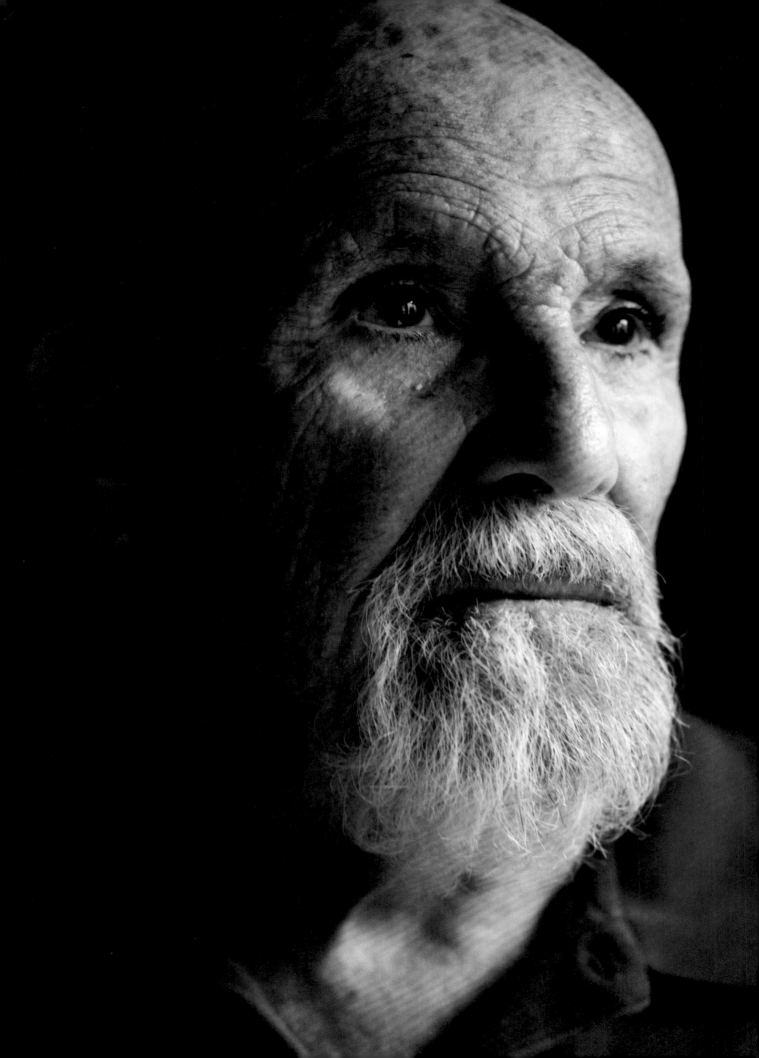

As a hidden child I frequently lecture to children about my experiences. My great concern is who will continue to tell our stories when we're gone in not too many years?

*John Balan*

---

**John Balan**

*Page 256*

As a hidden child I frequently lecture to children about my experiences. My great concern is who will continue to tell our stories when we're gone in not too many years?

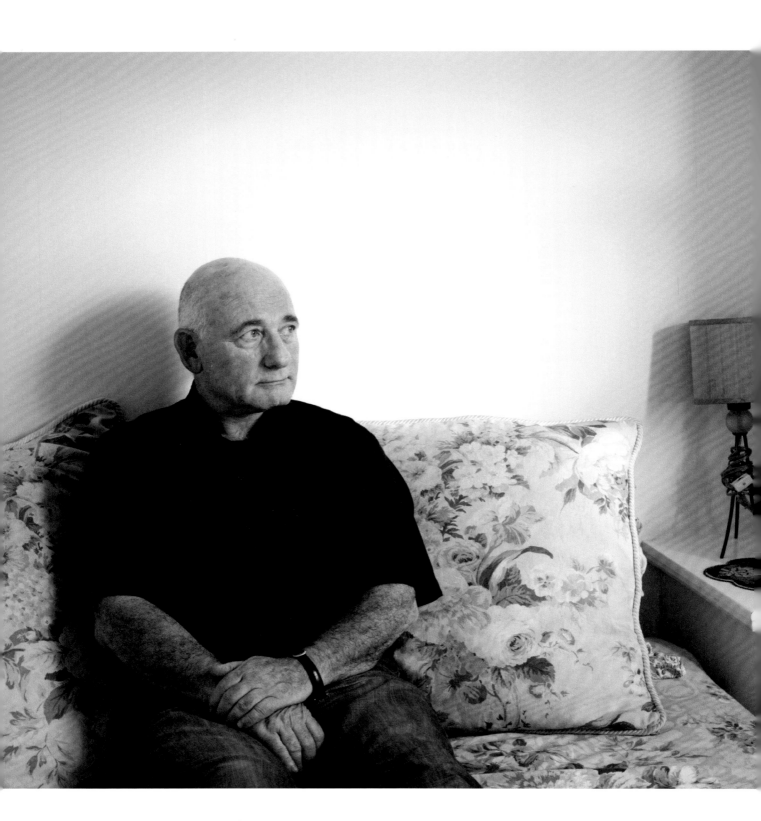

Each person has the capacity to be either a persecutor or a victim, and no country has a monopoly on either role. I believe it all comes down to personal conduct, embracing diversity and treating people fairly.

As a child I was a victim, a hidden child, separated from family and loved ones, and at War's end, taken from my loving adopted family and returned to my real parents. This sense of victimhood and disorientation took many years to overcome. My wife, my son, my sister are all-important. The family is everything!

Joe Gosler

**Joseph Gosler**

*Page 257*

Each person has the capacity to be either a persecutor or a victim, and no country has a monopoly on either role. I believe it all comes down to personal conduct, embracing diversity and treating people fairly. As a child I was a victim, a hidden child, separated from family and loved ones, and at War's end, taken from my loving adopted family and returned to my real parents. This sense of victimhood and disorientation took many years to overcome. My wife, my son, my sister are all-important. The family is everything!

I am grateful to my parents for
having the foresight to send me
to England on the Kindertransport,

Kurt Goldberger

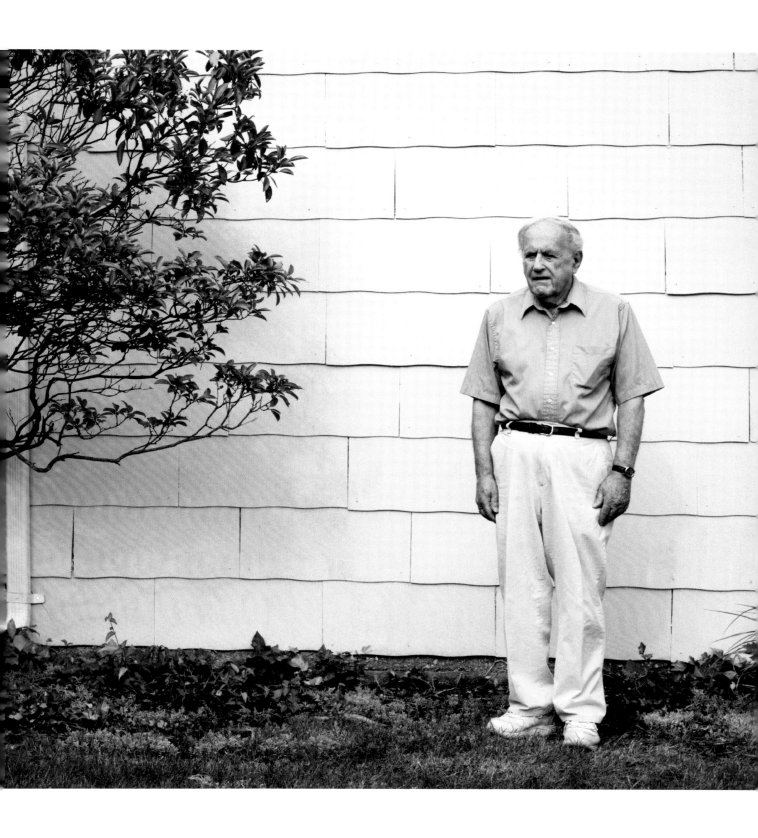

**Kurt Goldberger**

*Page 258*

I am grateful to my parents for having
the foresight to send me to England
on the Kindertransport.

195

*From Danger to Safety. I will always be grateful to those in Great Britain who made that possible.*

*Margaret Heller-Goldberger*

From danger to safety. I will always be grateful to those in Great Britain who made that possible.

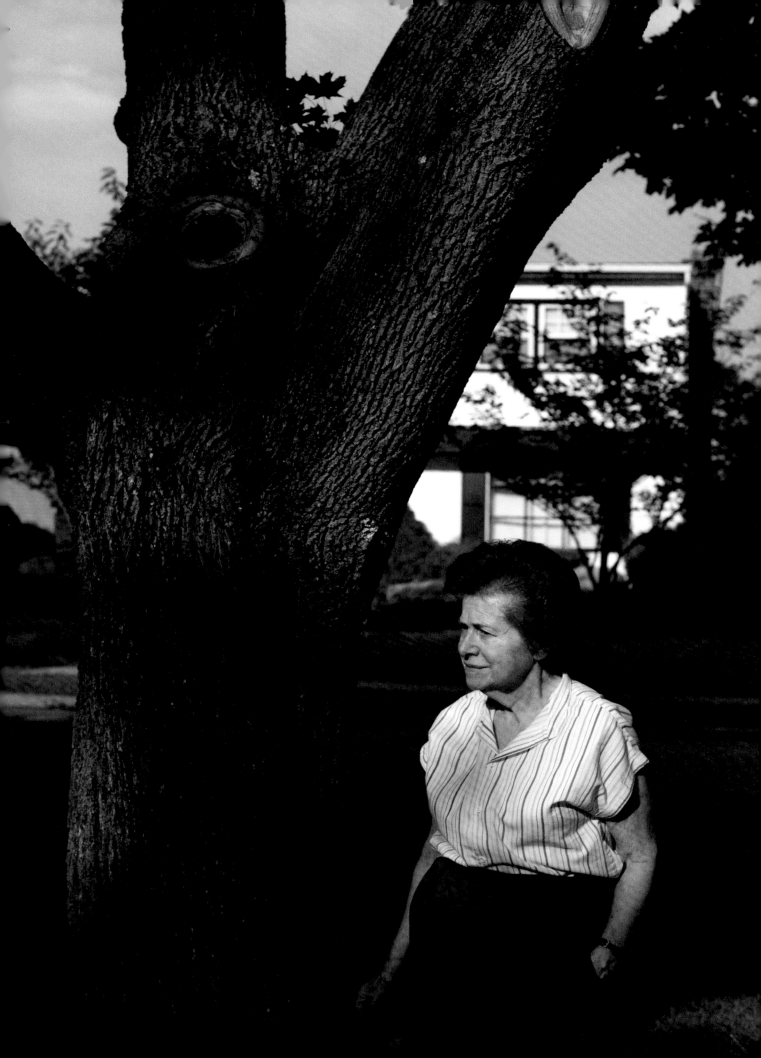

I have no memory of
the war — I was hidden
in a convent and on a farm.
when I met my parents
again — I told them what
I had undergone. what I
do remember is wanting
to go to America with
my sisters. I am
happy to be here and
with the life I have.
Lea Kanner Bleyman

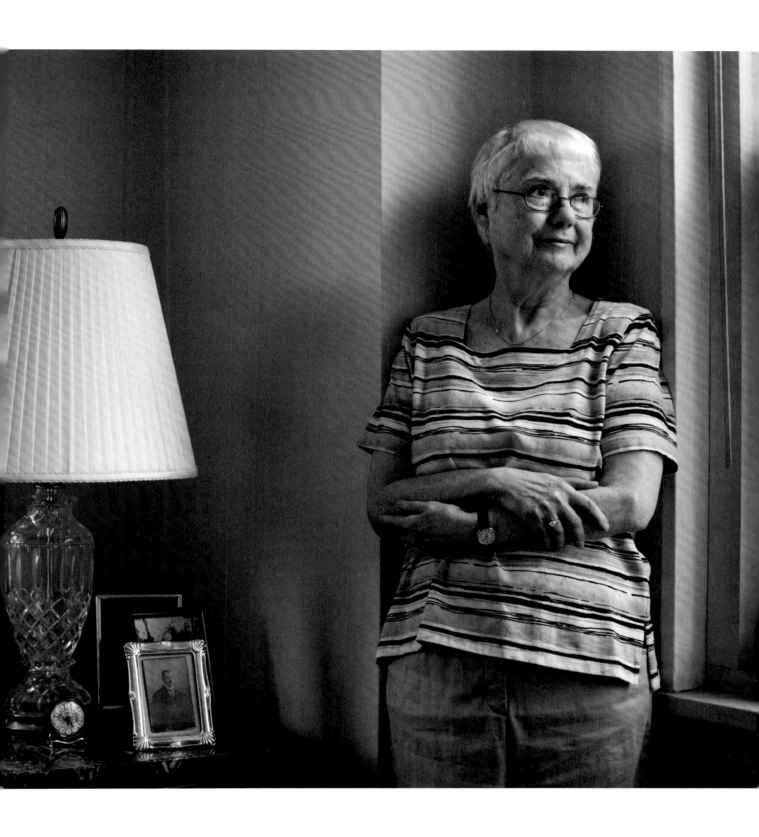

**Lea Kanner Bleyman**

*Page 259*

I have no memory of the war – I was hidden in a convent and on a farm. When I met my parents again – I told them what I had undergone. What I do remember is wanting to go to America with my sisters. I am happy to be here and with the life I have.

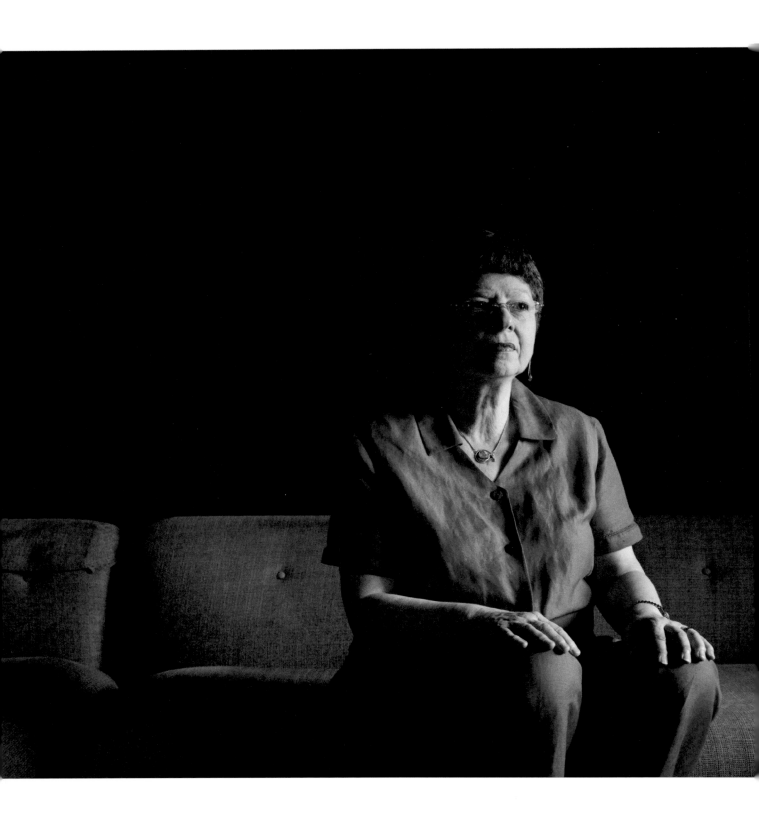

I was one of The
lucky ones – Smuggled out
of the Sosnowiec ghetto and
my mother's sheltering
arms into The protective
and loving arms of a
"second" mother.

*Aviva Cohen*

**Aviva Cohen**

*Page 259*

I was one of the lucky ones – smuggled out
of the Sosnowiec ghetto and my mother's
sheltering arms into the protective and
loving arms of a "second" mother.

"Selection"

When we arrived at Auswitz
The nazi's selected the fit
From the unfit.

- I tried to hold on to my Dear Mother.

At that moment Mengele kicked me
on the face and my teeth fell out,

- That was the last time I saw
my Dear Mother.

They Treated us like animals.

But we never became animals.

We helped each other,

they were animals but we
never lost our humanity,

We selected ourself for True life!

Olga Berkovitz

---

**Olga Berkovitz**

*Page 260*

**"Selection"**
When we arrived at Auschwitz the Nazis
selected the fit from the unfit.
I tried to hold on to my dear mother.
At that moment Mengele kicked me on
the face and my teeth fell out.
That was the last time I saw my dear mother.

They treated us like animals,
But we never became animals.
We helped each other,
they were animals but we never lost
our humanity.
We selected ourself for true life!

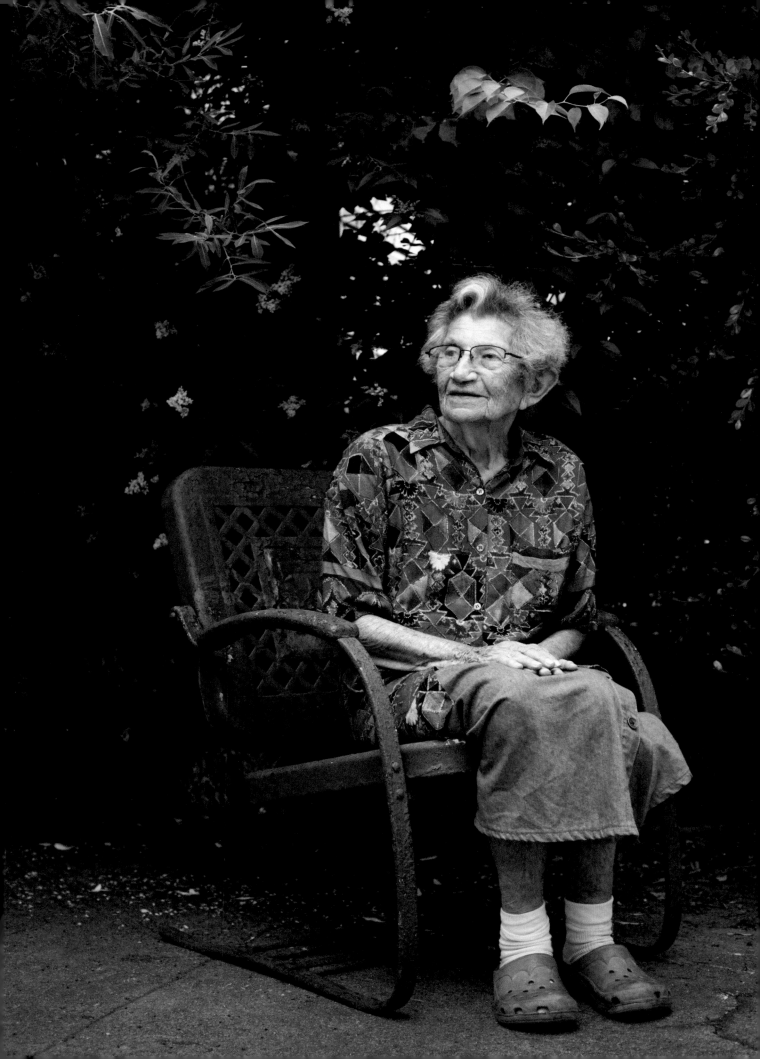

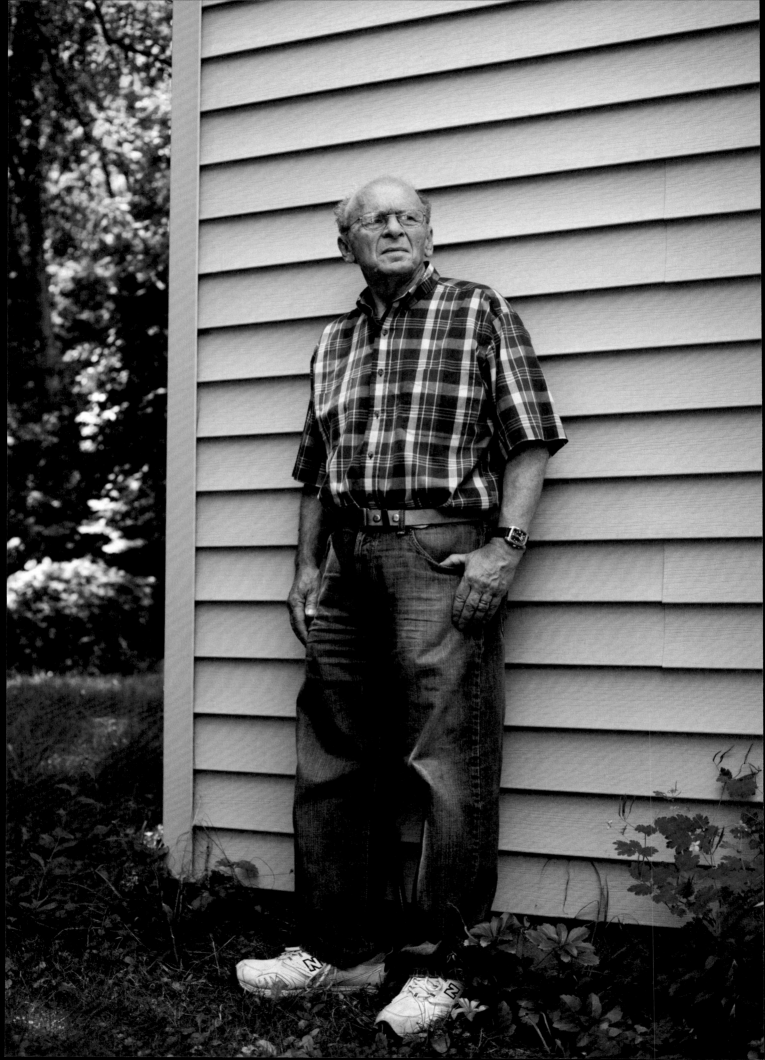

*The past, which is always with us,
is both an anchor and a beacon for
our lives. My good fortune is that
it has been more of a guiding light.*

Peter Stern

---

**Peter Stern**

*Page 261*

The past, which is always with us, is
both an anchor and a beacon for our lives.
My good fortune is that it has been more
of a guiding light.

The Germans were intent on destroying me,
but they didn't succeed. That's why I've
never wanted to be pitied. I'd rather be
perceived as someone who has made it,
who has overcome all kinds of obstacles –
and I have!

*Rosa Sirota*

---

**Rosa Sirota**

*Page 261*

The Germans were intent on destroying me, but they didn't succeed. That's why I've never wanted to be pitied. I'd rather be perceived as someone who has made it, who has overcome all kinds of obstacles – and I have!

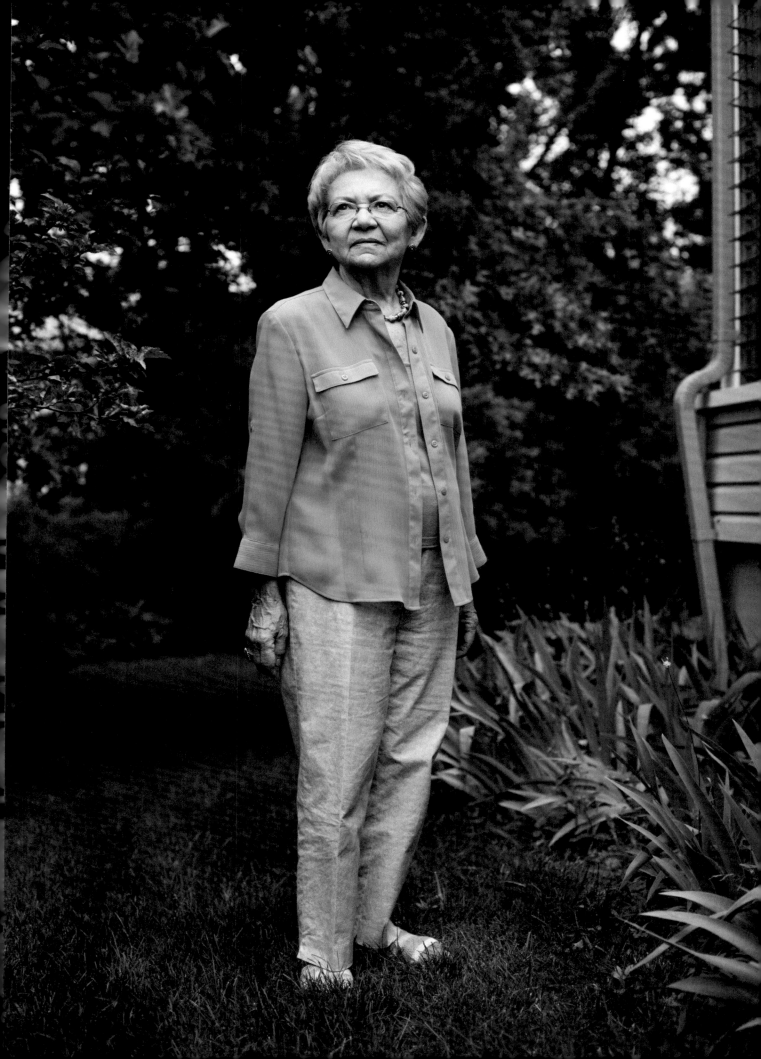

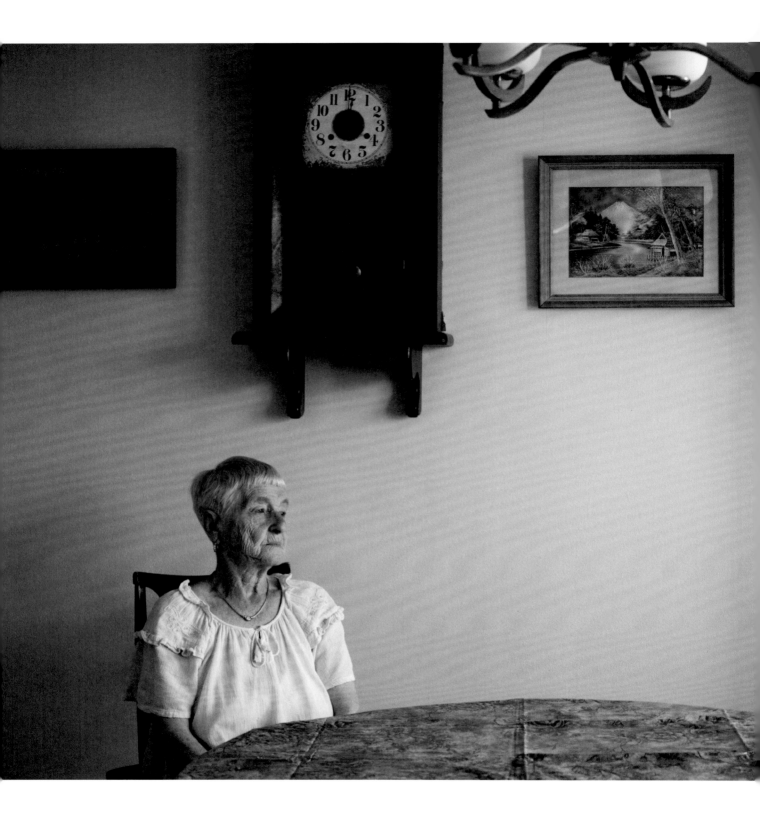

**Ruth Schloss**

*Page 262*

For almost 70 years I clung to the memory
of my parents who lived in Nazi Germany –
frail and starving during World War II.

For almost 70 years I clung
to the memory of my parents
who lived in nazi germany —
Frail and starving during world
war II.

Ruth Schloss

*A dark cloud descended on Europe. We, the survivors, will never forget those who perished and always honor those who helped us to create productive lives for ourselves and our children.*

*Sarah Knecht*

---

**Sarah Knecht**

*Page 262*

A dark cloud descended on Europe.
We, the survivors, will never forget those
who perished and always honour those
who helped us to create productive lives
for ourselves and our children.

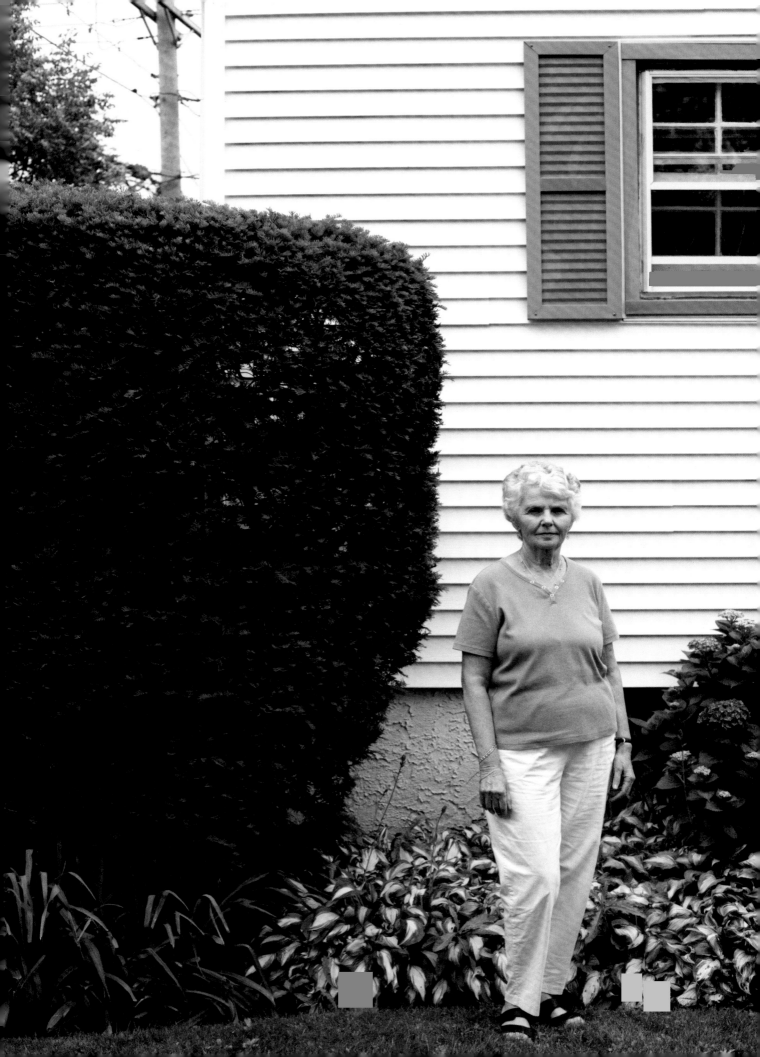

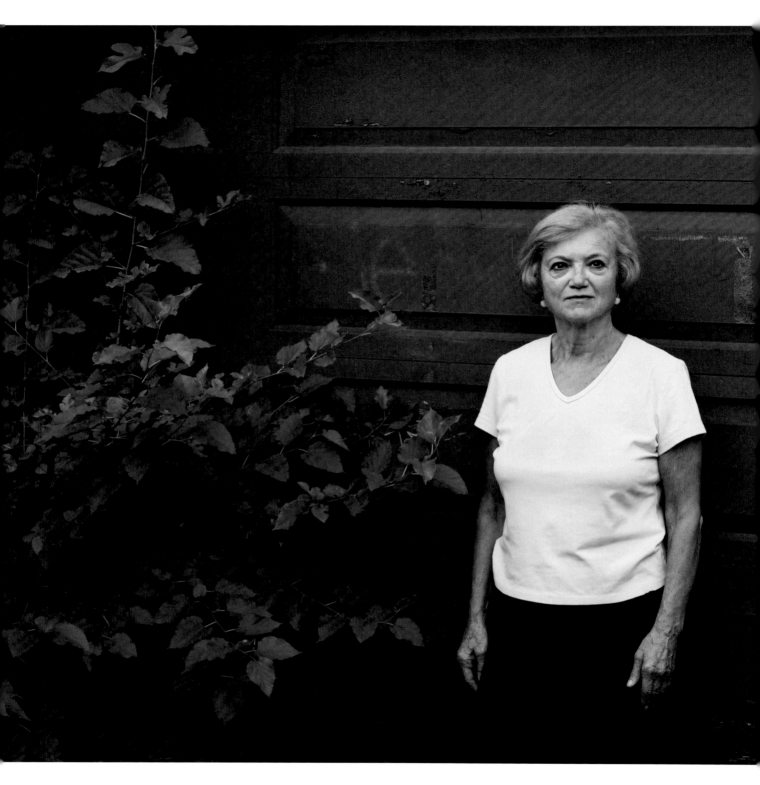

I was "LUCKY" to survive in hiding
with my immediate family, but the
HOLOCAUST has taken its toll on me
as well as the next generation.
although I try to remain optimistic.
It appears that world antisemitism is
again rearing its ugly head.

TOBY LEVY ~ B'Klyn. N.Y.

**Toby Levy**

*Page 263*

I was "LUCKY" to survive in hiding with my immediate family, but the Holocaust has taken its toll on me as well as the next generation. Although I try to remain optimistic, it appears that world anti-Semitism is again rearing its ugly head.

213

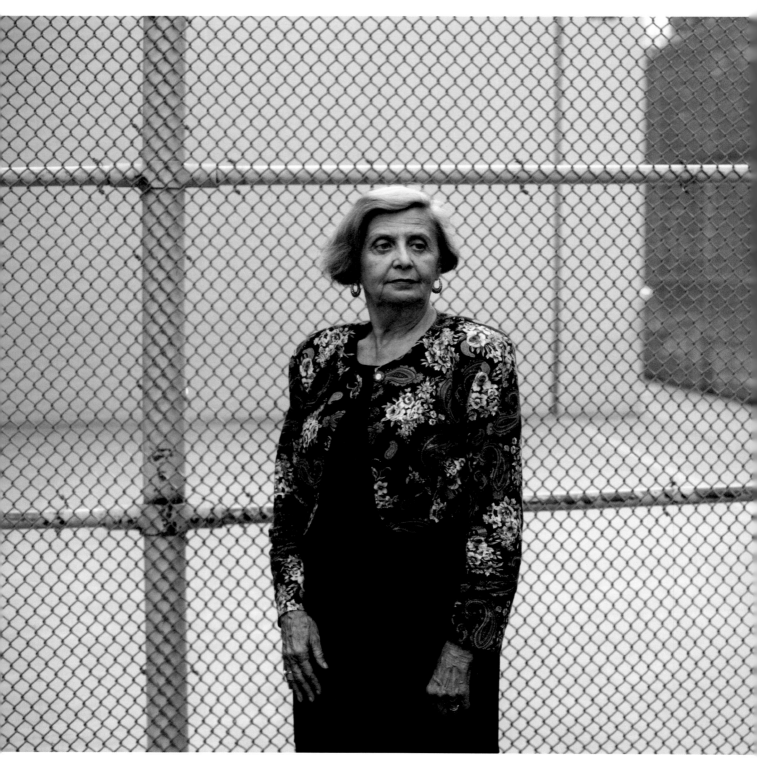

No child on this earth should
have to go through what I
did as a 6 yr. old in Auschwitz.
   This wald has to be made
safe for them. But Let's
never forget the children
who perished

Laura Lee Lynn

**Tova Friedman**

*Page 265*

No child on this earth should have to go through what I did as a 6 year old in Auschwitz. This world has to be made safe for them. But let's never forget the children who perished.

# Survivor

The biographies

Pages 10–11
Peter Lantos
London, UK

Peter Lantos was born in Makó, Hungary, on 22 October 1939. In the summer of 1944, as a child of five, he was deported with his parents, Ilona Somló (Schwartz) and Sándor Leipniker from Hungary to the Bergen-Belsen concentration camp[1] in Germany. His father died of starvation, while he and his mother survived. Many members of his large family perished in the Holocaust. His school years were dramatically interrupted by the Hungarian Revolution of October 1956. His plan to study medicine was first frustrated by the authorities, as he was on the "blacklist" of the Communist system.

After graduating from medicine, Lantos was awarded a Wellcome Trust research fellowship to study research methodology at the Middlesex Hospital Medical School, London. He arrived with a small suitcase and a few pounds in October 1968. As the one-year tenure of the grant was coming to an end, he decided, for political, professional and personal reasons, not to return to Hungary. For this defection the Hungarian authorities sentenced him, *in absentia*, to 16 months' imprisonment and total confiscation of all his belongings.

His career spanned 34 years, during which he contributed to the understanding of diseases of the nervous system. In 1979 he was appointed Professor of Neuropathology at the world-famous Institute of Psychiatry at the Maudsley Hospital, now part of King's College Clinical Neuroscience Centre. He has published in excess of 500 medical and scientific papers and become internationally known. He was elected to the Academy of Medical Sciences in 2001.

After retirement, Lantos began a literary career. Based on his childhood experiences, he wrote *Parallel Lines*, which has had four reprints, been translated into Hungarian, Italian and German, and sold over 12,000 copies. His first novel, *Closed Horizon*, is about the surveillance state of the near future. Two of his four plays have had rehearsed readings in London, and both are with directors and agents, with productions planned.

Pages 12–13
Alicia Melamed Adams
London, UK

"I was born Alicia Goldschlag in 1927 in Boryslav, which was then in eastern Poland but after the war became part of Ukraine. I survived the war in the city of Drohobycz, near Lwów, which had oil refineries. My father was an oil-mining engineer and my mother was a designer. Out of 30,000 Jewish people living in Drohobycz, only 400 survived and I was one of them.

My brother was just 17 at the time and wanted to study architecture. He worked at a brick factory, from which he was taken to Janowska concentration camp[2] near Lwów, and killed. When in the Drohobycz ghetto I worked on the Gestapo[3] building site, carrying bricks. Here I met Poldek Weiss, who was the son of the tailor for the Gestapo. Later on, we were working for Viktor Kremin[4] collecting rags and metal for his German recycling business. Such courageous people as Mr Kremin, and Mrs Cekalska, who hid my husband-to-be, could have been instantly shot if caught by the Germans and are now recognized post-war as the 'Righteous Among the Nations'[5] because they risked their own lives to save many Jews.

On 26 July 1941 my family were surrounded by Gestapo and taken to a local prison. It was their custom to keep people for three days in prison and then take them to Bronica Woods and shoot them. Today Bronica Woods contains six unmarked mass graves. On the way to the prison, I saw Poldek Weiss. He said that his father would make a suit for the commandant and he would beg his father to help me. And so on the third day I was released from prison as Poldek's wife, my mother pushing me forward when my name was called out by the German guard and shoving into my hand her coat, into the lapel of which a diamond was sewn. My parents were shot the next day.

After the war Poldek went to Canada with all his family, but I stayed in Poland and married Adam Melamed (now Adam Nathan Adams) in Warsaw. We left everything behind after the war and went to live in Paris, France, where we bribed the police to extend our residence permits. Then we came to England, where my aunt lived and, in 1951, my only son Charles was born. I studied at Saint Martin's School of Art and painted a short series of pictures about my painful experiences and the loss of my entire family, which I have exhibited ever since on Holocaust Memorial Day, lest we ever forget. Some of my paintings are in the permanent collection at the Imperial War Museum in London. Many of my pictures feature a cup with a heart because this expresses my naive wish that people and governments would find a way to resolve conflicts without wars.

My husband and I have four grandchildren."

*Pages 14–15*
Adam Nathan Adams
London, UK

"I was born Adam Nathan Melamed in 1923 in Lublin, Poland. When the war broke out in 1939, my father and I tried to cross the Bug River to Russia, but we were caught by the Germans and imprisoned in Lublin Castle[6]. There we spent one year being beaten and maltreated and we were always hungry. After release, we were sent to the Lublin ghetto[7], which was near Majdanek extermination camp[8]. During the liquidation of the ghetto, I lost my parents, my sisters and my whole family. I was the only one to survive.

Afterward I hid for some time in the cellar of a house belonging to Mrs Cekalska on Srodkowa Street, whose family was poor but who still used to feed me and my friend Julian Fogelgarn. From time to time, one of her sons used to throw apples from the tree into the cellar. Mrs Cekalska was recognized after the war as one of the 'Righteous Among the Nations'[5]. Following liberation by the Russians, I joined the Polish army.

After the war I met Alicia in Lublin and we were married. We emigrated to Paris, France, in 1947 and then came to England in 1950. I started a manufacturing business and became a supplier to Marks & Spencer, with whom I worked for the next 30 years. Alicia and I have one son, Charles, and four lovely grandchildren."

*Pages 16–17*
Aliza Shapiro
London, UK

"I was born Ilse Blum in Munich, Germany, on 16 November 1925 into a comfortable family in which I was the youngest of three and where I did all the things that nice little girls were supposed to do. It was not until 1934–5, when large torchlight parades, always manned by black-clad SS brigades, would frequently march past our windows at night, that I became aware of the fear and anxiety emanating from my parents, Moses and Frieda Regina Blum, as we all silently watched. However, my first life-changing experience was not until 9 November 1938. Following my expulsion from school for being Jewish, I found that my father had been arrested and taken to Dachau[9], the first of the German concentration camps[10]. Kristallnacht[11] had started. With a great deal of luck and the help of some truly good people, my father was released after six weeks, and my parents, my sister Bobby and I left Germany on 1 January 1939.

My parents went straight to England and my sister and I to my mother's family in France, so that my parents might have some time to find somewhere to live and learn a little English. After eight months in France (and in a French school), Bobby and I finally arrived in England, four days before the start of the war. At first, England just meant more school and yet another language to learn. But it was not very long until the Blitz began, and we sampled the various kinds of shelter, the best of which was undoubtedly the platform of Swiss Cottage Underground station in north London. It was an interesting time and I came to appreciate the tolerance, patience, sense of humour and camaraderie of the Brits.

Very soon after the end of the war, when we had learned of the destruction of European Jewry, including all our wider family, I became involved in Zionism and the quest for a

homeland of our own, where we would no longer have to passively endure persecution. I first joined the Zionist youth movement Habonim[12] and then got a job at the Jewish Agency for Palestine. Finally, on 8 August 1948, three months after the establishment of the State of Israel, I moved to our new homeland. I arrived during Israel's War of Independence (1947–9) and was, within a few days, allocated to work for Moshe (Moish) Pearlman, the head of the Public Information Office (PIO), drafting press releases. Once a precarious peace was established, work at the PIO eased up, and I joined a kibbutz (a communal settlement in Israel). Next, I decided that I had to join the army like everyone else, although I was by then 22 or 23, about four years older than the average recruit. After that came Officers' Training, which was a very different cup of tea – I really thought I would not survive. But I did, and in 1951, on Independence Day, I met Alec Shapiro, whom I married on 1 January 1952. In those days married women had an immediate discharge, and I got a new identity as Mrs Aliza Shapiro. Our son, Jonathan, was born in 1953 and our daughter, Naomi, in 1957.

In 1959, Alec, who was a production engineer, was recruited by a large British corporation to build a pencil factory in Kenya, so off we went to Kenya on a three-year contract. I was asked to be the editor of the journal *East African Trade and Industry*, through which I got to know the rising political stars. But in 1963 Kenya got its longed-for independence, the British moved out, the investment company went with them and we lost every penny we had. So we went back to England.

Alec found a new factory to build, the children settled into schools, and I met Anna Freud and became interested in psychology. I started training: first as a marriage guidance counsellor, then as a tutor for the relationship-counselling service Relate, and then as a family therapist. As well as working at two hospitals, I was employed by Shalvata, which is part of Jewish Care, a health and social care organization, where I worked exclusively with Holocaust survivors. Also, for 25 years or so, I had my own private practice. At the same time, I had a solid marriage, and I miss Alec, who died in 2011.

Now, at last, I am back in Israel – a very old lady, living in a retirement home. I am profoundly grateful for the life I have had and have never forgotten that if I had not been lucky enough to arrive in England on 30 August 1939, I would not have survived to be blessed as I feel I was."

**Pages 18–19**
**Barbara Stimler**
London, UK

Barbara Stimler (née Krakowska) was born on 5 February 1927, the only child of Jacob and Sarah Krakowski, and lived happily in the town of Aleksandrów in northern Poland. Barbara attended a convent school where she was the only Jewish child.

After the start of the war, life became chaotic. In January of 1940 her mother had to defend her with a knife from two drunken German soldiers who had broken into their house, intending to rape her. After hiding with Christian families, her family was herded into crowded ghettoes[13]. Barbara spent time in both Kutno ghetto and, later, Łódź ghetto, where she worked in the orphanage. One day, Barbara's father was taken for forced labour and she never saw him again.

In 1944 Barbara was deported to Auschwitz[14], forced to leave her mother in the ghetto. She never saw her mother again. As the Russians advanced, she was put on a death march[37] toward Germany. The confusion caused by Allied air raids meant that she was one of very few to escape. Her journey remained fraught with danger.

In summer 1946 she travelled to Britain, where she met her husband, Leonard (an ex-serviceman of the Polish army). They were married in Alie Street Synagogue in the East End of London and rented a flat in Cable Street, also in the East End. In 1949 their first son, Harvey, was born, and in 1952 they set up a business together running a tailoring company. Their second son, Stuart, was born in 1955 at around the time they bought their first house together in Neasden, north-west London. Their two grandchildren, Marcus and Tamara, were born in 1980 and 1983. Barbara passed away on 26 December 2015.
**MARCUS STIMLER (GRANDSON)**

**Pages 20–21**
**Fred Knoller**
London, UK

Fred (Freddie) was born on 17 April 1921 in Vienna, Austria, to David and Marie Knoller. When Hitler annexed Austria in 1938, Freddie ran away to Belgium and, later on, to France. When the Germans invaded France in 1940, Freddie adopted a false identity in Paris, taking German soldiers to nightclubs at Place Pigalle and receiving a commission from the nightclubs' owners. When he was captured in 1942, he had to reveal his true identity as a Jew, knowing he would be tortured otherwise.

In 1943 Fred joined the Resistance movement in the department of Lot in France, where he was involved in operations against German troop trains and learned to handle explosives and guns. In the summer of 1943 he was captured and sent to Drancy, France, and in October that year was deported to Monowitz-Buna concentration camp[14] in Poland, where he was held for almost two years. In January 1945 the camp was evacuated and Fred was taken to Nordhausen concentration camp[16] in Germany. From there, he was

again deported, this time to Germany's Bergen-Belsen concentration camp[1], where he was liberated by British troops in 1945, by which time he was in a very bad condition.

Fred's parents were deported to Theresienstadt transit camp[15] in Czechoslovakia in 1942. They were later sent to Auschwitz-Birkenau[14], where they were gassed and cremated in 1944.

After the war, Fred emigrated to America in 1947, married an English girl, Freda, in 1950 and went with her to England in 1952, where he has been living since.

In 2015 Fred was awarded a British Empire Medal by Her Majesty the Queen, Elizabeth II, for his services to Holocaust Education and Awareness.

*Pages 22–23*
Charles Hannam
Devon, UK

Karl Louis Hirschland was born into a German Jewish banking family in Essen, Germany, in 1925. He escaped to England on one of the last Kindertransports[17]. His mother died before Karl left; his father died in Theresienstadt transit camp[15] in Czechoslovakia.

At the outbreak of war Karl was interned in a youth penal facility in Oxfordshire, from where he was to be deported to Australia as a farm hand. Karl's sister, Margot, then in domestic service in Midhurst, Sussex, realized they were about to be separated and persuaded the headteacher of the local grammar school to take him in.

Some years later, with a near-perfect English accent, Karl secured a place to read history at Corpus Christi College, Cambridge. When he deferred this to join the British army, he was ordered to change his name. Now Charles Hannam, he was sent to Burma (Myanmar) and then India, returning to Cambridge in 1947. After graduating, Charles trained and worked as a history teacher before becoming a lecturer in education at Bristol University. He made great efforts to reinvent himself as an Englishman.

Charles's books, including three volumes of autobiography, were translated into 11 languages. He was a passionate socialist and his influential books about education and teacher training challenged many practices of his day. Charles had four children and eight grandchildren. His eldest son has Down's Syndrome. His book describing his and other parents' experiences did much to improve services. Charles was a highly cultured European intellectual with an extensive knowledge and love of art, history and philosophy, tempered by a wonderful sense of humour. In his 80s, Charles moved with his wife, Sue, to a smallholding in Devon. He died in May 2015, shortly before his 90th birthday.

WITH SUE HANNAM (WIFE)

*Pages 24–25*
Dr. T Scarlett Epstein
Sussex, UK

Trude Epstein was born Trude Grünwald in 1922 in Vienna, Austria. She became a Jewish refugee, escaping Hitler's annexation of Austria, via Yugoslavia, Albania[18], Italy and Germany, and eventually settling in England in April 1939; her autobiography, *Swimming Upstream*, recounted these experiences. She went on to study economics and political science before completing a Ph.D in economics, involving field work in India, under the supervision of Max Gluckman, the anthropologist. During this period she met and married Bill Epstein. Over the course of the rest of her life she continued with field studies in India and Papua New Guinea (PNG), publishing 14 books and more than 50 articles on her action research. She believed that the techniques developed by professional market research, combined with the skills and tools of marketing, could promote better health, real development and the alleviation of poverty, for which she campaigned. Epstein was awarded an OBE in 2004 for "services rendered to rural and women's development especially in PNG". She died in April 2014 at the age of 91.

*Pages 26–27*
Eva Schloss
London, UK

"I was born in Vienna, Austria, on 11 May 1929 to my parents Erich and Elfriede Geiringer. As our family was Jewish, we emigrated to Belgium and eventually to Holland in 1938, shortly after Hitler annexed Austria. The Germans invaded Holland in 1940 and our family went into hiding in 1942. In May 1944 we were betrayed, captured by the Nazis and sent to Auschwitz-Birkenau[14] extermination camp in Poland. The whole point of the process was to dehumanize us. When we were liberated by the Russians in January 1945 and they shared their bread and water with us, I cried – that was a kind, human action. Only my mother and I survived. My father and brother Heinz did not.

After liberation my mother and I were evacuated eastward into Russia, as fighting was still going on to the west. In May 1945 we were repatriated to Amsterdam. I resumed my education and eventually passed my matriculation examination. I then studied history of art at the University of Amsterdam for a year. In 1951 I moved to London to train as a professional photographer and worked there in a commercial studio for five years. I married Zvi Schloss in 1952, and in 1953 my mother married Otto Frank, the widowed father of the diarist Anne Frank. From 1972 until 1997 I ran an antiques shop in Edgware, north London.

Zvi and I live in London and have three daughters and five grandchildren. Since 1985 I have become increasingly active in Holocaust education and I am co-founder of the Anne Frank Trust, UK. In 2001 I was thrilled to receive an Honorary Doctorate in Civil Law from Northumbria University, England. In 2012 I was awarded an MBE for my work."

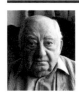

Oscar (Osias) Findling was born in Leipzig, Germany, on 10 August 1922. His father Berel and mother Sophie were deported to concentration camps[10] in Poland on 28 October 1938 together with Oscar's grandparents. With the help of the Youth Aliyah[19] office in Berlin, Oscar got a place in July 1939 on a Kindertransport[17] to Great Britain, where he stayed first at a Youth Aliyah refuge in Kent and later at Gwrych Castle in Wales and various hostels in Manchester. In 1942–4 Oscar worked in London on war work. In 1944 he joined the British army, was made interpreter and went to the Continent in November 1944. First he was in Belgium and from June 1945 until his demobilization in December 1947 he was in Germany, in various postings and places, including interpreting at the Belsen trial in 1945. Oscar married his wife Paulette in February 1950 and was in business manufacturing textiles until November 1995, when he retired. After retirement he joined his nephew in his diamond business, based in Hatton Garden.

Eve Kugler was born in Germany on 12 January 1931, the second of three daughters of Salomon David Kanner, the owner of a prosperous retail business. To escape the anti-Semitism of the Nazis, her father applied for a visa to the precursor of the State of Israel but was still waiting on Kristallnacht[11] in November 1938 when he was arrested and imprisoned in Germany's Buchenwald concentration camp[20]. The Nazis destroyed their synagogue, vandalized his store, smashing its windows and forcing her mother to sweep up the broken glass. Eve's mother, Amalia (Mia) Kanner, secured her husband's release from Buchenwald by procuring and presenting a forged visa to the Nazis and, with great courage, managed the family's escape to France just before the outbreak of the war in September 1939.

Eve and her sisters, Ruth and Lea (*see* page 259), survived in homes for Jewish children established by the Jewish children's welfare organization OSE (Oeuvre de Secours aux Enfants)[21] until passage to America was found for her and her older sister, Ruth. During the remainder of the war they lived in a number of foster homes in New York City, but not always together.

During the 1942 roundup of Jews in France, Eve's younger sister Lea was hidden in a convent and then on a farm. Eve's parents were arrested and taken to Nexon transit camp[22] in France, where horrendous conditions mirrored those in Auschwitz[14], except that there was no forced labour. After three months, at the time when 5,000 Jews were deported to Auschwitz, Eve's parents were two of just 23 Jews who were transferred to Gurs concentration camp, also in France. After this, her mother was sent to a free camp where she had to report and sleep every night. From there she contacted the French Resistance, who hid her. Eve's father was sent to work in a chemical factory in Bordeaux whose products supported the Nazi war effort. In October 1943 he was taken to Calais where he was forced to work seven days a week strengthening the sea wall against the anticipated Allied invasion. Finally, after weeks of backbreaking forced labour, he miraculously escaped and made his way to Limoges where he was given a false identity and work by the Resistance. Eve's parents were reunited with her sister Lea when central France was liberated in the summer of 1944. They joined Eve and Ruth in New York in 1946.

Eve started part-time work at age 14 and changed to full-time employment on graduating high school. She attended Brooklyn College after work in the evenings and, after five and a half years, she earned a BA degree with honours. She then earned a masters degree in international relations from the University of Pennsylvania. She worked first as a civil servant and subsequently as an award-winning journalist and press officer. She has two children, Vicki and Mark Rosenzweig, from her first marriage. In 1990 she moved to London where she married Simon Kugler.

Because of the trauma of living under the Nazis in Germany and wartime France, the separation from her family and the fear that her parents had perished, Eve could not remember events in Germany and France until her mother told her what had taken place. "My mother adamantly believed everyone had to know what happened," Eve said. The story of the family's survival is recounted in Eve's book, *Shattered Crystals*, available at http://www.shatteredcrystals.net. Now widowed, Eve lives in London where she is active in Holocaust education, speaking regularly in schools and synagogues, civic organizations and religious groups about her history.

"I was born in Fürth, in Bavaria, Germany, on 27 January 1931 and came to England in 1939 on the Kindertransport[17], followed a little later by my sister. My father Jacob and my mother Babette (Bella) perished in the Riga ghetto in 1942. On arrival at Southampton I was taken to a hostel in Margate, Kent, where I learned English and went on to primary school. Apart from a short period of evacuation, I lived in another hostel until I left school. I entered Jews' College in London, trained for the rabbinate and took up my first minister's appointment at Hounslow Synagogue, west London. I continued to two further

synagogue appointments, finally leaving the ministry to start a second career (one I had always wanted) as a teacher at JFS comprehensive school in north London, finishing my teaching years at the City of London School for Girls.

Retirement enabled me to spend much more time with my wife Ruth, who had been ill for some years; she died in 1996. In retirement I was much occupied in many areas – in education, general religious education in my borough (Barnet, in north London), local multi- and interfaith work as well as other committee work in the borough.

My main activities now are concerned with speaking about Kindertransport to schools in the UK and abroad, hospital chaplaincy, a voluntary chaplaincy to the local police and being a trustee of the Jews' Temporary Shelter charity. I enjoy life to the full, with family and social life playing a vital part. I have a son and daughter, and also grandchildren, two of whom are married and each have a daughter. The family and a very close friend Michelle give me great joy and a zest for life."

*Pages 34–35*
Henri Obstfeld
London, UK

Henri Obstfeld was born in Amsterdam, Holland, on 11 April 1940, one month before the German invasion. In 1942, at the age of two, he received instruction to present himself for work in Germany under police supervision. However, his parents, Abraham Obstfeld and Jacoba Obstfeld (née Vet), arranged for him to be looked after by a righteous Gentile[23] couple, Jakob and Hendrika Klerk, in Arnhem, Holland, under a false name (Hendrik Klerk) and posing as their nephew. His parents went into hiding in Haarlem, Holland, and survived the war. Henri was reunited with his parents soon after the end of the war.

In 1961 Henri came to Britain to study. Subsequently, he held a number of positions in optical and optometric education, finally as Director of the Optical Appliance Testing Service of City University, London, from which he retired at the end of 2014. Henri was for many years a member of the Executive Board of the World Federation of Jewish Child Survivors of the Holocaust and Descendants, and of the European Association of Jewish Survivors of the Holocaust, representing the Child Survivors' Association of Great Britain–AJR. He is married to Dorothy Schwab, the South African-born daughter of German Jewish refugees. They have two sons, Joel and Mark, and two grandchildren, Jonathan and Dania.

*Pages 36–37*
Marcel Ladenheim
Surrey, UK

Marcel was born on 7 June 1939 in Paris, France, to Julius Ladenheim and Jetti Blecher, who had moved there from Vienna, Austria, where his father had worked as a furrier. When the Nazis invaded France in 1940, his father was taken away, never to be seen again. Marcel, who was one at the time, later learned that his father had been killed in Auschwitz[14] in 1942.

Marcel's mother was heavily pregnant with Marcel's brother, and after she gave birth, the two babies were hidden, and taken care of, by two non-Jewish women friends, one of whom was a dancer with the Folies Bergère. It was not until the war ended that Marcel was reunited with his mother. She subsequently moved to Israel, and Marcel and his brother went in the opposite direction, ending up in the care of an aunt and uncle in Manchester, UK, in 1948.

Marcel became a British citizen in 1963, married Bobbie a few years later and prospered materially as well as matrimonially. "I am extremely grateful to the British government for taking me in, giving me an education and enabling me to make a decent living," he says.

*Pages 38–39*
Mirjam Finkelstein
London, UK

Mirjam was born in Berlin, Germany, on 10 June 1933, the daughter of the great archivist of the Holocaust, Alfred Wiener[24], and his wife Margarethe. A year later, to protect the work of the archive, which Wiener had begun in 1928, the family emigrated to Holland, where Mirjam was brought up with her two sisters, part of the same community as Anne Frank and her family.

Within a decade even Amsterdam wasn't safe enough, so Alfred Wiener took the archive to London in 1939. He obtained visas for his family, but it was too late – they were trapped by the invasion of Holland in May 1940. So it was that in June 1943 they were arrested and taken to the Westerbork transit camp[22] in Holland. Narrowly avoiding transportation to Auschwitz[14], where Mirjam's aunt, uncle and cousin lost their lives, they were taken in December 1943 to Bergen-Belsen concentration camp[1].

For a year they survived the cold and the hunger of this disease-ridden starvation camp. Then, in January 1945, came rescue: Mirjam and her family were included in a rare prison swap. Her mother stood upright just long enough to be allowed on the exchange, and survived just long enough to see her girls to freedom. On the night of their arrival in Switzerland, she died.

Mirjam eventually settled in London, marrying Ludwik Finkelstein, a survivor of Stalin's Siberian prison camps. They had two sons and a daughter, Anthony, Daniel and Tamara. Speaking to schoolchildren about her experiences, Mirjam finishes her talk with the words "and we lived happily ever after".

DANIEL FINKELSTEIN (SON)

*Pages 40–41*
Maurice Blik
London, UK

Maurice Blik was born to Barend and Marie Blik in Amsterdam, Holland, on 21 April 1939. By the age of four, he was face to face with the questions and choices about existence that philosophers, artists and religions have left unanswered. Having been deported as a small child to the Bergen-Belsen concentration camp[1] in Germany, he was liberated in 1945, along with his mother and sister Clara, and taken to England. His two uncles, aunt and cousin were murdered in Sobibór extermination camp[23] in Poland, his sister and grandmother in Bergen-Belsen and his father in Auschwitz[14].

Maurice has lived in England ever since his arrival there. For four decades Blik stayed silent about his experiences in Bergen-Belsen, but his trauma finally found a voice in the passionate and exquisite sculpture that began to emerge in the late 1980s, when he created a series of horses' heads. These noble creatures possess an energy and a life force that seem to have been harnessed just long enough to take their shape in the clay itself. Later he progressed to more figurative work in which the irrepressible joy of life and the destructive, impenetrable shadow of existence are held together in a struggling unity.

Maurice Blik has had an extensive career in art education, teaching at all levels from primary school to postgraduate. He has a postgraduate Art Teacher's Certificate with Distinction from London University. Having begun in the 1980s to develop his own artwork, he gave up teaching in 1991 to work full time on sculpture. In 1996 he was elected President of the Royal British Society of Sculptors and is a Fellow of the Royal Society of Arts. Maurice Blik works in the UK and the US, where he was awarded residency by the American government as "a person of extraordinary artistic ability".

Maurice has a wife, Debra, a son, Belisarius, and a daughter, Cornelia.

*Pages 42–43*
Rita Knopf
London, UK

Born on 21 September 1931 in Vienna, Austria, Rita went to a school in the Second District of the city. When her father Robert left for England in 1939 to escape the Nazis, she and her mother Irene had to stay in Vienna, as Rita's grandmother was ill with Alzheimer's and unable to travel. In 1942 she was deported to Theresienstadt transit camp[15] in Czechoslovakia, where she remained with her mother until 1945. Freezing and hungry, she was lucky not to succumb to typhoid, as diseases were rife. An inmate risked their life by trying to give the children lessons.

The camp was liberated in 1945 by the Russians, whereupon Rita and her mother were transported to a displaced persons (DP) camp[24] in Deggendorf, Bavaria, which was organized by UNRRA (United Nations Relief and Rehabilitation Administration)[27]. Eventually she joined her father and other members of her family in England after a six-month stay in Paris, France. In spite of not speaking English, she finished her education and decided at the age of 17 that she wanted to be a fashion designer. She met her husband Kurt in the Jewish Ex-Servicemen's Club, and, after they married, they lived in the US for a year before returning to the UK in 1959. Their two sons were born in 1968 and 1971. She now has five grandchildren. Her husband died in January 2015.

*Pages 44–45*
Ruth Barnett
London, UK

Ruth was born to parents Louise Maria Michaelis (née Ventzke) and Robert Berndt Michaelis on 23 January 1935 in Berlin, Germany. She came to England at the age of four, with her seven-year-old brother, on the Kindertransport[17] in 1939. She worked for 19 years as a secondary school teacher and for 30 years as a psychotherapist, and for over 15 years she has been giving talks, seminars and workshops at schools, colleges and conferences, on "The Holocaust, Racism and Genocide" and "Understanding Trauma and Transmission of Trauma".

Ruth is married to Bernard Raymond Barnett, with three children and two grandchildren. Her first book, *People Making People*, was a school textbook for child development. Her second book, *Person of No Nationality*, was published by David Paul Press in 2010. Her third book, *Jews & Gypsies, Myths & Reality*, which was published on Amazon in 2013, challenges racist stereotypes.

A second edition of *Person of No Nationality* will include the fact that Ursula Krechel won the 2012 German Book Prize at the Frankfurt Book Fair with her novel *Landgericht* (meaning "State Justice"), which is based on Ruth's father (a Jewish judge who had the courage to return to Germany in 1947), whom Krechel calls Richard Kornitzer. She used a chapter from *Person of No Nationality* to write in *Landgericht* about the Kindertransport. In May 2015 an event to honour Judge Robert Michaelis was held in Berlin in the court from which, in 1933, he was chased out by the Gestapo[3] at the point of a gun. The German broadcaster ZDF has now made a film of *Landgericht*, including a documentary that tells the real story of Ruth's family.

Ruth's fourth book, published by the National Holocaust Centre in 2015, is *Love, Hate and Indifference: the Slide into Genocide*. She is currently writing a fifth, *Quality & Inequality: the Value of Human Life*.

*Pages 46–47*
Vera Schaufeld
London, UK

Vera was born in Prague, Czechoslovakia, on 29 January 1930. She grew up in Klatovy in south-west Bohemia. Her father, Eugen Löwy, was a lawyer and a prominent figure within the Jewish community. Vera's mother, Else Löwyová, was the first woman in her town to become a doctor. Klatovy was a small but progressive place, and Vera had a happy childhood. She never experienced or witnessed any forms of anti-Semitism and was hardly aware of being a minority until the Germans invaded Czechoslovakia in March 1939. "Within a few days, my father was arrested because his name appeared on a list of prominent Jews. Suddenly the atmosphere of fear grew," she recalls.

Shortly after the German invasion, Vera experienced anti-Semitism first-hand from a teacher. She remembers realizing that to the teacher she had become "the Jew", losing her personal identity. Her father was arrested and her mother was no longer able to practise as a doctor, yet Vera admits that as a child she had little understanding of what was happening in Germany: "I suppose my parents wanted to shield me, but this was no longer possible."

One day, after school, Vera's mother surprised her by taking her to a small park. She was told that she must go to England on her own. Trying to reassure her, Vera's mother said that she and Vera's father would try to join her in England as soon as they possibly could. When Vera arrived at Prague railway station, she was devastated to be told that the parents of all the children were not allowed onto the platform to say goodbye. "My last sight of my parents was as they stood behind the barrier, waving their handkerchiefs, while I looked at them out of the train window," she said.

This would be the last time Vera would see either of her parents. Vera's memory of arriving in England was sitting at London's Liverpool Street station, surrounded by other children who had also been saved by Sir Nicholas Winton[28], fearing that she would not be collected by anyone.

A Christian couple, Leonard and Nancy Faires, agreed to take Vera into their home. Their daughter, Betty, was three years older than Vera, and Vera remembers her as being very kind – kind enough to share her pocket money! Before the war broke out, Vera's parents had sent her presents, and they were even able to speak to her on the telephone, but after the declaration of war, on 3 September 1939, Vera had no further news of her parents.

On 7 May 1945 Vera's English lesson was interrupted by an announcement that the war in Europe was over; Germany had unconditionally surrendered. Vera was ecstatic. She remembers thinking: "This is wonderful. I shall see my family and friends soon." It was after a trip to the cinema, where Vera saw images from the concentration camps[10], that she learned that no one in her family had survived.

During the time Vera had spent in England, she had had very little contact with other Jewish people. For this reason, she decided to travel to Israel to spend a year working on a kibbutz. Here she met Avram Schaufeld, who had survived Buchenwald concentration camp[20] and Auschwitz[14]. Vera and Avram were married in 1952.

Before moving to Israel, Vera had trained to be an English teacher and when she returned to England, with Avram, she continued to work as a teacher.

In 1972 Vera took the decision to use her experience of learning English as a child in order to teach English to a group of Ugandan and Kenyan children, who had recently arrived in Brent, north-west London. Most of the children were of Asian descent and had been expelled from Uganda by Idi Amin, the then President of Uganda. Amin had given all members of the Asian community living in Uganda in 1972 just 90 days to leave the country, and many members of the community sought refuge in the United Kingdom. Evidently, experience of being a refugee during the war had shaped Vera's life choices.

It was 50 years after her journey to England that Vera learned about Sir Nicholas Winton and the role he had had in saving her life. In 1988 Vera was invited to participate in Esther Rantzen's television programme *That's Life!*, where she met other children, now adults, who had been saved by Winton. Following this, Vera developed a lifelong friendship with Sir Nicholas and his wife, Grete.

Both Vera and Avram work closely with the Holocaust Memorial Day Trust to share their stories and to ensure that future generations will preserve the memory of the Holocaust.

*Pages 48–49*
Benjamin Kinst
Melbourne, Australia

Benjamin Künstlich was born into an Orthodox Jewish family in Baranów, Poland, on 6 August 1913, to Mojżesz and Rachel (née Scheer). His brothers were Efraim and Eliezer; he was the youngest. The Künstlich family moved to Kraków in 1914 at the beginning of World War I. Mojżesz was in the army. In 1925 they opened a kosher guesthouse in Rabka-Zdrój, Poland. The boys continued their schooling in Kraków and spent their holidays in Rabka. In 1936, Benjamin, a qualified accountant, joined the family business. By now the family owned and operated two guesthouses. A year later he met his future wife, Hanna Siebzehner, also from Kraków.

When Germany invaded Poland in September 1939, Rachel packed three rucksacks and told her sons to head east to Lwów, the Polish city invaded by Russia in 1939, where they could find work and be safe from the aggressor. Hanna and her siblings followed in the coming weeks. Benjamin and Hanna married on 8 January 1940. They continued to live and work in Lwów but refused to take up Russian citizenship. Consequently, on 30 June 1940 they were taken in the middle of the night and transported to work camps[29] in eastern Siberia, travelling 30 days by cattle train. The men cut trees, the women the lower branches, in exchange for meagre rations and a bed. When Germany invaded Russia in June 1941, Russia signed a treaty with Britain, resulting in the release, over the next few months, of all Polish nationals from Russia's work camps.

Benjamin and Hanna then travelled to Kazakhstan, to warmer weather, working for the Polish delegation in Russia and later for local government companies. They stayed until a repatriation treaty between Poland and Russia allowed them to return home.

On 20 May 1946 they crossed the Polish border. It was then that Benjamin found out that Mojżesz and Rachel, who had stayed in Rabka, had been executed by gunfire and buried in a mass grave, near the police school, sometime in August/September 1942. Efraim, who had stayed in Lwów, was taken to the Janowska work camp[2] in Poland, and then murdered, most likely by the Nazi paramilitary death squad Einsatzgruppe C[30], in the nearby Lisinski forest. Eliezer, who had gone to live in Tarnopol in Poland (now Ukraine), was transported to Auschwitz[14] and later to Mauthausen concentration camp[31] in Austria, where his death is recorded on 25 January 1945. Hanna's brother never returned from Siberia. Three sisters were killed, either by bullet or by gas. (Hanna's parents had died before the war.)

Two sisters survived. Benjamin and Hanna joined them in Warsaw and they rebuilt their lives: Benjamin as an accountant, Hanna as a bookkeeper, within the new Communist regime. In 1958, renewed anti-Semitism saw Benjamin, Hanna and their eight-year-old daughter, Krysia (Krystyna), sail to Australia to be with Hanna's niece, an Auschwitz survivor. They began a new life once again, this time in Melbourne.

The early years were hard, but as they learned the language and gained recognition for their professional qualifications, they were able to establish a comfortable, peaceful and safe life. Hanna died in Melbourne in 1996, at the age of 82; Benjamin in Melbourne in 2009, aged 96. Benjamin and Hanna had two granddaughters, and Benjamin lived to know his first two great-granddaughters. Two more great-granddaughters were born some years after his death.

KRYSTYNA KINST (DAUGHTER)

*Pages 50–51*
Bronia Rosenbaum
Melbourne, Australia

"I was born Bronia Zborzencka on 15 April 1926 in Łódź, Poland, to an Orthodox Jewish family. My father, Pinchas Mayer Zborzenski, and mother, Bajla Rajza (née Majerfeld), gave us a happy home. I had six siblings – my sisters, Rusza, Pola, Genia, Helen and Lola, and my brother, Herszel Tanachen (Hersh Tadeusch). My sisters and I went to a certain Polish government public school where all the children attending were Jewish. My young brother attended *cheder*, a Jewish school that focused on learning Hebrew and religious knowledge.

Our father ran a well-known tailoring business and workshop in the centre of Łódź. Our mother was a good homemaker and kept us all busy learning how to sew and knit, writing and attending to our school studies. We did well in school. At home, we spoke Yiddish and Polish. We attended Hashomer Hatzair and HaNoar HaTzioni, both Jewish youth organizations that frequently ran fun events for children.

In late 1939 my father began to find it impossible to continue his business in Łódź because of widespread anti-Semitism. The German soldiers, who were already occupying Poland, announced to the Jewish people in Łódź that all Jews were to go to a railway station next to the Bałuty quarter, where they were to wait in a big school. At the time, we didn't know that the Germans planned to liquidate all Jews.

While waiting there, my father was approached by a friendly Polish man who was a previous business customer. He quietly told my father to take his family and leave as quickly as possible through the back door of the school, not to talk to anyone, and to take a train anywhere in order to escape the place. So my father took the family by train to Szydłowiec (Poland). The journey lasted three days, as the railway lines were very busy.

On arrival, we had nowhere to live, but my mother found a Jewish friend who was willing to put up all nine of us in their home. The Germans were already occupying the town, but there weren't many German soldiers around at that stage. A little later, we moved again to another flat, which had only one and a half beds. In the meantime, my father did a little tailoring, while my mother travelled into the countryside and bartered small items such as hairbrushes, combs, matches, candlesticks and saccharin, which was rare by then, in return for some food.

On some days, my mother would walk up to 12 kilometres (over 7 miles) per day to barter. When some of the villagers found out she was bartering items for food, they told her they remembered her great-grandfather, Herszel Frischman, who had lived in Szydłowiec a long time before, and the villagers remembered that they had liked him. As a result, they offered my mother and family a permanent place to stay overnight in a barn's loft in Ostałów whenever it was too late to return to Szydłowiec. Ostałów was a small village about 10 kilometres (6 miles) from Szydłowiec.

Sometimes, while my mother was away bartering, I found work with my sister Genia in fields around Szydłowiec, weeding farmers' crops in return for some soup or anything to eat. We found work by listening to the street chatter in Szydłowiec.

A year passed, and then one day a terrible thing happened. While I was playing with other children in the street, an open truck with German soldiers drove in very quickly. The children playing around the street were frightened and ran away, but one little boy, who was five or six, was struck in the head by the Germans' truck and was instantly killed. The Germans noticed the accident but ignored the child lying dead in the street. The boy's grandfather ran out screaming and crying bitterly, and then picked up his grandson's body from the street, so he could be buried later.

In 1941, German trucks started coming into Szydłowiec to collect Jews to work in the HASAG munitions factory[32] at Skarżysko Kamienna. One day when I was playing in the street, a truckload of Germans came and grabbed me, along with a few adults, and took us to HASAG to work. Not long after, at work there, I saw my sister Pola arrive.

When I worked at HASAG, they didn't feed us much, except for a bit of soup or bread during the day (half of which was stolen before we received it). The German engineers weren't nice to the Jews. I was told that nearly all of them lived in flats with their families in the town. I remember a certain German engineer, Bosch, a quiet man, who tricked me into believing that if I finished my task more quickly, I would get some bread. But once, when I finished my task and went to get some bread, Bosch saw me and hit me. The truth was that the work never ended – it was just about making us work faster.

Being on the night shift at HASAG, I tried to sleep during the day. But then I experienced one of the most horrible days of my life. A few hours before our evening shift and roll call, some of us were outside in the cold, cleaning ourselves up. The HASAG's police manager-in-charge, accompanied by German soldiers, suddenly appeared – he was looking for people to take for private purposes. Everyone had to stand to attention, but I got away and hid under a bed, with my sisters standing in front to distract them. They asked, 'Where is that little girl [meaning me]?' but nobody seemed to know. The soldiers looked for me but finally left.

Upon their departure, another little girl, who was around 13 years old, unfortunately happened to be passing by, not knowing what had just happened inside. She was grabbed instead of me for their sinister purposes. The Germans took that little girl to their headquarters for one hour. We later saw her being escorted by six soldiers with machine guns (two in front, two alongside, two at the back) walking slowly in the direction of the forest beyond the wall of our camp. While we were all wondering what might happen beyond the wall, we heard gunshots. During all this time, the girl's family was working on a day shift, not knowing what was happening. When they arrived back from work, they heard the terrible story of their daughter's fate, and every one of us was in utter shock, screaming and crying beyond grief.

Not far from my barracks, there was a Ukrainian solder in a black uniform at the HASAG main gate. On every occasion, when I had to do cleaning just outside my barracks, he would shout at me, 'Do you want to run away, little girl? I'll open the gates for you – run, run!' and I could hear him proceed to click his gun. But I replied loudly each time, 'No, no, I won't run away!' It was a daily torment that I had to endure.

In 1944 all the workers, not just Jews, were relocated from Skarżysko Kamienna to a new HASAG munitions factory at Częstochowa. We remained there until the liberation of Poland by the Red Army in January 1945.

My parents, brother and three of my sisters had all died in the Holocaust – the Nazis had sent them to the gas chambers at the Treblinka extermination camp[33]. Rusza, Pola and I were the only ones to survive, but we had lost our home and possessions. After the war, the three of us came back to Łódź and stayed with a group of friends who had survived the war. Rusza and Pola met their partners in Poland and they emigrated to Israel, where they lived to an old age.

In Łódź, I was introduced, through family, to Natan Rosenbaum, who had been born in Łódź in 1907. Natan was 19 years older than me. He was an intellectual who had mixed in Jewish literary circles in Poland before the war, and he was a profound public speaker. Natan and I fell in love, and we married in 1947 in Bad Reichenhall, Germany, while on our way through Europe searching for lost family. Afterward, we made our way to Prague, Paris and Brussels. While in Brussels, we decided to go to Australia, and the American charity HIAS (Hebrew Immigrant Aid Society) assisted us to fly to Sydney.

When we arrived in Sydney in 1948, Natan's family helped us find a place to live in Randwick, near Bondi. After some time, we relocated to Waitara, a suburb of Sydney. Natan and I had our own knitting business in our garage. In later years, Natan worked as a laboratory assistant at Gore Hill Technical College in New South Wales. He was very happy there and made many friends. In 1955 we had a son, Phillip Mark, and for his Hebrew name we gave him my father's name, Pinchas Mayer. Phillip later married an Israeli, Michelle, and now I have five grandchildren – Talia, Ariel, Dean, Leeor and Shani. Natan and I remained happy together for 54 years until his death in 2001.

In the years after the war, Natan helped me rediscover my life and not to despair. I will never forget my past. It makes me question everything, especially why it all happened without earlier intervention. How could mankind go through such a terrible bloody war – or any war, for that matter? Yet I survived my ordeal to tell a small part of one person's tragic story here.

Since we shall all pass from this life one day, I believe it is so important to tell history's undistorted truth and learn lessons from it, so as not to repeat the mistakes of the past. We need to create a better life and planet for all, to live a life examined (as Socrates said), for the sake of future generations among all peoples and religions. We must respect each other and try to live in peace and harmony."

*Pages 52–53*
Cesia Altstock
Melbourne, Australia

Szyfra Cesia Altstock (née Auster) was born in Lwów, Poland, on 11 November 1924 as the youngest of six children, to parents Shmarieh and Zosia in a one-bedroom flat, a kosher home. Aged only 15 in 1939 when war broke out, Szyfra witnessed her mother being taken away by an SS officer, who said to her: "You can stay – you will get to live a little longer." Not much later, her father was taken away. Syzfra lived in the Lwów ghetto for almost two years, leaving only for various work duties. Her oldest brother, who was outside of the ghetto (as the Germans needed him to work as an electrician), arranged for Szyfra to assume a Polish identity and spend the remainder of the war in Austria. She returned to Poland after the war – only her three brothers had survived.

Szyfra married Maurycy Altstock in Gleiwitz in 1946, then they made their way to Germany where a number of displaced persons (DP) camps[24] were located. Following the birth of twin sons in Ulm, and then the death in hospital of one of them, the couple emigrated with their son, Ferdinand, to Australia in 1950. Their daughter, Susan, was born six years later. Szyfra worked for many years as a sewing machine operator. She rarely spoke about the war, although she would often mention her parents. When her husband would tell stories about it, she would always unsuccessfully try to silence him. He died in 2012. At the time of writing this biography, she is still alive, living in an aged care facility with severe dementia. She still has her daughter, four grandchildren and five great-grandchildren.
SUE BENEDYKT (DAUGHTER)

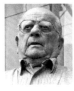

*Pages 54–55*
Manek Altstock
Melbourne, Australia

Maurycy (Manek) Altstock was born in Złoczów, Poland (now in Ukraine), on 15 October 1914, the fifth of eight children, to parents Zygmunt and Freda in a two-bedroom flat, a kosher home. Maurycy went to accounting school for two years but his postmaster father's illness (typhoid) meant that Maurycy had to go out and work.

In 1940 he joined the Polish army but as the war momentum developed, he was on the run from the Germans, spending time in hiding and in various work camps[29]. He found himself on a train with his father and two of his brothers destined for the death camps[34]. On his father's insistence he escaped the train after kissing his family goodbye, never to see them again. He relived many stories from the Holocaust all of his life but would always conclude with this story, each time breaking down and crying. Of his family of ten, only one of his brothers and one of his sisters survived.

In 1946 he married Szyfra Cesia Auster in Poland. In Ulm, Germany, she had twin sons, but one (Solomon) died in hospital; they took the other (Ferdinand) and emigrated to Australia in 1950. A daughter (Susan) was born in 1956. They lived a tough, hard-working but happy life, doing whatever work he could find. When he died in Melbourne in 2012, he was survived by his wife, his daughter and four grandchildren, and he knew that he was soon to be a great-grandfather.
SUE BENEDYKT (DAUGHTER)

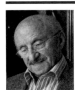

*Pages 56–57*
David Prince
Melbourne, Australia

David Prince was born in Łódź, Poland, in 1925. His parents were Frymet (née Klejnbaum) and Israel Prinz. David had a twin brother, Henry. Israel was a draughtsman and Frymet a homemaker. The family enjoyed a middle-class, traditional Jewish lifestyle until the boys were 14 years old, when war broke out.

The family moved into the area designated as the Łódź ghetto and remained there until just before the liquidation of the ghetto. David worked as a metal turner. They witnessed the deportation of many relatives, friends and other Jews during these years. In late August 1944 Frymet, Israel, David and Henry were deported to Auschwitz-Birkenau[14].

Upon arrival, Frymet was immediately separated from the others and sent straight to the gas chambers. David never got a chance to say goodbye to his mother. Israel, David and Henry were destined not to stay long in Auschwitz-Birkenau and were taken to a work camp called Friedland[31], in Lower Silesia. They were liberated on 9 May 1945.

After a brief return to Poland, David and his brother and father lived in Regensburg, Germany. David found out about the programme enabling Jewish students whose schooling was interrupted by the war to enter university. He moved to Munich and successfully prepared for the entrance exams and began studying pharmacy. At the Ludwig Maximilian University of Munich, David met another survivor, Ella Zalcberg, who was studying dentistry. They married, and in 1950, after David graduated, they emigrated to Melbourne, Australia. Because his professional qualifications were not recognized in Australia, David worked as a turner and fitter in a factory, and then went back to pharmacy college, qualifying as a professional man and buying his own pharmacy. Ella supported him in every way throughout this arduous process. The pharmacy was successful, and their son Issy became a pharmacist, too, working with David as a partner for over 30 years. Ella died in 2013.

FRANCES PRINCE (DAUGHTER)

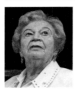

*Pages 58–59*
Ella Prince
Melbourne, Australia

Ella Prince (née Zalcberg) was born in Warsaw, Poland, on 14 February 1927. Her parents were Rosa (née Gringlas) and Isaac Zalcberg. Rosa was a dentist and Isaac was a civil engineer. Ella had a younger brother named Samuel. The four of them were incarcerated in the Warsaw ghetto. Samuel was murdered in the Nazi extermination camp Treblinka[33]; he was ten years old. Rosa, Isaac and Ella survived the Warsaw ghetto uprising of April 1943. They were then taken to the Majdanek extermination camp[8], also in Poland. Rosa and Ella never saw Isaac again. From Majdanek, Rosa and Ella were sent to Auschwitz-Birkenau[14], where they "lived" for 18 months. Next they were sent to the German concentration camp Ravensbrück[36], and finally on a death march[37]. Mother and daughter survived.

After the war they made their way to Munich. Rosa became the Chief Dentist for the JDC (American Jewish Joint Distribution Committee)[38]. Ella, through a programme enabling Jewish students whose schooling was interrupted by the war to enter university, at the age of 19 began studying, like her mother, to be a dentist. At the Jewish students' cafeteria at the Ludwig Maximilian University of Munich, Ella met another survivor, David Prinz (Prince), who was studying pharmacy. They married in December 1947 in Munich. After David graduated, they decided to leave Europe and emigrate to Melbourne, Australia, arriving in January 1950.

Life as new immigrants was difficult on many levels, including the lack of language and a very different cultural and social milieu. Ella and David had a son, Issy, who was born in 1951, and a daughter, Frances, who was born in 1958. David went back to pharmacy college, qualified and bought his own pharmacy.

Ella and David befriended many people and Australia became a much-loved home for them. Issy became a pharmacist, too, and Frances became a Jewish educator. She married Steven Kolt and they have two children. Issy married Wendy Nissen and they have two children and two grandchildren, the second of whom, Rosie Ella, was born nearly two years after her great-grandmother Ella passed away on 30 December 2013 in Melbourne.

FRANCES PRINCE (DAUGHTER)

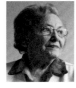

*Pages 60–61*
Deborah Ann Tuckman
Melbourne, Australia

Deborah Ann (Dorly) Tuckman (née Kreisel) was born in Radautz, Romania, on the 12 December 1924 – although she always disputed this, claiming it was 1925. She had one older brother and a younger sister. Her parents, Oscar and Rebecca (née Schaffer), both died very young – her father in Romania in 1926 and her mother in Ukraine in 1941, during the Holocaust.

When Dorly was a teenager, Jewish students were no longer allowed to attend school, so she took up dressmaking work. Dorly spent the war in concentration camps[10] throughout Ukraine. Like all survivors, she had a number of traumatic near-death experiences that shaped her into the person she became – most notably surviving a firing squad before managing to escape into the forest.

After the war she moved back to Radautz and married her husband Mark in 1947, before moving to Israel in 1951 where her two sons were born. However, the constant threat of war was an all-too familiar feeling. The story goes that they decided to toss a coin, with heads being Canada and tails Australia – they moved to Australia, via Venezuela, in 1963. Like many Jewish migrants to Australia, they worked in the *shmatter*, or rag trade. They bought a factory and settled in the Melbourne suburb of Brighton.

Dorly was always prepared to help people unconditionally, placing the needs of others – most notably her children – ahead of her own and undoubtedly did the same for her five grandchildren, who were her greatest source of pride. She died in 2012.

The collection of photos that Dorly kept from her childhood and early adult years was astounding. The images were all in stark contrast to the darkness of her past, as she truly found the joy in life through her family and the close friends she made along the journey.
GIDEON TUCKMAN (GRANDSON)

*Pages 62–63*
Dita Gould
Melbourne, Australia

"I am Edith Dita Gould and was born in Vienna, Austria, on 14 December 1933, where my mother, Eli Deutsch, was from. My father, Nandor Deutsch, was Hungarian. We lived in a small town called Dunaszerdahely that is referred to as little Jerusalem.

When false accusations were cast against my father, we decided, in 1941, to move to Hungary's capital, Budapest, where we would be safer. We lived well, as my father re-established himself in textiles. I went to Jewish school again.

When the Nazis occupied Hungary on 19 March 1944 the edict came – we had to wear the yellow star. I was branded! No more school. My father was conscripted to a work camp[29], and we had to move into yellow-star houses[39].

Then my father arranged for my sister, who was 6½ years old, and me to be hidden in a newly built hospital on the outskirts of Budapest. We could never step outside. Our windows were blocked out. Nevertheless, after about six weeks we were discovered and were marched into the ghetto[13] on 13 December 1944, where we had to throw our valuables into a large wooden crate. Through the greatest of miracles, we were helped by a friend of my father whom I recognized. He smuggled us out of the ghetto in potato sacks to the Hotel Gellért, where a room on the mezzanine level was the hiding place for the families of forced labour workers. We were there for a long time, surviving alone with no one to care for us.

Almost at the end of the war, I was reunited with my parents. They barely recognised me, I was so skinny. We went back to our hometown, where we were unable to find our relatives. Not one child survived from my Jewish school. We waited in vain for our affidavit number to come through from America. It had been arranged by my mother's siblings in 1941 but it never came, so we emigrated instead to Australia.

I was very unhappy for the first two years. From the age of 14, I worked on two shifts making wafer biscuits in the family factory. At 18, I married Michael Gould and had three beautiful boys. They grew up well. I worked in an art gallery, and then we started a gallery of our own with my middle son in 1981 but I'm retired now. I look after my investments, attend lectures, plays and movies, play bridge and tennis, walk four times a week, exercise, travel, visit Israel annually, and devote myself to charities. I am fortunate to have five grandchildren and a great-granddaughter. I love life and make the best of every day."

*Pages 64–65*
George Stein
Brisbane, Australia

George was born on 1 February 1927 to parents Nicholas (Michoel) and Helen (Hannah) Stein in Nagyvárad (Oradea) in what was then Romania and later Hungary. After the German invasion of Hungary in 1944, the Jews in Nagyvárad were rounded up and placed in a ghetto[13]. Shortly after this, George and the whole of his family were shipped to the Auschwitz-Birkenau[14] extermination camp in Poland. Arriving there, George managed to cheat death when, because of his mechanical skills, he was recruited to work as a slave labourer at a Volkswagen plant, assembling V1 rockets. When that plant was destroyed, he was moved to a special underground factory at Dora in Germany's Harz Mountains, near Nordhausen[16], where he was forced to work on the construction of V1 and V2 rockets.

As German defeat seemed inevitable, George and the other Jewish slave labourers were moved to the Bergen-Belsen concentration camp[1] in Germany, where he was liberated by British troops in April 1945. Of all his extended family, only George and one of his aunts managed to survive the Holocaust.

After the war George lived in a displaced persons (DP) camp[26], where in 1947 he met and married Trude – the great love of his life. In the same year, George and Trude were moved to another DP camp, in Italy. Here they both joined the defence organization Haganah and trained to become soldiers of the long-hoped-for Jewish state. In May 1948 they flew to Israel and put their training to good use in the War of Independence. George finished his active army service in 1951 as a sergeant in the Israeli signal corps.

George and Trude moved to Australia in 1953 with their sons Reuben and Michael. Three further children, Hannah, Frank and Benny, were born in Australia.

After a successful career as a motor mechanic and service station owner, George is now retired. He has also been very active in communal life, giving freely of his time and efforts to a wide variety of organizations in the Jewish and broader community, especially the South Brisbane Hebrew Congregation, where he was president for many years and managed the rebuilding of their synagogue after the original building was destroyed by fire. He has also been particularly active in the area of Holocaust commemoration and still regularly gives lectures and speaks about his experiences in the Shoah (the Hebrew term for the murder of European Jewry; the Holocaust). George has grandchildren in Australia and Israel. He is now one of only a handful of survivors in Queensland, Australia.

*Pages 66–67*
Erika Hacker
Melbourne, Australia

Erika Jakon was born in Vienna, Austria, on 7 April 1928, the youngest of three children. In 1939 Erika and her elder sister, Theresa, were sent to Belgium with the Red Cross children's transport. They stayed there for two years and then asked the German commandant of Brussels to be allowed to return to Vienna because they were worried about their mother.

In 1942, Erika, together with her sister and mother, were transported to Theresienstadt transit camp[22] in Czechoslovakia. Between 1942 and 1945, the three of them were moved from one concentration camp[10] to another, including Gross-Rosen camp[40] in Poland, Flossenbürg camp[37] in Germany, Auschwitz[14] in Poland, and finally Christianstadt, a sub-camp of Gross-Rosen.

The Christianstadt camp was liquidated in January 1945 as the Allied army approached. A thousand women were sent by foot to Flossenbürg in a death march[37]. Only 250 women survived, including Erika, her mother and her sister. During the death march, the three of them tried to escape five times and were successful on the last occasion, when they found shelter with a Czech peasant family. After being liberated by the US army in April 1945, they returned to Vienna and were reunited with their brother, who had also survived.

After the war Erika worked for the International Committee for Holocaust Survivors, where she met her husband, Egon Hacker. They married in Vienna in 1949 and then emigrated to Australia in 1951. Their daughter, Judy, was born in 1955. After they struggled financially in the early years, Egon went back to his studies, and his accountancy career took off, enabling them to enjoy a good quality of life, which included many trips back to Vienna. Meanwhile, Erika worked as an accountancy machine operator and, later, as a shop manager in women's retail. Egon passed away in Melbourne in 2005 but Erika is keeping busy going to the gym, catching up with friends and spending time with Judy.
JUDY HACKER (DAUGHTER)

*Pages 68–69*
Ester Braitberg
Melbourne, Australia

Ester Braitberg was born in Łódź, Poland, on 2 April 1928 to Mojsze Jozef and Pessa Matla Lewkowicz, "I was only 11 when the war broke out. They created big walls around our house and many families moved in. Łódź ghetto was where I watched my father die of pleurisy in 1943. Only six weeks later, my sister Hannah died of a broken heart – she could not go on without her father. Hannah was only nine years old. We lost everyone and we heard rumours of trains and gas chambers.

On 23 August 1944 we were pushed onto a cattle train. When we came out, we heard screaming – someone told us we were in Auschwitz[14]. Mengele[42] pushed me to the right and my mother to the left. I cried. Mum's last words were, 'Ester, run, don't let them beat you, you're so tiny, so skinny, don't let them beat you.' I ran. I never saw my mother again.

We were sent to many camps and then, when they knew they were being defeated, they sent us on death marches[37]. When the British came, we didn't feel like we had survived. We didn't feel liberated.

It wasn't until I met my husband, Mayer, in Belgium that I found happiness again. We had a beautiful group of friends, all of whom had survived different concentration camps[10] in Poland and Germany.

Mayer and I were married in 1947. We moved to Australia and had two beautiful children. We now have six grandchildren and five great-grandchildren. I hope that in the future I will have many more.

My Mayer died in 2010 – I miss him every day."

*Pages 70–71*
Mayer Braitberg
Melbourne, Australia

Mayer Braitberg, known as Zaida to his grandchildren, was born to parents Gershon and Mariem Braitberg on 30 December 1925 in the shtetl[43] of Bełchatów, Poland. Raised in a religious household, he was a mischievous child, the second youngest of six children.

Zaida turned 14 the year the war broke out. He watched his sisters, baby brother and parents march toward the gas chambers of Chełmno extermination camp. With that devastating separation came a prevailing silence that consumed Zaida. What Zaida went through during the Holocaust he shared with the love of his life, Ester Lewkowicz, with whom he spent 62 years, and his Holocaust-surviving brothers, Hershel and Motek. Zaida and his brother Motek survived together through Auschwitz[14] and Mühldorf[44], Kaufering[45] and Landshut[46] work camps[29] in Germany. They survived starvation, disease, daily degradation and even queues to the gas chambers.

Once liberated, Zaida was only interested in building a family and leaving the past behind him. He met Ester in Belgium, where they married and remained until voyaging to Melbourne, Australia, in 1950, where they were reunited with Zaida's brothers Hershel and Motek. The three brothers made new lives in Australia. Ester and Mayer's new beginning was a struggle, but their strong work ethic and partnership saw them become successful tailors and milk bar owners, and run a popular cake and bread stall at the Queen Victoria Market.

Zaida's new chapter brought him joy as he became the proud father of two children, the grandfather of six and the great-grandfather of one. Four more great-grandchildren were born after his death.

The light that shone in Zaida's eyes when he saw his family needed no words; his triumph against adversity spoke volumes. Zaida died in Melbourne in 2010.

ESTER BRAITBERG (WIFE), MAYER'S CHILDREN AND GRANDCHILDREN

*Pages 72–73*
Jack Sperling
Melbourne, Australia

"My father, Jack Sperling, was born Jakub Efraim Szperling in Tomaszów Mazowiecki, Poland, on 10 November 1916 to Mordcha and Rajzla (née Szwarcman). He was the youngest of five children, who lost their mother at a young age and were raised by a stepmother and their father.

When the war broke out, it become apparent to my father that the Nazis would invade Poland and the Jews would be in great danger. His father didn't agree but encouraged him to leave if he felt that way. My father subsequently made his way to Russia after being told that people were living well there, only to find them struggling. He then joined the Polish army, encountering huge anti-Semitism, and made his way to the Middle East. There he fought alongside the British, who moved up and were stationed in Italy when the war ended.

He then made his way to Munich, Germany, to try to find records of his family, only to find out that 64 people in his family had perished in concentration camps[10]. He decided to go as far away from Europe as he could – but he needed a wife. He met my mother, Jetka (Judy) Sekler, and married her in the displaced persons (DP) camp[26] in Feldafing, Germany, in 1950. The next year, they emigrated to Melbourne, Australia, where he lived until his death in May 2011, aged 94. Rosie Davis was his only child but gave him three grandchildren, whom he adored and lived for. He was blessed to know three great-grandchildren, deriving huge joy from them as he was of sound mind until he died. He always believed that God saved him for a reason!"

ROSIE DAVIS (DAUGHTER)

*Pages 74–75*
Kitia Altmann
Melbourne, Australia

Born in Będzin, Poland, on 1 March 1922, Kitia (Henrietta) was 17 when the war broke out. Soon after, the Jewish population of Będzin was moved into the crowded Będzin ghetto, where Kitia and others did forced labour making German SS uniforms. The factory where she worked was run by a German manager, Alfred Rossner[47], who pleaded for extra rations and protection for the families of the 3,000 workers, but in 1944 he was arrested and hanged for abetting Jews. He was later recognized as one of the "Righteous Among the Nations"[5] by Yad Vashem[48].

Kitia was sent to Annaberg work camp (a sub-camp of Flossenbürg concentration camp[41]) in Germany and from there to Auschwitz[14], where she was tattooed with the number A-25441 and witnessed the horrors and deprivations of that inhuman place. From there she was sent to the German concentration camp Ravensbrück[36] and finally, near the end of the war, to Helmstedt-Beendorf in Germany, a women's camp where she was forced to work in an underground Siemens munitions factory on the production of V2 rockets.

After liberation by the Red Cross in April 1945, Kitia was taken to Malmö, Sweden, where she stayed until 1946. She then joined her brother and her father's family in Paris, France. Her mother, Zofia (Zysla) Szpigelman, had survived the war and was reunited with her children in Paris, but her father, Mojzesz Szpigelman, had died on one of the notorious death marches[37] toward the end of the war.

In early 1947 Kitia got married in Paris and then emigrated with her husband to Melbourne, Australia, in the middle of that year. They had one child, Eugene, who was born in 1949 and who now lives in Israel. Kitia remarried in 1970 to her beloved husband Fred, who died in 1999. In 2013 she was awarded a Medal of the Order of Australia "for service to the community, particularly through the Jewish Holocaust Centre".

JOE LEWIT (NOT RELATED) & JULIA MONIQUE REICHSTEIN (NOT RELATED)

*Pages 76–77*
Jadzia Opat
Melbourne, Australia

Jadzia Opat (née Hupert) was born into a prosperous family in Pabianice, Poland, on 28 October 1924. She was the youngest of four children, who all survived the Holocaust. Her brother, Shmuel, fought with the partisans (Resistance fighters), and her sister Guta and Guta's daughter, Dora, survived on Aryan (non-Jewish) papers. Jadzia and her sister Sala were among the very few who were liberated from the Częstochowa work camp in January 1945. Their father, Yekutiel (Ksiel), was murdered in Poland's Majdanek extermination camp[8] – we do not know the fate of her mother, Alte Perle, née Weitzman.

Jadzia twice saved Sala from a selection[49], once offering a German officer a diamond to take her sister out of the line. She said, "He could have taken the diamond and put me in line as well." But she trusted her intuition.

Jadzia married Ephraim Meierowitz in Germany in 1946 and had a daughter, Anita. After moving to Israel, she had another daughter, Rachel (Fay). Jadzia and Ephraim divorced ("Hitler was not a good matchmaker"), and in 1962 she travelled to Melbourne, Australia, where she reconnected with a friend of her brother's from Pabianice. Six weeks after her arrival they were married, and she brought her daughters to a new life in Australia with David Opat and his two daughters. Sadly, Anita passed away in August 1992.

Jadzia had an indomitable will to survive, but her experiences in the Holocaust were not trivialized or forgotten, and she twice testified at war-crime trials in Germany. She educated herself in the arts, especially music, theatre and opera. Bridge was a passion and she was an astute businesswoman. However, family always came first, and she had invaluable advice for them all. Her many sayings (handed down to her by her grandfather) are still quoted by her family today, such as: "Better is the enemy of good" and "Even a blind chicken can find the corn."

Despite these axioms, Jadzia was a gambler at heart, risking everything to make a new life, taking on business ventures by instinct and still trusting strangers to keep their word. She entertained extensively and cooked and baked for the Women's International Zionist Organization (WIZO). Her world-famous nut cake was a sought-after delicacy. A woman of valour and vision, Jadzia died on 21 October 2013 in Melbourne. Loved and respected, she is dearly missed by her children, six grandchildren and eleven great-grandchildren.

FAY BOCK (DAUGHTER)

*Pages 78–79*
Leon Jedwab
Melbourne, Australia

Leon was born on 30 October 1923 in Zagórów, Poland. With his mother and father, Leon's family of seven ran a general store and were well known to the township.

As Leon grew into his teens, the trouble with neighbouring Germany became more and more apparent through 1936–7, so much so that his father and two older brothers went to Australia, where extended family had made it possible for the whole family to emigrate. Unfortunately, it was late 1939 by then, and there wasn't time to get the rest of the family out of Poland. Leon's father was convinced by others that it was unsafe to return once war had been declared.

A witness to the German invasion of Poland on 1 September 1939, Leon was just 15 years old when he and the rest of his family were removed from their home. With his mother and siblings in the Zagórów ghetto, Leon, being young and fit, was sent to the first of many work camps[29]. There he managed to keep alive because of the support of a boy, Chaim, who was engaged to Leon's sister.

In 1943 Leon and Chaim were moved to Auschwitz-Birkenau[14]. They stayed alive through many extremely dangerous and trying situations and were eventually, in 1945, marched to Buchenwald concentration camp[20] in Germany. Many people died on these death marches[37], but with the two boys together and the thought of his family in Australia as a deep incentive, Leon kept going. The threat of death did not subside, right up until the last days before liberation from Buchenwald by the US forces in April 1945. Unfortunately, Chaim died just days after liberation. Leon continued on to Paris, France, via Sweden, on his own, and in Paris a travel permit, supplied by his father for passage to Australia, was waiting.

A long trip by French freighter to Australia reunited Leon with his father and two older brothers, who had lived out the war in Melbourne. Leon was the only survivor of those left behind in Poland. His father had started a clothing manufacturing business with his two sons, and Leon joined them, working in the business his whole adult life.

He married a Polish girl, Tosha, who had also survived the war in Europe, and they had two daughters and a son, who all still live in Melbourne. He has three grandchildren and is happily retired in Melbourne at the terrific age of 93. Leon's Auschwitz tattoo is 144768; Chaim's was 144769.

HELENE JEDWAB (DAUGHTER)

*Pages 80–81*
Tosha Jedwab
Melbourne, Australia

Tosha was born in Poznań, Poland, in 1932. She was in the Warsaw ghetto from 1940 to 1943. On the day before Rosh Hashanah (the Jewish New Year) 1942, her father, Morycz Płocka, was taken away. Ten days later, on Yom Kippur, her brother, Lutek, was also taken. Neither was ever seen again, and it is believed that their final destination was Treblinka extermination camp[34] in Poland.

When Tosha's mother, Sally, was sent to Bavaria to work in 1943, Tosha was protected under a false identity and lived with a kind Polish family. They took care of her at great risk to themselves, until mother and daughter were reunited after the war. Tosha and her mother then lived in Sweden for two years and eventually emigrated to Australia in 1948. Tosha married Leon Jedwab, another brave survivor, in Melbourne in 1952.

HELENE JEDWAB (DAUGHTER)

*Pages 82–83*
Leon Rosenzweig
Melbourne, Australia

Leon was an exceptional person. He loved to sing and dance and had an unshakeably positive outlook on life. He always maintained that no matter what the Germans took away from him during the war he more than made up for it afterward.

Born to parents Iczek-Ber Rosenzweig and Esther Rosenzweig (née Knobler) on 23 June 1918 in Słomniki, Poland, Leon was interned in a number of camps during the war, including Płaszów work camp[50] in Poland and Buchenwald concentration camp[20] in Germany. He, a brother and a sister were the only survivors of a large family that perished in the Bełżec extermination camp[51].

In 1952 Leon emigrated to Australia with his family, working there as a tailor and in later years as a retailer. He had a wonderful family life, with a loving and devoted wife, Lucia, to whom he was married for 67 years, an only son, Marcus, two grandchildren, Jason and Eden, and six adoring great-grandchildren. Leon passed away peacefully in Melbourne in 2013, one month short of his 95th birthday, a defiant symbol that the survivors had won.
MARCUS ROSE (SON)

*Pages 84–85*
Lucia Rosenzweig
Melbourne, Australia

Lucia Rosenzweig (née Chorowicz) was born on 12 December 1924 in Kraków, Poland, to parents Markus and Estera (née Ladner) and was one of five children. She lived her early life in the resident's cottage adjoining the New Jewish Cemetery. Her grandfather, Pinkus Ladner, who was a celebrated elder statesman of Kraków, was in charge of the cemetery for over half a century.

During the war, Lucia was incarcerated in Płaszów labour camp[50] in Poland, and in Auschwitz[14] concentration camp in Poland (her identity number was A22316), as well as Theresienstadt transit camp[15] in Czechoslovakia, from where she was liberated. She was an identical twin but was fortunately separated from her twin sister, Giza, during the war and so avoided the notorious "experiments" on twins by Dr Mengele[42]. Lucia recalls standing in the selection[49] line before Mengele and being directed toward the line of the "living". Lucia survived the war, as did her mother and twin sister.

Lucia married Leon Rosenzweig in 1945 in Kraków and was happily married for over 67 years. She was a wonderful wife and mother. They had one son, Marcus, two grandchildren and six great-grandchildren. During her last years Lucia was a resident of an aged-care home in Melbourne, Australia. Although confined to bed toward the end, she had an indomitable will to live and looked forward to each day. She passed away on 29 March 2016, aged 91.
MARCUS ROSE (SON)

*Pages 86–87*
Lina Varon
Melbourne, Australia

Born in Naples on 21 November 1920 to Mayer Beraha and Bella Beraha (née Benusiglio), Lina was the youngest child of the Beraha family, Sephardic Jews who migrated to Italy from Salonica (now Thessaloniki, in Greece) after the Great Fire of 1917 destroyed two-thirds of the city. Lina had four older brothers. Her father, a dentist, died when she was seven, and her mother then ran their dental supply business. Lina loved the view of Mount Vesuvius overlooking the magnificent Bay of Naples, where they swam and sailed, often to Capri for picnics. She studied piano, sitting her final examinations early in order to gain her music degree before the Italian anti-Jewish Racial Laws[52] came into effect in 1938.

During World War II, the family was interned as Jews and enemy aliens, in Greve (now Greve-in-Chianti), Tuscany. The only Italian-born member of her family, Lina managed to obtain Italian citizenship and the ability to travel around when she turned 21. With the assistance of sympathetic Italian police, she organized the family's escape to Rome after having witnessed the roundup of the Jews of Florence in 1943. In Rome the family hid underground on false papers, often narrowly escaping the Gestapo[3]. Miraculously, they survived and were able to return to Naples after liberation.

In 1946 Lina met and married Moshe (Maurice) Varon, from Yugoslavia, whose large Sephardic family had perished in Treblinka extermination camp[33] in Poland. After their only daughter, Ruja, was born in 1947, the couple emigrated to Melbourne, Australia, where Lina's brother lived. Moshe, an electrical engineer, also worked with Lina developing and marketing a dental product. They were very close to Ruja and their three granddaughters, Rachel, Ruth and Laura. Moshe died at the age of 86 years. Lina rejoiced in all her family, including four great-grandchildren, until her death on 8 January 2016 at the age of 95.
RUJA VARON (DAUGHTER)

*Pages 88–89*
Mary Elias
Melbourne, Australia

Mary Elias (Mariska Kohn) was born on 4 October 1926 in Gúttamási in Hungary. The approximate population of this small town was 800, and Mary's family was the only Jewish family. Her parents, Miklos and Teréz Kohn (née Fried), owned a shop that was split into a pub and a mixed business selling grocery items. Mary attended school in Gúttamási and later went to high school in the neighbouring city of Várpalota where she lived with her aunt.

In 1944 Mary and her family were taken to Auschwitz-Birkenau[14] concentration camp in Poland, and she never saw her parents again. After some time she was transferred to

233

the Lippstadt work camp, a sub-camp of Buchenwald[20] that held women, where she built parts for German aircraft as part of the SS Kommando Lippstadt I.

After the war Mary met Gyuri (George) Elias in the Hungarian city of Székesfehérvár; they married and had three children. During the Communist era in Hungary, shortly after the war, they smuggled themselves across the border and lived in Vienna, Austria, for some time. Next they made their way to Chile, where they lived for a few years until civil unrest broke out there. The family then moved to Melbourne, Australia, where Mary lived until she passed away on 24 April 2013.

DORON ELIAS (GRANDSON)

---

*Pages 90–91*
Maria Lewitt
Melbourne, Australia

Maria Lewitt (née Markus) was born in Łódź, Poland, on 2 July 1924, to a well-to-do family who owned textile mills. Maria's father, Borys Markus, died in 1939 following a brutal beating by an SS officer. Maria and her sister moved into the Warsaw ghetto with their mother, Lydia Markus (née Wagin).

With false papers obtained by her non-Jewish aunt, Aleksandra Żmigrodska, they escaped to the "Aryan side" (the part of the city outside the Jewish Quarter), and later to Aleksandra's home in the countryside. Maria's paternal uncle, aunt, young cousin and aunt's younger brother, Julian, joined them. Lydia and her sister Aleksandra were actively involved with the Polish resistance all through the war years. While in hiding, Maria fell in love with Julian Lewit and married him. Their son, Joe, was born in December 1945. For risking her life in hiding and saving the family, Aleksandra has been honoured by Yad Vashem[48] in Jerusalem as one of the "Righteous Among the Nations"[5]. Maria, Julian and Joe lived in Paris, France, for a year, and then in 1949 the family emigrated to Melbourne, Australia, where their son Michael was born in 1953.

Maria had always had a love of poetry and literature and dreamed of becoming a writer. She began by learning English and in the late 1950s she attended writing classes at the Council of Adult Education. Her first published short story was in the *Herald Sun* as finalist in a competition in 1972. Maria was secretary to the Victorian Fellowship of Australian Writers in 1990–3, was a committee member in 1981–9 and is a Life Member. She won the Alan Marshall Award in 1978 for her autobiographical novel *Come Spring*, her account of her experiences during the Nazi occupation of Poland, and the 1986 New South Wales Premier's Literary Award for its sequel *No Snow in December*, her account of migration to and settlement in post-war Australia. She is published in literary journals, anthologies and newspapers.

In 2011 she was awarded a Medal of the Order of Australia "for service to the Jewish Holocaust Museum and Research Centre as a volunteer, and to literature as a writer and educator". Maria has four grandchildren, Michelle, Natalie, Simon and Alex, and five great-grandchildren.

WITH JOE LEWIT (SON), MICHAEL LEWIT (SON) AND KARIN LEWIT (DAUGHTER-IN-LAW)

---

*Pages 92–93*
Mietek Skovron
Melbourne, Australia

Born in Miechów, Poland, on 16 October 1912, Mietek was the fifth of six children of Machel Lewek Skowron and Chaja Ryng. He left home at 17 and built up a business as a painter in Sosnowiec, Poland. After the Germans occupied the country he escaped to Ukraine, where he worked in the coal mines, but in April 1940 he returned to Poland, where he married Ida Rotensztajn and resumed his painting career. They had one child, Aleksander, born in August 1942.

From early 1943, Mietek was imprisoned in a series of camps: Markstädt and Fünfteichen[53] sub-camps and Gross-Rosen work camp[40], all in Poland, Mauthausen concentration camp[31] and Gusen II sub-camp, both in Austria. After liberation (from Gunskirchen, a sub-camp of Mauthausen) he learned that his wife and son had perished in Auschwitz[14].

On 13 June 1946, at Bytom, Poland, he married Marysia Rajs (1917–80), who was also a survivor of the camps (Huta Laura, Blechhammer, Peterswaldau). A son, again named Aleksander (Alex), was born on 12 June 1948.

Marysia and Mietek both worked in the state public service, but Mietek, finding he could do better as a painter, took up his trade again. In December 1956 the family emigrated to Israel, where they lived in Tiv'on, before moving on to Australia in March 1958. They settled in Sydney, where one of Mietek's two surviving siblings, Henry, had lived since 1948.

Mietek pursued his painting career, while Marysia became an accountant's bookkeeper. After Alex married a Melbourne girl, Ruth Paluch, and moved to that city, his parents followed, in June 1980, establishing a new home there; on 22 November 1980, however, Marysia suffered a fatal heart attack. Six years later, Mietek married Guta Scholl (née Goldberg); they were together until her death in 2007. Mietek died on 22 February 2013 in Melbourne, aged 100. At the time of his death he had two grandchildren, and two great-grandchildren have since been born.

ALEX SKOVRON (SON)

*Pages 94–95*
Sarah Saaroni
Melbourne, Australia

Sarah (Sabka) was born in Lublin, Poland, on 8 June 1926. Before the war, her parents, Aron and Estera Fiszman, owned a shop selling clothing in Lublin, where she grew up with her older siblings – a sister, Zosia, and two brothers, Gidal and Julek. At the outbreak of war, the family was moved into the Lublin ghetto[7], but when deportations began they went into hiding in a nearby village. Her parents arranged a false birth certificate for her so that she could go to Germany to work as a Polish Christian girl. During that period, she was betrayed by Polish friends and captured several times. Each time, she managed to escape. One brother left Poland for Palestine in 1937, and the other brother survived the war in Russia. The rest of her entire family perished.

After the war Sarah was in a displaced persons (DP) camp[26] in Italy and from there made her way to Palestine to rejoin her brother. She was a member of the Haganah, the national army that developed into the Israel Defense Forces, helping to form the new State of Israel. In 1948 she married her husband, Levi (Lewi), who had survived in Russia and had joined General Anders's Polish army in the Middle East. They emigrated to Australia in 1953 with their two young children, Gideon and Adina, sponsored by the brother that had survived in Russia and had settled in Melbourne.

In 2015 Sarah was awarded a Medal of the Order of Australia "for service to the community, particularly through the promotion of tolerance and diversity". Sarah has five grandchildren and three great-grandchildren.

JOE LEWIT (NOT RELATED), ADINA KLEINER (DAUGHTER), SERGE KLEINER (SON-IN-LAW), GIDEON SAARONI (SON) & DOROTHY SAARONI (DAUGHTER-IN-LAW)

*Pages 96–97*
Sam Goodchild
Gold Coast, Queensland,
Australia

Sam Goodchild was born Srulek Israel Gutkind in Błonie on the outskirts of Warsaw, Poland, on 5 August 1926. His mother, Sura Dina, was a housewife and Jewish community worker; his father, Moishe Gutkind, was a farmer and tailor. He had two older brothers, Yankel and Tanche. Sam's twin brother had died at birth, and Sam used to say that he survived the Holocaust because he had the luck of two. He went to a public school, where he often fought anti-Semitic insults, and he also went to *cheder* (a traditional primary school teaching Hebrew and the elements of Judaism).

Sam was 12 when the family was forced into the Warsaw ghetto. To help his family, Sam would smuggle himself out of the ghetto, exchanging clothing for whatever food he could get. One day while he was out, his mother, father and brothers were taken away. He found himself alone.

Eventually Sam fought with the Resistance in the Warsaw Ghetto Uprising of 1943, running messages between cells and making Molotov cocktails. When the ghetto was burned to the ground by the Nazis, Sam was taken to Germany's Buchenwald concentration camp[20]. He went from there to Majdanek extermination camp[8] in Poland and finally Auschwitz[14]. When he saw the infamous "*arbeit macht frei*" ("work sets you free") sign (which appeared at the entrance to Auschwitz and some other camps), Sam swore to himself that he would come out alive. He did slave labour there until he was liberated in 1945.

Not wanting to return to Poland, Sam went to a Kinderheim[54] in Belgium. Eventually he ended up in Melbourne, Australia, where he met and married Suzanne Miodownik, a Holocaust survivor from Paris, France. They had two daughters, Fay and Roslyn Goodchild, and a granddaughter, Hannah Goodchild. Sam became a successful and respected businessman. An incredibly well-adjusted and optimistic survivor, Sam gave talks to secular high schools about his Holocaust experiences. He died on 5 April 2016.

FAY GOODCHILD (DAUGHTER)

*Pages 98–99*
Suzanne Goodchild
Gold Coast, Queensland,
Australia

Suzanne Goodchild was born Sura Dina to Chana and David Leib Miodownik in Żelechów, Poland, on 20 August 1929. When she was just three weeks old, her parents moved to Paris, France, where a second daughter, Fanny, was born. Suzanne had a happy childhood until the Nazi occupation.

When the Nazis began rounding up the men to take to camps, her father escaped the city. Suzanne and her mother were smuggled out later beneath the false bottoms of coffins, as the cemetery was outside the city's walls. Her parents put her in a Catholic monastery and school in the French countryside where her Jewish identity was kept secret, while her parents hid underground at a farm nearby. Sadly, her sister Fanny had been in Poland visiting her grandparents when the war broke out, and she was murdered, along with both Chana's and David's extended families.

After the war Suzanne and her parents returned to Paris, where they were forced to go to court to get their apartment returned to them, as it had been appropriated by a non-Jewish family[55]. Suzanne began studying pharmacy at the Sorbonne but her father never again felt safe in Europe, and in 1950 they emigrated to Melbourne, Australia. Eventually, David, who had been a tailor in Paris, opened his own clothing factory. Because of language and financial difficulties, Suzanne could not continue her studies and had to work at the factory

to help support the family. This is where she met her future husband, Sam (Gutkind) Goodchild, a Holocaust survivor from Poland, who also worked there. They married in 1952 and had two daughters, Fay and Roslyn Goodchild, and a granddaughter, Hannah Goodchild. Suzanne was a devoted wife, mother and grandmother who dedicated her life to the betterment of her family as well as being a strong supporter of many Jewish charities. She passed away on 5 September 2014 on the Gold Coast, Queensland.

FAY GOODCHILD (DAUGHTER)

*Pages 100–101*
Annetta Able & Stephanie Heller
Melbourne, Australia

The identical twins Annetta Able and Stephanie Heller (née Heilbrunn) were born on 4 February 1924. They had a happy childhood in Prague, growing up in a well-to-do, assimilated family, until the Nazi occupation of Czechoslovakia, from March 1939. The Nuremberg Race Laws[56] forced Jews to wear the yellow star on their clothes and imposed further restrictions on their everyday lives, such as banning them from schools, clubs, theatres and even parks. Their way of life changed drastically.

The twins' parents tried to get them and their younger sister, Elizabeth, to England via the Kindertransport[17] arranged by Sir Nicholas Winton[28] but they were unsuccessful as all three children were not able to join one family. Time ran out for other arrangements. The twins were subsequently employed by a Jewish orphanage in Prague, and they boarded there. In 1941 their parents and younger sister were suddenly transported to the Polish ghetto in Litzmannstadt (Łódź) – they were never seen again.

At the orphanage, Stephanie fell in love with Egon Kunewalder, who also worked there. They got married so they could stay together. Egon's parents and other relatives were sent to Theresienstadt transit camp[15] and later to Auschwitz[14]. In 1942 the twins and Egon were also sent to Theresienstadt, where both girls worked at a hospital in an infectious-diseases ward. Egon worked with the Jewish ghetto police. In 1943 Annetta, Stephanie and Egon were transported by cattle truck to Auschwitz, where they lived in Camp Bllb, the family camp.

The infamous SS officer and physician Josef Mengele[42], who performed pseudo-medical experiments on prisoners, particularly twins, selected Stephanie and Annetta for the experiments in his notorious research laboratories. He extracted blood, which was sent to Berlin for testing, and he later performed blood transfusions on them from male twins. This produced very bad side effects, which made both girls feel they were going to die. They recovered, however, and continued to be "guinea pigs" for Dr Mengele.

Egon worked delousing the prisoners' clothes while he was in Auschwitz. He was later sent, along with most of the able-bodied male prisoners, to Schwarzheide work camp[57] in Germany.

Dr Mengele planned to have the twins impregnated by two male twins, to find out whether they would produce twins. He wanted to engineer an accelerated population growth of a master race through multiple births. Fortunately, the Red Army was advancing on Auschwitz, so Dr Mengele abandoned his research and disappeared.

The Germans murdered most of the sick prisoners and embarked on a torturous death march[37] with the remaining prisoners. It was a cold January and the prisoners had only the clothes on their back since arrival in Auschwitz. Many died on the way, either falling by the roadside or being shot by the guards. On arrival at Ravensbrück concentration camp[36] in northern Germany, the surviving prisoners were transported the next day to Malchow transit camp[22] in Mecklenburg because of overcrowding in Ravensbrück. The twins and the other prisoners were still guarded by the German soldiers, but the killing had stopped. Annetta contracted typhoid at this time, but she recovered.

When the war ended, the German guards suddenly left the camp and the prisoners were able to walk out. They mingled with many refugees from other camps in Germany who were trying to return to their homes. Eventually the twins reached the port of Lübeck, where the UNRRA[27] relief agency helped displaced persons with temporary accommodation while waiting for transport home. It was a long and difficult journey back to Prague.

On arrival, they discovered the full horror of the war. Their entire family had been murdered by the Nazis, and Stephanie's husband, Egon, as well as his whole family, had also perished. As they could not do anything for their own family, the twins decided to try to help others, so they enrolled at a nursing school, working and studying at a hospital.

Annetta met and married Jiri Able, who had also survived Auschwitz. Their first son, Michael, was born in Czechoslovakia. Stephanie emigrated to the new State of Israel, working in a state hospital in Haifa. Annetta, with Jiri and Michael, followed, settling in the Givat Haim kibbutz. They became the pioneers building the new State of Israel. Another son, Daniel, was born to Annetta and Jiri, and a daughter, Daphne, followed. Stephanie married Sigfried Stiasny, but the ravages of the war were such that the marriage failed.

Later, Stephanie met Robert Heller, a Jewish tourist from Kenya; he and his family had moved to Kenya at the eleventh hour before Europe fell to the Nazis. Stephanie and Robby fell in love, and they built a new home and family in Kenya, where their daughter Naomi

and son John were born. They were happy there but when Kenya gained its independence from Britain, life became dangerous and unsettled. Robby and Stephanie decided to emigrate to Australia. A year later, in 1963, Annetta's family also emigrated to Australia. The twins were together again, and have been inseparable to this day.

Both sisters are widowed now. Annetta has three children, eight grandchildren and three great-grandchildren. Stephanie has two children, seven grandchildren and one great-grandchild. The twins celebrate their triumph over Hitler every day – they know that their growing families are their victory over the Nazi regime.

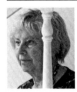

*Pages 102–103*
Silvia Migdalek
Melbourne, Australia

"I was born on 1 August 1929 in Herne, Germany. My parents, Freda Bergwerk and Norbert Andacht, and I lived in Germany until being transported to Zbąszyń, Poland, in October 1938, as part of Germany's expulsion of Polish Jews. For three months we lived in the Zbąszyń railway station and army barracks. After that we stayed with my paternal grandparents in Stanisławów (then in Poland but now part of western Ukraine), until we found our own place, just before the outbreak of World War II. I loved being close to my father's family. Stanisławów was under Russian occupation, but I was only ten years old and I enjoyed school and had a great sense of freedom living under Communism.

My father worked in a Russian timber mill, and because there was talk of the Russians leaving, we were conflicted about whether to leave with them or stay under German occupation. We stayed. My father built a hiding area, which saved us from being part of a group of between eight and twelve thousand Jews rounded up by the Germans and shot on 'Bloody Sunday'[58], 12 October 1941, just prior to the establishment of the Stanisławów ghetto. However, after another roundup we were taken to the ghetto. There I found that my paternal grandparents and uncle had been shot dead. My parents started to prepare false papers for me.

At the age of 12, I was smuggled out of the ghetto by my parents and given the false identity of 15-year-old Janina Jaskiewicz. I went to live with our Polish ex-neighbours. Then, in February 1943, after hearing that the ghetto had been liquidated, the mother of the young women who were hiding me didn't want me to stay and suggested suicide as an option for me. Her daughters, however, helped me to join a Polish forced-labour transport to Germany. I believed this to be my best option for survival.

In Germany I became a maid in a guesthouse in Garmisch-Partenkirchen, working from 5am until 9pm every day. Being under constant pressure to hide my real identity, I never uttered a word of German. When the war ended, in May 1945, I stayed on because I had nowhere else to go and I was unaware that any Jews had survived.

One day, a young survivor fell off his bicycle outside the guesthouse and came in asking for medical assistance. Shmulek (Sam) Migdalek was the first Jewish person I had seen since leaving the ghetto. Upon discovering I was Jewish, he convinced me to reveal my true identity to my employers, who had been unaware that I spoke German. They were shocked.

Sam and I married one year later. Together with his only surviving sibling, Charlie, we applied to leave Germany. Sam's aunt sponsored our application to emigrate to Australia.

Charlie, Sam and I lived in Fitzroy, a suburb of Melbourne. We immediately became involved in the Kadimah Cultural Centre, and Sam joined the Yiddish theatre group. I learned English and Yiddish.

Our first daughter, Miriam, was born in 1948. She and her family emigrated in 1976 to Israel, where she still lives. Norma, our second daughter, born in 1952, lives in Melbourne. We started a clothing factory in Richmond, another suburb of Melbourne, in 1950, and we also established Kochavim Attractions, bringing Israeli entertainers to Australia. In 1957 we visited my mother's three surviving sisters in the US. I have been involved in many community groups and have broadcast in Yiddish for an ethnic radio station. Sam, who was also an artist, painted a picture depicting my escape from the ghetto and my last moments with my parents.

Following the murder by the Nazis of most members of our families, and Sam's and my survival against all odds, we saw the creation of our own family as our greatest achievement. Our two daughters, three grandchildren and five great-grandchildren (with another on the way) are our triumph over the Nazi regime."

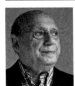

*Pages 104–105*
Tuvia Lipson
Melbourne, Australia

Tuvia Lipson was born on 26 June 1925 in Łódź, Poland, the youngest of five children of Jacob Nachum and Malka Lipszyc. He was 14 when German forces occupied Łódź in 1939. By May 1940 the family had been moved into one room of an apartment in the Łódź ghetto. Young Tuvia worked in a factory until August 1944 when he was sent with his family to Auschwitz[14].

Upon arrival in Auschwitz, Tuvia was separated from his family. He was sent to work in a coal mine, was subsequently taken to Mauthausen concentration camp[31] in Austria, and was finally sent to Ebensee work camp in Austria.

After liberation in early May 1945, Tuvia was moved to Mandatory Palestine[59] by the Jewish Brigade[60] and served in the Israel Defense Forces until 1958, retiring with the rank of major. In 1960 he emigrated to Australia, where he was reunited with two siblings who had also survived the Holocaust. He ran the family textiles business until 1997/8. After that he became heavily involved in Melbourne's Jewish Holocaust Centre, where he still works as a guide today.

JACK LIPSON (SON)

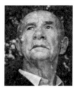

**Pages 106–107**
**Zvi Sharp**
Melbourne, Australia

Zvi Sharp (Hersek Szarfsztum) was born in Ryki, Poland, on 3 March 1928, to Yitzchak, his father, and Malka, his mother. With his brothers, Mayer, Mendel, Laibl and Gershon, he was brought up in a religious Jewish family and went to regular school and *cheder* like any other child in his town. In 1940, along with all the Jews of Ryki, Zvi's family was held in the town ghetto[13]. The family stayed here for two years, cramped in one room of a house.

Around May 1942 they were marched to Dęblin, Poland, from where he was separated from all his family members, whom he would never see again. For the next two years he remained in Dęblin work camp as a slave labourer working at the Luftwaffe airfield. In 1944 he was moved a number of times from one work camp[29] to another – from Dęblin to Lublin and Częstochowa in Poland, then Buchenwald[20] and Colditz in Germany, and finally Theresienstadt transit camp[15] in Czechoslovakia, from which he was liberated in 1945.

After the war Zvi left Europe with the Jewish youth groups on illegal ships[61]. They were stopped and held by the British in Cyprus, then released, arriving in Palestine in 1947. The next year, he volunteered to fight in Israel's War of Independence.

In 1950 Zvi married Miriam Bercovici, who herself had come to Palestine from Romania in 1947. They had two children, Ian (Yitzchak) in 1951 and Henry (Chanan) in 1959.

The family emigrated in 1961 to Melbourne, where Zvi's only surviving uncle lived. Zvi worked in a textile factory until retiring in 1997. Their son Ian married Diana Sackville and they had three children; their other son, Henry, married Ruth Zandle and they had one son. Zvi and Miriam have three great-grandchildren. Today, Zvi and Miriam are enjoying old age and living in their home in Melbourne.

JOSH SHARP (GRANDSON)

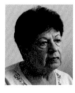

**Pages 108–109**
**Abigail Kapulsky**
Ramat HaSharon, Israel

"I was born in June 1938 in Kovno (Kaunas), Lithuania, to my parents Akiva Kapulsky and Rachel Kapulsky (née Vaintraub). When I was three years old, Lithuania was occupied by the Nazis, and in August 1941 we were transferred to Kovno ghetto. Subsequently, in 1944, my parents smuggled me out of the ghetto to righteous Gentiles[23], who didn't have children of their own, and they hid me in their house until Lithuania was liberated. In July 1944 my parents were killed in the ghetto when it was burned down.

My mother's brother, Chaim Vaintraub, and his wife, Helena (Lola), then took me from the family where I had been concealed and adopted me as well as my other cousin, Itamar, whose parents had also been killed. I went to live with Chaim, Helena and their son, Dan.

I studied medicine at Kaunas Medical Institute and graduated as a doctor in 1963. I emigrated to Israel, via Poland, in 1969. For 30 years, until my retirement, I worked as a doctor in Ramat-Gan, where I still live today."

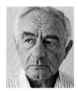

**Pages 110–111**
**Itamar Carmon**
Ramat HaSharon, Israel

"I was born on 26 June 1939 to Aron Vaintraub and Lea Vaintraub (née Jezersky) in Lithuania. In August 1941, the Jewish population was transferred to the Kovno ghetto, in Vilijampolė, the Jewish district of Kovno (Kaunas). I lived there with my parents until April 1944, when they smuggled me out of the ghetto in a potato sack to righteous Gentiles[23]. However, they were unable to hide me from their children, and I was returned to the ghetto. I was then smuggled a second time from the ghetto to Gentiles, this time for payment. My parents were killed when the ghetto was destroyed in July 1944, a month before the Soviet army liberated Kovno.

My uncle, Chaim, and his wife Helena (Lola) Vaintraub adopted me, and my cousin Abigail Kapulsky was adopted by them at the same time. We were raised in their family together with their son Dan.

I became an electrical engineer, and then obtained permission to emigrate to Israel in 1971, where I built a new life in Jerusalem. Since retirement, I have lived in Tel Aviv."

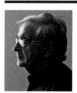

**Pages 112–113**
**Dan Vaintraub**
Ramat HaSharon, Israel

"I was born in Kovno (Kaunas), Lithuania, on 10 November 1938 – the actual Kristallnacht[11]. My parents were Helena Vaintraub (née Girshovich) and Chaim Vaintraub. We are survivors of the Kovno ghetto, along with my cousins Itamar Vaintraub/Carmon and Abigail Kapulsky, who lost their families in the ghetto and then were adopted by my parents.

I graduated as a structural engineer from Kaunas Polytechnic Institute in 1961. I have lived in Israel since January 1972 and, since 1976, have been a self-employed structural engineer. I am married to Larisa (my second marriage) and have two children

from my first marriage: a daughter, Aliya Laniado, who was born in 1971, and a son, Gilad, who was born in 1974. I also have five grandchildren, from both marriages. My interests include astrophysics/cosmology, philosophy and Renaissance art."

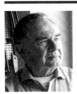

*Pages 114–115*
Aryeh Luria
Ra'anana, Israel

"I was born in 1937 to Lea and David Luria (Lurje), a housewife and a merchant in the city of Shaulay, Lithuania. Shortly after I turned four, Germany conquered Lithuania. My family tried to get away but got caught in a German air raid and had to return to the city, to be put into a ghetto[13] along with the rest of the Jewish community.

Shortly after we had moved into the ghetto, my younger brother, Simcha, was born. The danger around us continued to escalate. A vivid memory I have is of the Kinder Aktion (murder of the children) in 1943 – the German attempt to kill all Jewish children, and also the elderly. My family hid myself, Simcha and our cousins, Miriam and Danny, in a potato cellar. When the Germans had left, we were lifted back out, almost dead but also triumphantly alive. Such close calls continued to occur until 1944, when it was clear to my parents that we must all escape. Thus, my mother smuggled four children (myself, my brother and my two cousins) out of the ghetto and paid a local farmer to hide us in an intricate hiding place under the floors of his barn. My father stayed back in the ghetto.

After a long and torturous period of hiding we were liberated by the Red Army and rejoined my father in Shaulay. He had survived but many other family members did not.

After a short period as refugees in Munich, Germany, we emigrated to Israel, first to a kibbutz, then to Ra'anana. My triumph is the life I have built. I married my wife, Ora, became an El Al flight engineer and have a wonderful family of three children – Irit, Dorit and Shay – and ten grandchildren."

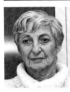

*Pages 116–117*
Erna Stopper-Bindelglas
Jerusalem, Israel

"My parents, Sophie Thaler and Yizchak Eisig Stopper, came originally from Galicia, in Poland. After they married they settled in Amsterdam, Holland. I was born in Amsterdam on 13 November 1930. My two older sisters and younger brother were also born there.

My father died in Auschwitz[14]. My mother and older sister were in Germany's Bergen-Belsen concentration camp[1] and survived. My other sister survived Auschwitz and several other camps. My brother and I were hidden in Holland during the entire war. Between 1943 and 1945, I was hidden with different families, moving 13 different times. After the war the five of us were reunited in Holland, and in 1949 we moved to Israel.

In 1957 I met my husband, Paul Melvin Bindelglas, while I was on a visit to Amsterdam; he was visiting there from New York, where he was born. In January 1959 we got married in Jerusalem, and I moved to New York, where my husband was practising medicine. The first of our four children was born there. After three years we moved to Phoenix, Arizona, where our other three children were born. We lived in Phoenix until 1994, when my husband and I moved to Israel.

In November 2014 my husband passed away. My two daughters live in Israel, one on Kibbutz Ketura in the south and one in Herzliya. My seven grandchildren also live in Israel. My two sons live in the United States, one in Phoenix and one in Santa Monica, California."

*Pages 118–121*
Azriel Huss & Rivka Huss
Jerusalem, Israel

Feiga Rivka Huss (Slomovits-Lieberman) was born in Ruscova (Transylvania), Romania, on 17 September 1922. Her parents were Chaim and Sassi Slomovits and she had seven brothers and sisters. Though she was very bright, she went to school only until the age of 12, when she had to go to work as a seamstress to help support the family.

The day after Pesach (Passover) in 1944, the Germans took the family to the Viseu de Sus ghetto in Romania, where Feiga Rivka worked cleaning streets. After Shavuot (the Feast of Weeks holiday) in 1944, they were deported to Auschwitz[14]. At the incoming selection[49], she was separated from her father and never saw him again. Her mother and six younger siblings were sent by Josef Mengele[42], the notorious SS officer and physician at Auschwitz, to the gas chambers to be murdered. Feiga Rivka and her sister Shoshana were eventually liberated from Auschwitz on May 1945 and went back to the town where they had been born, hoping to find other family members who may have survived, with no success. Shoshana left for Israel in 1946.

Azriel Huss was also born in Ruscova, on 10 July 1922. His parents were Shmuel and Sassi Huss, and he had seven brothers and sisters. At the age of 11 he was sent to the Romanian city of Satu Mare to learn to be a carpenter. In 1940 he was drafted into the Hungarian army, which at the time occupied Transylvania, and he laboured in work camps[29] throughout the war. Like Feiga Rivka's family, Azriel's family was taken to the Viseu de Sus ghetto and later to Auschwitz; except for his brother Zvi, they were all murdered. After the war Azriel and Zvi returned to Ruscova, and in 1946 Zvi left for Israel.

In 1946 Azriel and Feiga Rivka, who had dated before the war, were married in Ruscova. They had two children, Sonia and Shmuel Chaim. In 1961 they were finally allowed to

leave Romania and go to Israel (via Sweden), and in Israel they built new lives. Until he retired, Azriel continued working as a carpenter, helping to build the new country. Feiga Rivka passed away on Israel Independence Day, 10 May 2011. As well as their two children, Azriel and Feiga Rivka have nine grandchildren and, so far, ten great-grandchildren.
SONIA TRAEGER (DAUGHTER)

*Pages 122–123*
Barend (Yssachar) Elburg
Rehovot, Israel

"I, Yssachar (Barend) Elburg, was born on 19 May 1940 in Hilversum, the Netherlands, ten days after the German troops invaded the country (and France, Belgium and Luxembourg). I am the first-born son of Karel Elburg and Frieda (née van Dam). My parents did not clam up but – when we grew up – told us what had happened to us during the Holocaust.

Until the summer of 1942 we lived in Leek, in the Netherlands. From the summer of 1938 my father had been the reverend of the small Jewish community. My mother was a local girl who liked the newly appointed reverend so much that they married a year after his arrival.

After deportations to camps in Poland had started, taking most of the Jews from our village, in the summer of 1942 all remaining Jews from the provinces were ordered by the Nazis to move to Amsterdam, where we lived for about a year.

During a *razzia* (raid) in July 1943 we were arrested and transported to the Jewish Theatre (Hollandsche Schouwburg), which served as a prison for the adults, while children were put in a children's home across the road. Groups of Resistance workers, together with the Jewish manageress and staff of the children's home, managed to smuggle out hundreds of Jewish children. Luckily, I was one of them. The manageress was not so lucky – she perished in the camps. I was hidden by two non-Jewish families in Beek, Echt and Roermond, all in the southern province of Limburg.

My parents succeeded in escaping from the theatre and were also hidden in Limburg. Only after their liberation in September 1944 were they told that I was concealed not far away. The town of Roermond was liberated in February 1945, and shortly after that my mother came to fetch me. Luckily my parents, my sister (born in 1943) and I all survived the Holocaust. Together with a brother born in 1947, my sister and I grew up in a 'normal' family, although without grandparents and with just a few relatives.

The non-Jewish people who hid my parents, my sister and me were all awarded the 'Righteous Among the Nations'[5] award by Yad Vashem[48].

After 1945 we lived in a few towns until in 1954 we moved to Amsterdam, where I attended the Jewish High School and was active in Bnei Akiva (a Jewish youth movement), where I met my wife, Lieneke Elburg-Blomhoff. We were married in 1963 and have two children and eight grandchildren. Since moving to Israel in 1972, we have lived in Rehovot. I am retired from IBM where I worked for many years, and I am active as a volunteer in quite a few organizations of Holocaust survivors."

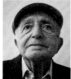

*Pages 124–127*
Edith Sykora & Joel Sykora
Ra'anana, Israel

"My mother, Edith Sykora (née Lisszauer), was born in 1929 in the city of Miskolc, Hungary. Her father was taken to a work camp[29] and managed to survive the war. She and the rest of her family were taken to Auschwitz[14]; only she survived. She got sick and survived a death march[37] only because some other girls pulled her along.

My father, Joel Sykora (born Joel Stern), was born in 1924 in the small town of Irshava in Czechoslovakia (now in Ukraine). The major town in the area was Munkács (or Mukacheve, also now in Ukraine), where my father went to *yeshiva* (a Jewish educational institution studying religious texts). Joel's parents and eight of his siblings were sent to Auschwitz; none survived. Because Joel and one sister had gone to Budapest, they were sent to work camps instead. At one point, Joel jumped from a train but he was recaptured. He also escaped from a work camp during a blackout and was given refuge in a Swedish Red Cross safe house by Raoul Wallenberg[62]. Joel and the one sister survived, and he managed to find her after the war.

Edith and Joel each eventually wound up in New York, where they met, married and raised a family – myself and my younger brother. A couple of weeks after they married, Edith's father arrived and lived with us for over 30 years. My wife, Gabie, and I moved to Ra'anana, Israel, from New York in 1993. In 2006, Edith and Joel made *aliyah* (emigrated to Israel) to be near us. They have seven grandchildren. My father passed away at home on 13 July 2014."
DANNY SYKORA (SON)

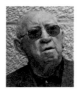

*Pages 128–129*
Jacques Stroumsa
Jerusalem, Israel

Jacques was born in Salonica (now Thessaloniki, in Greece). His father, Abraham, taught Hebrew at secondary school, while his mother, Doudoun, was a seamstress. The young Jacques played the violin, and, after passing the French baccalaureate exams at the end of high school, went to France to pursue engineering studies, in Marseilles and Bordeaux. With the start of World War II, he returned to Greece, was drafted into the Greek army and was posted to Albania. During the German occupation of Greece he lived in Thessaloniki, studied at the university and got married.

In April 1943 he was deported to Auschwitz-Birkenau[14] with his family, along with the whole Jewish community of the city. His pregnant wife, Nora, and his parents were murdered in the gas chambers upon arrival, but Jacques was designated to play first violin in the camp's orchestra. A month later, he started working as an engineer in a factory at Birkenau, part of Auschwitz-Birkenau. Toward the end of the war, a death march[37] brought him to the Austrian concentration camp Mauthausen[31]. Only his sister Bella survived the camps, while their sister Julie and their brother Guillaume died there.

After liberation in May 1945, Jacques decided to stay in France and he married Laura, a Greek survivor of Bergen-Belsen concentration camp[1]. Since June 1967, they have lived in Jerusalem with their three children, where Jacques became director of the municipality's public lighting services. After retiring, he devoted much time to lecturing to youngsters, both in Israel and in Germany, about deportation. He died in 2010.

MARGO STROUMSA-UZAN (DAUGHTER)

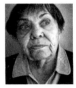

*Pages 130–131*
Leah Ben-Dov
Rehovot, Israel

Leah Ben-Dov was born Lucia Spiwak on 27 September 1930 in Sarny, Poland (now Ukraine). Her parents were Josef Spiwak and Nechama (née Tendler). In the early 1930s Josef and Nechama moved from Sarny to Rokytne, Poland (now Ukraine). In June 1941 Rokytne was captured by Nazi Germany so Nechama sent Lucia eastward with her maternal uncle, Avram Tendler. Lucia, her uncle and his family started a journey that lasted several months, until they reached Uzbekistan and settled on a *kolkhoz* (collective farm).

After a year, Lucia, who was by then 12 years old, discovered that her paternal aunt, Sonya Hochman, lived in Kokand, Uzbekistan. Lucia walked alone for 30km (18½ miles) along a railroad to meet her aunt, who handed her into an orphanage in Kokand. Lucia stayed there for two years.

In 1945, after the war ended, she returned to Poland, where she found out that none of her family had survived. After six months, Lucia joined a group of Jewish youth, and with them she moved to Bielsko, Poland. In 1946 the group was moved to Italy, where they were taken to the Alpine village of Selvino and housed in a former Fascist children's home called Sciesopoli. Here the child survivors, known as "The Children of Selvino" were able to recuperate, regain their youth, and rebuild their trust in humanity as well as hope for a better future. They were also taught Hebrew, instructed in their Jewish culture and heritage and prepared for the next chapter of their lives – in Israel.

In February 1947 they boarded the illegal immigrant ship[61] *Chaim Arlozorov* and sailed eastward. The ship was intercepted by British battleships on the coast of Israel, and they were sent to detention camps in Cyprus. Lucia eventually arrived in Israel in September 1947. Toward the end of 1948 Lucia (from then on called Leah) and the Aliyat Hanoar youth group were sent to settle at Kibbutz Tze'elim.

She got married on 23 October 1953 to Arie Ben-Dov, lived in Rehovot and had four daughters, Michal, Naama, Tami and Yael. At the age of 50, Leah studied history and political science in the Open University of Israel. She also studied music and played the organ with a private teacher, later studying for a year at the local conservatoire. Leah had a wide range of hobbies, including painting, enamelling, beading, baking and other handicrafts. She also volunteered in helping Holocaust survivors who resided in Rehovot.

Leah, who had lost her family in the Holocaust, was particularly proud of her own large family: her four daughters and their husbands, 18 grandchildren and great-grandchildren with whom she kept close contact. Leah passed away on 24 April 2014 at the age of 83.

MICHAL LEVY, NAAMA GROSSMAN, TAMI SHARON & YAEL SEGAL (DAUGHTERS)

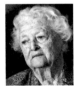

*Pages 132–133*
Lidia Vago
Petach Tikvah, Israel

Lidia Vago (née Rosenfeld) was born in the Transylvanian district of Romania on 4 November 1924 to father Dr Endre Rosenfeld and mother Dr Jolán Harnik. Her sister was born in April 1927. Her parents, assimilated Hungarian Jews, were both physicians.

In September 1940 Northern Transylvania was annexed to Hungary. Lidia continued high school in the newly founded "Jewish Gymnasium" in Kolozsvár (Cluj), the capital of Northern Transylvania, graduating from the school in 1943.

When the German army occupied Hungary, on 19 March 1944, Lidia was studying French and English at the Notre Dame de Sion convent institute in Budapest. On 10 June, the Rosenfeld family arrived at the "Judenrampe" of Birkenau[63]. The young sisters were found fit for work but their 46-year-old mother was sent to the gas chamber. Their 48-year-old father dug tunnels in Austria and died in an American hospital in May 1945.

The sisters went through the "reception ceremonies" in the Central Sauna; a hall with female barbers and shower rooms – rites of passage into slavery. These were followed by four weeks in the horrendous quarantine camp – absolute, atrocious inhumanity. On 8 July 1944 there was the registration and tattooing. Lidia became A-9618 and the new name for all the Jewesses: Sara. Lidia and her sister were then transferred to the women's work camp. They worked in the "Union" munitions factory in Auschwitz.

On 1 October 1944 they were transferred to a small new camp in Auschwitz[14]. Lidia became very ill on 20 December and was hospitalized and forgotten.

On 18 January 1945 Auschwitz was liquidated and evacuated. The death march[37] was three days of concentrated horror ending with a stand-up journey in a "freezer train" to Ravensbrück concentration camp[36] in Germany, arriving late one evening. The sisters felt imminent death. Lidia was registered with a new number – 99626.

In mid-February they were transported to Neustadt-Glewe, a sub-camp of Ravensbrück. By then the sisters were infested with hundreds of lice. They worked in the Dornier aircraft factory. They were self-liberated on 2 May 1945, and the Soviet troops arrived soon after.

Back home in Romania, Lidia was reunited with her fiancé, Bela Vago, and they were married on 21 October 1945. They both achieved university diplomas and in 1949 got teaching appointments at the university. Lidia is now fluent in six languages. Their son Andrei (Raphael-Rafi) was born in 1946 and Anton (Ariel) in 1955. The family made *aliyah* in 1958. Lidia taught English at high schools and Bela became a professor of modern history at the University of Haifa. Tragedy struck in 1984 when Bela suffered a near fatal stroke in New York. Lidia took care of her husband on her own for 18 years and he died five years later in a nursing home.

Lidia devoted her years of retirement to some worthy Holocaust-related projects. She is the head of the Auschwitz "Union" Survivors' Organization. She also helped to raise funds to erect a commemorative sculpture by the Danish sculptor, Joseph Salamon, at Yad Vashem[48], dedicated to the memories of Ala Gertner, Roza Robota, Regina Safirsztajn and Ester Wajcblum, the four women who sacrificed their lives to aid in the revolt by the Sonderkommando in Birkenau on 7 October 1944[64]. Lidia headed the committee that traced the survivors of the Jewish Gymnasium and organized their first world reunion, as well as compiling an album of more than 300 photos connected with their school.

Lidia's revenge: "Our two sons, our six grandchildren and our six great-grandchildren. And our old–new land, the State of Israel, with its old–new language – Hebrew – the mother tongue of our grandchildren and great-grandchildren."

*Pages 134–135*
Moshe Shamir
Ein Gedi, Israel

Moshe Shamir was born on 14 July 1944 in Samarkand, Uzbekistan. His father, Berek, was an officer in the Polish army who later had a business as a furrier. His mother, Pesa, was a housewife.

Sensing the impending danger when the war began, the family travelled to Czechoslovakia. In 1946 they crossed over to a displaced persons (DP) camp[26] on American territory in Germany. In April 1948, in spite of the British Mandate forbidding Jews to emigrate to Israel[65], he boarded the *Pan York* at Marseilles with his parents and maternal grandparents. This 4,570-ton American steamship was used by the Mossad LeAliyah Bet (a branch of the defence organization Haganah) for the illegal immigration of Jewish refugees into Palestine[61] and was given the unregistered name Kibbutz Galuyot, which means "ingathering of the exiles".

Moshe was educated in Israel and, after his mandatory army service, decided to go to the US, where he studied marketing. On a trip back to Israel, he met his wife, Heather, who was originally from South Africa. They married and had two daughters, Joy and Rona.

After 16 years in the US, the family moved back to Israel to live at the kibbutz at Ein Gedi on the western shore of the Dead Sea. Moshe's various roles within the community have included managing the kibbutz and looking after the health and welfare of the 200-plus inhabitants. Moshe retired in January 2016. He has five grandchildren.

WITH HARRY BORDEN (NOT RELATED) AND MIRIAM HECHTMAN (NOT RELATED)

*Pages 136–137*
Pr. Irene Eber
Jerusalem, Israel

Irene Eber (née Geminder) was born on 29 December 1929 in Halle (Saale), Germany, to Helene Geminder (née Ganger) and Yedidia Geminder. After she and her family were deported from Halle in October 1938, she lived in her father's small town, Mielec, in Poland, where she attended the Beit Ya'akov School for Girls.

Irene's life as a pupil ended when the German armies invaded Poland in September 1939. The Germans burned large parts of Jewish Mielec, killing numerous Jews. Years of fear followed and, for nearly two years thereafter, Jewish boys and men were caught in the streets and taken to forced labour camps[29]. Irene attended a clandestine school for several months, as education for Jews in public schools was forbidden.

At the beginning of March 1942, it was ordered that Mielec be cleared of all Jews. After many old people were murdered and younger men consigned to work camps, the rest of the Jewish population was sent to the vicinity of Sobibór extermination camp[25] in Poland. Although Irene's family managed to escape, they were soon deported, being moved from place to place until ending up in the Dębica ghetto in Poland. When the ghetto was converted into a work camp in the autumn of 1942, the 12-year-old Irene escaped. She returned to Mielec and was hidden by a merciful Polish family.

At the end of war in 1945, her mother and sister had miraculously survived on Schindler's list[66] and found Irene. The three travelled to Germany in search of relatives, and in 1947 Irene left for the US. There she decided to study Chinese and applied for a scholarship to attend Pomona College in California. Despite never having attended high school, she earned a BA *summa cum laude* (with the highest distinction) in three years.

Irene married and continued her studies, with fellowships from Claremont Graduate University enabling her to earn a Ph.D in Chinese studies. In 1969, when the Department of Asian Studies at the Hebrew University of Jerusalem was established, she came at last to Israel, where she is the Louis Frieberg Professor of East Asian Studies (emeritus). She has lived in Israel ever since, teaching, doing research and writing. She is now retired and has written, edited and translated ten books as well as many articles. Her research in recent years has dealt with transcultural Jewish–Chinese relations, including the Chinese translation of the Hebrew Old Testament. Irene has two children and three grandchildren.

*Pages 138–139*
Relli Robinson
Haifa, Israel

Relli Robinson was born on 11 March 1939 in Warsaw, Poland, to Franka (née Fersztendik) and Michał Głowinski. She moved to the Warsaw ghetto with her parents and maternal grandfather, Dawid Fersztendik, at the time of its establishment in 1940. In January 1943 she was rescued from the ghetto and taken to a hiding place with a Polish couple, Janina and Józef Abramowicz, who saved her life under an assumed identity. Living with her Polish rescuers, Relli was the only member of her family to survive the Holocaust. Both her parents and her maternal grandfather were murdered in the massacre[67] that took place at Trawniki forced labour camp[68], near Lublin, on 3 November 1943.

In 1950 Relli arrived in Israel, where she lived in the home of her father's family, in Pardes Hanna. After graduating from Kfar Hayarok Agricultural High School, she served in the Israel Defense Forces engineering corps and in the navy. She studied in Jerusalem at the Hebrew University and in Los Angeles, California, at UCLA. She married her husband, David Robinson, in 1962. For over 30 years she held senior academic executive positions at the University of Haifa, Israel, the last of which was executive head of the Welfare and Health Sciences Faculty.

In 2011 she published *Raking Light from Ashes*, a novel relating the true story of her survival during the dark days of World War II. It reflects a child's struggle to comprehend a world gone mad and her determination to become mature and optimistic – always to look for light. The book unfolds a wide, panoramic human drama that begins in conquered Warsaw and ends in the independent State of Israel. *Raking Light from Ashes* has won a grant from the Israeli Ministry of Culture to be translated into English and hopefully published in an English-speaking country.

Relli Robinson is a resident of Haifa, Israel, a mother of a daughter, Michalle, and a son, Nattiv, and a grandmother of six grandchildren.

*Pages 140–141*
Roni Raanan
Herzliya, Israel

"I was born Renato Abeasis in Tripoli, Libya, in 1928. As my father had been born in Malta, a British colony at the time, the family members were British nationals. I had one brother and two sisters. In those days, living among the Libyan Arabs was peaceful.

I studied in an Italian school and made good progress in my studies until Mussolini came to power and joined with Hitler to spread hatred against the Jews. Slowly the situation deteriorated, so we moved to a Jewish school run by Italians. In 1940, under a dictatorial and Fascist regime, Jews were forced to quit school. I was 12 years old. By then, the war was in full swing, with British and American fighter planes bombing Tripoli nearly every day.

Those of us with British citizenship were suspected of helping the British, so we were transferred to Italy. In 1941 my father received a letter from the Fascist police that stated that the family should prepare to sail to an unknown location. On 17 January 1942 we sailed to Naples, unprotected through a sea full of mines. Worried that there were spies among us, they split us into two groups: Christians and Jews.

When we arrived in Naples, we were loaded onto a train that took us to a secluded place near the Adriatic Sea. The building was intended for seniors. We stayed there for two years under reasonable conditions, receiving aid from the Red Cross. The children studied in an improvised classroom. I celebrated my Bar Mitzvah there.

The British raided North Africa and southern Italy and ruled these areas, but the Germans managed to get to Civitella del Tronto before the English. When they found out we were Jews, they confiscated our food packages.

After two years, the Jewish group, consisting of 96 people, made the hard trip to the German concentration camp Bergen-Belsen[1]. After four days of an exhausting drive, we arrived there in May 1944 in a terrible state. At the entrance to the camp we were stripped, and our documents, passports, jewellery and anything of value were taken. At the camp gate was a sign stating '*arbeit macht frei*' ('work sets you free') as at Auschwitz[14] (the sign appeared at the entrance to a number of camps).

The conditions were extremely difficult, with 180 people living in one hut. We received three beds, each accommodating two people. Our bed was close to the toilet so we could not sleep because of the stench, as well as the cold and hunger.

Every two weeks we were ordered to take a shower at night-time, during the freezing cold or heavy rain, causing us to shout and scream. The water was cold and the soap was stamped with 'JUDEN'. There was no separation between parents and children. The Germans liked to abuse us and often turned off the water leaving us soapy. We were plagued with lice at the time. The hardest part was that we had to behave like animals, where only the strong survive. Hunger took over and we could not hug or comfort one another. Conditions were so harsh that people became indifferent and unsympathetic to each other as each person fought for scraps of food. When my father's dad sliced a piece of bread, everyone would lunge at it like an animal. The will to survive took over any kind of human emotion.

Carved into my heart is the time they took my brother, George, to work on the roads. The hunger and cold were so unbearable that he collapsed. The *kapo*[69] started yelling at him. At some point, my brother got up and began to beat the *kapo*, until a German arrived with a weapon and imprisoned George in a bunker.

The level of hygiene in the camp was very poor. We ate turnips cooked in water and stale spinach soup full of worms. I remember that I stole turnip and potato peelings.

We didn't imagine there was a crematorium at the camp. We saw piles of bodies, but we did not ask questions because we had other existential questions – there are things that are hard to explain.

One night in 1944, at around 3am, we were woken up and given bread, margarine and jam, which pleased us very much. We were then gathered into a large hall to be counted. One person was missing, and one of the guards pointed out that one was in a bunker. The German officer gave an order to release the person immediately. When George arrived, everyone cried so much to see the severe state he was in and his inability to stand up on his own.

A person in charge of us told us to prepare for a trip. Driving through the night in buses and cars, we found ourselves in the morning at Biberach internment camp[70], near Biberach an der Riss, in the south of Germany. At the camp, we were treated well, received medical treatment and were provided with everything we needed to survive.

In April 1945 France announced that we should leave German soil. Some left for the US, some came to Israel, and my family went back to Libya.

During 1947, and as the State of Israel was declared, the situation deteriorated for Jews in Tripoli. As if our suffering the horrors of the Holocaust weren't enough, the Arabs of Libya were actively looking for Jews in order to injure and kill any they could find. There was nowhere to go because war was raging in the new State of Israel as well. Eventually, out of fear of persecution, my mother decided to make *aliyah* in 1951.

In Israel I joined the army and became a radio operator. I was happy to serve my country despite the harsh conditions. Following my discharge, I worked for the postal service. It was during that time that I met Amalia Felus, who later became my wife. Five months after our wedding, I started working for the government, where I was employed for 37 years. Amalia and I had four children, six grandchildren and one great-grandson. My oldest son, Drori, unfortunately passed away in 2000. Our remaining children are Yael, who lives in Israel and has three beautiful daughters; Meir, who is single and lives in Los Angeles; and Mony, who is married and lives in Costa Rica."

*Pages 142–143*
Ruth Lavie Jourgrau
The Jezreel Valley, Israel

"I was born in Amsterdam, Holland, on 21 October 1934. My parents, Dov (Dubi) Jourgrau and Lea Jourgrau (née Friedmann), met in Palestine in 1923 or 1924 and got married there. My father was born in Radautz, which was then in Austria (and is now in Romania), and my mother in Tarnów, Poland. She went to Palestine with a group of *chalutzim*, or pioneers, who established Kibbutz Beit Alfa. My father went as the first of his brothers, to find out if they could emigrate, too. Since the kibbutz did not want him to study, they moved on to Jerusalem, where my father worked with architects.

Later he studied carpentry in Bodenbach, Austria. My mother went to live in Amsterdam, where her brother was living. When my father returned to Amsterdam, he had his own workshop where he made beautiful furniture. My mother was a housewife.

At that time, Holland was occupied by the Germans, and gradually life became very bad. Around the end of 1942 or beginning of 1943, we went into hiding; non-Jewish friends helped us to find hiding places. Somebody betrayed the family that was hiding my mother, and so she was captured and sent to Westerbork, a Dutch transit camp[22] for Jews before they were sent to Poland. My father learned this and left his hiding place, after having come to me crying that they had taken my mother. I never saw him again – I was told he let them catch him.

My mother was sent to Sobibór extermination camp[25] in Poland and was gassed the same day. Father was in Auschwitz[14] for almost a year doing slave labour, and nobody knows how he died.

From that time until the end of the war, I was hidden by around 17 families, one after the other, throughout Holland – three times with a group of 10–12 other children. The woman we were with moved from place to place – a dangerous operation! During that time I never left the homes of my rescuers. I had many hiding places, mostly in lofts where old furniture and suchlike was piled in front of panels that hid the little recesses.

One time Germans approached the farm of a family I was staying with without their knowledge, having been informed that a little Jewish girl was hiding there. The soldiers entered the house without invitation and appeared suddenly in the kitchen. I was sat at the kitchen table writing something. The farmer whispered 'put your head down, don't look up'. The soldiers wandered through the house without giving me so much as a look! The family had taken in two refugees from South Holland who had fled to the North because there was fighting nearby; these girls had dark hair, so the Germans asked for their papers. The older one started to flirt with them and, because of this, they didn't look at me. After they went away I cried for a long time.

Another time when the Germans came I was put in a hiding place. The soldiers didn't find me and went away. It was quiet in the house and I waited for someone to let me out. But nobody came and I lay there crying for hours – even wetting my pants. Later the family told me that the Germans had come back a second time, wanting to surprise them and thus find me out of my hiding place, so they could not let me out. I thought the family had forgotten me, yet it was lucky I didn't escape by myself. I was hysterical and cried for so long that the family fetched a doctor who knew of my existence. He gave me some medicine and I finally calmed down.

At the end of the war I was liberated by the Canadian army at a farm in North Holland. I waited a long time for someone to come and fetch me. I waited for my parents even though I knew in my heart they were dead. I felt it. The farmer had put my name on a list that was published in Amsterdam and one day a woman I remembered as a friend of my parents came and took me back to the city with her, and her family took me in. I didn't feel happy there, so another family, also friends, took me to their home and there I was relatively happy and adjusted quickly to family life with this couple and their two daughters, one of whom was the same age as me. I started to live again and felt loved. At school I was a very good student so, the following year, I skipped fifth grade and joined the sixth class in my old school with children I remembered from the first grade. During the war I did not learn at all, of course, but I read every book I could lay my hands on, including the New Testament.

Later on, my father's brothers, who were living in Palestine, located me. They wanted me, the daughter of their oldest brother, with them, so they took me to Palestine just before the Israeli War of Independence despite the fact that I had already changed address so many times and finally felt happy. Another war...

I did not adjust to the family in Palestine at all. It seemed to me they hadn't wanted me in truth but were afraid of what people would say if they wouldn't take me in. After a year I told them I wanted to leave for a boarding school, and after telling them I would do nothing at school if they would not let me go, I was allowed to leave for an agricultural school in Nahalal. I was there for three years, and met a boyfriend – Amnon Lavie (before that Palewitch). We were married after I graduated in 1953. We had four children – three girls, Vered, Nama and Leah, and a boy, Dov. Sadly, Leah died when she was just under a year old from a heart disease.

I have six grandchildren (two from each of my children) and three great-grandchildren. My husband Amnon died in 1991.

Now I live alone in my home on a moshav (co-operative agricultural community). My son lives in the same community. My oldest daughter lives in Tel Aviv and my youngest in Zurich.

I have written a book called *Roots in the Air* to describe the rootlessness I felt after changing places so many times. The book was published in Israel as a private edition, and in Holland it was published in Dutch by a traditional publisher. People bought it and there was a second edition, too.

Sometimes I write pieces for the Dutch–Israeli community in Israel. The organization sends a newsletter now and then to all members by email.

My life now at the age of 81 passes quietly (if only there was no war here). I study 'Modern History' one day a week at the regional college for elderly people, walk a lot, visit family and friends (I still drive my car), have a boyfriend (but we do not live together) and 'live my life'."

*Pages 144–145*
Jack Jaget
Herzliya Pituach, Israel

Jack (Kuba) Jaget was born in 1935, in Bóbrka in Poland, to Leon and Sarah. When the Nazis took over all the Jewish businesses and homes in the town in 1942, a law was passed that you could no longer own your home or business. Leon therefore worked in the restaurant that he had previously owned. Once the persecutions started, Sarah predicted that the Nazis would kill all the Jews, and she felt they should find a hiding place. Leon said that what happens to other Jews will happen to them, but Sarah responded: "I want to live." The family knew a Polish farmer from a nearby village, and Sarah proposed to the farmer: "If you will hide us, then this building we own will be yours." She thought it would all be over in six months.

The farmer hid them for 22 months under a pigsty near his house. A Ukrainian boy helped to dig a ditch where the pigs stood and then covered it over. The family lived in this ditch and couldn't stand up for the entire time they were there. Jack's twin brother, Philip (Lipa), and his sister, Cecelia, couldn't walk when they finally got out. Though his whole family survived the war, they were the only family from his town that did. "Of our 96 friends and children that we knew, nobody survived except me and my siblings."

After the war, the family eventually ended up in Germany in the American displaced persons (DP) camp[26] Foehrenwald. From Germany they travelled on the ship *Marine Perch* to the US, arriving in New York City on 13 May 1946.

Jack first attended *yeshiva*, then studied music and art at high school, and received a scholarship to study graphic design at the Cooper Union. He worked for the publishers Simon & Schuster, World Publishing and Viking, worked on *MD Magazine* and designed children's books, including working with Eric Carle (most famous for his children's book *The Very Hungry Caterpillar*).

Jack met his Israeli-born wife, Varda, when she visited New York and they married on 28 May 1961. They lived on Long Island, New York, until 1974 and then emigrated to Israel. They have three children, Rina, Doron and Hadara, and six grandchildren. Jack's brother and sister live in the US. His parents moved to Israel, but his father passed away in 1976 and his mother died about 15 years later.

Jack has met with the children of the family that hid his family during the war. Drawings that Jack drew in hiding are now in Yad Vashem museum[48] in Jerusalem. He still has his father's yellow star.

WITH VARDA JAGET (WIFE) AND MIRIAM HECHTMAN (NOT RELATED)

*Pages 146–147*
Sarah Capelovitch
Rehovot, Israel

"I was born in Kovno (Kaunas), Lithuania, on 1 December 1937 to parents Chaja Schilingovski-Bolnik and Zvi Schilingovski. My father was murdered on 18 August 1941 in the 9th fort outside Kovno as part of the mass murder of Lithuanian Jewish intelligentsia[71] that occurred that year, after being moved into the Kovno ghetto. At the age of five, I was smuggled out of the ghetto just before they took all the children away. I was hidden among the brigade of women as they left at dawn to be taken to a work camp[29]. My mother and my aunt, Dr Bela Baron, a dentist, pushed me into a doorway by the bridge. I then had to cross the bridge myself, to be met by the son of a Gentile woman, Konstantza Brazeniene, Mindaugas. Konstantza hid me for a year at her house while my mother was at the horrible Stutthof concentration camp[72] in Poland. Thankfully, she survived Stutthof.

I am known as Cookie to other survivors and to my family and friends – Sarah was my middle name. I was baptized into Catholicism during the Holocaust and named Katerina, or Katerinele, by my 'Tetule' (auntie in Lithuanian). I was robbed of my childhood and have no possessions from that time – only the embroidered wall hanging that you see in the photograph. We moved to Israel in May 1948, during the War of Independence. I met my husband, Peter Bernard Capelovitch, in Montreal, Canada, while studying at McGill University after completing my military service in Israel and being released in September 1958. We married in Israel in July 1961 while I was on summer holidays from university. After returning to Canada I eventually made *aliyah* with my husband and two daughters in 1973, just before the Yom Kippur War. For me it was a homecoming."

*Pages 148–149*
Shalom Eilati
Jerusalem, Israel

Shalom Eilati (Kaplan) was born in Kovno (Kaunas), Lithuania, on 21 May 1933. His mother, Leah Greenstein-Kaplan, was a nurse and poet, and his father, Israel Kaplan, was a teacher and writer. In 1941 he and his family were imprisoned in the Kovno ghetto, where he survived the Kinder Aktion (murder of the children) in March 1944. That year, on his mother's initiative, he escaped from the ghetto, crossing the river in a boat and walking alone past the guards. He owes his life to six brave Lithuanians, who hid him in two different sites.

Shalom survived the war but his mother and little sister, Yehudith, did not. Yehudith had been smuggled out of the ghetto several months before him and was well looked after for six months by a childless couple and the mother of one of them. Yehudith became like a daughter and granddaughter to them. Then, inexplicably, only a month or two before the liberation the husband took her to the Gestapo[3].

Shalom's father, who had previously been deported, had endured a series of concentration camps[10], including Kaiserwald[73] in Latvia and Dachau[9] in Bavaria, and then, at the age of 42 and weighing only 30kg (66lb), he survived the death march[37] just before the end of the war. From the first days of liberation, he began to collect fresh, authentic testimonies of the survivors, which became the cornerstone of the Yad Vashem[48] archives in Jerusalem. He reached Israel in 1948 and became a historian of the Lithuanian Jewry. Author of multiple works of literature, his writings in Yiddish – among them a collection of black humour from the concentration camps (*Jewish Folk Expression under the Nazi Yoke*) – were highly thought of. He died at the age of 101.

Shalom returned to Kovno after the liberation, living for a time in a Jewish orphanage. In 1946 he went to Palestine, finishing junior school in Tel Aviv and high school in Tel Yosef in the Jezreel Valley. He became a member of Kibbutz Tel Yosef, and later served as the secretary of the kibbutz.

He served as an officer in the Israel Defense Forces, an agronomist with a Ph.D in horticulture, a tour guide and a publishing editor. He was one of the volunteers who prepared the ground for the agricultural settlement of Kibbutz Ein Gedi near the Dead Sea. Later he was a regional viticulture researcher in the Arava valley in southern Israel and a lecturer in horticulture at the Hebrew University in Rehovot.

Shalom was among the founders of the Israeli Environmental Protection Service and, from 1974 to 1980, he served as the editor of its national annual report. Between 1981 and 1994 he compiled the *Cathedra*, a scientific quarterly published by Yad Ben-Zvi on the history and settlement of Israel.

In 1999 he published in Hebrew a literary autobiography, *Crossing the River*, about his childhood during the Holocaust. The English version was published in 2008 by the University of Alabama Press and was widely reviewed. In 2009, he made a highly successful book tour in the US. A paperback edition was published in 2013. The book has been translated into German (*Am anderen Ufer der Memel*) and was published in 2016 by the Denkmal Stiftung in Berlin.

Shalom is married to Miriam and lives in Jerusalem. He is father to two daughters, and a son, and has five grandchildren.

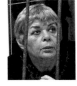

*Pages 150–151*
Vera Meisels
Tel Aviv, Israel

The writer, poet and sculptor Vera Meisels was born to Cecilia Meisels (née Gardos) and Zoltan Meisels in Prešov, Czechoslovakia, on 10 June 1936. On 23 December 1944, at the age of eight, after five days of travel in a train wagon without food and water, she was taken to the Theresienstadt transit camp[15]. She had travelled via Auschwitz[14], where the Commandant refused to take her party in (they even didn't open the door of the train's goods wagon) because the gas chambers and the crematoria had recently been destroyed. In 1949 she emigrated to Israel. She studied sculpture at the Avni Institute in Tel Aviv, married and had two children, her daughter Yael, born in May 1968, and her son Ofer, born in September 1971. Today Vera lives in Tel Aviv. She gives testimonies and lectures about her childhood during the Holocaust.

Her sculptures are in collections around the world, including the "Survivor" statue in the US Holocaust Memorial Museum, Washington DC, and statues in the Yad Vashem museum[48] in Jerusalem, the Slovak National Museum in Bratislava, and Israel's Beit Theresienstadt museum.

Vera has published stories, poems and books, including *Searching for Relatives* (Gevanim, Israel, 1997), poems in Hebrew; *Svetluska v Terezine* (G&G, Prague, 2001) in Czech; *'s Firefly* (G&G, Prague, 2001) in English; *Moje vytrhnute korene* (SNM, Bratislava, 2005) in Slovak; a story in *Salty Coffee: Untold Stories by Jewish Women* by Katalin Pécsi (Novella, Budapest, 2007) in Hungarian and English; *Threshold of Pain* (ebook from https://verameisels2.wordpress.com) in English; and *Shred of Memory* (Stiematzky, Israel, 2015) in Hebrew.

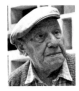

*Pages 152–153*
Yaakov Kronenfeld
Rehovot, Israel

"My father was born on 6 February 1919 in Gura Humora (Gura Humorului), a small town in northern Romania. He had three brothers and four sisters. He was at school until the age of 14 and then worked at the family's bakery. In 1941 they were transferred to a work camp[29] in Transnistria (which, with the German invasion of the Soviet Union, had become a Romanian-controlled territory with Odessa as its local capital). There he did forced labour building a bridge over the Southern Bug river between Trihati and Nikolaeve. In 1945 Yaakov was able to come home, where he was employed in the bakery until 1947, when he received confirmation that he could emigrate to Israel.

The ship he was travelling on from Romania was diverted to Cyprus by the British army, and Yaakov stayed in Cyprus for two years. He married my mother Rachel in Cyprus, and my sister Bilaha was born there in 1949. That year, they emigrated to Israel. I was born in 1953. Yaakov worked at a bakery until 1968, and he subsequently worked in the military industry until retiring in 1989. My mother passed away in 2001, and my father in 2014.

We are a very proud family. My sister was a nurse for 42 years at a hospital in Be'er Sheva, retiring in 2014. She has three children and five grandchildren. I am an electronics engineer and have worked as a high school teacher for 28 years. I have three children and four grandchildren."

ARIE KRONENFELD (SON)

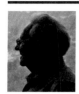

*Pages 154–155*
Janek (Yona) Fuchs
Haifa, Israel

Janek was born in Lwów, Poland, in 1925 to Zilla (née Catz) and Aaron Fuchs. He studied at the local Jewish school, and he and his older brother, Moshe (Mundek), learned Hebrew and received a Zionist education at home.

In June 1941, as the Germans entered Lwów, Janek witnessed the Lwów pogroms[74] in which thousands of Jews were murdered over just a few days. In November that year, the surviving Jews were ordered into a ghetto[13]. Because of his "Aryan" look, Janek was encouraged to escape by his parents. His father obtained a forged birth certificate for him and sent him to stay with a non-Jewish friend in a nearby village. Longing for his family, Janek returned to Lwów a few weeks later. In the ghetto Zilla died as the result of an untreated disease. In the summer of 1942, most of the ghetto residents were sent to the Bełżec extermination camp[51] in Poland. Janek, his father, Aaron, and his brother, Mundek, hid in an attic, but they were later taken to the Lwów-Janowska concentration camp[2] in Poland.

On Christmas Day 1943 Janek and his friend Marian Pretzel took advantage of the guard's drunkenness, dug underneath the fence and escaped. Wearing clothing they had taken from the camp, they pretended to be Polish tradesmen and travelled east to Kiev. There they found work in a German company, where, because of his fluency in German, Janek was appointed the company's interpreter and was sent to Lwów to recruit more workers. He leveraged this assignment to bring 20 Jews from Lwów to Kiev, among them Aaron and Mundek. All 20 were saved except for his father and brother, who were murdered in Kiev by the Gestapo[3]. During his trip to Lwów, Janek found documents belonging to a German soldier in the train's lavatory. The documents helped Janek and his partner Marian to obtain German army uniforms. With Marian expertly forging the stamp on the documents, the two of them posed as German soldiers and were able to travel across occupied Europe.

Narrowly escaping the Gestapo, they arrived in Bucharest, Romania, where Janek purchased a weapon and used it to train youngsters of the Gordonia youth movement (a Zionist youth movement founded in the 1920s that had gone underground in 1941). On the request of Gordonia, Janek and Marian later travelled to Budapest, Hungary, endangering their lives again to smuggle a Jewish girl to her family in Romania.

In November 1944 Janek emigrated to Israel, where he made his home in Haifa. He had one son, Michael, with his first wife Hanna. He met and married his second wife, Ina, in 1962. He raised three children and is grandfather to fourteen grandchildren and two great-grandchildren. Janek has been active for many years in providing testimony and legacy of the Holocaust to future generations, lecturing in Israel and abroad to schoolchildren, university students, soldiers and many more. His story was documented in his book *Field Post 27023* and is mentioned in the books *By My Own Authority* by Marian Pretzel (1985) and *My Private War* by Jakub Gerstenfeld-Maltiel (1993). An ABC network documentary "Outwitting Hitler" was broadcast in the US and Australia.

Janek claims that his survival was a result of three "Ls": Looks, Language and Luck. We, his family, add to those qualities his courage, energy, determination, positive attitude and optimism.

WITH TOMER FUCHS (SON)

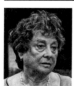

*Pages 156–157*
Agi Muller
Connecticut, USA

"I was born in Budapest, Hungary, on 12 May 1935 to parents Dora Donner and Joseph Fertig. The war was looming, which is why I am an only child – my parents feared for the future. Hitler's army marched into Budapest in the spring of 1944 and the city was liberated by the Soviets later that year. During all those months, my mother and I were hiding in different places, while my father was seeking new places for us to hide. Life was still difficult during the Soviet occupation. My mother passed away in early 1951 from illnesses she incurred during the war.

After finishing high school I attended college. During the Hungarian Revolution of October 1956, I was able to leave the country and so I headed to the free world. In the beginning I worked at all sorts of jobs, as I didn't speak English. In 1963 I got married to Thomas Muller, another Hungarian, and we had two wonderful sons. David, the first child, went overseas after finishing college and lives in London with his second wife and their son; David's daughter from his first marriage is studying in Holland. Our second son, Roland, stayed in the US and is currently living in New Jersey with his wife and younger son, who is finishing high school. Their older son is studying at the University of Indiana. Now that my husband has passed away, they are the only family I have on this continent."

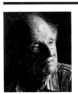

Arno Roland was born Arno Rosenfeld in Berlin-Wilmersdorf, Germany, on 14 April 1923. He was the son of Erich Rosenfeld, the owner of a picture frame moulding factory that was started in 1879 by Arno's grandfather, Arnold Rosenfeld. Arno's mother was Gertrude Rose from Hanover, Germany.

Gertrude loved Berlin and what the city had to offer. She appreciated art and had a liberal perspective. The rising difficulties for Jews in Germany distressed her beyond endurance. In September 1938 Gertrude went to a hotel and took an overdose of barbiturates – the police commented that many women had done the same recently.

During the Kristallnacht[11] in November 1938, Arno's father was in Holland on business, and he registered Arno and his brother, Ulli, for a Kindertransport[17] to Holland. Both boys left Berlin for Holland in 1939.

In the Dutch city of Eindhoven, they were sent, along with other teenage boys, to the Dommelhuis (a large retirement home with many rooms), where Jewish children fleeing Germany and Austria were temporarily housed. Arno observed: "It was in this setting that I found myself for the first time in my life in an all-Jewish company. There was a mixture of liberals, Zionists and religious youngsters. Coming from a mostly non-observant home, I was intrigued by and drawn to the Zionists because of their idealism. Interestingly, one of my best friends was Orthodox, whom I admired for his honest beliefs held without fanaticism." The group of refugees was transferred to a new location, in the centre of Rotterdam, in late 1939.

In May 1940 the Nazis invaded Holland and German bombs destroyed the new refuge. Arno described the scene in Eindhoven: "I watched from the sidewalk as the German troops marched into the city. And I realized that we had not travelled far enough with the Kindertransport to be in safety as my father had intended."

Arno's father had remarried, and in 1941 he left Berlin for Lisbon, even though it was highly unusual for a Jew to be able to leave Germany during the war. He stayed in Portugal for two years before being able to move to New York in 1943.

Arno found shelter with the Grünfeld family in Eindhoven, then the Linnewiels in Arnheim. Ulli lived with a family in Amsterdam. Then in 1942 they had to go into hiding to avoid deportation, but Ulli was arrested in the street wearing the yellow star. He was sent via Holland's Westerbork transit camp[22] to Auschwitz[14], where he was killed on 21 August 1942 – he was 16 years old. Arno was saved by a Dutch couple, as he explained: "In 1942 the Dutch Resistance brought me into a hiding place. My protectors were a 70-year-old couple, the Hurkmans, who had declared themselves ready, based on their socialist convictions, to save a young boy from deportation. For this act they would have faced the death penalty if my hiding place had been betrayed."

He described his life at that time: "Two years alone in a cold attic, staying in bed during winters to keep warm, itching with frostbite and fleas, I created pictures from veneer, played chess games, read English texts and read Tolstoy's *War and Peace* a dozen or so times to keep my sanity." (Arno said that, until relatively recently, "I had never confronted this part of my life in any detail, much less written about it. The workshop [which he attended many decades later] opened my mind to a past I had never revealed to myself, let alone to others.")

Arno explained how this came to an end: "One night in the autumn of 1944, I peered through the small attic window at the black patch of sky that had been my horizon for endless time, when I saw the air lit white and a sea of huge balloons floating toward the ground. Then, in seconds, the dark took over again until the next round of chasing light beams rolled across the sky and caught the drifting parachutes. And it began to sink in that the hour of liberation had reached this town at last."

After his liberation in 1944, Arno joined the British army as an interpreter in a Scottish regiment until the end of the war in Europe. He then volunteered for the Dutch army to help liberate the Dutch East Indies from the Japanese.

Much against his wishes, he joined his father in the United States in 1948. "The emigration to America meant, in effect, losing roots and identity again. I started to work for ten hours a day in a factory to earn money for my engineering studies. For ten years I commuted by subway in the evening, after a full working day, to New York University engineering classes and then graduate studies and a degree at Stevens Institute of Technology in New Jersey."

His first job was at IBM. He subsequently became an industrial engineering consultant with the Singer Sewing Machine Company for their European operations, and spent time working in London, Mexico, Russia and Germany. In the 1960s Arno moved to Leonia, New Jersey, where he bought a house, where he participated in local activities, including the community theatre, and was elected to the Leonia town council.

Although Arno had many friends, he remained solitary to the end of his life, unmarried and without children or close relatives. For much of his last 15 years, his close companion and partner was Lotte Noam. Together they spent time in Leonia, Switzerland, Israel and Berlin, and on many travels around the world. Arno died in Leonia on 8 August 2015, aged 92.

ELI NOAM

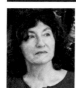

Ava Schonberg was born in Antwerp, Belgium, on 18 January 1937. She has two sisters: Celine, born in 1935, and Alice, born in 1941. Her parents were Rosa (née Elowicz) and David Schönberg, who were both born in Poland and had come to Belgium in 1935.

In September 1942 David was deported to a concentration camp[10] near Auschwitz[14] where he was killed by the Germans. Ava has no memory of her father. Following his arrest, Rosa was warned that she had been denounced to the Gestapo[3] for being a Jew, so she had to go into hiding with her three daughters. Rosa was hidden in an attic in Brussels, while Alice, the youngest, was placed with a family that treated her horribly. Celine and Ava were first hidden in an orphanage, then in a convent.

In April 1944 the Belgian underground smuggled Ava, her sisters and their mother into Switzerland[75], via France. In Switzerland, Ava was placed with a family in Zurich until the end of the war, Celine with another family, and Alice and Rosa in a Swiss refugee camp called Morgins.

When the war was over, they returned to Antwerp. Rosa remarried in 1950, to Rabbi Chaskel Halberstam, whose family had been killed in the war. In October 1953 the family emigrated to the US and settled in New York City.

Ava had a career in cytology, which she studied at Cornell University's medical college. She then worked in a major New York hospital where she became in charge of a cancer diagnostic lab. She also had a fine arts background, took early retirement and started painting again.

Although Ava did not marry, preferring to remain free, for 32 years she had a wonderful companion, Joseph Schwartzman, one of the World Trade Center architects. They were together until he died in October 2011. Ava still lives in Manhattan and continues to paint, and has shown her work in various galleries. Her sister Alice lives in Belgium and Israel, and Celine lives near Boston.

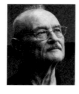

"Born in Warsaw, Poland, on 15 April 1936, I was just a young child when the Warsaw ghetto wall was erected in 1940. My family was then relocated to the ghetto. The streets were crowded with people and beggars. Bodies of children and old people littered the sidewalks. We were always hungry, and we feared capture and certain death.

My mother, Leokadia Sieraczek (née Ajzenberg), was captured by the Nazis in 1941 and executed. My father, Henryk Sieraczek, through his contact with one of his 'Aryan' friends, Jurek Bończak, arranged in 1942 my escape from the ghetto to stay on the friend's family farm in Ożarów, Poland. I lived in an old farmhouse, where I was hidden in a dark attic for over a year. After that I was allowed to live in the house except when visitors were expected.

In 1945 my father picked me up and we relocated to Wrocław, Poland. Our family was gone, and we wanted to leave Poland to emigrate to the US. From Wrocław we travelled in 1945 by freight train to the American Occupied Zone in Germany. We lived there in Zeilsheim, a displaced persons (DP) camp[26] near Frankfurt, from where we emigrated to the US in 1951. Here my father changed his and my name to Sears during the naturalization process.

In the US I studied electrical engineering and worked for Honeywell Aerospace for 40 years, earning 11 patents in my field. I am married, and my wife, Yael, was a chemist. Our son is a senior manager for a software company and our daughter is a professor in art history at Yale University. We are retired and currently live in Boulder, Colorado."

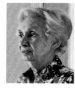

"I was born Esther Lea Helszajn in 1930 in Brussels, Belgium, and was raised in a middle-class Jewish family with two younger brothers who were twins. I had a normal childhood until 1939. When the Nazis entered Belgium, we fled to France and my father was transported to England by the military. My mother, brothers and I returned to our apartment in Brussels, where we lived in constant fear of deportation. We Jews had to wear the yellow star during the day, observe the curfew every night and endure daily raids by the Gestapo[3].

In 1942 we all went into hiding at separate locations – I was in a convent. Living in a convent was a totally different life. I was forced to give up my religion and beliefs and to live without all that was familiar to a child who had grown up in a Jewish environment.

I stayed there until September 1944 when the Allied troops entered Belgium. My mother and brothers had survived, and my mother picked me up. The four of us stayed another year in Brussels, until my father, who was then living in London, was able to arrange the necessary papers for us to join him there.

After the war I met my husband, who was a soldier in the Jewish Brigade[60]. We fell in love but he had to return to Palestine and I was leaving for England. A year later he came to London and we got married and left for Palestine. I was 17 years old. We lived in a suburb of Haifa and had two children – Elana and Harry.

In 1956, after ten years, the four of us moved to the US because the little that was left of his family went from the camps in Germany to live there and wanted us to be together.

Life in New York was very difficult at the beginning, with no language skills and two small children to raise. As time went by it got easier, and all I can say is that the best thing we ever did was coming to New York. Sadly, my husband passed away, and now I am retired and living in Florida. In addition to my two children, I have two grandchildren and a great-granddaughter. They are the loves of my life. The war years notwithstanding, life has been good to me."

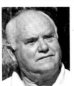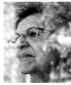

*Pages 166–169*
Bertha Strauss & Leo Dreyfuss
New York, USA

Bertha and her brother, Leo, were born in Karlsruhe, Germany, a city in the Upper Rhine Valley. Bertha was born on 5 January 1936 and Leo on 15 December 1937. Their grandfather was the last of a long line of Dreyfuss cattle-dealers who had lived in the area since the 18th century.

In October 1940, following the conquest of France, all Jews living along the French border were deported to camps in Vichy, France. Conditions were so bad that their parents gave them away to the Jewish organization OSE (Oeuvre de Secours aux Enfants)[21], which was allowed to operate children's homes, in the hope of a better future. In September 1942, after the police had raided the OSE children's home, Leo and Bertha were returned to their mother, to be deported. A few days later they were again taken out by the OSE. The last words their mother said to Bertha were: "Watch out for your brother." She was only six years old.

After leaving their mother, they were moved to various homes to escape police raids, at one point staying with French farmers in southern France. In May 1944 they were smuggled into Switzerland[75], to be taken in by their mother's cousin. The family included two younger daughters, which caused some friction – Bertha was treated rather like a Cinderella.

Two years later, they arrived in New York City, among a group of 23 refugee children, to live with their mother's sister, Tante Recha, who had been widowed the previous year. A week later they were enrolled in the NYC public school system, speaking Swiss German (with no one understanding them). After a summer of attending day camp, they were able to communicate.

Bertha graduated from school in 1954, to become a legal secretary. Three years later she married Walter Strauss. After giving birth to a son, she moved with Walter to Flushing, New York, where she became involved with Hillcrest Jewish Center, Hadassah[76] (the Women's Zionist Organization of America) and Israel. One of Bertha's greatest attributes is her cooking, and her cooking led to her freely catering fundraising luncheons and dinners for Hillcrest Jewish Center and for Hadassah. She eventually became Region President of Hadassah. Now widowed, Bertha still lives in Flushing and has two sons, two grandsons and two granddaughters.

Leo graduated from school in 1955 and went to work in a Wall Street brokerage firm. After three years he returned to school to study electronics but, after graduating, was unable to find employment, owing to a lack of experience. He enlisted in the US army, only to discover that he had abnormal colour perception, which meant that a career in electronics was not an option. After spending three years in the army (two of them in Germany), he returned to school, eventually becoming a mathematics teacher in the Bronx. After 29 years, he retired to live in Westchester, New York.

Leo has been married to Doris, née Kopelman, for 50 years; they have no children. They are members of the Hebrew Institute of White Plains (a modern Orthodox synagogue), Hadassah and Child Survivors, and he is treasurer of the Hidden Children of Westchester and of Doris's Hadassah chapter. Leo does much good in his community and is an amazing storyteller. His grandnephews and nieces love to listen to him.

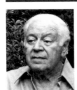

*Pages 170–171*
Charles Srebnik
New Jersey, USA

Charles was born in Brussels, Belgium, on 31 October 1934 to Polish refugees Marie Sluzny and Leon Srebnik. At the start of the war, Charles and his parents were hiding in a cottage in a forested town next to a lake. On hearing screams of "Help!", Leon dragged a priest out of the lake to safety – after which the priest wished to reward the family. Leon asked for Catholic papers for Charles (who was then five years old), so the priest baptized Charles, naming him Charles Bontemps, and provided the papers needed for getting him into a Catholic orphanage. Both Marie and Charles were able to leave the cottage to be safe in an orphanage in Namur with the help of Father Joseph André, who had saved many Jewish children from deportation and was later declared "Righteous Among the Nations"[5]. Charles spent time in a total of three orphanages, as he would be whisked away from each one when there were signs that a Nazi raid was imminent.

Toward the end of the war, Marie went to work as a maid in the home of Mr and Mrs Demuth, who also had a fabric store in Namur: this was the home of the underground movement in that area. Marie talked the participants into allowing Charles, who was by then ten, to leave the third orphanage and stay with them; they agreed, provided he

"worked". He was sent by bicycle to railroads to report the comings and goings of German soldiers. Playing ball near the Gestapo headquarters, he would allow the coloured ball to roll under the fence, the colour having a symbolic meaning to those inside.

Charles's father had been taken to Auschwitz[14] and had escaped, but he was recaptured and taken back to Auschwitz, where he was murdered. The Kazerne Dossin – Memorial, Museum and Documentation Centre on Holocaust and Human Rights, in Mechelen, Belgium, has pictures of Charles's life as part of its exhibition depicting Jewish life in Belgium before, during and after the war. The museum can also provide schoolchildren with a PowerPoint presentation about the persecution of Jews in Belgium; it focuses on the plight of the Srebnik family. (This museum was once the prison that interred Charles's father each time before he was shipped off to Auschwitz.)

Charles arrived in America on 26 June 1946 and attended school in the Bronx and Manhattan. He worked as a stockbroker on Wall Street until 1964, when he married JoAnn Levinson. Shortly after that, they moved to Presque Isle, Maine, where Charles was the president of the Maine State Potato Company and where he also built one of the first truck stops in America, Delta Truck Brokers.

In 1968 he sold them and returned to New York with his new family of two baby girls and a boy (another boy and girl came along in 1970 and 1971). He has been registered with the New York Stock Exchange (NYSE) since 1956, and in 1970 he became Head of Investment Banking for three NYSE companies. In 1981 he created one of the first biotech companies, Genetic Engineering, Inc., where in vitro fertilization was first used on his ranch with cows, utilizing non-surgical embryo transfer, along with other new scientific discoveries. These techniques are being used on humans today.

Though Charles still does investment banking on a regular basis, his passion today is helping survivors get pensions from the German government. Lately, with the help of Rockland Jewish Family Service, he has been even more successful.

WITH JOANN SREBNIK (WIFE)

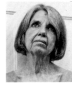

*Pages 172–173*
Christine Month
New York, USA

"I was born Krystyna Margulies in Kraków, Poland, on 17 January 1937. When I was five years old, my parents, Leon and Esther (Erna) Margulies, placed me in hiding with a Gentile family. It was led by Mrs Zosia Zajaczkowska, who had a sister, a mother and a daughter of my age living under the same roof. I did not attend school but the Zajaczkowski women taught me how to read and write. I lived with them as a Gentile – praying and going to church – until the war ended in 1945 when we were liberated by the Russians. Miraculously, my parents also survived, under similar circumstances.

In 1946 we went to Paris, France, seeking a visa to Israel. That never happened, but my mother's first cousin, Rabbi Pinchas Hirschprung of Montreal, sent us visas for Canada. With my new name, Christine, given to me by the principal of the school I went to in Paris, I lived in Montreal from 1949 to 1964. I became a schoolteacher, married Melvin Month (a theoretical physicist) and gave birth to two sons, Stephan and Hal.

The four of us then moved to the US, living for two years in Champaign-Urbana, Illinois, and for two years in Smithtown, New York, before buying a home and settling down in Stony Brook, New York. In 1969, I resumed my life as a teacher and taught at Tackan, an elementary (primary) school in the Smithtown school district, for 30 years. In 1998 I retired to a life of leisure – knitting, doing aerobics, taking trips to New York City, helping to raise my two grandchildren, Zachary and Eliza, and writing poetry. In 2009, I published a book of verse, *My Life of Rhyme**."

* FOR FURTHER INFORMATION, GO TO WWW.MELMONTH.COM

*Pages 174–175*
Debora Brenner
New York, USA

Debora Korolchuk-Brenner was born in Ostrów Mazowiecka, Poland, on 25 December 1937 to Menachem and Leah Korolchuk. In 1941, to escape the Nazis, the family fled to Russian-occupied Snow, in Belarus, where Menachem was able to find a job as a teacher. However, the situation in Snow became intolerable once the area was occupied by the German army in June 1941. The Korolchuks were forced to move from their residence into the ghetto[13].

In June 1942 Debora's family concealed themselves in a flimsy hideout while they heard how the town's Jews were massacred all through the night. Debora's father lost both his parents, his brother, sister-in-law, nephew and niece in the blood bath that ensued. With the exception of one other person, the Korolchuks were the only family to survive the Snow massacre.

The Korolchuks, along with their landlord, as well as Leah's sister (who was living with them at the time) set out to the forest in the early morning once the screams had stopped and all was quiet. They wandered in the area for days, living on whatever food they received from the farmers, in constant fear of being caught or denounced. The Nazis were always on their trail, only steps behind. At one point, Leah's sister and the landlord

tearfully parted ways from the Korolchuk family as they felt they had a better chance of survival without the small children holding them back, only to be caught and shot by a Nazi detail a short while later. After some time, the Korolchuks knocked on a farmhouse door and it was opened by Ivan Rudkovsky, who coincidentally was a teaching colleague of Menachem's. Menachem begged Ivan to take Debora and hide her, as, with her blonde hair and blue eyes, she did not look Jewish. Only with the exchange of gold coins and a ring that Leah Korolchuk had hidden in her garments did Ivan's wife agree to take in Debora. Meanwhile, Menachem, Leah and Debora's sister, Celia, were able to join the partisans with the help of Mr Rudkovsky.

Debora bravely survived torment, starvation and abuse, as well as a wild shootout between the Russians and the Germans. She even encountered Nazis face to face on several occasions while pretending to be a cousin of the Rudkovsky family. In spring 1944 Menachem came to pick up his daughter, only to find her unrecognizable; nor did she know her father.

After liberation, Debora and her family stayed in Nieśwież, Belarus, until they were able to make their escape across Russian-occupied countries to the West, where they ended up in the Foehrenwald displaced persons (DP) camp[26] in Bavaria, Germany. In 1947 they emigrated to the US.

There, Debora met and married the love of her life, Paul Brenner, a data-processing project manager, set up home with him in Brooklyn and had two children: Zev, a TV and radio personality, and Rochelle, a banking and finance professional.

ROCHELLE BRENNER (DAUGHTER)

---

Pages 176–177
Dora Reym
Connecticut, USA

"Dora Reym (née Estera Doba Pacht), my mother, was born in Wyszków, Poland, on 15 January 1915. She was the daughter of Chana Orner Pacht and Abram Pacht and the granddaughter of Jacob Wolfowicz Orner, the learned rabbi of Nasielsk, Poland, whose books of Talmudic commentary she collected with great pride.

Dora grew up in Będzin, married her childhood sweetheart, Mark Reym (Marek/ Moniek Hirsz Rembiszewski), and the year before Germany invaded Poland, gave birth to me. During the Nazi occupation, she developed her resourcefulness, courage and fierce will to live. Repeatedly she managed to save us from being transported to Auschwitz[14]. Eventually she was taken and endured two winters in Auschwitz, but she succeeded in escaping from a death march[37]. Against all odds, my father and I also survived. Reunited, we were finally allowed into the US after a four-year wait.

In her 60s, Dora learned to drive, taught herself to paint and started writing her memoir of survival. Excerpts appeared in an American magazine, and in translation in *Letras Libres* (Mexico and Spain). She poured her longing for her family and the way of life lost in the Holocaust into nostalgic drawings of prewar Jewish life and a powerful series of charcoal portraits of relatives, 36 of whom were murdered by the Nazis.

As my father's health, broken by extreme hard labour in the camps, deteriorated further, she devoted herself exclusively to his care; her artwork and writing stopped, never to be resumed. But her fierce will to live carried her into her 101st year. Toward the end, her nightmares of pursuit by Nazis and their dogs finally ceased and she died peacefully in 2015."

MIRA REYM BINFORD (DAUGHTER)

---

Pages 178–179
Mira Reym Binford
Connecticut, USA

"I was born Miriam Rachel Rembiszewska in Będzin, Poland, in 1938, the year before the Nazi invasion. At the age of five, in a series of improbable escapes engineered by my desperate parents, Dora Reym (née Estera Doba Pacht Rembiszewska) and Mark Reym (née Marek/Moniek Hirsz Rembiszewski), I was thrown over the wall of Rossner's[47] Małobądz work camp in Będzin, Poland in broad daylight – and rescued by strangers. These Polish Christians risked their lives to hide me for a year and a half. Although everyone else in both my father's and my mother's families was murdered, my parents survived the camps and we were reunited.

Eventually we emigrated to the US and built new lives in New York City. I became a documentary filmmaker and college professor, and for many years worked on films in India and Bangladesh. In midlife I turned to the Shoah, teaching the subject to college students and making a documentary film that draws on my personal story. *Diamonds in the Snow* depicts the experiences of Jewish children hidden from the Nazis, whose voices had often not been heard or believed. The film has been shown in the US on the PBS channel as well as in Europe, Mexico, Canada and Asia, in English, German and Spanish versions.

My life partner is Hank Heifetz, a poet, novelist, and translator from Sanskrit and Spanish.

Currently I am working on a book, *A Memoir of Survival in Three Voices*. It interweaves my parents' memories and reflections with mine, exploring our wartime experiences and

how they affected our lives afterward. The stories are told from our individual perspectives: my parents' words are taken from recorded interviews, my mother's unfinished memoir and the tiny diary my father kept during the forced march to his final camp."

*Pages 180–181*
Felix Fibich
New York, USA

Felix Fibich was born Fajwel Goldblatin in Warsaw, Poland, on 5 August 1917. He grew up in a family with Hasidic traditions, which were combined with the influences of modern Poland. His mother, Sarah/Shraga, and father, Simhas Goldblatt, owned Simha's restaurant on Malevsky Street in the heart of the Jewish area of Warsaw. His mother was the businesswoman, running the restaurant while his father preferred to study and was also a cantor on important holidays. Though his parents spoke Yiddish, they spoke Polish to their son, and he attended a Polish–Jewish high school.

Felix joined Michael Weichert's Yung-teater (Young Theater) in Warsaw as a teenager and acted professionally in several Weichert productions. Felix took his mother's maiden name, Fibich, as his stage name once he began performing. In 1936 he met Judith Berg, who was choreographing the troupe's production of *Wozzeck*; she was Felix's first dance teacher and his future wife. (Judith was born in Łódź, Poland, in 1905, and ran a prominent dance studio in Warsaw.) With Weichert's encouragement, Felix decided to pursue a future in the theatre.

Soon after the Nazi invasion of Poland in 1939, Felix and his parents, brother, sister and their families were forced to live in the Warsaw ghetto. In 1940 Felix planned a daring escape, as he described: "So I decided to escape to Russia, because I knew that in Russia the arts and artists are esteemed. Poland was divided by the Nazis and by Stalin: part of Poland was occupied by the Red Army, parts by the Nazis. After terrible bombardment in Warsaw in September (1939), and we survived the bombardment, the Nazis came in and they called me to do physical work, abused me and so on. I realized that my life was in danger, that I had to run. My mother said, 'We lived through one world war; the Germans will not eat us, and if we stick together, we'll survive.' But I felt that I couldn't stick it out, and one morning, without saying goodbye, I put on two shirts, two pairs of socks. A woman who was in love with me sewed money into the zipper of my fly, and I escaped."

Fibich was on a work detail to move cobblestones and work on the streets outside the ghetto, which is when he escaped, along with a friend. They hid until night-time, when they managed to reach "the demarcation line between the Russians and the Germans, and, when the sentries passed by, I ran through. And I was running, running – until I found myself some distance away...Then I kept walking. I arrived [at] a little town and saw the red banners with the Cyrillic letters, and I realized that I was now on the Russian side. I took a train to Białystok, a city which usually had [a population of] about 100,000 but [which] had swelled to half a million."

There, in Białystok, Felix was reunited with Judith and other Yiddish actors. They began performing under the direction of the comic duo Shimon Dzigan and Israel Shumacher, touring Odessa, Moscow and smaller towns. In June 1941, while the troupe was performing at an outdoor theatre in Odessa, the Germans began their attacks on Russia. "And this was Blitzkrieg. It was the end of our performances in Odessa...we knew from our experience in Poland that...the Russians would not be able to withstand the motorized army, when they were so primitive...So the director arranged immediate evacuation."

They all travelled by train and then by boat. Felix and Judith separated from the troupe in Armenia, developed their own duo show and married in Ashkhabad, Turkmenistan. In 1946 they were repatriated to Poland, where they discovered that all of Felix's family had perished. Two of Berg's sisters had survived in France. At first reluctantly, Felix and Judith directed a Jewish dance school for war orphans sponsored by survivors in Wrocław. Felix asked, "How can I dance on a cemetery?" but the children won him over.

"I just reached [out] my hand and patted this one child. He was so hungry for affection, for attention, that he came and sat down on my knees and embraced [me]. I felt the warmth of the child and I start[ed] to cry – and that was the reason I am alive... [I realized I had] to do something for these lost children. And I started to work with children – teaching them dancing."*

In 1949, refusing to live under Communism, Felix and Judith moved to Paris, France, with only a suitcase of costumes and music. They performed at the famed Archives Internationales de la Danse and other theatres, until they were brought to the US on 26 August 1950, sponsored by the Congress for Jewish Culture.

Only a few months later, their first concert was at Carnegie Hall. In 1987 both Felix and Judith were honoured as "Centennial Honorees of the Arts" by the Jewish Theological Seminary in New York for "Excellence in the Arts and the Promotion of Jewish Culture". Judith died in New York in 1992. In the 1990s, by then in his mid-80s, Felix experienced a renaissance as both a dancer and a choreographer. His homecoming to Poland as a dancer/teacher at the famous Jewish Cultural Festival in Kraków in July 1996 resulted in a Polish television special about him and requests for him to appear again in Poland.

In his lengthy and brilliant career, Felix choreographed; appeared on Broadway; performed in Yiddish theatre, in film and on television; and taught, directed and toured throughout the United States, Europe, South America and Israel. He died in New York on 20 March 2014 and is survived by his friend and heir, Jaya Pulami.

MIRIAM HECHTMAN WITH THE ASSISTANCE OF JAYA PULAMI, AND JUDITH BRIN INGBER, EDITOR OF *SEEING ISRAELI AND JEWISH DANCE*, DETROIT: WAYNE STATE UNIVERSITY, 2011. ALL QUOTATIONS EXCEPT [*] TAKEN FROM THE ESSAY BY FELIX FIBICH, FEATURED ON PAGES PP 47, 49-50, ENTITLED "THE UNWITTING GASTROL; TOURING THE SOVIET UNION, FRANCE, THE UNITED STATES, CANADA, ISRAEL, SOUTH AMERICA, EUROPE, AND BACK TO POLAND".

*Pages 182–183*
Frederick Terna
New York, USA

Frederick Terna was born on 8 October 1923 in Vienna, Austria, to a Prague family. The family returned to Prague soon after. Frederick went to school in Prague until the occupation of the city by Germany in March 1939.

From 3 October 1941 he was imprisoned in various concentration camps[10], among them the transit camp[22] at Theresienstadt[15] in Czechoslovakia, Auschwitz-Birkenau[14] in Poland, and a sub-camp of Dachau, Kaufering[45], in Bavaria. He was liberated in Bavaria on 27 April 1945.

His younger brother Tommy was deported by way of Theresienstadt to the extermination camp at Treblinka[33] in Poland, and he was killed on arriving there. Fred is the only survivor in the family.

After liberation he was hospitalized for a few months in Bavaria, then sent for further recuperation to Prague, where he married another survivor. They moved to Paris, France, late in 1946 and to New York in 1952. Frederick's first wife, Stella, died many years ago. He married Rebecca Shiffman in 1982, and they have a son, Daniel.

Fred Terna is a painter, and the Shoah and Jewish history are his themes. His paintings are symbolic and non-representational. He lectures widely about the Shoah.

*Pages 184–185*
Hana Kantor
New York, USA

Hana Kantor, née Szancer, was born in Strzemieszyce, Poland, sometime around 1926, though no one knows the exact date. As a teenager, she survived the Holocaust, enduring horrifying conditions in a string of work camps[29] and the loss of most of her family. She has spent every day since then rebuilding her life.

Just weeks after the war ended, she met a fellow survivor, Anschel Kantor, who became her beloved husband. After scraping through years in displaced persons (DP) camps[26], they arrived in New York City in 1949.

Seventy-one years after Hana was liberated by Russian forces, she counts her blessings: the memory of a long, close marriage; four children, twelve grandchildren, twelve great-grandchildren and counting; a group of close girlfriends who are all fellow refugees and survivors. Hana Lives in Forest Hills, New York, and Hallandale, Florida, and spends her summers at Silver Gate Estates, the last remaining bungalow colony in New York's Catskill Mountains populated by Holocaust survivors.

JODI KANTOR (GRANDDAUGHTER)

*Pages 186–187*
Henry Birman
New York, USA

"I was born on 3 June 1935 in Sosnowiec, Poland, and was the youngest of three siblings. Before the war Sosnowiec was a city of approximately 100,000 people, among them 30,000 Jews who thrived and prospered there. In the beginning of 1943 all Jews in Sosnowiec and the surrounding areas were rounded up and relocated to a newly created ghetto called Środula, located on the outskirts of the city.

My family survived many 'selections'[49] during our time in the ghetto. In September 1943 the Germans decided to liquidate Środula and send the occupants to Auschwitz[14]. After two days of havoc and deportation, only a small group of Jews remained. They were used by the Nazis to gather and sort the remains of the deported people's belongings. My mother, brother, sister and myself survived the deportation by being hidden in a standing-room-only bunker. My father was hiding elsewhere.

After staying in the ghetto for a few more weeks, my family and I were able to escape to the Gentile part of the city, hiding among Christian families. Not long after, my father and sister were denounced to the Gestapo[3], and they perished in Sosnowiec. Later on, my mother and brother, who were working for a German farmer, were found out and were sent to Auschwitz. My mother survived the camp, but my brother was sent to the gas chamber upon his arrival at Auschwitz.

After escaping from the ghetto, I assumed the identity of 'Henryk Bukowski', an orphan from the eastern part of Poland. Thanks to the kindness and humanity of many Polish families – labelled by the Germans as *volksdeutche*, who lived in the part of Poland that the Germans regarded as part of the Third Reich – I was able to survive. Twice I was transported across the German–Polish border by a German soldier, the son of a family with whom I was hiding. My last hiding place was in a little village in Poland called

Słowik, near the town of Kielce. I was there for a few months until the end of the war. Playing the role of a Catholic orphan quite well, I became an altar boy, thanks in part to a local priest who had taken a liking to me.

After my mother was liberated from Auschwitz, she found me in Słowik and together we returned to Sosnowiec, where I went to school. Later I went to Silesian Polytechnic to study engineering. After I graduated in 1956, my mother and I emigrated to Israel, where I served in the Israeli army and did engineering work for military installations, and was able to leave my memories of the past behind.

In 1961 I came to the US, where I reside now. I have one son, Mark, who lives in New York. Mark's mother Eva, my first wife of 40 years, who was also a Holocaust survivor, passed away in January 2000. I remarried, to Margarita, in 2003 and live a very happy and fulfilling life in New York City."

*Pages 188–189*
Inge Auerbacher
New York, USA

Inge Auerbacher was born on 31 December 1934 to parents Regina and Berthold Auerbacher in Kippenheim, Germany – the last Jewish child born in the village that year. She remained an only child. Inge experienced Kristallnacht[11] as a three-year-old child. Her father was a disabled veteran of World War I. He had been awarded Germany's Iron Cross, but this did not save him from being deported to the Dachau concentration camp[9] on 10 November 1938. Her grandfather suffered the same fate, but luckily they both were released from their torture after a few weeks.

Inge was imprisoned from 1942 to 1945 in the Theresienstadt concentration camp[15] in Czechoslovakia. Miraculously, Inge and her parents survived these terrible years, but at least 13 members of her immediate family were killed, as were many more distant relatives, bringing the total to at least 20. Inge is the only child survivor from the State of Württemberg who was deported from Stuttgart, Germany, to the concentration camps[10].

Inge and her parents emigrated to the United States in 1946. She suffered many years from tuberculosis – the result of the terrible conditions in the concentration camp. Years of hospitalization, chemotherapy and the loss of eight years of schooling followed. Despite all this, she graduated from Queens College in New York City with a BSc degree in chemistry. She worked for 38 years as a chemist in medical research and clinical work.

Now retired, Inge lives in New York City and travels to many countries to speak about the Holocaust, tolerance and human rights. She has been the subject of documentary films and the recipient of many honours, including New York State Woman of Distinction; Honorary Doctorate of Humane Letters from Long Island University, New York City; Ellis Island Medal of Honor; Louis E Yavner Citizen Award from the Board of Regents of New York State; Queens College Alumni Star Award; and many other citations from various governmental agencies. In 2013 she was awarded the Knight's Cross of the Order of Merit by the President of the Federal Republic of Germany for her commitment to tolerance and her fight for human rights.

Inge is the author of six books, which have been published in nine languages: *I Am a Star – Child of the Holocaust, Beyond the Yellow Star to America, Running Against the Wind, Finding Dr Schatz: The Discovery of Streptomycin and a Life it Saved* (co-author Dr Albert Schatz), *Highway To New York* and *Children of Terror* (co-author Bozenna Urbanowicz Gilbride). Many of her poems have been published and set to music. She gives lectures (to any age and at any venue) on the following topics: Memories of a Child Survivor of the Holocaust; her book *Finding Dr Schatz: The Discovery of Streptomycin and a Life it Saved*; The Nobel Prize Is Not Always Noble; Not All Holocaust Survivors Are Jewish.

*Pages 190–191*
John Balan
New York, USA

Born on 29 November 1934, John Balan (Jan Braun) was the only child of Cornelia (Nelly) Braun (née Grossmann) and Alexander Braun of Bratislava, the capital of Slovakia, which was then part of Czechoslovakia. John lived with his Orthodox Jewish grandmother until 1938, but it wasn't until recent decades that John embraced his Jewish roots.

Baptized just before his fourth birthday by a man his father had befriended, the family immediately began their efforts to lead their lives as Christians. "I went to Sunday school, and we went to church. We did all of these things, pretty much for the rest of my life," he explained. "My grandmother ran a very Jewish household. She was very much against this. She was angry at my father." Yet the family's hope was that their efforts would provide protection that was otherwise unavailable to Jews at the time.

John's family moved to the Jewish area of Bratislava in 1942. He did not consciously remember whether or not his parents explained the real reason for moving, whether it was because they were Jewish or because they wanted to be closer to the river. In hindsight, John acknowledged that knowing why their lives had to be disrupted – why they had to separate – would have made the separation easier to understand.

The decision to go into hiding was made in 1944. With the Nazi occupation of Slovakia, the situation was becoming more and more dangerous for John and his family. "It became

clear that we were days or weeks away from major, major deportations. The only alternative available, since you couldn't go east, south, west or north, was to find a hiding place – especially during the night." Nazi roundups took place in the very early morning hours.

John's teacher, Nora Palethys, and her husband, Karel, became friends with John's parents over time. John characterized Karel as "fighting for the underdog...being morally motivated". Knowing whom they were up against, Karel and Nora offered to hide the family. Every night, or whenever it was appropriate, John and his family would leave the ghetto[13] and sleep over with Karel and Nora and their child. After nearly two months of these nocturnal sojourns, a loud, close rumbling could be heard. "It was the noise of the roundup from within the apartment. We were on the very top floor. The searchers stopped on the floor just below. 'Let's go,' they called out. 'There are no more Jews left here.'"

It was increasingly difficult to maintain a safe haven for the household of six. The time came for the Brauns to separate from their friends and from each other. John's mother bribed her way into a Catholic-run tuberculosis sanatorium. John's father left for the farm of a woman who had been close to the family when John was a baby. John went to live with a family that was paid to hide him. John's father visited him nightly with the help of Karel, who would use a small flashlight to signal whether or not it was safe to continue down the road. (This flashlight is on display in the Children's Gallery of the Museum of Jewish Heritage, New York City.) Living apart lasted two months, but eventually the family was reunited after being liberated when the Soviet army passed through Slovakia. John and his parents became the Balans and emigrated to the US in 1948.

The family maintained their Christian identities after the war. "When we came to the US the first thing my parents did was join a church. I found it unpleasant not because I would have rather gone to a Jewish service but because it was boring to sit there," John recounted dryly.

Hints of a Jewish life presented themselves in subtle ways. "My cousins in Israel had made *aliyah*, so my father sent them some clothing. He asked them to send the mail to the office, rather than to the house, because he didn't want the postman to see that letters were coming from Israel."

As an adult, John would visit these cousins frequently and they would share their childhood experiences, but John maintained his non-Jewish persona. "I was raised this way, and I saw no great overpowering reason to change. Unlike some little kids who were hidden in a monastery and were actually raised Catholic, and don't remember their Jewishness because they went into the convent at age two or three, I was nine or ten, so I knew that I was Jewish, but for practical purposes, I wasn't. I went through high school that way...I went through college that way. I joined a Christian fraternity, not a Jewish fraternity."

John's partner of 36 years, Annie, was Jewish and made him aware of the Jewish world. This awareness, combined with dozens of trips to Israel, has helped to erode what John refers to as "the charade". What sealed his fate, however, was a professional experience that took place in the 1990s. Working at a phone company in Pennsylvania that employed more than a thousand employees, John was given advice that he considered the "straw that broke the camel's back". His attorney told him not to reveal his true identity, saying: "John, you know, you would be well advised, from a career point of view, not to reveal your Jewishness to this company."

Following a diagnosis of cancer in 1997, John sought help through meditation led by a rabbi he liked very much. He attended services and gained a sense of community unknown to him before. He became more involved and became a founder of the Shul (synagogue) of New York on the Lower East Side, where he held the role of treasurer for many years and watched with joy as the congregation grew. John admitted that it took some time to truly reveal who he was, even in this safe environment. "Whenever I say 'I am Jewish' I am very aware I am saying it." You can read more of John's history in the book *To Life: 36 Stories of Memory and Hope*. He worried that after survivors are gone, and the children of survivors are gone, after two or three generations no one would remember what happened to Jews during the Holocaust. His role, he felt, was to tell the story. John said, "I can contribute, I will do that." John Balan died on 31 January 2013.

PATRICE COLLINS (NOT RELATED) & ALAN RADDING (BROTHER-IN-LAW)

*Pages 192–193*
Joseph Gosler
New York, USA

"I was born in Groningen, the Netherlands, on 27 July 1942. Six months after my birth, through the Dutch underground, I was whisked away to live with a Christian family in Wageningen. My name became Peter Djkstra and I grew up in a household with two loving parents (selected through the underground) and newfound siblings, Anneke and Folie.

In 1945, after the war had ended, I was reunited with my own parents. Soon after, my mother gave birth to my sister, Marja. Life in post-war Holland was harsh; jobs were difficult to come by and everywhere there where memories. In 1949 we moved to Israel.

We lived on a kibbutz called Beit HaShita. The distance from relatives, the warm climate and the lifestyle on a collective were especially difficult for my mother. On the other hand, the kibbutz life proved essential to my development.

We moved to the US in 1953. This began my 20-year psychological journey. We moved around New York City, finally moving to Monticello, New York; there we lived on a chicken farm until 1960, when we moved back to New York City.

The 1960s were a period of awakening: politically, academically, socially. However, it wasn't until 1977 that I carved out my career, as a business manager in private schools. In the early 1980s I became a US citizen; I started work at Friends Seminary, a private school in Manhattan; our son, Jake, was born; I received my MBA; and Sheila Wolper (my wife) and I started a nursery school.

Today, I am retired and a trustee on several school boards. I write a little, take Arabic language classes, travel, garden and, most importantly, walk my dog, Milton."

---

*Pages 194–195*
Kurt Goldberger
New York, USA

Kurt was born in August 1925 in Vienna, Austria. He lived with his father Paul, a veteran of World War I, and his mother Emilie. Following the Anschluss in March 1938, when the German Third Reich invaded and annexed Austria, Kurt's father began considering how to get his family out of Austria. As a skilled worker, he was able to get a sponsor in the United States but he could not do the same for his wife and child. He convinced Emilie to leave for England in early 1939 to become a domestic servant and, a few months later, Kurt travelled to England on the Kindertransport[17] to be with her.

A week after Kurt was reunited with his mother, the committee responsible for him sent him to a hostel in Croydon, Surrey (now south London). When the war started, he was evacuated to Horsham, in Sussex, where he lived with a local family. Late in 1940, Emilie was removed from her job and detained as an "enemy alien" at an internment camp on the Isle of Man along with thousands more refugees, many of them Jewish. Hopeful that she and Kurt would soon get their visas and be able to leave for America, Emilie asked for her son to be sent to the Isle of Man so that they would be together when their papers arrived. When the visas came, they had no way out of England but they were released from internment and moved to Leicester.

Kurt's father had emigrated to the United States in late 1939. He had been willing to settle wherever there was work and was directed to Des Moines, Iowa. He became a United States citizen in 1944 and was able to send for Emilie and Kurt.

Kurt and his mother arrived in New York in 1944. They stayed with relatives in Brooklyn before travelling to Iowa to be reunited with Paul. Kurt got a job at MGM in Des Moines and, in less than a year's time, got a transfer to MGM in New York and worked there for the next five years. Kurt met Margaret Heller in 1948 and they married the following year. Their daughter, Ruth, was born in 1954.

Kurt and Margaret moved to Long Island in 1955, where they were active in civil rights issues, including attempts to desegregate their town. Kurt volunteered with the Anti-Defamation League (ADL) and the Jewish service organization B'nai B'rith[77]. He was appointed as one of the original commissioners of the Nassau County Human Rights Commission in 1963. In 1967, he was hired by the ADL and later by B'nai B'rith, where he remained until his retirement. After retirement Kurt continued to volunteer for the organization and held elected office.

Kurt also devoted much of his time to the Kindertransport Association (KTA), giving talks about the Holocaust and his experiences, and serving as the organization's president from 1999 to 2012.

In 2014, Kurt and Margaret moved to California to be closer to their daughter, their son-in-law, Warren, and their grandson, Brian. Kurt died in October 2015.

MARGARET GOLDBERGER (WIFE) & RUTH GOLDBERGER (DAUGHTER)

---

*Pages 196–197*
Margaret Goldberger
New York, USA

Margaret Goldberger (née Margarete Heller) was born in Berlin, Germany, in April 1926, and lived with her mother, Paula, her father, Arnold, and her brother, Hans (John). On 9–10 November 1938, on what came to be known as Kristallnacht[11], her father was arrested for being Jewish and imprisoned in a German concentration camp[10]. Margaret's mother contacted an American cousin to send US currency to help her to bribe the Nazis to release Arnold. Paula gave the few hundred dollars to the Gestapo[3], along with assurances that the family was planning to leave Germany. Arnold was released after five weeks of forced labour, starvation and frequent beatings. When their home and business were seized by the Nazis, the Hellers moved in with relatives whose property had not yet been taken from them.

The family had applied for an American entry permit but a high quota number meant that it might be two or three years until they would be able to leave Germany, so they made plans to get the children to England, signing Margaret up for the Kindertransport[17]

and enlisting Hans on a job training programme. In June 1939, Margaret travelled to England. She first lived with a family in London for a month and then in a hostel sponsored by the Jewish service organization B'nai B'rith[77]. On the day before World War II began, Margaret, along with thousands of children from London, was evacuated. She went to live in Cockley Cley, in Norfolk. In the autumn of 1941, the committee sponsoring the refugee girls sent those who had reached the age of 15 back to London to work. Margaret worked for a short time in a dressmaking factory but she and her best friend wanted to contribute to the war effort. They secured jobs in a munitions factory, where they remained employed until the end of the war.

After the war Margaret did various jobs until she secured a position at a boarding school, where she was able to fulfil her desire to work with children.

Margaret's parents were able to leave Germany early in 1941. Until that time, Arnold had been forced to do hard labour from which he never recovered. The couple travelled through France, Spain and Portugal before boarding a ship to New York. Arnold developed heart trouble and died in 1943.

When the war ended, Paula contacted various government officials, eventually securing the necessary papers to enable her children to emigrate to the United States. Margaret and her brother were reunited with their mother in 1946 in New York City.

Once established in America, Margaret went to night school to learn business and office skills. In 1948, she met her future husband Kurt, an Austrian refugee, at a club comprised mostly of young immigrants. Margaret and Kurt were married in March 1949. Margaret worked until her daughter Ruth was born five years later. She went back to work in 1959 and, for almost four decades, worked for two organizations that ran children's camps. She also devoted much of her time to the Kindertransport Association (KTA), giving talks about the Holocaust and her experiences, and serving as both co-chair of the Speakers' Bureau and as the organization's secretary.

After retirement Margaret was a docent at the Holocaust Museum on Long Island and for decades, while employed and after, she was an active volunteer and held elected positions with B'nai B'rith.

In 2014, Margaret and Kurt moved to California to be closer to their daughter, son-in-law and grandson.

WITH RUTH GOLDBERGER (DAUGHTER)

Pages 198–199
Lea Kanner Bleyman
New York, USA

"I was born in Halle, Germany, to Salomon David Kanner and Amalia (Mia) Kanner, on 9 November 1936. Precisely on my second birthday, on Kristallnacht[11], our business was destroyed and my father was arrested and taken to the German camp Buchenwald[20]. My mother got him out of the camp by presenting a visa to the local police station as they directed (the visa was a forgery as valid visas were impossible to secure), and in 1939 we escaped to France. There, we were helped by the French underground and the OSE (Oeuvre de Secours aux Enfants)[21]. After our mother placed my two sisters in one of the OSE children's homes, she volunteered to work there as a cook, and I was also placed in an OSE home. In 1941 my sisters, Eve (see page 221) and Ruth, aged 10 and 11, escaped on a Kindertransport[17] until safe passage to the US was found. My mother refused to let me go, as I was only five years old. Just before the roundup of Jews in France in 1942, my parents were sent to the French concentration camps at Nexon, Haute-Vienne, and Gurs in the Pyrénées-Atlantiques, while I became a Hidden Child[78], with a false, non-Jewish name. My parents were reunited when the Limoges area was liberated in August 1944.

After liberation I told my mother about my experiences as a Hidden Child. For a year I was hidden in a Catholic convent. Then I lived on a farm where there was a cave at the edge of a field; I saw people being pushed into the cave and the entrance barred so they couldn't get out. Another time people were shot and killed in that field. I coped with these horrors by giving these memories to my mother after liberation and forgetting everything except my strong desire to join my sisters in America.

In 1946 the family was reunited in New York. I was determined to be thoroughly Americanized, so I quickly put my German and French behind me and became fluent in English, which is easy for a ten-year-old. I attended university, earned a Ph.D and became Professor of Biological Sciences at Baruch College – The City University of New York, retiring in 2001. I am happily married to David Lewis Minn and have one daughter, Anne, a lawyer."

Pages 200–201
Aviva Cohen
New Jersey, USA

"My name is Aviva Cohen, aka Krysia Medzinska, aka Christiane Messing, aka Kristine Messing. I was born on 8 September 1939 in Dąbrowa Górnicza, Poland. My father, Henry Messing, was at that time already in hiding from the Nazis, as he was on their 'activist/Zionist' list. My mother, Lunia Reichmann Messing, along with her mother, somehow survived until 1943, when the local ghetto in Sosnowiec, Poland, was liquidated. Lunia smuggled a letter to Anna Rosenberg Smierchalska (who was living

as an 'Aryan' and had been engaged to my mother's brother, Sevek) asking her to take me. Both my mother and grandmother perished in Auschwitz[14].

Yes, I was lucky to be smuggled out of the ghetto, and I lived with Anna as her 'daughter', thus adopting a new identity and a new religion (Catholic) until the war ended and I was reunited with my father. My father remarried, to another Holocaust survivor, Ella Wolkenberg, and we left Poland for France with the intention of making it to Palestine.

Alas, this was not to happen. We lived in the suburbs of Paris, where my sister, Jeanette, was born in 1947 and we ultimately emigrated to the United States in 1951. I learned English and went to high school there, then college, where I majored in English. Subsequently, I taught high school English, obtained an MA in English education and began my Ph.D in drama. However, with the advent of my third child in 1971 it became too difficult to continue.

I have been married since 1960 to Sheldon Cohen. We have three sons – David, Aaron and Daniel – and seven grandchildren. We live in northern New Jersey, just outside of Manhattan.

After taking ten years off work to raise my children, I worked with an off-Broadway theatre company. After that I was an executive assistant in the fashion industry and later worked as my husband's paralegal/office manager in his law firm, until I retired in 2005. Two of my sons live in California, and my youngest, Daniel, did make *aliyah* in 2000, and has three half-*sabra* children (*sabra* refers to an Israeli Jew born on Israeli territory)."

*Pages 202–203*
Olga Berkovitz
New York, USA

24 May 1924 was a sunny spring day, in Hencida, Hungary. The gardens were radiant and the marketplace bustling as Serena and Samuel Szabo, who owned and ran the town's general store, celebrated the birth of Olga, their sixth child.

Twenty years later, in March 1944, the Germans occupied Hungary. All the Jews had to wear a yellow star. On 9 May the members of Olga's family were forced to pack one bag each and made to leave their home. They were sent to the Nagyvárad (Oradea) ghetto, a former marketplace that had housed and sold live animals.

Olga and her entire family were forced onto a train whose final destination was Auschwitz[14]. Many family members, including her dear uncle Moritz, died on the way. During selection[45], Olga was separated from her beloved mother by the infamous SS officer Dr Mengele[42], who "kicked her to the right with his black boots", knocking out her front teeth. Her mother perished that day in the gas chambers. Olga gave up on life then, until she was reminded by friends that she had sisters, uncles and aunts in the US and a whole life to live, so she struggled and survived in order to tell "our stories".

On 27 July 1944, Olga was marched into a brick building at Auschwitz, assuming she was about to be gassed, but quickly realized that it was a shower with real water. On the same day she departed for the next unknown destination, which was Germany's Langenbielau (a sub-camp of Gross-Rosen concentration camp[40]), where she became a slave labourer at an ammunition factory that was owned by the family of Karl Diehl of Nuremberg, called Diehl & Co, and is still in existence today.

Olga was liberated on 8 May 1945. All she could think about was who from her family had survived and how she could locate them. Like all Holocaust survivors, she was desperate to find any family members, especially her brother Joseph (Joe), to whom she was closest. After weeks of travelling, she arrived in her hometown of Hencida and, from a distance, saw a young man surrounded by her friends. There stood Joseph – he was alive. From that point on, they were always together.

After the war, Joseph worked for the US army in Frankfurt. He carried around a beautiful portrait of Olga at all times to show to his friends, in order to play matchmaker. His efforts were successful when he introduced Olga to his handsome friend Abraham Berkovitz. Abraham, who was from Transylvania, in Romania, proposed to Olga on the day that she was leaving by boat to emigrate to Canada.

Olga arrived in Canada and then settled in Detroit, in the US, where one of her sisters had lived since the 1930s. Abe and Olga married in Windsor, Ontario, on Tu B'Shevat (the 15th day of the Jewish month of Shevat) in 1950.

In 1961 Olga and Abe moved to Long Beach, New York. Abe was a plumber by profession and Olga a seamstress. The couple had three boys – Barry, Mark and Leo – and numerous grandchildren, who showered Olga and Abe with love. What was once a dream for Olga – having a family and her own children – became a reality, and she truly realized what a miracle it was to have been given the ability to have children and nurture her grandchildren after all that she had been through. Olga was an eternal optimist, a loving mother and grandmother and an extremely giving, compassionate and generous individual. What gave her the greatest satisfaction was her pride in her loving grandchildren.

Much later in life, Olga was one of nine original plaintiffs in a well-known and documented US class action lawsuit in which survivors of Nazi-era slave labour camps[29] sued Bayer, Volkswagen, Diehl, Daimler-Benz, and other major German companies that

willingly collaborated with the Nazis and greatly benefited from forced labour during World War II, for compensation. In December 1999 the plaintiffs won a settlement based on their testimony to the tune of $5.2 billion, although each individual received no more than $5,000.

Olga lived happily in Long Beach, close to her brother Joe, until she passed away in November 2010, shortly after being interviewed and photographed for this momentous project. In accordance with their fervent wish to be buried in Israel, Olga and Abe z"l are buried in Eretz HaChaim cemetery in Beit Shemesh, Israel.

BARRY BERKOWITZ (SON)

*Pages 204–205*
Peter Stern
Connecticut, USA

"I was born in Nuremberg, Germany, in 1936. My father was an auto mechanic and teacher at a vocational school; my mother stayed home caring for my younger brother, Sam, and me. In 1941 we were deported to Latvia, where my father and his students repaired army vehicles, there and later in Russia. Eventually we were put in prison in Riga, and then, at the end of 1943, sent back to Germany to concentration camps[10]. My father died in Buchenwald work camp[20]. My mother, brother and I were sent to Ravensbrück concentration camp[36], and then, in early 1945, transferred to Bergen-Belsen concentration camp[1]. On 15 April 1945 we were liberated by British forces.

After a year in Nuremberg and several months in displaced persons (DP) camps[26], we arrived in New York City in January 1947. Starting school for the first time at the age of 11, I attended public schools, and eventually the University of Missouri School of Mines, where I qualified as a metallurgical engineer.

I married Julie, a teacher, in 1965 and we moved to Newtown, Connecticut, where we had two sons, Joe and Bill, and where I retrained to become a middle school science teacher. After 30 years of teaching I retired to become a full-time volunteer, working for our local library and giving talks to schoolchildren on the Holocaust. In 2014 we moved to a retirement community in Haverford, Pennsylvania."

*Pages 206–207*
Rosa Sirota
New Jersey, USA

Rosa was born in Lwów, Poland, on 6 March 1933. Soon after the Germans invaded the country in September 1939, they arrested her grandmother and uncle and took her father to a work camp[29], from which he never returned. Jews who had not been arrested were ordered to move to the ghetto[13].

Rosa, who was eight years old at the time, and her mother had to leave all their possessions and move into extremely crowded quarters in the ghetto. Life there was terribly difficult. There was hardly any food, medical facilities were non-existent and there were constant raids in which Jews were rounded up and sent to concentration camps[10]. Once they were gone, no one heard from them again.

After a few months in the ghetto, Rosa's mother, Clara Binder (née Belf), managed to buy a Christian birth certificate, and they fled to Ukraine. There they lived with a peasant woman and her daughter, who didn't know their true identity – thus Rosa became a Hidden Child[78] living in full view. The four of them lived in one small room. Rosa and her mother slept on straw behind the stove – the space was so small that her mother could not even stretch her legs. Their goal was to be invisible, yet to blend in as common peasants. Rosa did not go to school and was not allowed to play with other children for fear of being discovered. She went to church and pretended to be a Christian.

Whenever they could find field work, they worked to make a little money or bring home food for everyone's dinner. After a few months, her mother and other women from the village were taken by the Gestapo[3] to work in their laundry. Because she was not a typical peasant and was very efficient, she was accused of being Jewish and arrested on the spot. The next day when the Gestapo came to interrogate everyone in the house, Rosa knew she had to keep their secret, a secret never to be revealed on penalty of death. She denied being Jewish and did not admit that she understood when they spoke to her in German. This was the most agonizing time – she felt totally alone and helpless. They told her that she would never see her mother again if she didn't tell the truth, and yet she kept quiet. For two weeks Rosa didn't know if her mother was alive or dead.

Since the Gestapo could not prove that she was Jewish, her mother was finally released from jail. However, she was forced to continue working in the laundry, which continued until the Soviet army liberated their area in 1944. They then returned to Poland, only to find that Rosa's father, Chaim Binder, had been killed, along with everyone else in the family, except for one uncle, Chaim Spring. Rosa's mother eventually married him and they had a baby boy, Albert.

Poland for them was nothing but a painful cemetery, and they embarked on the life of "the wandering Jew". The goal was to go to the US, where Rosa's stepfather had family, but the immigration laws and the quota for Polish Jews made it extremely difficult. They

moved to Hungary, Czechoslovakia, France and Venezuela, where after four years of hiding and moving, Rosa finally went back to school. She made up most of the lost time by skipping grades.

The family had to wait a total of seven years before their Polish quota number came up and they could emigrate to the US. However, after only four years in Venezuela, at the age of 17, Rosa was able to come to a boarding school in the US alone on a student visa. She finished high school and then got a business degree from college, followed by a Master's in education. At college she met her husband, Howard, and they had a son, Stephen, and daughter, Lorraine. Now they also have three wonderful grandchildren and the sun shines on all of them.

*Pages 208–209*
Ruth Schloss
New York, USA

Ruth Schloss (née Strauss), daughter of Julius and Mathilde (née Moses) Strauss, was born in 1926 in Höheinöd, Germany, and grew up in Waldfischbach, where her father worked as an accountant and bookkeeper. In 1937, when she was 11 years old, life changed for ever. As the political situation toward Jews in Germany became intolerable, Ruth could no longer attend school and was shunned by her peers. Afterward she was tutored at home, and received Hebrew lessons from her father's cousin. Her father lost his jobs as a result of the anti-Jewish laws and Ruth suffered other torments. People threw stones at her, pushed and hit her in the streets and had their dogs chase her. Her former school friends refused to associate with her.

In March 1939, with the situation for Jews in Germany deteriorating, her parents made the heart-wrenching decision to send her out of Germany, putting her on the Kindertransport[17] to France. Ruth was one of 145 children whom the Baroness de Rothschild welcomed into her castle outside of Paris. When France was invaded in 1940, however, Ruth again was on the run from the Nazis. With the help of the French underground, she was part of a pack of children living in the woods and subsisting on leaves and roots for several months.

Meanwhile, on 22 October 1940, the German authorities rounded up Ruth's parents, along with some 7,500 Jews from the Saar, Palintinate and Baden, and deported them to the Gurs concentration camp in southern France. Since Ruth's father spoke some French, each day he was brought from Gurs to Lagney for forced labour. During 1942 Germany began large-scale roundups and deportations of Jews from France. Ruth's parents were both sent to Drancy and in early September 1942 placed on convoys to Auschwitz[14] where they perished.

The French underground arranged for Ruth's passage to Switzerland[75] in 1943. Shortly after she had crossed the Swiss border, the Swiss police handed her to the Germans who were occupying France. Ruth was imprisoned and then shipped to Rivesaltes internment camp[79], where many paused on their way to Auschwitz. Many survivors had miraculous moments, and Ruth's came when a Jewish-born converted priest came to the camp. Abbé Alexandre Glasberg[80] had had an epiphany and dedicated himself to saving Jewish children from the Nazis. Glasberg smuggled four children out of the camp, and Ruth was one of the four. He cared for them and led them through the woods. Ruth was entrusted to a convent where the Mother Superior, knowing she was Jewish, looked after her safely until the end of the war.

Ruth made her way to the US in 1947, and in 1950 she married Ralph Schloss. They have a daughter, a son and three granddaughters. Ruth's message is: "Please, if you can, help your neighbour. Let's all work together to make a good world."

LLOYD SCHLOSS (SON)

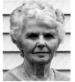

*Pages 210–211*
Sarah Knecht
New York, USA

"I am Sarah Knecht and I live in Lynbrook, New York. I was born on 18 February 1938 in Hrubieszów, Poland, near the Ukrainian border. Along with several close relatives, I fled Poland with my mother Necha Yenta Engelsberg and father Shiya Klig just prior to Hitler's invasion. They ran across the border to open fields where the bombs were flying; my uncle, who was carrying me, had to kneel near the ground to protect me.

After days of travelling in a transport train, in unsanitary and dangerous conditions, we arrived in Tashkent, Uzbekistan. There we settled for the duration of the war, from 1939 to 1945. I lived in a one-room apartment with my parents, aunt and two uncles. Tragedy struck in 1941 when my mother went to town to buy some sugar and never returned. She was found drowned in a nearby river. We never found out what actually happened. A year later, my father became very ill and died of dysentery.

My two uncles left to join the Russian army while we were in Tashkent. My aunt took care of me. I went to a school, created by the local Jewish people who were waiting out the war. Life went on. I made friends, but I dreamed of my parents returning to me. In 1945, at the end of the war, my uncles returned from the army and took me with them to Poland, and a year later they took me to a displaced persons (DP) camp[26] in Steyr, Austria, where we lived for two years.

In 1948 I was sent to live with a relative in Brooklyn, New York. I sailed with a group of children on a very stormy ten-day voyage.

After graduating from high school in 1956, I married my husband Theodore E. Knecht. I now have three grown children, five grandsons and one great-granddaughter. I worked as a primary school teacher, and for the last 20 years of my career I was Assistant to the Dean of Students and served as a guidance counsellor at Queens College in New York."

Pages 212–213
Toby Levy
New York, USA

"When I looked out at the sea of young, innocent faces staring up at me expectantly, instead of the speech I had so carefully prepared I decided to speak from my heart. 'You are very lucky you were born here in this wonderful country,' I told them. 'Appreciate what you have and don't take any of it for granted. The freedom you have here in America is worth everything.' I still couldn't believe that I, an immigrant who was just learning the language and customs of my new country, had been chosen as the valedictorian of my eighth grade graduating class in New Orleans. How did this happen?

Born in December 1933, I grew up in Chodorów (then a small town in Poland, now in Ukraine and called Khodoriv). My parents, Moshe and Cylia Eisenstein, owned a yard goods store in the market square. They were well known and respected, and had a reputation for being generous and honest. Life was comfortable. I was six years old and had not yet started school when World War II broke out in 1939. From 1939 until 1941, the Russians occupied the town. Although they confiscated all our valuables, we were still able to remain in our home and life was bearable.

In June 1941 German soldiers marched down the main street of Chodorów. I still remember their shiny black boots rising and falling in unison as they pounded on the ground. Even at that young age, I knew somehow that it meant the abrupt end of my freedom and childhood. From then on, we lived in constant fear and food was scarce.

Soon the Germans started 'relocating' and killing the Jews. To survive, families needed to be lucky, smart enough to plan ahead and able to get help from others. One night when my father didn't come home from work, my mother went looking for him and found him in the police station, barely alive. He had been caught bringing a brick home from the lumberyard and had been beaten within an inch of his life. But he survived and, because he did, we also had a chance.

It wasn't long before my father again heard rumours of an impending German 'action' (mass killing). It was time for the family to go into hiding. My father was a very resourceful and ingenious person. He had been building a fake wall in our cellar for months. He knew that one day we would have to hide behind it. The entire family crawled down the small hole he had excavated beneath the cast iron stove and shut the trapdoor from the inside. I remember hearing the German boots stomping through our house – those horrible shiny boots – and my grandfather, who was too frail and elderly to crawl into the cellar, being dragged out of his bed. He resisted, saying, 'No, shoot me here.' Then shots echoed through the house and we all knew he was gone.

My father put his fingers to his lips and I knew that any sound could be our last as the Germans continued their search. Suddenly, the cellar door opened. I was startled and let out a gasp. 'What was that?' I heard a soldier ask. They pounded down the stairs, with flashlights on. As I cringed there, I thought, 'Would the soldiers realize that the bricks on one wall looked newer than the rest?' I held my breath, hoping it would not be my last. Suddenly, we heard a cat's soft meow. One of the soldiers laughed, saying, 'Oh, it was just a little black cat. Let's get out of here.' With that, they departed, leaving us in that cellar, shivering in fear, but thankful to be still alive. The next day when we came out of hiding we found my grandfather dead.

Within a few months, the Germans announced the 'relocation' of all Jews to Lwów. My father's instinct told him that the soldiers were lying, and he decided not to follow their orders. He told us we would not leave, and instead started looking for someone to help us. In spite of his reputation, it still took several months to find a place to hide. It was very disheartening. There were nine of us: myself, my grandmother, my parents, my older sister, and my aunt and uncle with their two children. We finally moved into a barn loft belonging to a woman with a teenage son. Her husband had been taken away by the Russians. My father promised to give her everything he owned when the war was over. Her name was Stephana but we called her 'Pritza' – our queen, our saviour, in Polish.

We hid in the loft most of the day, with little room to move about. For short periods of time, my father would let us stretch our legs down on the barn floor. One day, we were doing that when all of a sudden the barn door opened and there was Pritza. That would normally have been fine, except that a young Ukrainian policeman was behind her. He was checking for hidden Jews in houses and barns. We scrambled behind the hay but still saw the shock on Pritza's face as she thought we had been spotted. She quickly shut the barn door and we waited in the dark for the soldiers to come. He must not have seen us,

as he reported only that he had seen animals in the barn, which he registered with the officials in town. Once again, we were lucky to be alive.

After this close call, Pritza was understandably worried for her and her children's safety. She told us we would have to leave. As my father pleaded with her, she responded, 'Why don't you try someone else?' Jews had lived in Chodorów for hundreds of years and everyone knew each other. My mother and my aunt went searching for people they knew, and not a single person wanted to take us in. One man said very clearly, 'I will pretend I never saw you, disappear.'

After that, we realized we had no place to go. My parents knew it was time to separate and say goodbye. My father said that my sister and I were going to stay together. My mother said I had to be quiet, obey my sister and not leave her side. 'Always remember who you are. If we don't come back when the war ends, look for Jewish agencies to take you away from this place. Do not let anyone adopt you or convince you to stay here. We have family in the United States and in Palestine.'

I was in shock, speechless, and their words made little sense. As an eight-year-old, I did not comprehend the situation fully. I held my sister's hand while my parents kissed us and cried. In the middle of our goodbyes, Tajik, Pritza's 16-year-old son, suddenly appeared in the barn. He warned his mother that if she chased us away we would surely die. 'You are staying here and I will make you a better hiding place. I will protect you,' he reassured us.

One day Tajik brought us a bowl filled with delicious cherries from the harvest. Today, whenever I eat a cherry, it immediately brings back to me memories of Tajik. He was always there for us with whatever we needed, whether it was food or protection. One night my uncle wanted to see what time it was and he turned on his flashlight to look at his watch. Suddenly we heard a commotion outside. Tajik immediately came running and told the Germans who had come to inspect that it was his flashlight. Another time a local teenager was prowling around the barn and demanded, 'What are you hiding here?' Tajik answered defiantly, 'Jews, do you want to see?' For the next two years, the nine of us hid in the barn's loft. My father kept a sheet on the wall and marked each day including every Sabbath and Jewish holiday.

The last year of the war, Pritza took in two Germans, for her protection and extra food. That made our lives even more difficult. We were in constant fear and could hardly breathe, knowing that they might hear us. I remember one time Pritza brought us a pound of bread. We had not eaten for days. My father sliced the bread and gave a piece to everyone. My mother cut her portion in half and gave one piece to my sister and the other one to me. This devotion to her children in the face of starvation is a powerful memory that shaped my future outlook on life.

For three months before we were liberated, Lwów was bombed daily by both the Russians and the British. Pritza and her children had moved out of the house when the bombing started, and she only came from time to time to the farm to pick vegetables. We also took chances to do the same so we wouldn't starve. However, fear had overtaken us – what if the barn's roof was bombed and we were killed or at the very least discovered? So my father dug a hole in the floor, with a trapdoor and just enough access for air to allow us to breathe. We were hungry, dirty with lice and insects and with little hope.

One day, under heavy bombardment, we were huddled in the hole when we heard two German soldiers come into the barn. We didn't dare move or even breathe for fear of discovery. Since we didn't hear the soldiers leave, we assumed they were lying down in the barn. We sat quiet the entire night and it felt like we would suffocate. Finally, we could sit no longer. My father motioned that he would open the trapdoor and crawl out. If the Germans were there, he would give himself up so they would take him away and we could survive. He slowly opened the door and looked around – the Germans had left. We climbed wearily back up to our hiding place in the loft and slept, secure that, at least that day, we had once again survived.

In June 1944 we were liberated by the Russians. We came out of our hole and smelled food. However, the Russians told us not to eat and instead find someone who could nurture us back to health. We were lucky again – a woman took us in, gave us a bath and put us to sleep in a bed with clean, crisp white sheets. She nursed us back to health for the next five weeks, and from then on we had enough food because my father traded with the Russians.

Ironically, the positions were now reversed, as Pritza came to us for food. We never saw Tajik and his sister again because their mother was terrified that if anyone found out that her family had hidden Jews they would be killed, even though the war was over.

With the help of Jewish agencies we lived for the next four years in a displaced persons (DP) camp[26] in Linz-Ebelsberg, Austria. We had a place to sleep, food to eat and even a school at which to study.

Our family finally emigrated to the US in 1949 and settled in New Orleans on Carondelet Street, next to an Orthodox synagogue, which my father attended every

day. Although I was 16 years old, I had to start at the very beginning and attended first grade at Jackson elementary school. I excelled in maths and science, but I found learning the new language challenging. Nevertheless, I persevered. At the end of eighth grade I graduated with honours.

This is something I learned from watching my two very strong parents. My father was always enthusiastic, interested in everything and full of life. This positive outlook on life helped get our family through the war and made him successful in America. When we arrived in New Orleans he stayed true to his beliefs and refused to work on Shabbos (the Sabbath). I couldn't understand why we should remain religious when our people had suffered so much, but his answer was always the same: God gave man a choice. It was man who chose evil, not God.

And so my father became a pedlar, a salesman of yard goods, which was a trade he knew well. And although he didn't speak the language, after working long hours and making many sacrifices he was ultimately able to start his own business. This taught me an important lesson early in my life – if you have the desire to succeed, you will, even if you are faced with many obstacles and challenges.

As soon as we arrived in America, we started sending packages back to Stephana's (Pritza's) family. My mother corresponded with her until her death. Tajik eventually married and had two sons living in Spain. Years later we were informed that they needed surgery. My father promised to send money for the procedure on one condition, that they tell their children what their great-grandmother had done for the Jews during World War II. Eventually we received a letter that we had saved two lives.

Chodorów had 4,000 Jews before the war started. Only 31 survived and those were thanks to the generosity of righteous Gentiles[23] who hid them. After my mother and my sister passed away in 2004 I travelled to Yad Vashem[48], the World Holocaust Remembrance Center in Jerusalem, to make sure that Tajik and Stephana were recognized as the 'Righteous Among the Nations'[5]. I couldn't rest until I took care of this. Their names are listed under their town, Chodorów (Khodoriv), in Ukraine. To this very day I still send money to their descendants as compensation and a reminder of their bravery. Because I grew up hearing my father repeat the story, I was compelled to always remember and be grateful to those who hid our family and those who liberated us.

After graduating from high school in New Orleans, I moved to New York City, where I met my husband, Harry Levy. We married and I continued my education and became a bookkeeper, and then worked alongside Harry in his jewellery business in Manhattan. After he passed away in 2008, I have continued to run the business. My vacation time is spent in Israel.

My husband and I raised two beautiful and successful children, both of whom have chosen careers in the healing professions – Howard is an orthopaedic surgeon and Myra an occupational therapist. I am also the proud grandmother of four grandchildren.

As a docent (volunteer guide) at the Museum of Jewish Heritage in New York, I teach students that even in the darkest of times you have to stay hopeful and strong. If you have the desire, you will succeed. And I tell them I speak from experience. Although I was an immigrant, my good-natured enthusiasm and excellent grades made a lasting impression on my teachers and classmates, and that's how I found myself on graduation day applauded for my achievements by an audience of my peers.

During my long life I have faced many physical, emotional and financial hardships but I have always confronted these trials with determination to overcome whatever obstacles came my way. And I did. This resilience in the face of adversity was the legacy bequeathed to me by my mother and father, who provided me with a strong and enduring heritage that has given my life purpose and meaning. It is a legacy that I strive daily, in my work and my relationships, to pass on to the next generation."

*Pages 214–215*
Tova Friedman
New York, USA

Tova Friedman was born on 7 September 1938 in Gdynia, Poland, to father Usher Machel Grossman and mother Reizel Pinkuschevitz Grossman, whose hometown was Tomaszów Mazowiecki in Poland. She is one of the youngest survivors of Auschwitz[14], and probably the youngest who has any memory of what happened. At this notorious extermination camp, 99 per cent of all children under the age of 12 were murdered on arrival at the camp. "Therefore my survival was a miracle," she says. Out of five thousand children who lived in Tomaszów, only four survived. Tova is the youngest.

After a three-day trip in a cattle car, with no food or water, six-year-old Tova arrived at Auschwitz in May 1944, where she was stripped, examined and tattooed, and had her hair shaven. She was sent to a children's barracks, awaiting extermination. On the scheduled day, about six weeks before liberation, her barracks was taken to the gas chamber, but the gas malfunctioned and the children were sent back. "Don't worry," she told her mother, "they'll get us next time."

In January 1945, knowing that the Russians were closing in on the camp, the Nazis decided to march the remaining inmates out of the camp to Germany. Tova's mother hid Tova and herself among corpses in the infirmary, and thus spared them from the death march[37]. On 27 January the Russians liberated the camp. Tova was almost 6½ years old. She says: "I speak for the children who have been gassed, shot and starved to death. I speak for those whose voices have been silenced."

Tova and her mother made it back to Tomaszów to await the return of family and friends. Out of the 15,000 Jews who had been living in Tomaszów, 300 returned. After a year and a half, Tova's father and his three sisters came back. Not one person returned from Tova's mother's family of Gerrer Hasidim (members of this Jewish sect) – 150 people, brothers, sisters and their children, perished. At that time there were anti-Semitic gangs roaming all over Poland, killing those who returned from camps. Tomaszów was not friendly toward its returning Jews, and some townspeople killed one of Tova's father's sisters.

Tova and her family were taken to a displaced persons (DP) camp[26] in Germany, where they spent about three years. In 1950, when Tova was 12, the family went to America. She says: "I tried to share the horrors, but nobody would listen. My teacher in school tried to have me cover my tattooed number."

Tova had never been to school, knew no English and could not read or write – yet in one year she was at the top of her class. Her father insisted that she have a Jewish education, so, in addition to attending public school, she was sent to a Jewish school. She met her future husband, Maier, there. "He was the only one who could speak Yiddish with me, and he showed me how to order lunch in a drugstore." Tova obtained a BA in psychology from Brooklyn College, and an MA in English from the City College of New York, majoring in black literature. She married Maier and they moved to Israel with their two children, Risa and Gadi. In Israel she taught ESL (English as a Second Language) for ten years at the Hebrew University in Jerusalem. The family, now with two more children, Itaya and Shani, returned to the US, where Tova then obtained an MA in social work from Rutgers University. "I always felt that one needs to make a difference in this world. You need to leave this earth a little better than you found it. As is written in the *Ethics of the Fathers* (a compilation of the ethical maxims of rabbis from an earlier age), the work (to repair the world) is great, and though it is not incumbent upon you to finish it, neither are you free to desist from trying."

Tova was the Executive Director of the Jewish Family Service (JFS) of Somerset, Hunterdon and Warren counties in New Jersey, for 21 years. Now retired as a director, she continues to serve JFS as a family therapist. "I feel that it is a privilege to be in a position to help those who turn to us in their hour of need."

Tova shares her experiences with children and adults, in schools and prisons, in churches and synagogues, conferences and symposia, and through books and movies. In 1998, Milt Nieuwsma, a visiting professor at Rutgers, interviewed her and two of her friends and survivors, and put their stories into a book, then called *Kinderlager*, now reprinted as *Surviving Auschwitz*. These three young girls came from the same town in Poland, and survived Auschwitz to be three of the four child survivors from Tomaszów. In 2005, Tova went with one of them, Frida, and one each of their children, to Europe, accompanied by a film crew from WGVU, a PBS station at the University of Grand Rapids, Michigan, to film their stories, "so the whole world will never forget".

In 2016 Tova, together with her daughter, Taya, and Taya's four sons, Eitan, Ari, Noah and Aron, went on a pilgrimage to Auschwitz. "I wanted my grandchildren to see Auschwitz first-hand, so they could share it with the future generations when all the survivors will be gone."

Tova shares her story to remind everyone that hatred, prejudice and violence destroy both the victim and the perpetrator. She tries to instil hope, to enable us to rebuild and reconstruct ourselves and our communities, and to inspire people to continue the unceasing battle against the forces of evil.

# Endnotes

**1.** Bergen-Belsen

Established in 1940 in north-western Germany, Bergen-Belsen was exclusively a prisoner-of-war camp until 1943, when parts of it became a concentration camp. It was the recipient of thousands of prisoners put on forced death marches from camps in the east as Allied troops advanced. The prisoner population grew from 7,300 inmates in July 1944 to over 60,000 by the time British troops liberated the camp on 15 April 1945.

**2.** Janowska

Built in September 1941 as a forced-labour armament factory near Lwów in south-eastern Poland; a month later a concentration camp was built next door. The camp was liquidated in November 1943.

**3.** Gestapo

The Secret State Police of the Third Reich. They were responsible for the prosecution of enemies of the Reich.

**4.** Viktor Kremin

Viktor Kremin was a German industrialist who expropriated Polish Jewish businesses in Radom, Lublin and Galicia with a special focus on businesses that recycled industrial waste. His workers were allowed to leave their ghettos to work in his factories and were generally given more food than other ghetto residents. They were also granted temporary reprieves from various roundups because of their "vital worker" status.

**5.** "Righteous Among the Nations"

An honorary title given by the State of Israel to non-Jewish individuals who saved or rescued Jews during the Holocaust, risking their own lives to do so. Recipients are commemorated in the Garden of the Righteous Among the Nations at Yad Vashem, Israel's memorial to the victims of the Holocaust. The title was awarded from 1953 until 1963 by Yad Vashem, and after 1963 by a commission headed by a Supreme Court justice. So far, over 26,000 people from more than 50 countries have been recognized with this title.

**6.** Lublin Castle

From 1939 to 1944, Nazis used the already established prison at Lublin Castle in Lublin, Poland, to imprison Polish Resistance fighters and Jews. It held 40,000–80,000 prisoners during the Nazi occupation.

**7.** Lublin ghetto

From November 1939 in Nazi-occupied Poland, Jews were forced to move to Jewish reservations in Lublin and elsewhere, and in March 1941 the Lublin ghetto was officially designated. There were approximately 40,000 residents in the ghetto when the Germans began to evacuate and destroy the ghetto on 17 March 1942. The majority were sent to the Bełżec extermination camp.

**8.** Majdanek

An extermination camp located on the outskirts of Lublin, Poland, Majdanek operated from 1 October 1941 until the Soviet army liberated it on 22 July 1944. The exact number of victims killed at this location has been long debated; the current estimate is between 95,000 and 130,000. It was not destroyed by the Nazis before liberation and was the first concentration camp discovered by the Allies.

**9.** Dachau

Dachau was the first concentration camp established by the Germans, in March 1933. Built in a former munitions factory in southern Germany, the camp was originally intended to hold political prisoners, which it did exclusively until 1938. It was a model for future concentration camps and served as a training camp for SS camp guards. It was liberated by the US army on 29 April 1945.

**10.** Concentration camp

These were camps established from March 1933 by the Nazis in Germany and Nazi-occupied Europe for the imprisonment of anyone the Reich considered an enemy, which eventually included Jews. There were over 40,000 camps and incarceration locations in Europe. Many were vast complexes, containing a number of satellites, or sub-camps.

**11.** Kristallnacht

During the night of 9–10 November 1938, the Nazis incited a pogrom against Jews in Germany and annexed Austria and the Sudetenland (the northern and western border regions of Czechoslovakia) in what has been termed Kristallnacht ("Night of Broken Glass"). This night of violence included the pillaging and burning of synagogues and the breaking of windows and looting of Jewish-owned businesses. Approximately 30,000 Jewish men were arrested and sent to concentration camps that night.

| | |
|---|---|
| **12.** Habonim | Found mainly in English-speaking countries, this is a Jewish youth cultural organization based on the ideals of socialism and Zionism. |
| **13.** Ghetto | An area of a city where Jews were forced to live, typically in very difficult, cramped conditions. Ghettos were usually sectioned off from the rest of the city with walls or fences. Most ghetto residents were eventually deported to concentration camps. |
| **14.** Auschwitz-Birkenau | Auschwitz-Birkenau was an evolving complex in Nazi-occupied Poland that was opened as a concentration camp in 1940. In 1942, a killing centre was added. There were three main camps: Auschwitz I, Auschwitz II (Birkenau) and Auschwitz III (Monowitz-Buna, also known as Buna-Monowitz). It was the largest camp complex established by the Germans. Over one million people perished at Auschwitz, 90 per cent of whom were Jews – most were murdered at Auschwitz II. The Soviet army liberated the complex on 27 January 1945. |
| **15.** Theresienstadt | This camp/ghetto was created by the Nazis in late 1941 in Terezín, in German-occupied Czechoslovakia, as a "model Jewish settlement" to convince investigators from the International Red Cross that Jews were being resettled in the east in order to supply Jewish labour. With the characteristics of a transit camp, a ghetto and a concentration camp, it was unique in the SS camp system. Approximately 140,000 Jews were transferred to Theresienstadt and were eventually deported if they did not perish in the poor conditions. Theresienstadt was the German name, and Terezín the Czech name. |
| **16.** Nordhausen | Also known as Dora-Mittelbau or Mittelbau-Dora, this concentration camp was opened near Nordhausen, Germany, in the summer of 1943 as a sub-camp of Buchenwald. In October 1944 it was declared a separate camp. It held an average of 15,000 prisoners. The inmates were tasked with building an industrial complex for munitions manufacture, including the V2 rocket. To avoid Allied bombing, the Nazis decided to construct the complex underground. Forced to build tunnels in the surrounding mountains, prisoners lived and worked underground from the camp's inception until spring 1944. The mortality rate here was higher than at most other camps. It was liberated by the US army in April 1945 but by that time most inmates had been put on death marches or evacuated to other camps. |
| **17.** Kindertransport | A programme that brought nearly 10,000 children from Germany, Austria, Poland, Czechoslovakia and the Free City of Danzig to Great Britain during the nine months before the outbreak of the war in September 1939. (One final ship left the Netherlands in May 1940.) Children were placed with foster families or they stayed at farms, schools and hostels. There were also Kindertransports to other countries, such as France, Belgium and the Netherlands. |
| **18.** Albania sanctuary | After Nazi Germany occupied Albania in 1943, the government and its citizens defied their occupiers by refusing to turn over lists of the 200 Jewish residents in the country or the approximately 600–1,800 Jewish refugees from nearby countries. This act of defiance was rooted in the Albanian code of honour "*besa*", meaning "to keep the promise", which involves keeping one's word, being trustworthy and caring for those in need. Nearly all Jews residing in Albania during the war were saved by the only country in Europe with a Muslim majority. |
| **19.** Youth Aliyah | The Youth Aliyah organization, founded in Berlin on the day that Hitler took power, on 30 January 1933, transferred over 14,000 German Jewish children to Palestine and Britain between 1933 and 1945. It is still involved in the rescue of Jewish children today. |
| **20.** Buchenwald | This concentration camp was established in central Germany in July 1937 as a men-only camp. It wasn't until early 1944 that women were sent there. The largest concentration camp in Germany, Buchenwald held approximately 250,000 inmates over the course of its existence. Prisoners were from all groups persecuted by the Nazis and from all countries in Europe. As Allied forces drew closer in April 1945, 28,000 prisoners were evacuated. When the US army liberated the camp on 11 April 1945, 21,000 inmates were still remaining. |
| **21.** OSE (Oeuvre de Secours aux Enfants) | OSE (the Society for Rescuing Children) is a Jewish humanitarian organization based in France. Before and during World War II it aimed to help, protect and hide Jewish children, from France and other countries of Western Europe, whose parents were in concentration camps or had been killed. OSE ran children's homes throughout France until 1942 when the Nazis started deporting Jewish children from orphanages to concentration camps. It then began to smuggle children to neutral countries or to hide them using false identity papers. |
| **22.** Transit camp | Transit camps were large-scale collection points for Nazi prisoners before they were deported to a concentration camp or an extermination camp. |

| | |
|---|---|
| **23.** Righteous Gentiles | Used in rabbinical Judaism, this term "righteous Gentiles" refers to non-Jewish individuals who abide by the Seven Laws of Noah (those Jewish commandments that are applicable to non-Jews). However, it can also be used in a less formal sense, and it led to Israel's Holocaust memorial Yad Vashem's honorary title "Righteous Among the Nations" for those who actively helped Jews in defiance of Nazi policy. |
| **24.** Dr Alfred Wiener | A German Jewish intellectual who began to gather evidence about the rise of the Nazis in Germany as events unfolded. Having fought in World War I, Wiener was shocked at the surge of German right-wing anti-Semitism, which blamed Jews for Germany's defeat. Working with the Central Association of German Citizens of Jewish Faith, he aimed to collect, record and disseminate material that would serve as a warning about the dangers of the rise of Nazism. Dr Wiener and his collection eventually relocated to London, where the collection still operates as the Wiener Library, in Russell Square. Dr Wiener's wife did not survive the Holocaust, but he was reunited with his three daughters after the war. |
| **25.** Sobibór | This extermination camp was constructed in the spring of 1942 in the village of Sobibór, in Nazi-occupied Poland just west of the Bug River. As early as autumn 1942 Jewish labourers were forced to exhume mass graves in order to burn any evidence of the murders that took place there. At least 170,000 people perished at Sobibór. |
| **26.** Displaced persons camps (DP camps) | These special camps were arranged to house and treat more than 250,000 Jewish survivors who had no home to return to after the war ended on 8 May 1945. Camps located in Germany, Austria and Italy were overseen by Allied authorities and UNRRA (United Nations Relief and Rehabilitation Administration). |
| **27.** UNRRA (United Nations Relief and Rehabilitation Administration) | The United Nations Relief and Rehabilitation Administration, or UNRRA, existed from 1943 until 1947. According to its charter, its charge was to "plan, coordinate, administer or arrange for the administration of measures for the relief of victims of war in any area under the control of any of the United Nations through the provision of food, fuel, clothing, shelter and other basic necessities, medical and other essential services". It was the leading agency helping to repatriate displaced persons after the war. |
| **28.** Sir Nicholas Winton | Between January and August 1939 Nicholas Winton arranged the successful evacuation of 669 Czechoslovakian children to Britain. Winton was a British citizen who was introduced to the children's plight after he was invited to Prague by his friend Martin Blake, an associate of the British Committee for Refugees from Czechoslovakia. The last, and largest, group – consisting of 250 children – was meant to leave by train on 1 September 1939, but Hitler's invasion of Poland on that day meant that the train was cancelled. Only two children who were scheduled to leave on this train survived the war. |
| **29.** Work camp (labour camp) | A camp where prisoners were forced to work for military purposes or private companies. |
| **30.** Einsatzgruppe C | Mobile killing squads composed of Security Police and SS Security Service, the Einsatzgruppen travelled to local communities, behind the German army as it advanced east, to murder anyone deemed an enemy of the Reich. Shooting was the preferred method of killing but later mobile vans were employed that used the exhaust from the vehicles to kill their victims. There were four Einsatzgruppen squads – Einsatzgruppe C started in Kraków, Poland, and advanced across western Ukraine. |
| **31.** Mauthausen | Almost immediately after the annexation of Austria in March 1938, a concentration camp was established near the Austrian town of Mauthausen, south-east of Linz. Within two years, it had become one of the largest camp complexes in the German Reich. An estimated 197,000 people were inmates at this camp between March 1938 and May 1945. The SS guards abandoned the camp on 3 May 1945, and American forces liberated it on 5 May 1945. |
| **32.** HASAG/Hugo Schneider AG | A metal-goods manufacturing company based in Leipzig, Germany, that expanded dramatically during World War II using forced labour from concentration camps and ghettos in Germany and Poland. During the war, the company focused on arms and ammunition manufacturing. It was the third-largest user of forced labour in Europe. |
| **33.** Treblinka | Built in July 1942 in a heavily wooded area north-east of Warsaw, Treblinka was one of the first Nazi extermination camps. Between July 1942 and November 1943 an estimated 870,000–925,000 Jews perished there. In autumn 1942 Jewish labourers were forced to exhume bodies and burn all evidence of mass graves. On 2 August 1943 there was a revolt at the camp by the remaining prisoners, who rushed the main gate in an attempt to |

escape. Many were killed in the process but around 300 did escape. All but about 100 were tracked down and killed, but 70 survived the war. The remaining prisoners were forced to dismantle the camp and destroy the incriminating evidence before being shot. Although the extermination camp (Treblinka II) was officially closed at that time, the work camp (Treblinka I) continued operations, and arriving Jews who were too weak to work were still sent to Treblinka II to be killed. In late July 1944, as the Soviet army closed in, guards shot the remaining 300–700 prisoners before quickly destroying the remnants of the camp.

**34.** Extermination camp

Extermination camps (or death camps) were designed to facilitate efficient mass murder. They included Auschwitz II (Birkenau), Bełżec, Chełmno, Majdanek, Sobibór and Treblinka, all of which were in Poland.

**35.** Friedland

A sub-camp in the vast Gross-Rosen concentration camp complex, Friedland was an airplane-parts facility that built mainly propeller blades. Prisoners at this factory were largely Polish, Czech and Hungarian Jews.

**36.** Ravensbrück

Opened in May 1939, this was the largest female concentration camp in Germany. In spring 1941, a small men's labour camp was built nearby. By 1942, Ravensbrück was being used as the main training location for female SS guards. Approximately 130,000–132,000 women were incarcerated at Ravensbrück over the course of its operation. The inmates were from all the countries of Nazi-occupied Europe. It was liberated by the Soviet army in April 1945.

**37.** Death marches

A death march was the forced transfer of prisoners to the interior of the German Reich to avoid approaching Allied forces. Initially, the evacuations were done by train, starting in the summer of 1944, but as winter approached, prisoners were forced to evacuate on foot. An estimated 200,000–250,000 prisoners were murdered or died on these marches.

**38.** JDC (American Jewish Joint Distribution Committee)

Founded in 1914, the JDC is a Jewish humanitarian assistance organization. Before, during and after World War II it helped Jewish survivors by providing emergency relief in the form of food, medicine, clothing and supplies, and also assisted with long-term rehabilitation.

**39.** Yellow-star houses

A network of around 2,000 houses in Budapest in which over 200,000 Jews were forced to live in 1944. Both the houses and their residents were obliged to display the Star of David.

**40.** Gross-Rosen

Established as a sub-camp of Sachsenhausen camp in summer 1940, Gross-Rosen, in Poland, was reclassified by the SS as a separate concentration camp in May 1941. Around 125,000 prisoners were incarcerated at Gross-Rosen or one of its vast network of nearly 100 sub-camps during the war. It was liberated by the Soviet army on 13 February 1945.

**41.** Flossenbürg

This concentration camp was built in May 1938 in Bavaria, Germany, near the Czechoslovakian border. The majority of inmates came from Nazi-occupied Eastern Europe. Previous to 1944, the majority of prisoners at this camp were political prisoners. The camp was liberated on 23 April 1945 by the US army. Approximately 97,000 people were inmates at Flossenbürg over its years of operation.

**42.** Josef Mengele

Josef Mengele was senior SS physician from 1943 to 1944 at Auschwitz-Birkenau. In addition to assisting with the selection process as trains arrived, he also conducted cruel and deadly medical experiments on prisoners.

**43.** Shtetls

Shtetls were small, poor Eastern European towns with a predominantly Jewish population and a centuries-old traditional way of life; they were eradicated by the Nazis.

**44.** Mühldorf

This work-camp complex, like Kaufering, was established in summer 1944 as a series of satellite camps of Dachau. It supplied slave labour for factories in the area and for the construction of underground bunkers intended to be used for a jet-engine factory. The majority of prisoners were Hungarian Jews. When the US army discovered the camp in April 1945, all the labourers had already been deported.

**45.** Kaufering

Like Mühldorf, this was a network of work camps established in 1944 as satellites of Dachau concentration camp. Inmates were forced to dig tunnels and underground bunkers to be used for the manufacture of fighter aircraft out of the reach of Allied bombs. Prisoners were put on a death march to Dachau as the US army approached in April 1945.

**46.** Landshut

Established as a satellite of Dachau concentration camp, this was a work camp supplying slave labour for local industry.

| | |
|---|---|
| **47.** Alfred Rossner | The German manager of a uniform factory in Będzin, Poland, Alfred Rossner worked directly under the SS. He protected thousands of Jews in his workshop because the work they were doing was considered essential for the German war effort. For a short time he was able to obtain special privileges for his workers, such as exemption from deportation, and increased food rations. During the first large deportation from Będzin, in May 1942, Rossner drove his one-horse buggy into the poorest quarters of the town shouting in Yiddish to the inhabitants to disregard the summons of the Judenrat (the Jewish Council, controlled by the Nazis) and not to report for deportation. He continued to assist and protect his workers, until the Gestapo arrested him in December 1943. A month later he was hanged, almost certainly for aiding and abetting Jews. Rossner was recognized by Israel's Holocaust memorial Yad Vashem as "Righteous Among the Nations". |
| **48.** Yad Vashem | Established in 1953, Yad Vashem is Israel's memorial to the six million Jewish victims of the Holocaust. Located in Jerusalem, the complex includes memorial sites, museums and a Garden of the Righteous Among the Nations. |
| **49.** Selection | After arrival at a camp, prisoners were subjected to a selection process in which SS doctors divided them into two groups – those who were strong and healthy enough for labour and those who were sent immediately to their death. |
| **50.** Płaszów | Established in 1942 near Kraków, Poland, Płaszów began as a work camp for Jews recently deported from the Kraków ghetto, and was designated a concentration camp in January 1944. At its height, Płaszów had 20,000 prisoners. Oskar Schindler's factory was nearby and used workers from this camp; Schindler attempted to protect his Jewish workers (about 900) from abuse in the camp and deportation to extermination camps. In the summer of 1944, as Soviet troops advanced, the Nazis began evacuating the camp, and in January 1945 the remaining prisoners were sent to Auschwitz. The Nazis completely dismantled the camp, having exhumed and burned all evidence of mass graves. When the Soviet forces arrived on 20 January 1945 there was nothing left of the camp. |
| **51.** Bełżec | Bełżec, in Poland, was one of the first Nazi death camps. Between 430,000 and 500,000 Jewish and Roma prisoners are thought to have died there between March and December 1942. In the spring of 1943 the Nazis dismantled the camp and burnt evidence of mass graves using Jewish forced labour. By June, the site of the camp had been ploughed, crops planted and a house built to disguise it as a farm. There were only seven known survivors. |
| **52.** Italian anti-Jewish Racial Laws | Similar to the German Nuremberg Laws of 1935, Italian anti-Jewish Racial Laws stripped Jews of their basic civil rights, restricted their access to education and banned their travel. The Italian laws were in effect from late 1938 until the fall of Mussolini on 25 July 1943. |
| **53.** Markstädt and Fünfteichen | Sub-camps of the vast Gross-Rosen concentration camp complex. |
| **54.** Kinderheim | A children's home or orphanage. |
| **55.** Appropriation of Jewish property | As the Nazis swept through Europe, they seized the property of so-called enemies of the German Reich. This included homes, businesses and their contents. After the war, most countries in Western Europe created some legal framework to allow the return of stolen property. In some cases, ownership of the property was contested and families had to go to court to prove ownership. Most countries behind the Iron Curtain did not have such laws until after the collapse of the Soviet Union. |
| **56.** Nuremberg Race Laws | These antisemitic laws were introduced at the annual party rally of the Nazi Party on 15 September 1935. They institutionalized the racial theories on which Nazi ideology was founded, excluding German Jews from Reich citizenship and prohibiting marriage and extramarital relations between Jews "those of German or related blood". The laws were expanded on 26 November 1935 to include Romani people and Afro-Germans. They had a crippling socio-economic impact on the German Jewish community, disenfranchising them and removing many of their political rights. |
| **57.** Schwarzheide | This sub-camp of Sachsenhausen in Germany was a synthetic fuel factory. The US Air Force bombed the factory in a raid on 11 September 1944. |
| **58.** Bloody Sunday | On 12 October 1941 thousands of Jews from Stanisławów in Poland (now in Ukraine) were gathered on the town's market square, before being marched to the Jewish cemetery. Mass graves were already dug and the Jews were ordered to undress and hand over all their |

valuables. They were then lined up in front of the pits and shot. An estimated 8,000–12,000 Jews were massacred that day, which became known as Bloody Sunday.

**59.** Mandatory Palestine

The geopolitical area, overseen by British civilian administration, was known as Mandatory Palestine (or the British Mandate for Palestine or just the British Mandate). Established by the League of Nations, it came into effect on 29 September 1923 and ended on 14 May 1948.

**60.** Jewish Brigade

A military formation of the British army established in September 1944 and composed of more than 5,000 Jewish volunteers from Mandatory Palestine. The Brigade fought against the Germans in Italy from March 1945 until the end of the war in May 1945.

**61.** Illegal post-war immigration from Europe to Palestine

After the war, Britain continued to keep strict controls on immigration, which resulted in Europe's Holocaust survivors using the Zionist underground to emigrate illegally to Palestine. It is estimated that over 100,000 people tried to emigrate to Palestine. Many were intercepted by the British Royal Navy and were sent to internment camps in Cyprus or Mauritius or a detention camp in Atlit in Palestine.

**62.** Raoul Wallenberg

A Swedish diplomat stationed in Budapest, Wallenberg saved thousands of Hungarian Jews by issuing certificates of protection and providing shelter in buildings deemed to be Swedish territory. On 17 January 1945, during the Red army's siege of Budapest, Wallenberg was detained by Soviet officials on suspicion of spying. He reportedly died in a Soviet prison.

**63.** Birkenau's Judenrampe

From February 1942 Jews transported to Auschwitz-Birkenau in cattle wagons on freight trains carrying 2,000–3,000 people disembarked onto the wooden ramp known as the Judenrampe, alongside a railway siding. Approximately 500,000 Jews descended onto this structure, and it is thought that at least 75 per cent were gassed immediately at Birkenau. The use of the ramp was discontinued at the end of April 1944, because of the completion of a railway spur extending all the way to the gas chambers inside the camp.

**64.** Sonderkommando revolt

During the summer of 1944, a number of young Jewish women who were working as slave labourers in the munitions factory Weichsel-Union-Metallwerke, located just outside the Auschwitz concentration camp, smuggled dynamite to members of the camp's Resistance movement over a period of months. Despite being under constant observation, the factory women managed to take small amounts of gunpowder, wrap it in bits of material and paper, hide it on their bodies, and then pass it along the smuggling chain. The dynamite was passed on to members of the Sonderkommando (the Jews who were forced to work in the crematoria at Auschwitz, before being killed themselves after a period of weeks or months). The aim was to blow up the crematoria as part of a general uprising that was to encompass Auschwitz II (Birkenau), the labour/extermination camp. On 7 October 1944 the Sonderkommando, upon realizing that they were soon to be executed by the Nazis to prevent them from reporting on what they had witnessed at the camp, decided to act on their own. They succeeded in partially destroying one crematorium with the dynamite smuggled to them, but the armed revolt failed and the general uprising never took place. The revolt cost hundreds of lives, with most of the Sonderkommando being executed. Some of the women factory workers, including Ala Gertner, Regina Safirsztajn and Ester Wajcblum, who had been involved in the plot, and the ringleader of a Birkenau resistance cell, Roza Robota, were brutally tortured by the SS due to their involvement in the plot, yet they never betrayed the other members of the underground movement. They were publicly hanged on 6 January 1945. The bravery and resistance of these four young women is commemorated in a sculpture by Joseph Salamon at the Yad Vashem Holocaust memorial in Israel.

**65.** British Mandate prohibiting Jewish immigration to Palestine

After a record number of Jewish immigrants entered Mandatory Palestine in 1935, the British administration told the Jewish Agency that less than one-third of the quota of immigration visas it asked for would be approved. Jewish immigration was to be restricted to 75,000 over the next five years, after which it would be halted altogether. Even after the war, the British administration would not allow Jews to immigrate to Palestine. Anyone who wanted to reach Palestine had to do so illegally. It is estimated that between August 1945 and the establishment of Israel in May 1948, nearly 70,000 people immigrated in this way.

**66.** Schindler's List

Oskar Schindler, a German industrialist, owned an enamel works factory on the outskirts of Kraków, Poland. Schindler utilized Jewish workers from the nearby Płaszów work camp in his factory. In October 1944 he received permission from the German Reich to relocate his factory to Brünnlitz, in the Sudetenland (formerly Czechoslovakia), and through negotiations and bribes he was able to transfer more than a thousand Jewish workers to the new factory in order to protect them and ultimately save their lives.

| | |
|---|---|
| **67.** Trawniki massacre | At the end of October 1943 all slave labourers in the Majdanek complex (Majdanek, Trawniki, Poniatowa, Budzyń, Kraśnik, Puławy and Lipowa) were ordered to dig anti-tank trenches around their camps. On 3 November their true purpose was revealed when the labourers were lined up along the trenches and shot. Approximately 43,000 people died. |
| **68.** Trawniki | This concentration camp was established south-east of Lublin, Poland, in July 1941 to incarcerate Soviet prisoners of war. From September 1941 to July 1944 it was a training location for police auxiliary guards. Additionally, from June 1942 to September 1943 it became a Jewish work camp. Finally, from September 1943 to May 1944 it operated as a sub-camp of Majdanek extermination camp. |
| **69.** Kapo | A prisoner assigned by the SS to supervise the other prisoners. |
| **70.** Internment camp | Internment camps were set up by the German army to hold Allied civilians. |
| **71.** Murder of Jewish intelligentsia | As the Nazis advanced east, they often targeted the intelligentsia (doctors, academics, judges, community leaders) in the countries they occupied. Their goal was to stop these groups from organizing anti-Nazi activities. Both Jewish and non-Jewish intelligentsia were targeted. In Poland, even the children of intelligentsia were murdered. |
| **72.** Stutthof | Established as a civilian internment camp on 2 September 1939, this was the first concentration camp outside of German borders, becoming a concentration camp in January 1942. Stutthof was located east of Gdańsk (Danzig), Poland, in a secluded, wooded area. SS guards began to evacuate the nearly 50,000 inmates in January 1945 – only half survived the evacuation. The camp was liberated on 9 May 1945 by Soviet forces but there were only about 100 inmates left, who had managed to hide during the evacuation. |
| **73.** Kaiserwald | Located near Riga, Latvia, this concentration camp was established in March 1943. In August 1944 the SS started to evacuate the camp as Soviet forces neared. Before the evacuations began, all Jews under 18 and over 30 were executed. Those remaining were evacuated to Stutthof camp. The Soviet army liberated the camp on 13 October 1944. |
| **74.** Lwów pogroms | Under the provisions of the 1939 Soviet–German Pact, Lwów fell under the control of the Soviet Union. In June 1941, when Germany invaded the Soviet Union, the Germans gained control of Lwów. Afterward, the Germans were able to convince the local population that the Jews in the city supported and helped the Soviets. Ukrainian mobs massacred Jews in two pogroms, the first from 30 June to 2 July and the second from 25 to 29 July 1941. Approximately 5,000 Jews were killed within a one-month period. |
| **75.** Swiss asylum | During World War II, Switzerland had a policy of armed neutrality. Given its shared border with so many Nazi-occupied countries, it was seen as a safe haven by Jews fleeing Nazi persecution. Switzerland only granted asylum to individuals being persecuted for political beliefs, not for religion, so most Jews who entered the country had to be smuggled in. |
| **76.** Hadassah | Founded in 1912, Hadassah is an American Jewish women's volunteer organization. |
| **77.** B'nai B'rith | Founded in New York City in 1843, this is a Jewish community service organization focused on fighting anti-Semitism and anti-Israel bias. |
| **78.** Hidden Children | Only 6–11 per cent of Europe's prewar population of Jewish children survived World War II (compared with 33 per cent of the adult Jewish population). The majority of these survivors had been able to hide during the war either by obtaining false identities that allowed them to be placed with Christian families if they looked "Aryan" or by being physically hidden in attics, cellars, sewers and barns. They were often referred to as Hidden Children. |
| **79.** Rivesaltes | Established in 1936 in the South of France, near the French–Spanish border, this internment camp was originally built to hold refugees from the Spanish Civil War. In January 1941 the Vichy government began to send Jews and "undesired refugees" there. It functioned as a transit camp, and the majority of its prisoners were sent on to Auschwitz or to Gurs internment camp in south-west France. The camp was closed in November 1942. |
| **80.** Alexandre Glasberg | Alexandre Glasberg was a Jewish-born French Catholic priest. After Germany invaded France, Glasberg began to assist Jews who were being persecuted by the Nazis, helping to establish shelters and safe houses where Jews could hide during the war. He was awarded the title of "Righteous Among the Nations" by the Yad Vashem Holocaust memorial. |

# Index

Page numbers in *italics* refer to photographs. Major page references are in **bold** type.

# Acknowledgements

**Harry Borden** is one of the UK's finest portrait photographers and his work has appeared in many of the world's foremost publications including the *New Yorker*, *Vogue* and *Time*. He has won prizes at the World Press Photo awards (1997 and 1999) and was a judge in the contest in 2010 and 2011. In 2005 he had his first solo show at London's National Portrait Gallery, which currently has over a hundred of his prints in their archive. In 2014 he was awarded an Honorary Fellowship by the Royal Photographic Society.

**Miriam Hechtman** is an Australian journalist and producer. She has worked on several Holocaust-related projects, including Showtime's television documentary "Outwitting Hitler". Growing up in Melbourne's Holocaust survivor community with four survivor grandparents, Miriam has always been interested in the effects of the Holocaust. She feels the survivor community's unique wisdom will be helpful to other survivors of genocide and hardship. In joining Harry on this project Miriam was able to interview each of the survivors on film about their experiences and life after war.

*Miriam's contribution to this project is dedicated to her grandparents, Resi and Pinchas Koplowicz and Serla and Laibl Hechtman, who were all survivors.*

An Hachette UK Company
www.hachette.co.uk

First published in Great Britain in 2017 by Cassell, a division of Octopus Publishing Group Ltd, Carmelite House, 50 Victoria Embankment, London EC4Y 0DZ
www.octopusbooks.co.uk

Text and images copyright © Harry Borden 2017
Design and layout copyright © Octopus Publishing Group Ltd 2017

Distributed in the US by Hachette Book Group, 1290 Avenue of the Americas, 4th and 5th Floors, New York, NY 10020

Distributed in Canada by Canadian Manda Group, 664 Annette St., Toronto, Ontario, Canada M6S 2C8

ISBN 978-1-84403-906-7

A CIP catalogue record for this book is available from the British Library.

Printed and bound in China.

10 9 8 7 6 5 4 3 2 1

Editorial Director: Trevor Davies
Creative Director: Jonathan Christie
Senior Editor: Leanne Bryan
Researcher/Project Partner: Miriam Hechtman
Additional Historical Text: Mary Vrabecz
Copy Editor: Alison Wormleighton
Senior Production Manager: Peter Hunt

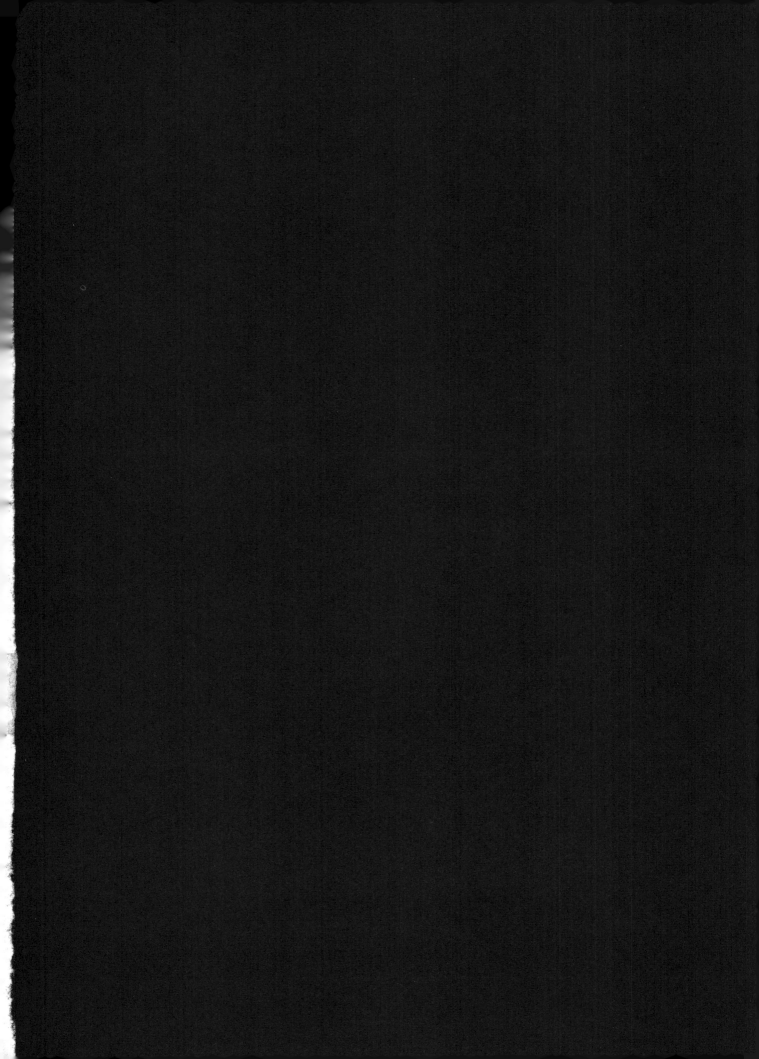